CANADIAN
COUNTRY
FURNITURE
1675–1950

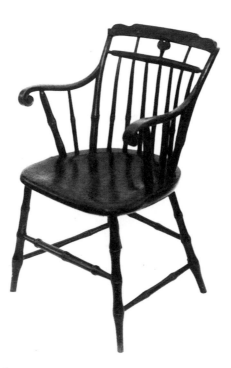

To Susan,
whom I so greatly love and admire

CANADIAN COUNTRY FURNITURE

1675–1950

MICHAEL S. BIRD

Foreword by Howard Pain
Introduction by Claudia Kinmonth

Stoddart

A BOSTON MILLS PRESS BOOK

Canadian Cataloguing in Publication Data

Bird, Michael S., 1941-
 Canadian country furniture 1675-1950

Includes bibliographical references and index
ISBN 1-55046-087-0

1. Country furniture - Canada - History. I. Title.
NK2441.B57 1994 749.211 C94-931435-8

First published in 1994 by A BOSTON MILLS PRESS BOOK
Stoddart Publishing Co. Limited The Boston Mills Press
34 Lesmill Road 132 Main Street
Toronto, Canada Erin, Ontario
M3B 2T6 N0B 1T0
(416) 445-3333

Design by Andrew Smith
Copy-editing by Kathleen Fraser
Page composition by Andrew Smith Graphics Inc.
Printed in Canada by Friesen Printers

Photo Credits *(by figure references)*
Birmingham Museum and Art Gallery, 14; Canadair Collection, 171, 193; Canadian Museum of Civilization, 239, 240, 256; Desbrisay Museum, 8; Detroit Institute of Arts, 229; Henry and Barbara Dobson, 47, 57, 69, 175, 234, 367, 368, 374, 375, 408, 418, 424; George Georgakakos, 145; Glenbow Museum, 29, 525 (left), 528, 530, 533, 534, 536, 537, 540, 541, 545, 672; Jim MacLeod, 479, 510, 624, 658, 671; Montreal Museum of Fine Arts, 16, 165, 176, 184, 187, 192, 196, 231; New Brunswick Museum, 56, 74; Newfoundland Museum, 42; Nova Scotia Museum, 34, 37, 38, 86; Howard Pain, 250, 251, 254, 255, 257, 262, 265, 267, 269, 271, 272, 276, 279, 280, 282, 293, 299, 342, 346, 380, 392, 395, 409, 410, 412, 417, 420, 425, 426, 435, 436, 439, 440, 442, 449; Walter Peddle, 10, 71, 87, 113; Quebec Museum, 225; Royal Ontario Museum, 7, 67, 75, 122, 169, 170, 173, 174, 177, 178, 179, 180, 185, 186, 190, 191, 197, 199, 221, 222, 237, 241, 243, 244, 246, 253, 371; Stanley Sherstibitoff, 646; Paul Smith, 26, 447, 493, 494, 497, 509, 513, 516, 518, 577, 656, 659, 700; SusanWhitney, 555; other photography by the author.

Key to Abbreviations
AGNS Art Gallery of Nova Scotia
CMC Canadian Museum of Civilization
CMC (CCFCS) Canadian Museum of Civilization: Canadian Centre for Folk Culture Studies
JSH Joseph Schneider Haus Museum
JSH (CHC) Joseph Schneider Haus Museum: Canadian Harvest Collection
ROM Royal Ontario Museum

CONTENTS

FOREWORD

With the publication of *Canadian Country Furniture*, the subject of country furniture in Canada is expanded and defined in a way that has not been done before. For the first time we have an opportunity to see the remarkable variety and richness of the Canadian country furniture heritage, from coast to coast, in one well-organized study. Certainly there is an impressive list of earlier works on early Canadian furnishings, but these have largely been regional in scope or very general in approach. As well, the focus of these studies has been primarily on those parts of the country which were settled in the 18th and 19th centuries. There has been virtually nothing published on the furniture made in the areas of later settlement, particularly Western Canada.

It is only rather recently that the great variety of traditional Eastern and Northern European furniture forms have had exposure in other parts of the country and been widely accepted as important. In this ambitious undertaking, material representing several ethnic groups, including the Hutterite, Mennonite, Doukobor and other communities across Western Canada, takes its rightful place as a major facet of our Canadian furniture heritage.

The author has also spared no effort to include examples from the Atlantic Provinces, Quebec and Ontario which provide a fresh and well-balanced view of the popular forms and regional styles from those areas. Alongside some of the previously published icons that have helped form our image of these regional furniture traditions, we see examples which add depth to our understanding. For instance, in the wonderfully decorative items from Newfoundland and the simple sturdy pieces from the Acadian settlements we are reminded of often overlooked aspects of Canada's multicultural heritage.

In selecting over seven hundred illustrations, the author has included many examples which incorporate carved, cut-out and painted embellishment. The result is a compendium of folk decoration, including elements and motifs that have been used for centuries in the older traditions of Europe and the British Isles. These wonderful, decorative items have great appeal in our highly mechanized world and are an important part of the Canadian tradition and clear evidence that our forefathers were not always serious and certainly not dull.

However, the triumph of this long overdue cross-country study is in bringing together this remarkable variety of traditional furnishings which were made in backwoods and prairie workshops, and in the hamlets, villages and towns of a developing country. In this way, *Canadian Country Furniture* gives us not only an impressive new view of Canadian country furniture but much to contemplate about the character of our complex nation.

HOWARD PAIN

INTRODUCTION

An invitation to write the introduction to a new and definitive book on Canadian furniture is like an invitation to explore a new country, bringing with it a nervous excitement and sense of anticipation. For the reader turning the first few pages, these feelings are heightened not only by the discovery of previously unknown designs but also in recognizing familiar aspects of furniture from other parts of the world. Just as one glimpses similarities and characteristics common in members of the same family, Canadian furniture reflects and departs from its Old World parentage in ways that are both subtle and arresting.

Canada is made up of a colourful mosaic of contrasting groups from diverse areas. Distinct concentrations of settlement originated from England, Scotland, Ireland, France, Germany, Poland and the Ukraine. Further cultural clusters can be identified from parts of America and Russia, and can be divided further by their religious inclinations; hence the Amish, Hutterite, Mennonite and Doukobor settlements. The dilution of such different groups into a "New World" society and the endurance and alteration of identifiable characteristics of their furniture design produce a study of settlers at their most creative and imaginative. The author explains and debates the meeting point and compromise that inevitably occurs at the junction of aesthetics and function. Furniture is always a synthesis of these two and these aspects combine to reflect the owners' and makers' cultural origins uniquely.

Michael Bird introduces us to each cultural group in terms of its origins and defining characteristics. He explains how and why they set out on the journey to Canada, whether driven there through persecution, poverty or famine, or assisted by grants not only from Canadian authorities but also from the governments of their homelands, eager to rid themselves of a surplus poor population. Many gained passage on ships whose primary purpose was to export Canadian grain or timber, and they fulfilled the purpose of ballast on the ship's return voyage. These poor migrants often suffered terribly during the journey, risking death by cholera or starvation, hence the terms "coffin ships." They arrived with what they could carry, and always tended to settle together in closely knit communities upon arrival. The names they gave their new settlements reflect a distinct nostalgia: Newfoundland, Nova Scotia, Halifax, Glengarry, New Waterford and New Glasgow. Having set the cultural scene for each group, the author provides an outline of the style and decoration of the furniture of each homeland. Once this background is established, the furniture built for the New World homes is described in terms of use, construction, style and decoration. The relationship between the remembered furniture of the Old World (as a rule the portable trunk was the sole import) and that of its rebirth in the new society is discussed, and is surprisingly unpredictable. As the author explains, it is almost as fascinating to ponder the designs which were abandoned as it is to discover which elements were

retained, adapted, or synthesized into a new regional style.

Unlike most furniture historians, Bird has photographed the vast majority of the furniture himself. This approach enabled him to examine each piece minutely and at first-hand, providing the opportunity for thorough object analysis, comparative analysis, and also commentary on methods of construction, timber types, and stylistic innovation and idiosyncrasy. The monumental task of this research, undertaken over six to ten years, has carried him thousands of miles across the length and breadth of Canada. The enormity of such a task is breathtaking and also helps explain why a study of this magnitude has not been undertaken before now. When discussing such a labour of love, he admitted to me somewhat ruefully that the geographical magnitude of the work had confronted him one day as he examined a dish cupboard in a kitchen overlooking the Atlantic Ocean, while recalling his previous week's preoccupation with a dish cupboard in a kitchen which overlooked the Pacific!

Bird has sought out an extraordinarily diverse range of furniture to bring his text alive. His photographs show articles from museums and private collections, as well as surviving examples of furniture within the homes for which they were originally made. This latter group, so often neglected in other studies, is an ever diminishing one, threatened not only by the advances of the ever hungry antique trade, but also, perhaps understandably, by the inevitable process of modernization. The amount of time devoted to tracking down such elusive furniture in situ is equatable to looking for the needle in the haystack.

The complex relationship between furniture of the Old World and that of the New World, with its cross-cultural links and interdisciplinary approaches, is made possible by studies such as this. Here I must declare a particular interest, not only as a furniture historian, but also as one who has always specialized in and researched Irish country furniture. Therefore I awaited this splendid manuscript impatiently, fascinated to see how the significant number of immigrants of Irish origin translated their designs into New World or Irish-Canadian forms. The majority of these Irish settlers arrived during the prolonged tragedy and distress of the so-called potato famine which ravaged Ireland in the 1840s. The greatest number of these arrived in Canada around 1847. Upon arrival, they were delegated the second-rate, barely arable coastal hinterlands which had been rejected by previous waves of settlement.

Typically they settled in close-knit groups, often choosing Scottish neighbours. Some of the furniture that they built for themselves and others setting up new homes closely resembled designs which had endured for hundreds of years in Ireland. The settle bed, an ingenious dual-purpose design known to have endured in Irish farmhouses since the early 17th century, reemerged in Irish-Canadian homes in significant numbers. It was still customarily positioned against the rear wall near the hearth, and in French Canada was called the *banc-lit*. Such transfers of designs can be seen not only as the survival of familiar, tried and tested old forms, but can also be useful signposts to areas of Irish settlement. Comparisons

between the Old and New World designs not only inform how our ancestors survived despite harsh and unfamiliar conditions, but also how they absorbed and adapted local customs into their new way of life. It transpires that these adventurous settlers abandoned as many of their traditional furniture forms as they rebuilt. That there is only a rare reemergence of the ubiquitous three-legged "creepy" stool, so familiar in both Irish and Scottish homes, suggests that improved architectural conditions, in particular the wooden rather than earthen floor, may have contributed to its obsolescence. There is no discovery of the extraordinary massive canopy bed, which in Ireland was completely covered over by an arched or canted wooden tester, with a curtain across the front. It used to keep the whole family warm and sheltered from drafts, as well as protecting against the leaks and drips of the thatched roof. Likewise the built-in "outshot bed," once common throughout the north and west of Ireland, accommodating grandparents beside the warmth of the fire, seems to have been abandoned upon arrival in Canada. It may be that a new country and different architectural constraints rendered such designs unnecessary. Beds are amongst the more rare of surviving vernacular furniture forms.

One of the common denominators that links all the various groups of arriving settlers is the inevitable chest or trunk. The range described here, aptly placed at the beginning of each cultural description, can be seen as a microcosm of the book's broad range. The French version is no mere rectangular lidded box. Instead its makers created a top and sides which were ergonomically curved to fit comfortably under the travelers' arm, while simultaneously recalling the French *ébénistes'* (cabinetmakers') skill in producing complex curves which were fashionable during the 18th century. The Ukrainian New World trunks are shown to have a unique and removable five-footed plinth, also used beneath wardrobes and cupboards. The essential trunk, which by its variation is shown to combine function with individual and recognizable aesthetics, served not only as a container for valuables and provisions wanted on voyage, but also served as a seat during the journey and upon arrival. On a more tragic note, such trunks apparently were expected to serve as containers for their owners' bodies should they perish during the journey.

Michael Bird is particularly well qualified to undertake such an ambitious study. He has an enormously impressive list of books and articles to his name and has organized a number of exhibitions of Canadian furniture. It was at his exhibition of Mennonite and Hutterite home furnishings held in the grand portals of the Canadian Embassy in London that I was first introduced to the author. It was on hands and knees, together examining the minutiae of a particularly fine *Schlafbank* from Manitoba, that I realized that we spoke the same language of enthusiasm about country furniture. The mood of the assembled group of designers, academics, curators, craftspeople and their families reflected a similar excitement and enthusiasm for the simple yet beautiful display. There is no doubt that this new and definitive text will also be warmly welcomed.

CLAUDIA KINMONTH, RESEARCH FELLOW, BRUNEL UNIVERSITY

ON FURNITURE AS AN OBJECT OF STUDY

UTILITY AND BEAUTY. These two qualities have rarely been far apart in the making of furniture. In our brief survey, we shall consider furniture both as functional object and as work of art, acknowledging, along with both producers and users, that these two considerations have long been closely allied in defining handmade objects and objects made in the community workshop.

When furniture is included in art-historical discussion, it is often relegated to the status of minor arts. Such designations are patronizing at best and contemptuous at worst, but they grow to some degree from a tendency to divide the world of art into those things which are beautiful alone and those things which are functional as well as beautiful. Needless to say, the categorization is very inconsistent. Consider, for instance, that architecture, the most highly functional of all public art forms, is accorded an aesthetic status frequently denied to furniture, which is, of course, a kind of interior architecture. Perhaps the tendency to treat the subject of furniture lightly has in part to do with the etymological element, in that furniture is regarded as something transitory or temporary. (In Italian, French or German, the terms for furniture — *mobilia*, *meubles*, *Möbel*, respectively — simply mean portable.)[1]

This sampling of Canadian furniture considers the practical use of pieces, sometimes defined anew in the specific regional contexts in which they were made or adapted. At the same time, the examples included here, while drawn from a wide cross-section of forms, periods, styles and regions, are not chosen with the intention to represent every category. Furnishings examined here are not given consideration because of how well they exhaust the lists suggested by household inventories of given times, but on the basis of how these functional objects reveal both practicality and something of the aesthetic sensibility of communities and individuals who made and used them. Many of the furniture pieces shown in the following pages could be criticized as "better" rather than "typical" examples; that criticism is accepted, but it points toward a purpose with which this study is not primarily concerned. The works illustrated here serve to demonstrate the integration of usefulness and artistic sensitivity of nearly three centuries of artisans working in communities from the Atlantic Provinces to British Columbia, living on the coasts, the plains and in the valleys of a vast land.

The artistic value of what is frequently termed "fine" furniture has long been acknowledged. Most Canadian furniture falls outside this high-style category. In his study of early cabinetmaking, Donald B. Webster suggests that refined furniture is almost a trace element in the Canadian context: "I have found no examples of truly 'Great'

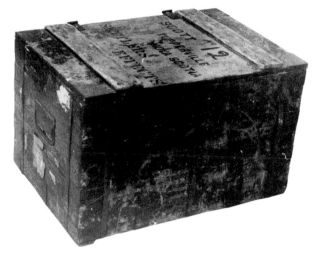

IMMIGRANT'S TRUNK, BRITISH ISLES TO NOVA SCOTIA: 19TH CENTURY; PINE.

It may well be that the first furniture of immigrants was the trunk which carried their personal possessions. Little more than a crate, it could function as a table, seat, or storage container during the first months of abode on foreign shores. This British trunk found its way to a home in a new-found land, and is stamped Scott no. 12 / Tupperville / Nova Scotia / Settlers Effects. *Kings Landing Historical Settlement.*

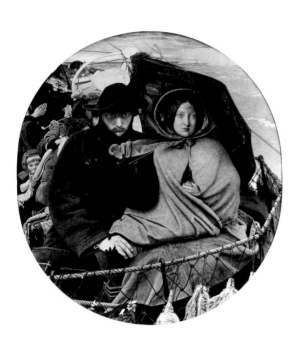

Georgian-Canadian furniture . . . the conditions, structure and environment of English-Canadian society at that time . . . just could not foster or support that sort of lavishness and opulence.[2] Nevertheless, the range of furniture made in Canada, particularly within the broad spectrum of what might be called "country," is breathtaking. Although some furniture was brought to both French and English Canada, the proportion of such importation was almost negligible. In contrast to the claim that most Australian furniture was shipped there from England,[3] this seems not to have been the case at all in Canada. Perhaps immigrants coming to Canada already knew what Catharine Parr Trail advocated with regard to the high cost of bringing such items from home: "As to furniture and iron-ware, I would by no means advise the emigrant to burden himself with such matters; for he will find that by the time he reaches his port of destination, the freightage, warehouse room, custom-house duties, and injury that they have sustained in transit, will have made them dear bargains."[4]

The absence of grander furnishings in Canada does not preclude aesthetic insight. An artistic process as important as that which led in Europe to the production of the great Design furniture of the 18th and early 19th centuries can be recognized in the creation of simpler furniture in communities across Canada. In his survey of Newfoundland furniture, Walter Peddle warns of the danger of comparing Newfoundland furniture with that produced in centres of urban sophistication, using the imagery of "equating cod fish with brook trout."[5] Rather than comparing art with non-art (a Philadelphia Chippendale highboy and a Manitoba Ukrainian dish cupboard), we are comparing two forms of artistic expression as distinct as opera and street theatre. What is artistically evident in the work of Canada's country furniture makers, visibly expressed in the several hundred examples shown here, is a vitality of creative ingenuity, a quality which has on occasion been noted with regard to country furniture made in Ireland.[6] The work of country cabinetmakers in areas frequently remote from urban centres is almost always as inventive as it is traditional. While there may be some truth in the notion that people in isolated contexts, far from their homelands, may resort to certain conservative impulses (the desire to perpetuate the familiar in new situations), invariably they are compelled to make modifications of old ways to fit changed circumstances. While one would not expect to discover a Scottish cabinetmaker in Maritime Canada producing avant-garde objects purely on artistic speculative impulse, conversely, one would not likely find a completely static perpetuation of old ways. An interesting manifestation of this process of mingling the traditional with the new is the fact that Scottish chair makers on Nova Scotia's South Shore made chairs which almost always resemble American examples rather than those forms which they had known and probably made on earlier occasion in Britain. No less ingenuous are furniture examples made elsewhere in Canada which bring together both

memory and innovation. Many tables, cupboards and other case pieces retain vestiges of remembered style and construction technique, but time and time again are vastly more than dull repetitions of earlier pieces. The German immigrant cabinetmaker John Gemeinhardt of Bayfield, Ontario, was able to amalgamate elements of neoclassicism, Gothic, baroque, Biedermeier and Eastlake furniture styles in the pieces he made for his own family and relatives in the late 19th century, demonstrating that he was slave to no single source of ideas. When Doukhobor furniture makers in Saskatchewan and British Columbia blend Russian baroque carving with trendy mass-produced forms advertised in early 20th-century furniture catalogues, they engage in the inventive combining and recombining of ideas which are at the heart of the creative artistic process.

The integration of the desire to provide aesthetic pleasure with the need to make functional furniture is often evident to visitors to Old Order Mennonite households in Waterloo County, Ontario. There, a people commonly described as "plain" will frequently speak of a chest or cupboard as "nice" (in that culture, a not-so-vapid word which tends to be used to describe the beauty of embroidery, *fraktur* or furniture). In some cases beauty and ethics come together, as in the case of a decorated dowry chest or the illuminated birth record, where either text or visual motif, or both, may have a symbolic association with a spiritual purpose. In other cases, the recognition of beauty may have a less clear (but probably implicit) connection with the ethical dimension, as in the case of Mennonite author John Ruth's contention that among relatively plain people there is an unmistakable "aesthetic of the plain."[7] In other contexts, such as among the poorest inhabitants and furniture makers of rural Ireland, the spirit of decorative display is evident in the making of utilitarian kitchen storage cupboards, as is pointed out by Claudia Kinmonth in her impressive study of Irish country furniture: "The dresser is unique amongst the furniture of the Irish kitchen because of its primary role as an aesthetic and decorative focal point, a role simultaneously combined with the functional storage of kitchen 'ware' and utensils."[8]

That furniture is not only a vehicle of art (as in applied, carved or painted decoration), but is art itself, is eloquently expressed in the words of furniture historian John Kirk: "American 17th- and 18th-century furniture played an extremely important role in its environment; it acted as its sculpture."[9]

Like sculpture or painting, and engineering or architecture, Canadian country furniture gives witness to the intelligence of those makers who transformed inherited tradition to suit their new circumstances. The process can in a surprising number of cases be "read" from the furniture itself, which becomes our three-dimensional text, telling us sometimes of wit, nostalgia, love, spirituality and practicality, and always of creativity. In all of these ways they serve as a manifestation of George Hepplewhite's desire to "blend the useful with the agreeable."[10]

On Defining Country Furniture

Although wishing to avoid becoming hopelessly entangled in a conceptual problem, we must give some consideration to defining that body of furniture which we choose to call "country." It is a term much used in books on furniture of Europe and North America, and the frequency of its appearance has by no means given us a description which is consistent in meaning.

At one level, country furniture has come to mean "rural," that is, made by and for a population living remote from urban centres. In some instances, these users of furniture may live not only on farmsteads but also in villages, and may include small shop owners and village tradespeople (potters, ironsmiths, wagon-makers and the like). In other cases, when the emphasis is primarily on the owners or dwellers of the farm, the understanding of country furniture comes closer to the idea of "peasant" furniture. This latter description is found less commonly in the British Isles and North America, and more frequently in descriptions of nonformal furniture made in various regions of Continental Europe.

It is useful to think of a sort of vertical and horizontal measure when speaking of furniture as "country." The vertical scale used to define country implies a class-structural component. The movement downward of styles and techniques, from the aristocracy to the middle class, had already been set in process by the translation of the ponderous sumptuousness of the designs of William Kent and Robert Adam into the more generally marketable productions advertised by George Hepplewhite (*The Cabinet-Maker and Upholsterer's Guide*) and Thomas Sheraton (*Cabinet-Maker and Upholsterer's Drawing Book*). Interestingly, Gerard Brett refers to Hepplewhite's designs as "Adam in the vernacular."[11] The wealthy can, and did, purchase the more expensive furnishings of acclaimed cabinetmakers of the day, or even commissioned them to produce customized pieces at yet greater cost. The simpler furniture affordable to those of lesser means could be defined as country by virtue of its less-sophisticated construction and more commonplace materials (pine or other softwood). The upper classes had mahogany in their homes; the lower classes had pine. That the latter lived in emulation of the former is suggested in the way the woods themselves were described. For example, New Brunswick birch and Ontario cherry were known as "poor-man's mahogany."[12]

The horizontal measure defines country furniture as that which is made and used by people living at some distance from urban centres. Even those of relative affluence might seek out the work of craftsmen with formal training but whose geographical distance from major centres sometimes meant that even their most accomplished work was a provincial interpretation of more sophisticated prototypes.

If country furniture is simply furniture made away from urban centres, we cannot automatically conclude that such furniture is less competently made. Indeed, British furniture historians, when speaking of

furniture made in Great Britain, sometimes use "country" to mean furniture which is made away from London, but of a style and technical sophistication of the highest degree. Such is the case with regard to the long-successful firm of Gillows of Lancaster, which made refined pieces for the gentry and aristocracy of the north, operating from at least the early 18th century and well into the later styles of Hepplewhite and Sheraton.[13] Given the complexity of its products, some of which were later to appear in Thomas Sheraton's design books, one would hesitate to call such furniture "country."

In an English context, country furniture is sometimes defined less in terms of the competence of the maker than in terms of its placement in the home of the client. In their discussion of 18th-century furniture, Peter Johnson and Noel Riley suggest that at one end of the scale of furniture production is that of country furniture, which they define as the work of single craftsmen (rather than large firms), "sometimes estate carpenters for the nobility" who "continued to turn out serviceable furniture for the less well off or for the unimportant rooms of important houses."[14] In this framework, such furniture is defined not by its association with regional or folk traditions, nor with the self-taught nature of nonprofessional makers, but rather with the manufacturing shortcuts predicated by the insignificance of the room or the smallness of the pocketbook.

The notion of country furniture frequently suggests the archaic. In this sense, the craft of country furniture making is seen to be a late phenomenon, an imitation, a following, even a throwback to earlier forms and trends established earlier in metropolitan centres. In this understanding, country furniture is conservative, not forward-looking. Such furniture is characterized by its *retardataire*, or out-of-date qualities. When the discussion of furniture turns to issues of imitation and provincial modification, it calls to mind the parallel discussions of art and folk art. Some attempts to define folk art emphasize its naïve or primitive character, as in the case of untrained painters such as America's Grandma Moses or Canada's Jeanne Thomarat, who produced seemingly rustic counterparts to more sophisticated landscapes or portraits.

The tendency to regard country furniture, as well as folk art, in terms of its conservatism has the unfortunate consequence of ignoring its inventive element. The process of emulating sophisticated models, and having to do so with limited financial means and technical expertise and less than the best materials, may itself entail extraordinary degrees of ingenuity. Emulation under such circumstances means adaptation, and adaptation is frequently the arena of surprising inventiveness.

Another attribute serving to distinguish country furniture may be what is seen to be its less skilled means of execution. In comparison to those works of supreme cabinetry art, in which the product could come about only as the result of lengthy apprenticeship, country furniture has a less impressive pedigree. While it is undoubtedly true

that most formal furniture reveals more than ample proof of higher technical artistry, it would be incorrect to suggest that high craft does not also characterize country furniture. In some cases, the degree of technical competence may be less important than its application. The fine inlaid detail of a sophisticated Montreal clockmaker's art may be not greatly superior in technical virtuosity to that of German immigrant John P. Klempp, even though the former's overall statement might be more aesthetically refined than Klempp's "pull-out-all-the-stops" approach (fig. 404).

For many interpreters the selection of woods may comprise a fair-weather guide to categorizing formal and country furniture, hardwoods being the preference of the former and softwoods the lot of the latter. It is the case that much of formal furniture, particularly following the time of Robert Adam and other designers who advocated the harmonizing of architecture and furniture, was constructed of the more elegant hardwoods, which would stand well in the panelled rooms of fine homes. Woods imported from the New World, particularly the highly treasured rich-grained mahoganies, became increasingly expensive when import taxes on these materials were dropped in 1720.[15] The obvious expense of such woods added to the emerging appreciation of furniture as prized possession and even art. As more homes of the aristocracy and gentry came to serve as showplaces, the demand for lavishly produced furniture increased. Needless to say, those of lower economic means were not principal patrons of the crotch-mahogany and figured-maple furniture industry. What furniture was to be had in the more modest cottages of these classes was almost invariably pine, simply stained or painted. That best-known chronicler of everyday life in early Canada, Catharine Parr Trail, gives us a sense of the comfortable suitability of pine furnishings, either as "first" furniture or as generally proper for the modest home of the "small farmer": "In furnishing a Canadian log-house, the main study should be to unite simplicity with cheapness and comfort. . . Those who begin with moderation are more likely to be able to increase their comforts in the course of a few years."[16]

Her advice is as specific as her information as to expenses and materials to be had in the new Canadian domicile: "Let us see now what can be done towards making your log parlour comfortable at a small cost. A dozen of painted Canadian chairs, such as are in common use here, will cost you 2 pound 10s. You can get plainer ones for 2s9d or 3s a chair; of course you may get excellent articles if you give a higher price; but we are not going to buy drawing-room furniture."[17]

That this furniture is not merely for the shanty, but for the home of the modest farmer, and even for those settlers with a modicum of education possessing literacy, is revealed in her comments regarding the desirability of bringing along a few books, prints or pictures, which she calls "intellectual luxuries."[18] She further recommends the use of pine, which, when stained, makes a handsome substitute for oak or walnut in the construction of tables or shelves.[19]

Even within single categories of furniture, country furniture need not always mean simple as opposed to complex. Is a painted-pine architectural corner cupboard made by the Mennonites of Waterloo County necessarily any less sophisticated than the formal English neoclassical cabinet from which it received its distant inspiration? Is the high-style piece in this case any more complex with regard to design or construction than the country cousin? If country meant only simple, did Thomas Chippendale have a country concept in mind when he advertised in his *Gentleman and Cabinet-Maker's Directory* (1754) that furniture makers should feel free to simplify his designs to fit the circumstances of their customers? His proclamation notwithstanding, it is doubtful that Chippendale had in mind anyone of modest means even when the process of simplification was endorsed, particularly if such simplification had to do with the occasional detail rather than the piece as a whole — how much can one really simplify an elegant bookcase? However, it is possible that some of these modified pieces, still considered formal or high style by their placement in studies on furniture history, were in fact not necessarily as complex as some country equivalents made in the distant North American colonies throughout the following decades.

To avoid the extreme alternative of total abandonment of terminology, we have to acknowledge that any meaningful use of the description "country" requires our awareness that it is an extremely fluid term. Indeed, the concept must be flexible enough to permit inclusion of Nova Scotia chairs in relation to their New England counterparts, or Quebec case furniture and pieces made in France. Jean Palardy has said that "compared with the furniture of France, the furniture of New France is massive."[20] It is of interest to note that the Nova Scotia chair maker Jay Humeston, who had worked earlier in Delaware and South Carolina, advertised in 1804 that his chairs and settees were "equal to the best British manufacture."[21] The comparison is, of course, with English country furniture, within which fall such types as those advertised, rather than with formal cabinetry. In yet another context and considerably later time, much of the furniture of Western Canada, made variously in Ukrainian, Hutterite, Mennonite or Doukhobor communities, may be seen to have country character in the traditional expression of the countries or regions from which these groups came to Canada. Further, such furniture is described as country in relation to sources as various as Russian formal, German Biedermeier, or French styles emulated in the capitals of Eastern Europe.

Canada is a land whose architecture and furniture is often competent in design and eloquent in expression. It is also, however, a land without the design books and vast workshops of England or France, or even the sophisticated centres of art and craft found in other European nations. There was no *Gentleman and Cabinet-Maker's Directory* published in Canada, and if Canadian furniture makers made direct use of such a manual, we have no concrete evidence of this. According to Donald Webster, we do not have surviving drawings from any early Canadian

cabinetmakers. (A late, modest exception is John Gemeinhardt's sketch-books, which indicate something of his workmanship in the late 19th century in Bayfield, Ontario; but the case is so rare and so late as to amount merely to the variation that proves the rule.)[22] Even when formal furniture was produced in Canada, it is formal only in relation to the vast range of provincial work, but hardly so in relation to, say, the more sophisticated expression of the British and American workshops of the Queen Anne, Chippendale, Hepplewhite and Sheraton periods. As Howard Pain puts it, "The Upper Canadian expression of a formal style is likely to be caricature-like in its economy of detail."[23] When Barbara and Henry Dobson organized a major exhibition of Canadian fine furniture in 1982, their conceptual definition was what they called "Provincial Elegance."[24] Stanley Johannesen, in his foreword to the same publication from the 1982 exhibit, refers to the Quaker notion of beauty as "of the best sort, but plain," reminding us that this impressive aesthetic achievement of early Canadian fine furniture is not equatable with its formal prototypes.

Given the paucity of formal design books and the existence of so few formal pieces of high-style cabinetry, perhaps it can be rightly said that in most cases Canadian furniture is by nature country furniture.

While recognizing these many differences within the realm of country furnishings in Canada, there is also a common denominator at work in the many instances considered in the following pages. In regions as diverse as Nova Scotia and British Columbia and cultures as varied as Mennonite and Doukhobor, a sense of the importance of retaining past wisdom is relevant. In this regard, one must acknowledge a certain conservatism about such furniture. Whatever modifications are made in accommodation to New World circumstances, the furniture of these transplanted communities reveals an indebtedness to Old World practice and expertise which is rarely thrown out in wholesale manner. John T. Kirk, searching for roots and also for distinctiveness of New England furniture as compared with that made earlier in England, finds time and time again that prototypes for most New World forms can be found in the earlier setting with regard to design, manner of construction, painted decoration and other detail. At the same time, there is what Kirk calls an almost imperceptible but real "line" or "contour" to American furniture, which in the end makes it never quite the same as what went before.[25] In the Canadian context, Donald Webster has argued for a recognizable albeit subtle distinctiveness of Georgian furniture of Ontario, Quebec and the Maritimes in comparison to its British sources. Yet, at the same time, it is Webster's contention that throughout this vast land and this time period, the furniture of Canada shares in a phenomenon which he calls the "cultural cloak,"[26] that is, a conserving and perpetuating within the new and unfamiliar world of those elements which provide a comforting and nourishing continuity with an older and more familiar world. In the process of donning a European cloak, however, these newcomers did not hesitate to do what tailoring was needed for life in a changed habitat.

An alternative term frequently used to describe furniture is "vernacular." The concept has a long-established place in linguistic discussions, alluding to the regional or local languages of European culture, in contradistinction to Latin, which was considered the universal language of learning. As such, the vernacular language was local, provincial, unpolished. There is, for purposes of categorizing art, architecture and furniture, a similar distinction between that which is high style and congruent with canons of a universal aesthetic on the one hand, and that which is local and of lesser aesthetic merit on the other.

As with discussions of folk art, the language of country furniture seems more secure when it is the common and informal language of those who are particularly fond of the objects under consideration, and less secure when subjected to rigorous linguistic analysis. "Folk art" has seemed to mean something for those who have studied, collected or appreciated it for many years; a similar situation pertains to the subject of "country furniture," especially in juxtaposition with that other term, "vernacular furniture." David Knell refers to a generally accepted definition of vernacular furniture, as "a relatively unsophisticated product of ordinary people, normally of a regionally traditional design frequently made of native materials, and usually with connotations of general utilitarian use — the furniture 'of the people,' as opposed to that of a privileged few."[27] In a parallel context this is essentially the definitional language of folk art, expressed variously in the United States as "the art of the common man in America" (Holger Cahill) or in Canada as "a people's art."[28] Despite difficulties of defining ordinary people (while ordinariness may apply to the socio-economic status of people, the word can hardly define people themselves), these conceptualizations are helpful to the degree that they suggest furniture or art produced and used comparatively close to home, and in the case of utilitarian folk art, infer the close intermingling of art and function. Furthermore, they suggest an aesthetic sensibility of makers who are not necessarily unaware of the art of the academy, but are not confined by its strictures. Unlike folk art, of course, furniture is inescapably useful — certainly so in intention, if not always in practice. The close connection between storage and display is suggested in Dean Fales's declaration of furniture's raison d'être: "Two of the basic urges of man are collecting and then finding a place to store what has been collected."[29]

Perhaps in recognition of the elusive nature of such definitions, we find ourselves in particular sympathy with David Knell's ingenious statement that "country is the vernacular word for the vernacular."[30] The terminology is no less adaptive than the makers whose creations and modifications are the subject of the present overview.

Styles and Influences

A brief overview of Canadian country furniture reveals a stylistic range of vast proportions. The diversity of furniture is, of course, a visual corollary of the long chronology and cultural richness which make up the Canadian social fabric itself.

From the Atlantic Provinces to the valleys of the Canadian Rockies is found a spectrum of cultural communities and perpetuation of traditional architecture and furniture representative of many countries of Central, Northern and Eastern Europe. There are, of course, additional communities with cultural roots in Asia and Africa, as well as Central and South America. These other groups, having arrived for the most part at later dates or producing a less conspicuous body of traditional furniture, invite further study in other contexts.

The principal cultural groups under consideration in this enquiry include communities from the British Isles (England, Scotland, Ireland), France, Germany, Poland, Russia, the Ukraine, the American British colonies, and the southeastern region of Pennsylvania. There are also groups which are defined by religious factors, such as the Mennonites and the Amish, whose roots are not confined to single countries but possess a broadly defined Germanic cultural identity, even though they have lived at different periods of time in several lands. Most Canadian Mennonite groups, for example, originated in Central Europe but had lived for a century or more in regions as far flung as Pennsylvania or Russia before establishing themselves in Canada.

The chronological spread is as dramatic as the cultural range. The furniture in this study falls approximately within the time span from 1675 to 1950. This nearly three-hundred-year range embraces the earliest joined furniture made in or around Montreal in New France to the latest examples of Ukrainian or Doukhobor traditional workmanship on the Canadian prairies or in the Kootenay Mountain valleys of British Columbia. Common to all these examples is a perpetuation of construction techniques or styles brought to a new-found land from the homelands of the furniture makers or their ancestors.

Styles and sources are more fully considered in the sections dedicated to regions and cultural groups. By way of general introduction, brief reference is here provided to general European styles which were to serve as either remote or immediate inspiration for country furniture made in Canada.

Style Influences Important in Eastern Canada*

English
Jacobean 1603–1660
William & Mary 1689–1702
Queen Anne 1702–1714
Georgian 1714–1810
Regency 1810–1820
Victorian 1837–1900

French
Louis XIII 1610–1643
Louis XIV 1643–1715
Louis XV 1715 1774
Louis XVI 1774–1774
Directoire 1793–1804
Empire 1804–1814
Louis Philippe 1830–1848

German
Renaissance 1600–1700
Baroque 1700–1750
Rococo 1750–1800
Empire 1800–1815
Biedermeier 1815–1848

American
Jacobean 1620–1700
William & Mary 1700–1735
Queen Anne 1730–1760
Chippendale 1755–1795
Federal 1790–1820
Empire 1810–1845
Victorian 1840–1900

Polish
Renaissance 1600–1700
Baroque 1700–1750
Rococo 1750–1800
Neoclassical 1790–1815
Biedermeier 1815–1848

Style Influences Important in Western Canada

German
Early Neoclassical 1770–1815
Biedermeier 1815–1845

Russian
Early Neoclassical 1770–1815
Later Neoclassical 1815–1845

Ukrainian
Early Neoclassical 1775–1815
Later Neoclassical 1815–1845

American
Empire 1810–1845
Victorian 1840–1900

Catalogue Styles
Late Victorian 1845–1870
Eastlake 1870–1900
Waterfall Designs 1920–1940

Generally speaking, the periods of production of major country furniture groupings in Canada can be suggested by the following rough scheme:*

Atlantic Provinces
Anglo-American 1750–1900
Acadian 1740–1755; 1775–1925
German 1750–1925

Quebec
French 1675–1900
Anglo-American 1775–1900

Ontario
Anglo-American 1790–1900
Pennsylvania-German 1790–1925
Continental-German 1830–1900
French 1750–1900
Polish 1860–1900

Western Canada
Germanic (Mennonite) 1875–1950
Germanic (Hutterite) 1920–1950
Other Germanic 1890–1950
Ukrainian 1885–1950
Russian (Doukhobor) 1899–1950
Polish 1900–1950
Other (Icelandic, Finnish, Scandinavian, etc.) 1900–1950

*Dates are approximate.

Furniture: The Basic Forms

While furniture is found in many varieties, it is useful to consider the possibility that its seemingly limitless manifestations are in essence the variations of a smaller number of central themes. For the most part, the furniture in the following pages is that of the domestic environment, with only occasional reference made to ecclesiastical examples, pieces used in public buildings, or symbolic furniture used for ritual or metaphysical purposes. The distinctions are not absolute, of course. The furniture discovered in the tomb of King Tutenkhamen was, to be sure, of the symbolic kind, to provide comfort in the an afterlife in his tomb, upon his celestial voyage, and eventually in a place of final enthronement in paradise. Yet, this furniture is recognizably functional in his terrestrial life. In terms of emphasis, however, the bulk of the pieces considered in the following pages are ones which would have been found in the homes of several generations of settlers and their descendants in Canada. They are what could be termed "household furniture."

Kenneth L. Ames groups furniture into four categories, related to four basic functions served in the home — furniture "to sit on, to recline or sleep on, to put articles in, or to work at and display articles on" — and additional objects are created by combinations of these four forms.[31] From these functional categories, furniture may then be classified by four fundamental forms: seats, beds, boxes, and tables. To these four forms I have added a fifth, catch-all category of smaller forms which includes wall shelves, small boxes, frames and miscellaneous accessories, or other variations as the situation demands.

Forms and Their Modifications*

Seating	*Boxes*
Stools	Trunks
Chairs	Transitional chests
Benches	Chests of drawers
Box-benches	Desks
	Commodes
	Buffets, sideboards
Beds	Clothes cupboards
Bench-beds	Dish cupboards
Beds	Bookcase cupboards
Tables	*Smaller Forms*
Large "kitchen" tables	Wall shelves
Stands	Frames, wall boxes
Small "work" or game tables	Small boxes
Writing tables or desks	Accessories and utensils

Modifications can move from more than one than form toward the same result or more than one modification can come from the same form. For example, both the seat and the cupboard can be seen as modifications of the box; likewise, the dish cupboard might be seen as a modification either of the box or the table.

ATLANTIC PROVINCES

Anglo-American

The earliest indications of furniture making in Atlantic Canada are little more than suggestions, in the form of ships' passenger lists. According to George MacLaren,[1] the arrival of 2,500 English settlers at Halifax included Edward Draper, the first recorded cabinetmaker to work in English Canada.[2] Also in this company were fourteen joiners and turners, "all capable of making basic furniture."[3] The fact that these names and descriptions appear on early passenger lists by no means answers the question of whether they actually made furniture. Tangible evidence is yet to be found. At best, we can say that the potential for relatively complex furniture (joined, rather than mere slab-construction) existed in Nova Scotia from the middle of the 18th century. If such a small body of furniture existed, it would have represented the exception to the situation observed by the Rev. James MacGregor, who reported that "their furniture was of the rudest description. Frequently a block of wood or a rude bench, made out of a slab, in which four sticks had been inserted as legs, served for chair or table."[4] Very little large-scale organized furniture production is recorded from the earliest decades, although occasional references do convey a picture of individual artisans from the middle of the 18th century. In Newfoundland, provincial records indicate that an early cabinetmaker, John Daily of St. John's, was engaged in negotiations with Thomas Stokes, "Merchant of Devon, England," in 1789, with regard to tenancy on premises he had been using for some years earlier.[5] In about 1780 Joseph DeGant, a chair maker in Halifax, operated what may be the earliest documented chair factory in Canada.[6] Among other early furniture establishments in the region were George W. Hancock's cabinet and upholstery business in St. John's (opened 1815),[7] the firm of Tulles, Pallister and McDonald in Halifax (operating 1810–1811), Thomas Nisbet in Saint John (operating 1814–1838),[8] and Alexander Lawrence in St. Stephen, New Brunswick (operating circa 1835–1880).[9] Added to this list are many operations which specialized in the production of chairs, noteworthy names such as DeGant, Humeston, Cole, Gammon, Vinecove, Waddell, and the Sibley family.

Some intriguing names appear in records, yet for these no known examples of furniture exist. Among them are the names of three Goddard brothers (Daniel, Henry and Job) of the illustrious Rhode Island family of cabinetmakers who produced some of the most sophisticated of known American cabinets for wealthy clients. While the Goddard brothers who came to Canada are listed or believed to have resided at several places in Nova Scotia (Shelburne, Digby, Halifax), they have left no visible legacy. No furniture has been located in Canada that corresponds to the grand productions of the Goddard family in Newport, leaving us to wonder whether that absence is due to whim of maker or choice of

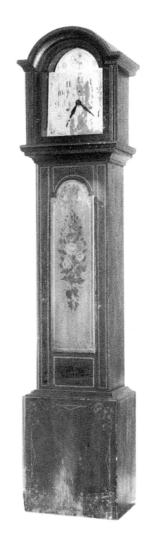

1. TALL-CASE CLOCK: NOVA SCOTIA: 19TH CENTURY.

This clock found in the Wolfville area is competently designed and constructed. The applied door has an arched top as well as an arched bonnet in the Queen Anne style. The painted decoration, although early, may have been added some time after the clock was made, at which time it was given a simpler feather-grained finish. Randall House Museum, Wolfville.

client. Given the considerable expense of such pieces, one would suspect that lack of a moneyed clientele dictated production of furniture of more modest scale. Of course, the prolific English designer George Hepplewhite has no firmly attributable pieces of furniture to his name, either, but even though no examples bear his signature, there do exist many worthy pieces possibly of his workmanship. That is not the case with the Goddards in Canada.

The British settlement of the Atlantic Provinces, notably the regions which in time were to become the provinces of Newfoundland, Nova Scotia, New Brunswick and Prince Edward Island, occurred in several places over a considerable period of time. With the establishment of Halifax as capital, by the English governor Edward Cornwallis in 1749, there ensued a steady influx of British immigrants over the next decades. In the 1760s and 1770s significant numbers of Yorkshire immigrants came to areas north of Halifax, settling along the Bay of Fundy and near the present-day towns of Kentville and Wolfville.[10] Scottish settlement, which was to take place for nearly a century in parts of the Atlantic region and Ontario, had its first significant beginnings in 1772 with the arrival of Scots at Pictou, a town whose architecture is today recognizably of Scottish vernacular influence. More Scottish immigrants, particularly Highlands refugees from the Clearances, arrived during the middle of the 19th century, settling in large numbers throughout Cape Breton Island. Groups of Irish immigrants also arrived during the 19th century, many of them taking up the poorer lands farther inland or back from the river plots claimed by earlier settlers. Many Irish settlers found their way to Cape Breton, planting roots near areas of Scottish settlement. The largest groups of Irish immigrants found their way to Newfoundland, where they formed small coastal communities, especially along the north shore and various bays of the Avalon Peninsula.

The final Anglo-American group of importance were the Loyalists (and pre-Loyalists) who migrated to the Atlantic Provinces from New England and the mid-Atlantic colonies.

The British conquest of French Canada in the 1750s led to the eviction in 1755 of Acadians from lands where they had made their homes for many years. To fill the lands vacated by the expelled Acadians, the Nova Scotia government offered financial incentives to New Englanders willing to move to Canada. Pre-Loyalist settlers, small in number, found their way in the 1760s to the southwest coast of Nova Scotia and to the Annapolis Valley. Many others planted stakes in the Truro area of Colchester County and in the lowlands near Amherst, Nova Scotia, and Sackville, New Brunswick. New Englanders founded a trading post at the mouth of the St. John River in 1762, while others took up farmland along the St. John River east of present-day Fredericton. Before the American Revolution, these pre-Loyalists, or "planters," made up the principal English-speaking population in certain areas of Nova Scotia and of New Brunswick, which came into being when Nova Scotia was divided into two regions in 1783.

Americans who sided with the British cause found themselves in disarray in the waning years of the American War of Independence. Many found their way to Canada, boarding ships that departed frequently during the 1782–84 period.

The ranks of pre-Loyalists included some furniture makers, among them Ebenezer Beattie and Robert Brown, as well as the documented cabinetmaker James Waddell (1764–1851) of Truro.[11]

The subject of Anglo-American furniture made in the Atlantic Provinces is a vast one, worthy of thorough independent study, but for purposes of a broad survey, a few general observations can be made.

As mentioned earlier, the earliest specialized production of furniture in the 18th century in English-speaking Atlantic Canada seems to have been that of simple ladder-back and Windsor chairs, according to George MacLaren's observation that the fourteen joiners and turners who came to Halifax in 1749 "made chairs with rush seats."[12]

It was probably the demand for Windsor chairs that accounted for most of the business of the earliest recorded furniture factory in Canada of Joseph DeGant, the Halifax entrepreneur who opened for business around 1780.[13]

Chairs made in Atlantic Canada are more likely to reflect an American than an English background, in spite of the fact that the early chair makers were usually of English or Scottish background. The English Windsor chair type (pierced back-splat flanked by rods) seems to be an unknown form in Atlantic Canada.

In other respects, the background of furniture makers from the British Isles is clearly reflected in chairs and other furniture made in Atlantic Canada. Such details with regard to seating furniture are particularly well shown in Donald Webster's study of Canadian furniture of the Georgian period, in which he calls attention to Scottish, English and American influences.[14]

The early 19th century was a period of looking backward stylistically, both in Europe and North America, to early prototypes from Greece, Rome and even ancient Egypt. The North American phenomenon was, of course, an extension and later perpetuation of the European style, described generally by the term "neoclassical." In Canada, the form of neoclassicism which dominated furniture styles, particularly in the years from approximately 1810 to 1825, was the English Regency, a lighter counterpart to the robust French Empire (and, later, American Empire). The preference in Canada for the more delicate Regency style over the heavy French Empire was politically understandable. As Donald Webster argues, "The Regency . . . became fashionable in Canada, and for good reason. France and the United States had become allies during the American Revolution; in some ways the American Revolution was but another chapter in a century of English-French warfare."[15] Canadian furniture in the early 19th century reflects the Regency tradition, as seen in doorways and mantels (figs. 34 and 35), solid and glazed corner cupboards (figs. 37 and 38) or in chairs (fig. 82).

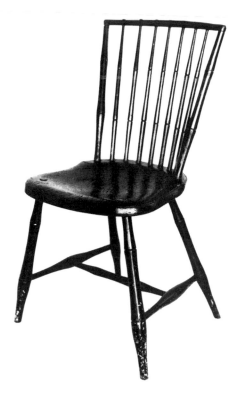

EARLY 19TH CENTURY; PINE SEAT AND HARDWOODS; 33¼"H (SEAT 17"H) X 16½"W X 15½"D.

A seven-spindle Windsor comb-back side chair, this example was made in Halifax by Joy Humeston, and is branded J. Humeston / Halifax *on the underside of the seat. This early chair-maker is listed by George MacLaren as operating his business from 1805–1815, specializing in the manufacture of bamboo chairs and settees. The lines are simple and the turnings somewhat underdeveloped, but the seat is well sculpted. The survival of such early, signed Canadian chairs is a rarity. A black overpaint covers the original finish.*

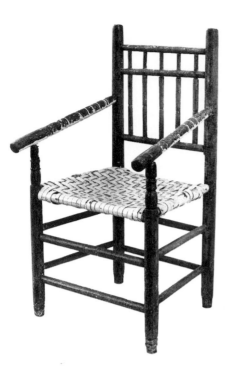

3. CHAIR, NOVA SCOTIA: LATE 18TH
OR EARLY 19TH CENTURY; BIRCH, PINE
SEAT, MAPLE STRETCHERS, ASH/MAPLE
BACK; 32¼"H X 22"W X 14"D.

*Made in the early 19th century, this
chair found in Colchester County can be
considered a stylistic throwback: the
type had passed out of vogue more than
a century earlier. Its inspiration is the
17th-century carver chair popular in
England and New England, noted for
its robust posts and vertical turned
spindles set between horizontal turned
rails. An innovative feature is the
downward slanting of the arms from a
high point on the back stiles.*

The study of New England furniture is made complex by virtue of
the necessary connection of the British design background to its American
adaptation. To John Kirk's observation that for New England furni-
ture makers, "England was home — virtually every form, every detail
had its source there,"[16] one is forced in the context of Atlantic Canada
to add the observation that there is a two-source consideration, draw-
ing upon both a British and a British-American background.

Archaic Tendencies

Furniture made in the Atlantic Provinces often reveals a freshness of
expression, and, at the same time, frequently draws heavily from the
past. Characteristic of such furniture is the presence of archaic details,
some taken from more formal furnishings, themselves already out of
date at the time of their making in the British Isles or New England.
Among the most dramatic examples of this extreme *retardataire* phe-
nomenon are various "carver" chairs, based upon a form popular in
Britain and New England in the 17th century and still made in
Newfoundland and Nova Scotia well into the 19th century (figs. 3, 87,
88). Chippendale chairs, too, made in Britain and America in the late
18th century, were produced in parts of Atlantic Canada a half century
or more later.

There is little consistency in which forms and styles were retained
and which were discontinued. The Scottish or Irish "creepy," a usually
three-legged stool which had probably been designed as a stable struc-
ture to rest on uneven dirt floors, is virtually unknown in Canada.
Perhaps comparatively late settlement, in which earthen floors had
largely given way to wooden ones, obviated the making of such furni-
ture. The shoe foot, a removable horizontal piece attached to the base
of cupboards and other furniture, also made for use on damp wooden
floors, continued to be found on furniture throughout the Atlantic
Provinces long after its original function was no longer a factor in its
making. Such inconsistencies suggest that furniture types or details were
sometimes continued or discontinued for a variety of reasons, reflect-
ing a hazy awareness of the line between function and appearance.
Although Catharine Parr Traill was explicit on the subject of function
when she made the observation that "the bottoms of the chests and
trunks should have two strips of wood nailed to them to keep them from
the damp floor,"[17] far less clear is the purpose of these shoe feet when
still used on furniture placed on wooden floors.

The Acadians

The earliest French settlement of Atlantic Canada dates from the 1534
voyage of Jacques Cartier, who landed at and explored areas variously
said to be present-day Prince Edward Island or Cape Breton.[18] While
the explorer John Cabot had come to these shores earlier, having left

Bristol in 1497 and arrived on St-Jean-Baptiste Day (June 24) of that year, it was the French who were to follow up on Cartier's discoveries by attempting to establish settlements on the shores of the Gulf of St. Lawrence and banks of the St. Lawrence River.[19] In so doing, they established as a French colony the country we today call Canada.[20] It was French fishermen who before 1580 dominated visits to the land now known as Newfoundland, and they eventually established a military and commercial base at Placentia in 1602.[21] The first continuous French settlement of Ile Saint-Jean, known since 1798 as Prince Edward Island, was begun just inside what was originally called Port La Joie (Charlottetown Harbour).[22] The Treaty of Utrecht (1713) divided ownership of the Atlantic region. The English were given Nova Scotia, Newfoundland and the Hudson's Bay Territory, while Ile Royale (Cape Breton) and Ile Saint-Jean remained French. The French presence in the Atlantic Provinces was strong from Cartier's first voyage of 1534 until the first British expulsion of Acadians from Nova Scotia in 1755 and Ile Saint-Jean (Prince Edward Island) in 1758.[23]

The Acadians are a people of French ancestry, but for the most part they became pawns in the struggles between the French and British. Defined as "descendants of the French settlers brought to Port Royal by early entrepreneurs and by the French government when Colbert promoted the colonization of New France,"[24] the Acadians were by no means enthusiastic allies of either colonial power in these grander territorial disputes. Both French and English used pressure and coercion to drive the Acadians into political alignments. From French attempts to force the Acadians to move onto French soil on Ile Saint-Jean or Ile Royale to British expulsion of Acadians and deportation to the American colonies or France itself, it is a cruel history of the uprooting of a people from the Nova Scotia land which had been their home since the early 18th century. British conquests in areas as diverse as Quebec City, Ile Saint-Jean, and Louisburg on Ile Royale meant that the Acadians were transported by shiploads in fulfilment of Rear Admiral Warren's (English Governor of Louisbourg) vow "to extirpate the French from North America."[25] The thoroughness of the attack against Acadian homes and farms in the Minas area is suggested in this description from G.G. Campbell: "On October 27th, fourteen vessels moved out of the Basin, and the people of Minas and Piziquid watched their deserted villages fading in the distance till Blomidon shut off the view. Then began the work of destruction, for there was much to destroy lest Acadians lurking in the forest should return. For days the smoke of burning buildings rose from every part of the country."[26]

In 1758, with the fall of Louisburg to the British, General Amherst issued his uncompromising command to "have the settlements in every part of the island absolutely destroyed, it may be done in a quiet way, but pray them be utterly demolished."[27] It is no wonder that so little early Acadian architecture, furniture, or other elements of their material culture have survived to the present day.

4. BOX LID, NOVA SCOTIA: THIRD QUARTER 19TH CENTURY; PINE; 14"H X 30"W.

With the dispersion of the Acadians from the Atlantic Provinces in the 1750s, few examples of their architecture or furniture have survived. The return of French-speaking settlers to some of these areas in the 19th century saw a modest revival of distinctive traditions of furniture style and decoration. A few pieces known to have been made on the French Shore by Henri LeBlanc of La Baie de la Riviere, Digby County, feature geometric and floral motifs, as in the case of this blanket chest lid. The inside is elaborately painted, while the outside was originally inlaid with lozenge-shaped pieces (now missing).

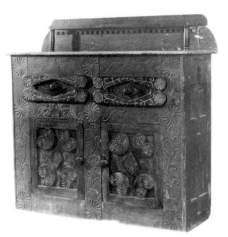

5. BUFFET, NEW BRUNSWICK:
CIRCA 1900; PINE.

*The design of this pine buffet, with
backboard and a shelf on supports over
a lower cabinet of doors and drawers,
is closely related to late Victorian and
hardwood pieces advertised in catalogues
at the end of the century. The wealth
of carved detail, extraordinary in its
profusion as well as boldness of
execution, places this piece within a
group of remarkably carved New
Brunswick furnishings, and calls to
mind the intriguing reference by Huia
Ryder to "exceptional carving on several
Acadian furnishings"* (Antique
Furniture by New Brunswick
Craftsmen). *There is some restoration
to the doors and upper portion of the
backboard. Ochre accents are visible in
the deep floral and geometric carving,
beneath the old or original stained
finish. This is an outstanding expression
of folk furniture. Kings Landing
Historical Settlement.*

Despite the shockingly complete devastation of their homes and farms, Acadian attachment to their land led to a surprisingly early return to the region, some coming back within a decade after the expulsions. Although many disappeared to be resettled permanently in France, Quebec, the New England colonies or the southern Mississippi River basin, some found their way back to Acadia, often surreptitiously and in remotes places where they might go unnoticed.

The quantity and range of Acadian furniture, even in later times, is greatly diminished by historical and socio-economic circumstances. Always a poor people, those Acadians who struggled back to the Canadian Atlantic Provinces after the Expulsion were so thoroughly dispossessed that their existence was marginal for many decades to come. Surviving pieces of furniture are of modest scale in form and construction, and the vast majority of examples are chairs. Occasional cupboards and other case pieces are found, as are trunks and other items which bear some Acadian markings in terms of construction or decoration.

Among distinctive features of the Acadian furniture of the Atlantic Provinces is the appearance of a degree of primitive elegance on simple pieces, as in the slightly curved legs and arm rests that are an earmark of Acadian chairs. Curved profiles may occasionally define chair backs and even table legs, although the non-survival of a wide range of furniture limits our knowledge of the variety of style applications.

One construction detail frequently pointed out in Acadian furniture is the dominance of tenon joints, which are run all the way through the mortise, showing through on the opposite side. In earlier furniture examples the joints appear as square or oblong, while later pieces are more likely to be marked by round tenons.[28]

The simplicity of Acadian furniture meant that decoration was generally sparse and of unsophisticated craftsmanship. There are exceptions to the rule, to be sure, and some of these may reflect the influence of contacts with other cultures during periods of exodus. Acadians in exile were thrown into contact with cultures as diverse as New England colonists and French inhabitants of Quebec or the lower Mississippi River valley.

Huia Ryder mentions an elaborately carved chest from Westmorland County in New Brunswick. The carved decoration is described as profuse: "It has incised carving on all sides and top, also on a false panel within the lid . . . The carvings are of jungle beasts and foliage. There is also a pair of love-birds similar to the Pennsylvania Dutch design on a bridal chest."[29] Of similar interest is the carved geometric and foliate decoration of a buffet from New Brunswick in the collection of Kings Landing Historical Settlement, with deeply incised whorls and vines on its drawers, doors and stiles (fig. 5). An Acadian craftsman, Henri LeBlanc, living in La Baie de la Riviere in Digby County, Nova Scotia, was a capable carver and painter, best known for an elaborately decorated box-lid attributed to his hand (fig. 4). One wonders what ornamentation was to be found on the box itself, given the tantalizing evidence of that part which has survived.

Further mention of carved decoration is made by Ryder with regard to a bench and a chest of drawers from Westmorland County. Especially intriguing is the comment that the carving on the chest is similar to that on an example found in Prince Edward Island. Three pieces of importance from the south shore of Prince Edward Island, all known to be the work of one maker, are benches with curved arms and deeply carved fans and lozenge motifs on their stretchers and backs. One ruined example is known to exist, as well as the two intact pieces shown in figs. 157 and 158.

In addition to carved embellishments, painted decoration is also known on a few rare Acadian furnishings. An outstanding instance of Acadian painted decorative treatment is a storage trunk in the collection of the Canadian Museum of Civilization (Centre for Folk Culture Studies). Its surface features painted stars, heraldic motifs, and the name Mary Fougère. The trunk was found in Nova Scotia and is believed to have been made in the Acadian community at Tracadie (fig. 162).

The Germans

The considerable influx of German settlers who founded several communities along Nova Scotia's South Shore began as a matter of government policy. Governor Cornwallis extended an invitation to the German states, as part of his plan to colonize Lower Canada with English or pro-English settlers to offset the French presence at Louisbourg and elsewhere. His welcoming of "German-speaking Protestants" brought ships with German passengers to Halifax in 1750, with the result that "by 1751 there were between one and two thousand in Halifax waiting to be assigned the lands promised to them."[30]

Besides the German Protestants in Halifax, a second, somewhat smaller group of French-speaking Protestants were transported there from the Montbeliard region of eastern France, an area lying to the southwest of Freiburg in Germany and Basle in Switzerland. This district had escaped the French annexation of the nearby states of Alsace and Lorraine, and its inhabitants, "French in language, but Protestant in religion," provided the South Shore of Nova Scotia with many of its first settlers.[31]

With the number of "foreign Protestants" exceeding 2,300 in Halifax by 1753, pressure was rising to find them lands outside the small port community. The governor arranged for them to be moved further down the South Shore, to Merligash (present-day Lunenburg). Several thousand German immigrants streamed to Nova Scotia over the following decade, stamping their cultural character on the language, folklore and material culture of the communities of Lunenburg County and surrounding areas. It is extraordinary that many of these German farmers were eventually to become competent in the fishing industry which shaped the economic future of their new home.

While Lunenburg decorative arts are highly distinctive and immediately

recognizable to connoisseurs of Canadian traditional folk art, it is interesting how little of a Germanic character is found in the architecture and larger furniture of the Lunenburg community. Although there are occasional case pieces and tables with a notably Germanic decoration, the distinctiveness tends to be defined by decorative detail rather than by the broader facts of style or construction technique.

Many of the early buildings of Lunenburg reveal little of the Germanic background of their builders and inhabitants. The earliest house in the village, reputedly built by German settler Bernard Kreller in 1762, is a gambrel-roofed Queen Anne structure that shows little visible Germanic architectural influence.

In some examples of architectural detail and larger case furniture, there exist elements of a Germanic decorative tradition that have been imposed upon forms which come out of an English or American design context. A mantel and a built-in cupboard in the Hamm House (figs. 129 and 130) are good examples of this amalgamation. The mantel and cupboard are essentially of Georgian style, while carved lozenges and a carved whorl on a piece not shown here may be more suggestive of a Germanic design tradition. Built into another room in the same house is a country Queen Anne dish dresser which has little stylistic association with Germany and much with Massachusetts. In another Lunenburg home is a simple Queen Anne arched corner-cupboard bearing a construction date of 1797, in which a carved heart offers some suggestion of a Germanic folk-decorative tradition (bearing in mind, of course, that the heart motif was by no means the monopoly of one culture) (fig. 131).

Smaller pieces of furniture seem more likely candidates for Lunenburg Germanic decorative embellishment. One reason may be thoroughly practical in nature: the complexity of detail and the comparative smallness of decorative format (chip-carving and painted geometric elements) lend themselves more readily to formats of modest sizes (tabletops, box lids, frames) than to the large surfaces of case furniture. Examples of such smaller furnishings with decorative embellishment are storage trunks (fig. 140), tables (figs. 6 and 103) or footstools (fig. 149).

Much more prominent in the way of strongly Germanic furnishings are the hundreds of small boxes, frames, shelves, wall boxes and utensils upon which a variety of carved and painted enhancement is to be found. Small boxes, used variously for fishing accessories, kitchen cutlery, household valuables, documents or personal possessions, are often the most dramatically decorated items, perhaps in view of their personal nature. Also evident in the Lunenburg decorative arts tradition is a notable predilection to carve or paint such mundane items as tool handles, ox yokes, planes, crooked knives and other utilitarian articles.

The interaction between Lunenburg Germanic decorative arts and influences from other cultures is also evident. At times there is a mingling of Germanic folk motifs (especially tulips or stars) with more general Maritime decorative motifs (faceted stars), as can be seen in the

6. TABLE, NOVA SCOTIA: 19TH CENTURY; PINE; 28¼"H X 38"W X 27"D.

Painted, carved and turned — all the stops have been pulled out in the transformation of a simple form to the this unique Lunenburg County table. The boldness of multiple ring-turnings finds its match in a striking scheme of red, black, green, yellow and orange colours. Further impact is created by deep relief-carved panels, fans, and a painted compass-star.

game board (fig. 155). In other instances, there is a blending of Germanic motifs with those made popular by Victorian sentimental decorative arts, as evident particularly in the chip-carved and painted decoration of wooden spruce-gum boxes. In yet other cases, there appears to be a bringing together of Germanic and Mi'kmaq decorative tradition, as in the desk and box in figs. 137 and 102.

From the earliest examples in the late 18th century — perhaps from the time of simple decorative inscriptions on paper or carved tombstones at Lunenburg and Mahone Bay, through rarely found illuminated birth records of the early 19th century — to the last remnants of carved and painted detail on simple, portable household objects of the mid-20th century, the Lunenburg decorative tradition shows a vibrant history. Its greatest flowering was a late one, occurring in the second half of the 19th and early part of the 20th century. It may well be that the phenomenon of continual fusing of decorative elements in new and changing combinations accounts for the very late continuation of Lunenburg County's tradition of decorated game boards, utensils and utilitarian articles, benefiting as it does from the stimulation of not one but several sources of design influence. As in the case of biological evolution, purity and survival do not necessarily go hand in hand.

Miscellaneous

Some pieces of furniture fall into small or rare categories, sometimes as exceptional instances produced within single cultures, or, alternatively, as hybrid creations drawing upon more than one cultural context.

A Labrador cupboard (fig. 164), made around 1900 by Manasse Fox at the village of Nain, is a rare example of Inuit furniture. Of simple construction, it is of decorative interest because of the apparent borrowing of motifs and colours from Inuit designs used in clothing. Like the designs effected by juxtaposition of pieces of coloured sealskin, painted geometric sections achieve the decorative effect on the doors of this cupboard.

The desk and box in figs. 137 and 102, most likely the work of one artisan, suggest a mixed background of Germanic and Micmac motifs. The scrolls (applied on the desk, painted on the box) are related to the undulating lines incised on other known Micmac boxes, and the heart is a motif long popular in the Germanic tradition.

Even more pronounced integration of elements is seen in several pieces of furniture with quillwork decoration on panels within frames made by someone adept in furniture construction. In the case of several chairs in the collection of the Nova Scotia Museum (fig. 86), the design of the furniture is essentially Queen Anne (or Queen Anne revival), while the decorative motifs in the quillwork are a blend of aboriginal and European motifs. That one such chair was made in Devon, in the west of England, indicates the fascination in that country with

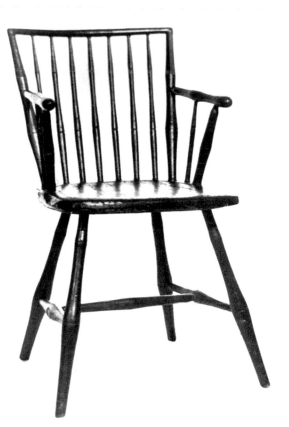

7. CHAIR, NOVA SCOTIA: LATE 18TH CENTURY; PINE SEAT AND HARDWOODS; 30"H X 17½"W.

While the earliest chairs in Nova Scotia undoubtedly date from the first decades of settlement after the arrival of immigrants in 1749, it was not until the practice of stamping, branding or otherwise signing examples became more common at a later time that we have firm evidence of manufacturing dates. The earliest branded Canadian Maritime chairs are those which bear the mark Degant, *the name of a chair maker who worked in Halifax in 1780. A few simple side chairs are known, some with flattened arrows, others with bamboo-turned spindles. This example is branded* DEGANT WAR HAL *and probably dates from the late 18th century. ROM (Canadiana Department).*

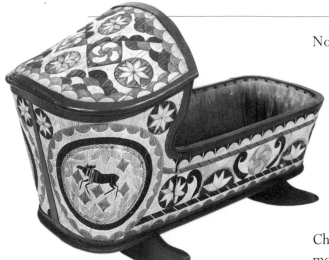

8. CRADLE, NOVA SCOTIA: CIRCA 1841; HARDWOODS AND PORCUPINE QUILLS; 29¼"H X 39¼"L X 20⅞"W.

This outstanding folk-art cradle is the result of a collaboration of artisans. The hardwood frame was made by Alexander Strum of Mahone Bay, and the elaborate quillwork was executed by Christianne Morris, a Mi'kmaq craftswoman of exceptional artistic ability from Chocolate Lake, near Halifax. The motifs are a blend of influences — the elk and scrolls familiar from native decorative arts, the stars and whorls derived from the folk-art tradition of the German settlers of Lunenburg County. DesBrisay Museum, Bridgewater.

North American motifs, not unlike the interest evident in the British ceramics industry, with its painted depictions of scenes remote from English life. The extraordinary quillwork cradle (fig. 8) adds other designs of an even more pictorial nature to the inventory of folk motifs with its depictions of Canadian elk.

Furniture Types in the Atlantic Provinces

CHESTS, CHESTS OF DRAWERS AND CASE FURNITURE

Chests were early furniture forms, and extremely widespread. So commonly used were chests in medieval times that chest makers had their own guilds.[32]

The earliest chests in the Atlantic Provinces are probably those which carried settlers' effects across the ocean to the new country. Few examples have survived from earliest times, although 19th-century specimens exist, some of which are stamped or painted with names of passengers and places of destination.

Early Atlantic chests are sometimes without bracket bases or legs to raise them from damp floors, which suggests that they may have rested on disposable mounts, perhaps no more elaborate than blocks of woods. While some early trunks were designed to carry the small quantities of bedding, kitchenware or personal possessions of immigrants, one unusual example may have served yet another purpose — that of transporting the corpse of the traveller if that person did not survive the trip.[33]

Other boxes which travelled with their owners were those used on fishing expeditions, where it was necessary to take along clothing, bedding and equipment necessary for the work of fishing. Because some outings on larger boats and schooners could last several days or weeks, sizable boxes were needed, many of which are distinguished by paintings of ships or other nautical decorative work inside lids or carved on the handles (beckets) at each end.

Domestic boxes served for the storage of bedding and were kept in bedrooms for this purpose.

As chests could serve more than one function, so their making could arise likewise from several motivations. It has been argued that in England the earliest use of chests was for the storage of books.[34] Certainly there is good reason to believe that trunks in churches, chapter houses or special rooms, such as those set aside for muniments, were keeping-places for books and documents, perhaps even items brought there for safe-keeping. A most engaging account of trunks serving this purpose is offered in the remarkable story of Thomas Chatterton, whose published poetry was disguised as medieval writings which he purported to have discovered among old papers kept in the coffers and chests, themselves locked in a room above the north porch at St. Mary Redcliffe Church in Bristol.[35]

From early times, domestic trunks were the keeping-place of the

wife's dowry, and therefore had a ritual importance in preparation for marriage. In cultures in which husband and wife receive (individually or together) a portion of their parents' inheritance, the dowry chest was the focal point for such possessions as were brought to the new relationship. Such trunks were often initialled or named, and sometimes decorated, to indicate their special ritual status. In this capacity, furniture was both symbol and reality — it was a container for inherited goods and it symbolized the custom by which such transfer of belongings from generation to generation took place.

There are some regional or cultural variations seen in both function and decorative treatment.

The simple six-board box which rested directly on the ground is a particularly common form throughout all of the Eastern Provinces. In such forms there is little distinction between their use aboard ship or in the home; in both cases, they served the most rudimentary function of storage. The addition of feet or bracket bases was a useful step in lifting the chest off damp ground, but was also a somewhat stylish enhancement if the ends of the bracket were well shaped or if finely turned feet were added. These more sophisticated forms were more often found in second or later generations of settlers, and among those experiencing some degree of economic prosperity and the opportunity to furnish homes in keeping with their improved fortunes.

Although many chests were simply stained, or painted a single colour, occasional examples were given some form of modest ornamentation. Interestingly, these decorative embellishments sometimes mark the point at which particular cultural folk art traditions become apparent, as evidenced, for example, in Germanic geometric motifs on a box from Lunenburg (fig. 106), a thistle from Scottish Cape Breton (fig. 125), or a name, flags and decorative motifs from the Acadian settlement at Tracadie (fig. 162).

The modification of the box form could lead easily to other types of household furniture, notably the chair, the bench, and the chest of drawers. The chest of drawers possesses the most readily visible connection with the form from which it evolved, particularly evident in the transitional chest (see fig. 99). The traditional blanket chest had a lift-top lid to permit access to its contents; it was but a small step to expand the means of entry by placing a drawer at the bottom. Known commonly as "transitional chests," this category of furniture resembles the blanket chest, in which both the traditional lift-top and the innovational drawer appear as simultaneous features. Eventually, the transformation from one autonomous form to another was completed by the elimination of the hinged lid and the placement of drawers from top to bottom.

The final evolution of this process is seen in the fully developed chest of drawers with fixed top, made for the bedrooms of homes throughout the Atlantic Provinces in the early 19th century. Such tall chests could provide storage for bedding, but also clothing and finery, while

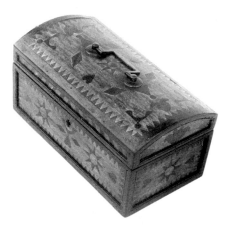

9. DOMED BOX, NOVA SCOTIA: LATE 19TH CENTURY; VARIED HARDWOODS; 4¾"H X 10½"W X 5¾"D.

Decoration of furnishings in Lunenburg County customarily takes the form of painted, inscribed or applied embellishment, and inlay is a less common ornamental technique. The star, circle, diamond and heart are typical "Lunenburg" motifs, but the tulip is a comparatively rare decorative motif in this region. While most decorated boxes from Lunenburg County are made of pine, this unusual piece is constructed of softwood but inlaid with several hardwoods of darker colour.

small drawers might accommodate jewellery or other personal possessions.

Desks are forms which may have more than one source, depending on their structure. The simplest and possibly earliest desks were little more than boxes with sloped lids which could be opened to permit access to a well. Because desks were associated with the activity of writing, they were both storage containers and work surfaces.

These earliest desk forms were small enough to be portable, and were sometimes placed on tables. Surviving box-desks generally have dividers or interior drawers for keeping records, papers and writing utensils. Some were fitted with external drawers, such as an 1816 example from Port de Grave, Newfoundland (fig. 10).

In time, the idea of placing a box-desk on a table led to the logical construction of a frame made specially for the desk, or of a desk with frame integrally attached. The most elaborate development of the desk took place when it approximated the chest of drawers, with a bank of drawers set below the slant-front lid, and became a free-standing case piece. The fullest expansion of the concept took place when a case of shelving, with glazed or panelled doors, surmounted the writing area, extending the desk into the more elegant secretary.

CUPBOARDS

On the basis of surviving cupboards found throughout the Atlantic Provinces, it is apparent that there was a huge preference for the open dresser. Glazed dressers are found there only occasionally, in contrast to their immense popularity in Ontario. In all four easternmost provinces — Newfoundland, Prince Edward Island, New Brunswick and Nova Scotia — the open dresser with doors below and shelves above was found in the kitchens of many homes, especially among the Irish and Scottish settlers, but also among the English, the Americans and even the Germans on Nova Scotia's South Shore.

The placement of open dressers in the kitchen is confirmed by their continuing use there in some homes in the Atlantic Provinces, by the survival of built-in cupboards which remain in their original contexts, and by interviews and research such as that which led to the publication of John Mannion's study of the Irish material folk tradition in selected communities of Newfoundland, New Brunswick and Ontario.[36]

The dresser was useful for storage, but also enabled the display of modest wares in its open upper section, however humble such utilitarian pieces might be. In the Atlantic Provinces there is considerable overlap in the design and use of dish dressers, so that a common form may be found among various cultural groups. Most dressers from these provinces tend to be tall relative to English dressers made in Ontario, and are more similar to examples made in Irish communities in that province. The fact that most East Coast dressers are tall may indicate the high proportion of Irish and Scottish settlers in that part of Canada. Some dressers found in the German communities of Lunenburg County

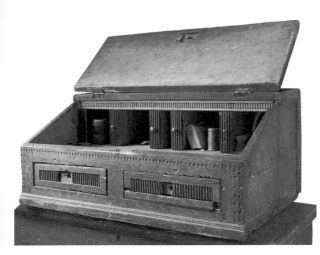

10. DESK OR DESK-BOX,
NEWFOUNDLAND: DATED 1816; PINE;
14⅜"H X 32⅛"W X 20"D.

Found at Port de Grave on Conception Bay, this desk is interesting because of its transitional components. It has a lift-top lid, which would normally preclude the inclusion of drawers inserted from the outside. In this combination, it possesses elements both of the storage chest and the chest of drawers. Like many early desks, it is made to rest on a table or frame. Chip-carved decoration and reeding, as well as a grain-painted finish, create complex patterning and textural impact.

are relatively low and wide, perhaps revealing greater indebtedness to English or American designs.

The dresser has a distinguished lineage, even if, etymologically, it is the poor cousin of the buffet. In medieval France and Burgundy, the *dressoir* was a functional piece used in the kitchen for dressing food (hence its name), while the buffet was more of "a status symbol for the display of other status symbols."[37] While it is sometimes suggested that the open dresser is derived from more formal furniture forms and hence constitutes a simplified structure, another possibility is that the dresser in fact represents the reverse process (one of greater complexity) and can be seen rather as an elaboration of the hanging plate-rack which hung on the kitchen wall over a table or "board."[38]

To be certain, there existed a high-style dresser which could be found among the furnishings of the aristocratic elite. It is reported that the height of such furniture and the number of allowable storage shelves was dictated by one's social status: "The Queen of France was permitted five shelves, the Countess of Amiens three, and lesser (but still noble) ladies could have one."[39] How different are the motives in 19th-century rural Britain, where the height of dressers was determined by an opposite set of circumstances. The greater height of Irish kitchen dressers was in fact in correlation to the deeper poverty of inhabitants living in one-room dwellings, where floor space was so valuable as to require that furniture be "wall-oriented," and walls, rather than scarce wood, could serve as the backing for cupboards.[40]

Dressers found in Nova Scotia reflect the modest circumstances of the inhabitants, sometimes by the simplicity of construction, at other times by a general adherence to this wall-hugging rule. Yet, in comparison to examples made in rural Ireland, Canadian Atlantic dressers are by and large deeper from front to back, particularly such pieces as are found in Scottish areas of settlement such as the Margaree Valley of Cape Breton. But while the relatively floor-oriented base sections and greater use of wood, particularly as backboards, are a Canadian feature, the upper sections possess a strongly Irish flavour, especially with regard to the continuing practice of carving decorative motifs in fretwork manner through the facia below the cornice.

SEATING

It may be the case that the earliest seats were indistinguishable from chests, a possibility known even in modern times to anyone who has attended a large family gathering at which extra guests have had to be seated on trunks because of a shortage of chairs for such occasions. Some furniture historians trace the earliest seating from the trunk by suggesting that surviving medieval seats are frequently little more than boxes in which the back stiles have been extended upward and fitted with backs. In Canada, a surviving form of this box-seat is occasionally seen in box-benches made in the 19th and early 20th centuries in Germanic settlements — notably among the Mennonites or Hutterites

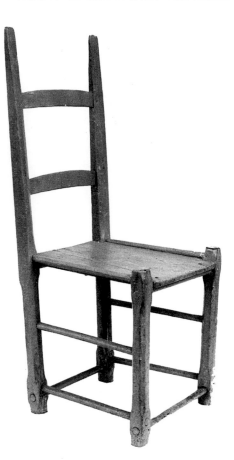

11. Chair, Nova Scotia: 18th
Century; hardwood, with pine
seat; 38"H X 15"W X 15"D.

*A chair with old yellow painted finish
from Annapolis County. Very much the
product of a simple workshop without
a lathe, the members of this chair are
made by skilful deployment of saw and
knife. Stretchers and slats are mortised
fully through openings in posts, with
a thin wooden seat set upon upper
stretchers. Some stylistic effect and
considerable lightening are achieved by
four-cornered chamfering of posts on
sections between upper and lower
stretches, and by tapering of upper
posts.*

of Western Canada, or in a rarer instance, in areas of Amish settlement in Ontario (see fig. 424).

In the Atlantic Provinces, a form of chair which continued to be made long after its style had gone out of vogue in Britain and the American colonies was the turned-spindle chair, known among North American furniture historians as the "carver" (or "carver-type") chair. Named after John Carver (circa 1575–1621) of Nottingham, the founder as well as first governor of Plymouth Colony, it is a form known from the first generations of Pilgrim settlement in New England, hence dating on these shores from perhaps as early as the 1620s. Quite remarkable is its long persistence, particularly in regions of Newfoundland, well into the 19th century. Its two-century popularity may be the logical consequence of the fact that, in comparison with other chair forms which required elaborate joinery, shaping, steaming or bending of members, the carver chair was comparatively simple in its construction.

The most popular chair form of late 18th- and early 19th-century production in Nova Scotia and New Brunswick was the so-called Windsor chair. The form appears to have had its birth in Britain, where it was produced in many villages. Because of the use of turned spindles inserted into the seat and a top rail, such chairs are sometimes called "stickbacks." There are many variations, depending upon placement of spindles, shape of back, means of structural support, and numbers of crosspieces. The exportation of English Windsor chairs to the colonies undoubtedly provided stimulation for making such chairs in North America, although it is as interesting to note the number of English forms not copied on this side of the Atlantic as it is to discover those which were continued. While the earliest Windsor chair production took place by mid-18th century in Philadelphia, the popularity of the form ensured its rapid dispersal through New England and those parts of Canada with significant numbers of settlers from both England and the American colonies. The oldest documented manufactory of Windsor chairs was the DeGant firm of Halifax (see fig. 7), soon joined by a half-dozen active firms and probably many more of lesser stature.

One of the most interesting groups of chairs made in Nova Scotia, from a somewhat later date, is attributed to the Sibley family of Stewiacke. The company flourished in the middle of the 19th century, and drew upon the skills of at least two Sibley generations.

Chairs generally associated with Acadian regions, but found also in areas of Scots-Irish settlement in Nova Scotia, are of simple mortise-and-tenon construction, with tenon ends inserted all the way through adjoining members and hence visible on the opposite side. These chairs often had woven or wooden-slab seats, with flat horizontal slats tenoned into square-cut posts (see fig. 161). Chairs of this construction were commonly made with board seats, but there are also examples with seats made of splint bark or rope. These latter variations are virtually identical to Irish *súgán* chairs, specimens of which are illustrated and

discussed in an important study by Claudia Kinmonth.[41] In Canada these chairs, with their visible joinery, have been described somewhat indiscriminately as "Acadian," and examples found in Prince Edward Island and Cape Breton may well have been made by Acadian artisans. Their similarity to examples known to have come from Irish settlements, particularly in New Brunswick (a known Irish-Canadian chair of this type is found in the collection of Kings Landing Historical Settlement), poses interesting questions of origin. It is possible that such chairs were made in Irish communities, from where the technique spread to Acadian areas of the Atlantic Provinces; the reverse is also a possibility. That such chairs may have been made independently in the two communities from earliest settlement is also a possibility, perpetuating a furniture form used at an earlier date not only in the British Isles but throughout much of the Western Mediterranean, as suggested by Bernard Cotton.[42]

The rocking chair became popular early in the 19th century, and was probably originally made by a simple process of modification — the addition of rockers to existing chairs. For this reason there are a surprising number of rocking chairs employing forms from earlier styles, even Windsors and wing chairs (figs. 12 and 118). Children's rocking chairs, sometimes recalling the settle form, are of slab construction with solid backs and arms.

An alternative form of seating, the bench, was made in many forms in the Atlantic Provinces. Early forms with solid backs, particularly as found in Newfoundland, have clear connections with the British settle, although they are considerably scaled down from the high-back forms known in England, Scotland and Ireland. Open-back versions are found more widely throughout the Atlantic Provinces. Some have flat or simply carved back-splats running from the seat or a bottom rail upward to the crest rail, while others have fully turned spindles rather than splats. Newfoundland, again, appears to have the greatest concentration of settles, although Windsor types are sometimes found in Nova Scotia, as well. A small group of unusual benches with elaborately carved detail have been found in Acadian areas along the south shore of Prince Edward Island (see figs. 157 and 158).

Later couch forms, based loosely on a variety of Victorian examples and "Madame Recamier" types, were made in Newfoundland and elsewhere. Several examples with Germanic decorative motifs (stars, whorls) have been found in Lunenburg County, Nova Scotia.

BEDS

The bench-bed, found in Ontario-Polish communities, or among Mennonites, Hutterites and Ukrainians of Western Canada, seems not to have gained favour among furniture makers or clients of Maritime Canada, apart from the possibility of an example once reported to Walter Peddle.[43]

Early beds seem to have been replaced more frequently, since so few

12. ARMCHAIR ROCKER, NOVA SCOTIA: EARLY 19TH CENTURY (ROCKERS POSSIBLY ADDED SOMEWHAT LATER); PINE SEAT AND HARDWOODS; 45"H X 25"W X 23"D.

Rarely does somber formality encounter casual inventiveness with stranger results than this modification of an earlier form for later use. Not all rocking chairs were made as such: many consisted simply of slat-backs or Windsor-style spindle-backs to which rockers have been added. In this rare Nova Scotia example, however, a heavy Chippendale-style wing chair has been so converted and de-formalized. A nearly identical example is shown in fig. 118. Ross Farm (Nova Scotia Museum).

early examples have survived for present-day study. Although the high-post bed was produced extensively throughout the late 18th century in Britain and in the American colonies, a tantalizingly small number of Canadian examples are extant. Among these pieces are both turned and square-post ("pencil-post") varieties. More common are the somewhat later low (or lower) post beds with heavier turnings, hence their popular designation as "cannon-ball" beds. Beds were frequently made high enough to permit the placement of a "trundle" or "truckle" bed beneath, to be stored when not needed but brought out when visitors came.

Some beds were made specifically for children, and were simply smaller versions of adult examples. For infants, however, specially designed sleeping-furniture took the form of the cradle, placed on rockers. Some cradles were open, but others had rather fashionable hoods, based on earlier British forms.

The press-bed is scarcely known in Canada, with a rare exception illustrated in fig. 13. This is one of those wall-oriented pieces of furniture found in tiny Irish cottages and other small homes in the British Isles, and may have simply been no longer necessary in the typically larger Canadian homesteads of the 18th and 19th centuries.

TABLES

As surfaces to work upon, and as places to eat at, tables took many forms. Among earliest examples are long, stretcher-based tables reminiscent of the refectory-table form dating from medieval times. In the Atlantic Provinces, small "tavern" tables were common both in public houses and in private homes. The three-legged cricket table, long popular and of widespread use throughout Britain, is known in the Atlantic region of Canada, but in relatively small quantities. In addition to a turned-leg example shown here, a tapered-leg cricket table is found in the furniture collection of Kings Landing in New Brunswick.

An efficient form which gained wider acceptance in Atlantic Canada was the chair-table, or a close variation, the hutch-table. The first combined the functions of a work surface with seating, while the second integrated table space with storage space. Such tables were commonly used for eating, because in the 19th century families often ate at the table rather than in chairs facing the hearth. When not so employed, the table was customarily pushed against a wall and the top tilted upright so that the chair function could come into use.

Stylistically, it was the Chippendale, and, somewhat later, the Sheraton and Hepplewhite forms which prevailed in Atlantic tables of the late 18th and early to mid-19th centuries. Country furniture makers could imitate with greater success the comparatively simple lines of turned-leg Sheraton or square-leg Hepplewhite tables, while the rich, subtle curvature or rich detail of the Queen Anne to Chippendale styles were not so easily emulated.

13. BED, NEW BRUNSWICK:
FIRST HALF 19TH CENTURY;
VARIOUS HARDWOODS.

This rare Canadian example of a type known as the press-bed resembles Irish beds which could be folded up flush against the wall to make better use of space in the typically tiny Irish peasant house of the 18th and 19th centuries. The turnings on the legs of this piece suggest a date of after about 1830, coinciding with the arrival of Irish immigrants in the Atlantic Provinces.

QUEBEC

New France

The history of New France — following a few early expeditions which were little more than probings of the North American continent — had its real beginnings when Samuel de Champlain arrived in a small bark canoe at the site of present-day Quebec on July 3, 1608.[1] In doing so, he was solidifying the French claim to land visited by Jacques Cartier seventy-three years earlier.[2]

The earliest visits by Europeans to Canada seem to have had little to do with thoughts of colonization, if by colonization we mean the transposition of a culture to a new land. In the words of J.L. Finlay, the expeditions to this continent could be described as ventures to pursue "European uses for Northern America."[3] Christopher Moore's definition of the change from visitation to colonization retains the resource-use motivation: "Whales and cod had been bringing Europeans to Canada for a century; it was beaver that gave them reason to stay."[4]

Judging by early population reports, this historical chapter did not promise a book. Champlain's aspirations were greater than those of the society under Pierre Du Gua de Monts, which expressed little interest beyond the maintaining of safe trade routes. Despite Champlain's attempts to establish a second habitation on the Island of Montreal in 1611, there was no significant follow-up action for three decades, although the name Montreal does appear on a map as early as 1612.[5]

When Richelieu became involved in the affairs of the colony of New France over a decade later, in 1627, habitations were pitifully small and far-flung. The population of the settlement at Quebec was only seventy-two,[6] and not of a size to inspire extensive construction, furnishing or artistic connoisseurship.

A major step forward in the consolidation of French culture on the St. Lawrence River was Richelieu's decision to reorganize the colony by the creation of his seigneurial system, which established an administration over fur-trading rights (the Compagnie des Cent-Associés), bestowed the rights of nobility to twelve of the one hundred members, and created a close-knit community of administrators, clerics, farmers and artisans. These policies were important factors in advancing the settlement beyond trading-post status and closer to Champlain's vision of a colony.

Undoubtedly the greatest advancement of the new colony was due to the vigorous policies of Louis XIV, who, beginning in 1663, effected dramatic changes by making forceful intervention in the workings of the seigneuries, introducing French governmental administration and organization, as well as establishing of the militia system and reorganizing the church under the hand of Monseigneur Laval, who inaugurated the parish structure. All of this work was undertaken in the face of disappointingly modest population increases for some seventy-five

years. Growth was inhibited by an absence of obvious economic opportunity, in combination with a policy under which New France was denied relationships with any countries other than France and the West Indies.

While fur traders and the settlers comprising the Cent-Associés were responsible for the establishment of Quebec, the creation of Montreal had much more to do with a religious vision, manifested in the actions of a devout soldier, Paul de Chomedey de Maissonneuve, and a determined Ursuline nun, Jeanne Mance, which led to the founding of a missionary society.[7] In time, the missionary society would disintegrate, but by the 1650s Montreal was experiencing cultural growth around its evolving commercial structure.

The Establishment of Arts and Crafts in New France

It was only two generations into the settlement of Quebec that Bishop Laval, recognizing the need for active promotion of the arts, established a school of arts and crafts. In 1675 he brought artisans from France to serve as teachers in the areas of carpentry, woodworking, masonry, stonecutting and other arts. A solid investment in the future of French Canadian artistic development took the form of two training schools, one at Cap Tourmente, St-Joachim, the other at the Seminary of Quebec.[8] While these training schools were short-lived, master craftsmen and apprentices inaugurated a tradition of woodworking, furniture-making and architectural work which would make itself felt throughout the colony for the next two centuries. The importance of these schools for the training of artists in the new colony has been recognized by art historian J. Russell Harper, in his contention that "an atmosphere was being created which was favourable to the arts"[9] By bringing artists and craft workers from France to the colony, it was possible to create a nucleus of teachers and students to establish styles and levels of artistic competence which would serve as reference points for succeeding generations of painters, sculptors, woodworkers and furniture makers throughout New France.

Perhaps of particular importance in the making of furniture for the growing number of homes, including those of the habitants, at the end of the 17th century and throughout the 18th century, is an event which took place in 1694. On April 14 of that year approval came from Louis XIV for the establishment by François Charon de la Barre of a charitable institution in Montreal which would serve as a refuge for orphans and for poor children. Included in the activities of this institution was instruction in the crafts, "giving them the best possible education."[10] If such instruction included carpentry, joinery and other furniture-making skills, which without doubt would have been highly marketable in a period of population growth and the ensuing construction of churches and homes along both sides of the St. Lawrence, the importance of this event would have been considerable. Some of the teachers

could have been apprentices of these earlier schools, and furniture made there could have served as models for instruction at the later school in Montreal.

It is interesting to observe a parallel between painting and furnishing in 17th-century French Canada. Some of this art was imported from Europe, and much more of it was brought in the style of these early teachers, their apprentices and later artisans inspired by both inherited technique and the presence of objects in the church or the seigneury. Early paintings, particularly works attributed to Hugues Pommier ("Abbé Pommier," circa 1637–86) and Claude François Luc ("Frère Luc," 1614–85), are firmly grounded in the French baroque styles which had become popular during the reign of Louis XIV. In some instances, as was the case with Frère Luc, the artist worked both in France and New France. In France Frère Luc worked on Louvre decoration under Poussin and earned the title of "Painter to the King." His work in Quebec may have been chronologically limited to the 1670–71 period, when he "spent most of his time in painting religious canvases to glorify buildings in the little colony."[11] Similarly, Abbé Pommier, possibly the first painter in Canada, was schooled in the grand manner in art, exhibiting a serious Renaissance classicism in style and content. In both cases it is difficult to observe significant differences between work done in France and in New France. As Harper so well puts it, "the majority of early Canadian artists, like Pommier, painted in a provincial Baroque or a provincial mannerist or some other provincial style, and were painters working in Canada rather than Canadian painters."[12]

However, certain nuances were discernible in situations where artists were working primarily (or entirely) in Canada, even among those who received their instruction from the French teachers in these early schools. For Harper, these nuances are evident in the "artist-priests" who had now become almost synonymous with painting in New France, such practitioners as the Jesuits Jean Pierron (1631–1700) and Claude Chauchetière (1645–1709), or others such as Jacques Leblond de Latour (1670–1715) and Jean Guyon (1659–87). Despite their training by accomplished French artists, a unique Canadian reality becomes increasingly evident in their work, not only with regard to subject matter but also in terms of a simplified style. Regarding paintings executed by these and other artists of the period, Harper claims that "all these canvases have archaic characteristics, are naïve and almost harsh in their stark simplicity and lack of colour."[13] It is these paintings and ones produced at even further remove from the great mainstream of European painting which occupy a range of artworks characterized variously as vernacular, primitive, or as folk art.[14]

A similar observation might be made about the production of the furniture of New France. Occasional pieces are of such sophistication that they are comparable to refined French furnishings made for the homes of the bourgeoisie. Although Canadian examples of such opulence and technical virtuosity are rare, they can be found in certain

church furnishings and even some domestic pieces executed by supremely competent master church-carvers such as Paul Labrosse, or members of the Le Vasseur, Liébert, Pépin, Quevillon and Baillargé families. However, such pieces are far from the rule, and were themselves often among the inspirations for work done by other indigenous furniture makers.

The situation with regard to painting in France and New France is analogous to that of the furnishings made in the colony. Palardy describes this relationship in terms of "the interpretations and the simplifications which distinguish Canadian from French furniture in a Louis XIII table, a peasant arm-chair, or a Louis XV commode. They were rarely exact reproductions."[15]

The richly varied furniture-making tradition in French Canada was to undergo many modifications within what is essentially an ongoing interpretation of French country furniture, some of which reveals the influence of other cultures in Canada, notably of an English and American nature. By the late 18th and especially throughout the 19th century, a significant body of "English" furniture had developed along the St. Lawrence and in the townships east of Montreal. Some of this furniture is the work of British or American artisans, but other examples came from the hands of French-Canadian furniture makers who were influenced by Anglo-American styles.

After the British conquest of New France, a small contingent of English merchants and soldiers settled in the principal towns of Quebec, yet they remained a tiny minority in a sea of French inhabitants. The first significant inflow of English-speaking immigrants took place after the American War of Independence. In its aftermath, Loyalists came to French Canada in considerable numbers, estimated variously at 9,000, 10,000 or even as high as 15,000 during the 1780s and 1790s.[16] These settlers, establishing themselves mostly in the Eastern Townships, were later increased in number by large waves of arrivals from the British Isles during the period of economic depression following the end of the Napoleonic Wars. The numbers from the British Isles exceeded 66,000 in the single year of 1832.[17] Yet another massive influx occurred during the 1840s, many of these Irish famine victims, with an average annual immigration flow in the 1840s and 1850s between 25,000 and 40,000 (over 90,000 arrived in 1847 alone).[18] Indeed, it has been claimed that the Irish were the most numerous immigrants in the population of Lower Canada through the 19th century.[19] The presence of large numbers of Loyalists and British settlers in Lower Canada was certain to have its influence on furniture design, and is evident in certain forms such as the American version of the Windsor chair, the English-style dish dresser and architectural corner cupboard, the design of tall-case clocks in various English styles, and the *banc-lit*, a bench-bed with almost no known French prototypes but exhibiting a striking similarity with examples common throughout Ireland.

Palardy refers to the "Canadian character" of the essentially French

furniture made in New France, describing, as does Harper, a naïvety of expression and simplification of technique. Of course, the Canadian character of these pieces is the result of more than primitive workmanship or naïve interpretation. It may include elements of these, but is also the result of new factors: materials, tools, contexts and cross-cultural influences. New France experienced the shifting consequences of wars between France and England and the interruptions of varied administrations. Additionally, the early French settlements found themselves in contact with English rulers or neighbours after the Conquest (1760) and as result of immigrations from Britain and from the American colonies when Loyalists migrated northward after the American Revolution. A furniture-making tradition which began as an extension or restrained extension of French styles in the 17th century was later itself subjected to the modifying influences of Anglo-American architectural and furniture styles of the late 18th and early 19th centuries, eventuating in what Palardy judges to have been a diminution of its original considerable achievement: "After 1820 a serious decline began, leading to a full break with the tradition and a loss of the aesthetic sense."[20] Between these earliest perpetuations and late rejections, however, was a long period of creative craftsmanship, frequently evident in the ingenuous mingling of stylistic influences which comprise much of the French-Canadian furniture-making tradition.

Furniture Styles in New France

The furniture of pre-Confederation French Canada was made over a period of time represented by the reigns of Louis XIII (1610–43), Louis XIV (1643–1715), Louis XV (1715–74), Louis XVI (1774–93), Napoleon Bonaparte (1793–1814), Louis XVIII (1814–24), Charles X (1824–30), Louis Philippe (1830–48), and Louis Napoleon (1848–70). Keeping in mind that Canadian furniture was an interpretation and not merely a copy, and a phenomenon which occurred somewhat later than the stylistic vogue in the home country, it is useful to consider certain general features of the major French styles which were to have their impact upon furniture-making in French Canada before examining the Anglo-American influences at the end of the 18th century and beginning of the 19th century.

The Louis XIII style came into being at the onset of French settlement along the St. Lawrence and was in full swing by the time of the establishment of Montreal in 1642. As a style, it outlasted the rule of the monarch for whom it is named. Because the lag between European style and its manifestation in the North American colonies was frequently a generation or more, it is not surprising that the Louis XIII style would be evident in much of the furniture made in New France at the end of the 17th century and continuing until approximately 1750. The style is characterized by several features with regard to detail and general form. Its first impression is one of a certain sobriety — straight

lines and large surfaces. Its profile is rectilinear rather than curvilinear. Decorative patterning of surfaces is achieved by panels, sometimes of square shape, but also in diamond or lozenge form. Legs and stretchers are complexly articulated, somewhat in contrast to the severity of overall forms, with alternating arrangements of ball-turnings and sometimes chamfered cubes.

The Louis XIV style, by contrast, was grandly and grandiosely sumptuous, by no means intended for those of ordinary or even more-than-ordinary means. It was a kingly expression, developed specifically for the interiors of the Louvre and Versailles, designed by Charles Lebrun (1616–90). Without even minimal concern for expense, this furniture was made of the most exotic woods, using refined means of joinery, costly fittings of bronze and ormolu, elaborate inlay and veneering, and employing esteemed artisans from across Europe. It has been said that with the personal commission of Louis XIV and "the virtual imprisonment of the aristocracy at Versailles, French furniture became almost a fine art," in which "bourgeois and provincial furniture, when it can be identified at all with certainty, is unimportant."[21] Typical among the pieces made for the palaces of Louis XIV and the Parisian aristocracy are gilded cabinets, cupboards and tables, or such specialized items as consoles, bureaux and coin cabinets. Expressions of *meubles de luxe* in the palaces of Louis XIV and of the Parisian aristocracy are both opulent and classical, but always of extraordinary sophistication and expense. Because of its restricted affordability to those of royal means, such grand furniture could never have a significant place in the lives of colonists, and scarcely so even by provincial imitation. However, faint inklings of an awareness of the style might be suggested by simpler forms of inlay, paint-simulated "gilding," or patterns cut or brushed upon surfaces in imitation of designs found originally in Boulle-work (a technique using brass, pewter and tortoise-shell) or other early forms of sophisticated marquetry. In such cases, the colonial interpretation of such grandiloquence is a faint shadow indeed.

With the death of Louis XIV in 1715 and the twenty-year abandonment of Versailles, French courtly life seems to have undergone a transformation from a rigid classicism to an atmosphere more lyrical in nature. In furniture style the change is seen in the replacement of the rectilinear heaviness of Louis XIV furniture by the more curvilinear, flowing lines of a newer style. When Louis XV returned to Versailles in 1735, he was part of an age in which styles became more casual, and in which furniture was made in response not merely to royal but also bourgeois demand. In furniture and architecture, as well as in painting, this was the age of rococo, which rejected classical forms in favour of asymmetrical design. Severity gave way to sensuousness, the static to the moving, the straight line to the arabesque, unidirection to undulation.

Among the developments associated with furniture of the Louis XV style are the cabriole leg, derived from the form of ancient furniture of Egypt, Greece and Rome, and ultimately modelled on the legs of animals.

The characteristic French term for the shape is *pied de biche* (foot of a female deer). The motivation for the design was perhaps not so much practical as aesthetic, especially in pieces where the curve of the leg was carried upward into the case or frame above for the explicit purpose of disguising joinery and establishing the appearance of a continuous flowing line. With the perpetuation of the curve from leg to frame and upwards through the back of a chair, such pieces of furniture became statements of lyrical elegance.

One of the terms associated with Louis XV and late-baroque style generally, "rococo" is a word derived from the French *rocaille*. The image of rock-and-shell decoration may have been taken from the kind of work found in the artificially constructed grottoes on the grounds of Versailles and used in the elaborate gardens from the French Renaissance. Against the rather somber effect of classicism in architecture, particularly in interiors and furnishings, the rococo spirit was one of natural freedom and was seen as a means of taking stylistic inspirations from the outdoor world, as manifested in the casual atmosphere in the paintings of Watteau (1684–1721). The lilting movement of such paintings and the flowing lines of chairs, as well as the panels and crests of furniture, effect a light-hearted emancipation from the heavy architectural sobriety of the Louis XIV style. As the new style unfolded, it was no longer confined to a realistic representation of the rock or shell motif, but rather was increasingly characterized by randomness, asymmetry and complexity, employing C-scrolls, S-scrolls and random curves.

On case furniture, the style is expressed in restrained form in the serpentine front of a chest of drawers or commode, especially in its popular "crossbow" (*arbalète*) approximation. Its non-restrained expression leads to the swelling of case forms in *bombé* fashion, a higher level of complexity entailing the elaboration of curves in more than one plane.

This flamboyant style received its greatest architectural expressions in Germany, while in France it produced the greatest range of furniture. In England, apart from Chippendale's use of rococo elements in his furniture designs, the style was tamed by the preference for a restrained Palladian classicism over the more exuberant Mannerist expressiveness.

A simplification of Louis XV furniture was seen in a process which began in the 1760s and achieved wide popularity through the 1770s. This process saw the modification from plastic lines to straight profiles both in overall form and its component details. The artistic preoccupation with masking joinery in order to give expression to the graceful play of lines in the earlier style yielded in the later 18th century to furniture which makes almost a display of functional supports. Arms and legs of chairs were given clear articulation as independent members, rather than as continuations of a single organic form. Decorative treatments such as banding, fluting or reeding were frequently used to accentuate the distinctiveness of a crest, a stile, a panel or a leg. The curve lost ground to the right angle. This new Louis XVI

style was, in effect, a new form of classicism, though without the grandiosity of the Louis XIV furniture of state.

The emergence of the Louis XVI style in France was greatly influenced by the growing interest in antiquity, following the excavations at Herculaneum and Pompeii. Studies of Greek ruins and a somewhat reductionist view of Greek and Roman design principles stimulated a vogue for furniture and interiors in what was believed to be the "Greek Taste." Its aesthetic and moral superiority were argued variously by James Stuart and Nicholas Revett in England in their drawings for *The Antiquities of Athens*, by the measured drawings of the French architect Jacques-Germain Soufflot, and by the catch-phrase "noble simplicity and quiet grandeur" from J.J. Winckelmann's *Geschichte der Kunst* (1764), in which he extolled the primacy of the Greek ideal in art.

The change in style, although an abrupt one in many respects, can be seen as a transitional process, taking place during the reign of Louis XVI. The transformation can, in fact, be seen in the evolution of design within the work of a single cabinetmaker, Jean-Henri Riesener (1734–1806). From his earliest work, just prior to his appointment as *ébéniste du Roi* (1774), to his later productions, the designs of Riesener underwent a change of emphasis, from the use of slightly curved legs and underframes to the more horizontal and vertical linearity in his later pieces.

Not only did rectilinear geometry gain prominence in Louis XVI furniture, stressed in the predilection for square panelling (itself further emphasized by use of mouldings for picture-frame enclosures), but there was also a return to symmetry of composition associated with the Louis XIV period. Gone were the skewed curves of the Louis XV style; when the curved panel, crest or skirt is used on a Louis XVI piece, it is bowed at the centre, with equal returns at each end. Gone, too, were sculptural manifestations of the curve such as those of the *bombé* forms used earlier, and no more in evidence are the naturalistic rock-and-shell effects previously popular. Capriciousness would not be considered good taste again until the age of Victorian eclecticism after mid-19th century.

In Canada, these styles were given provincial expression in the creative variations which come with particular economic possibilities, availability of materials, the competence of artisans, and external influences.

An examination of French-Canadian furniture quickly gives evidence of the strong role played by several of these styles, in particular those of Louis XIII and Louis XV, and, to a lesser degree, Louis XVI. The Louis XIV style had virtually no effect on the work of Quebec furniture makers, given the fact that the furniture of this period makes its impact almost more on the basis of the costly materials than on the basis of design considerations. French-Canadian artisans were highly skilled and frequently brilliant in their workmanship, but they used common, indigenous building materials, without the benefits of rare woods and expensive metals.

Louis XIII furniture in New France, made from the mid-17th to the

mid-18th centuries, retains many features of the European sources. This continuity is visible in the widespread use of raised panels on virtually every form of furniture.

The impact of the Louis XV style was felt in New France late in the 18th century, well after its period of European popularity, and was to continue well into the 19th century.

Furniture Types in Quebec

CHESTS, CHESTS OF DRAWERS, COMMODES, CASE FURNITURE

The earliest Quebec trunks are those made in France and brought along for the transportation of emigrants' belongings, or ones made in the early colony of similar form. These early chests were without feet, designed to rest directly on the floor of the ship's hold, or perhaps even to permit stacking under conditions of extremely limited space. Both flat-topped and dome-topped types are known from the 17th century. Some are the frame-and-panel type, while others are more simply constructed and are of the "six-board" variety.

However, another kind of chest is of special interest, in that it was of slender enough construction that it could be carried beneath the arm, as a kind of early carry-on baggage. Such chests were not merely round on top, but were round-sided as well, so that they could be held comfortably. Their shape calls to mind the medieval chest, which was little more than a hollowed-out log, truly a trunk in form and origin.

While many early chests are plain and permit little stylistic analysis, others are panelled in ways which reveal Louis XIII influences. This is especially noticeable in the case of several trunks with diamond-point or square panels. The later Louis XV style is occasionally reflected in some late 18th- and even early 19th-century chests with asymmetrically curved panels and carved ornamentation. An extremely rare Louis XV trunk, in the collection of the Provincial Museum in Quebec, has delicately shaped *pieds de biche*.

The early French-Canadian storage trunk, functioning as keeping-place for bedding, had feet which normally consisted simply of an extension of the stiles beneath the base of the chest. These feet were little more than functional, lifting the trunk from what was sometimes a damp floor. In an exceptional few cases, these extensions might be turned or chamfered. The later appearance of an outside bracket base enclosing the bottom of the chest was an English or American influence, increasingly common on trunks made after the first quarter of the 19th century.

Also of interest in Quebec is a small number of two-tiered trunks of 19th-century manufacture, consisting of a dome-top chest resting on a bracketed base section with other drawers. In some examples, both the lower and upper sections have drawers (fig. 18). Several closely related Irish prototypes are illustrated in Claudia Kinmonth's definitive

14. ARMOIRE: LATE 18TH OR EARLY 19TH CENTURY; PINE; 78"H X 47"W X 23¼"D.

What is unusual about this panelled armoire from Hemmingford is that it is not panelled at all. In fact, everything about this piece is other than what it appears to be. Although it copies the lines of a free-standing wall armoire, it is in fact an armoire or even a cupboard designed to fit into a corner. The slab doors are each cut from a single piece, with Louis XV panels actually carved from the solid. To further confuse the issue, the maker of this ingenious cupboard has carefully incised small circles at critical points to create the impression of pegs. It is likely that this piece was an adaptation from an 18th-century armoire, and indeed it bears close resemblance to two pieces found considerably farther east, at St-Marc-sur-Richelieu (figs. 97 and 98 in Palardy).

15. CHEST OF DRAWERS: 1848;
BUTTERNUT AND MAPLE;
48"H X 49½"W X 20¼"D

Another product of the same workshop that made the chests in figs. 246 and 247, this chest of drawers exhibits slightly more complex stylized tree motifs, as well as banding, escutcheons and full dating (1 Fevrier 1848), all rendered in light maple inlay against the darker butternut surface of the drawer fronts. While it is tempting to see these pieces as products of an English-Canadian artisan, information from the McCord Museum indicates in fact that these pieces are the work of M. Lapointe, a French-Canadian cabinetmaker in St-Michel de Kamouraska. McCord Museum, Montreal.

study.[22] Such two-part chests are further evidence of the influence of British and American styles in French Canada.

The metamorphosis of the chest to the chest of drawers was a feature of French-Canadian furniture, just as it was in the evolution of furniture in the English-speaking colonies. While occasional examples of Quebec transitional chests similar to the Nova Scotia piece shown in fig. 99 are known, the two-tiered chest may be another factor in the transformative process toward the development of the chest of drawers in New France. Such may be the route followed from the low chest to the bracket-based chests of drawers, many of which show Anglo-American influences in such features as flush drawers and Hepplewhite-style splayed feet (figs. 15 and 246).

Separate from the development of this more English-style chest of drawers is the commode, a form very French in background and French-Canadian in expression. Like the chest of drawers, the commode owes its origin to the box, or coffer, from which it grew in height and to which was added the feature of external drawers. Storage trunks were frequently made with internal drawers, generally of small size and for the keeping of personal possessions and papers. With the development of the commode, these drawers moved to the outside, and were of large size and intended for the storage of bedding when placed in bedrooms or for important domestic wares or valuables when situated in more public rooms in which dining or visiting took place.

The popularity of the commode in the French-Canadian home is of special interest since it reflects a situation quite different from that in France. Palardy points out two surprising facts which have to do with the date of Canada's earliest commodes and their widespread presence in habitant homes. While the earliest known French commode is said to have appeared not earlier than 1695,[23] there is circumstantial evidence of a Canadian commode made before 1685, reputedly left to the nuns of the Hôtel Dieu in Quebec by Madame d'Ailleboust in that year. If this information is accurate, the Quebec commode "would be the first commode in existence."[24]

The other surprising fact is that while the commode was found in many habitant homes of French Canada (and increasingly so after the Conquest), this piece of furniture was considered unaffordable to the peasantry in France. According to Palardy, "This same sort of luxury was quite beyond the means of the French peasant of the period. Only the bourgeoisie and the nobility possessed such furniture. . . ."[25]

In part, this dichotomous situation may have reflected the relative economic status of the French peasant and the Quebec habitant. The peasant was less well placed economically in France than was the habitant in Quebec, a fact observed by numerous visitors to France during the 18th and 19th centuries.[26] Another factor, however, may have been the continuing use in France of such furnishings as the medieval chest and the derivations of the Renaissance two-tiered buffet, which in combination could serve many of the purposes of the commode.

The earliest Canadian commodes are in essence chests mounted on bases, including the commode given by Madam d'Ailleboust to the Hôtel Dieu in Quebec. These early pieces might properly be termed coffer-commodes. and the early specimen in the Hôtel Dieu is a coffer situated on a Louis XIII base, so defined by its typical arrangement of complex turnings and chamfered cubes.

The majority of Canadian commodes are cases with a three-tiered arrangement of drawers. While most have three drawers, sometimes two drawers are placed side by side on one or more levels. Only rarely are drawers flush with stiles; in most cases, the drawer fronts are lapped over the edges of the surrounding framework.

It is with regard to commodes as well as armoires that the greatest range of stylistic variations is to be found. While the earliest commode is very much a Louis XIII piece, 18th-century examples show influences from many directions. Rarely identifiable vestiges of Louis XIV styling, such as a carved gendarme's hat, can be seen on at least one commode illustrated in Palardy (fig. 458), or in the occasional presence of shaped feet, carved to give a realistic impression of an animal hoof. The serpentine front, already beginning to makes its appearance in later Louis XIV furniture, but much more a feature of the Louis XV style, is widely used by French-Canadian commode makers. In some instances, the drawer front has a central recessed section flanked by two bowed sections, comprising what is popularly called an *arbalète*-fronted commode. Other Louis XV elements on Canadian commodes may include panels of undulating shape, rounded stiles, cabriole legs, elaborately scalloped skirts or carved *rocaille* decoration. In some pieces the *rocaille* decoration is carved into the surface of the base, while in others it is cut completely through, producing a highly sculptural effect. Extremely rare expressions of the transitional style between the Louis XIV and Louis XV tastes known as Régence are seen in elaborate commodes with swelling cases in *tombeau* or *bombé* form.

A most interesting commode type is distinguished by a block-front characteristic, in which the serpentine front is interrupted by a central forward projection. It has been suggested that this design, found on a number of late 18th- and early 19th-century Canadian examples, is evidence of American influence upon Quebec furniture. While it is true that there is an unmistakable similarity to the break-front or block-front chests made in the New England colonies, this does not preclude other possible design sources. The block-front idea was used also by European cabinetmakers, notably in Germany, later carried northward to Mecklenburg and Holstein, and there is the possibility that the convention may have found its way from a European source to France or England, as well as to the American colonies.[27] The precise origin of the block-front feature on French-Canadian commodes may be difficult to determine with finality, given its widespread use in areas of Europe even before its employment by the artisans of New England and New France.

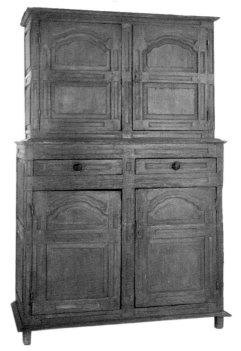

16. TWO-TIERED BUFFET: 18TH CENTURY; PINE; 76"H X 56"W X 22½"D.

A highly distinctive buffet, this piece is testimony to the art of panel-making and joinery. Deeply fielded rectangular panels on doors are set beneath symmetrically scalloped upper panels, vaguely reminiscent of the treatment of the armoire in fig. 202. Intensifying the sculptural effect of panelling is the device of chanelling, executed on the stiles, horizontal members, drawers and door frames, including complexly curved channels which echo the lines of the upper scrolled panels. Museum of Fine Arts, Montreal.

Of related construction is the desk, which in its simplest expression was little more than a box placed on a table or frame, but which evolved into a free-standing form with drawers and writing surface. French-Canadian desks exhibit a wide range of styles from Louis XIII examples, a few rare pieces of more monumental "Mazarin" inspiration, through forms with cabriole legs and other Louis XV features, and later slant-top or knee-hole varieties.

LOW BUFFETS, TWO-TIERED BUFFETS AND ARMOIRES

Among those pieces which can probably be regarded as evolutionary offsprings of the chest are the various buffets and tall clothes-cupboards made in French Canada from the late 17th century and for nearly two hundred years thereafter. Like the commode, these pieces are vertical extensions and functional enlargements of the lowly trunk.

The low buffet, or *buffet bas*, is perhaps the first transformation of the chest in the direction of the cupboard. While trunks began with lift-top lids, and then were transformed into transitional chests which combined the lid with a drawer inserted in the lower front, the low buffet replaces the drawer with a door. This change had to do in part with the new function and location of the buffet. Whereas the trunk was typically a bedroom piece for the storage of bedding, the buffet had a more public setting in a dining room, where it might keep food and eating-wares, or function as a surface from which prepared food could be brought to the dining table. Although its function probably changed little from the earliest to latest manufacture of these pieces, stylistic variations in the low buffet serve as a catalogue of the influences affecting most Quebec furniture over many decades. The earliest examples are of Louis XIII design: forms are rectilinear, and decorative detail is confined to simple geometric patterning accomplished by the arrangement of squares, rectangles and lozenges or even concentric circles or disks (*galettes*) in panelling and moulding. Such pieces are of early construction, dating from the late 17th to mid-18th centuries. Louis XIV influences are rare, but the Louis XV taste is given more than ample expression in the complexly curved panels, scalloped skirts, *rocaille* motifs and the occasional *arbalète*-fronted specimens made in the baroque manner. A return to a more sober straight-line sensibility, reflecting the Louis XVI taste in France (and Robert Adam in England), effected a return to simpler buffets in the late 18th century.

The two-tiered buffet, or *buffet deux-corps*, is, for all practical purposes, the amalgamation of two pieces, achieved by placing a buffet upon a buffet. In some examples, there is little visual distinction between the lower and upper sections other than the slight reduced size of the latter. In time, as furniture makers excelled in the art of harmonization of parts comprising the whole, cornices or even imposing pediments on the top imparted an architectural monumentality to the little cupboard so that it grew to wider functions and grander proportions. While it is probably reasonable to regard the two-tiered buffet as an evolution

of the trunk, through the *buffet-bas* to its grander form, this transformation did not occur within the history of Quebec furniture-making. The earliest two-tiered buffets made in French Canada date from approximately the same period as the earliest indigenously made trunks, so that the manufacture and stylistic modification of these two forms (along with the *buffet-bas*, as well) should be seen rather as parallel developments. The origins of the French-Canadian two-tiered buffet can be seen in a very close prototype of French Renaissance background. Such chests were in all likelihood meant for display (literally, since wealthy Renaissance families often owned pairs of chests on which were emblazoned the coats-of-arms of the bride and bridegroom).[28] The French version of this chest, as made on the Ile de France, was functional but no less lavish, and took the form of a two-stage cupboard, the *armoire-à-deux-corps*. Like its later descendants, it was comprised of two sections with panelled doors, the upper part smaller than the lower. That these pieces were for show is demonstrated in the lavish carved treatment, in which mythological figures or even caryatids supporting the upper section were meant to guarantee that these cupboards were statements of taste and affluence.[29]

Canadian descendants of the *armoire-à-deux-corps* are, to be certain, much simpler country cousins of their French counterparts. They are, in their comparative modesty, often highly beautiful pieces, exhibiting features of all the major styles from Louis XIII to Louis XV. It seems that about as many have drawers in one section (usually the bottom) as have no drawers at all. The Canadian examples follow the European format of two sections and four doors. In a few situations, lower and upper sections are of the same width and depth, giving the impression of four doors framed within a single case. Styles are as diverse as a flamboyant Louis XV (with the most exuberant of *rocaille* decoration or *bombé* cases) and a calmly disciplined Regency or Adamesque.

Perhaps the most eloquent statement of the French-Canadian furniture-maker's art was the armoire. This form may have evolved from the chest, as is most evident in examples which retained drawers below the customary tall doors used for hanging clothes or storing bedding. It appears that the earliest armoires were in fact church furnishings, perhaps used for keeping church plate and vestments. One specialized use may have a stronger etymological connection, for a certain type of cupboard, called an *aumbry*, was a storage place for food left over from a feast in the monastery or castle, set aside for distribution to the poor as alms. Such may have been the use of a 15th-century cupboard surviving in York Minster.[30] Historian John Gloag describes as armoires those first two-doored tall cupboards which evolved from the earlier four-doored cabinet. "The two-tiered cupboard with four doors became a high cupboard with two, known as an armoire, an inexact term which denotes an aumbrey or any large press or two-doored cupboard."[31] The armoire with drawers is not common in Quebec, but is widespread in Germanic households of Ontario and Western Canada. While the

most common Quebec form is the case containing two doors, its structure remains virtually unchanged from those examples with drawers in the base, since all are constructed in one large carcase, or frame.

Among the earliest Canadian armoires are examples which, although constructed as one carcase, have four doors, giving an impression of a two-tiered buffet. Such transitional pieces are interesting because they retain an earlier appearance even as they come to serve new functions. This disguising aspect is sometimes continued in later examples, when two doors are panelled in such as way as to resemble four doors. Conservatism of style and innovation of function sometimes maintain an uneasy relationship.

Another transitional feature occasionally encountered with armoires is the form in which the base retains a drawer, almost in the manner of a lift-top chest with drawers. Two rare examples of this form are illustrated in Palardy (figs. 47, 77, 88, 101). A fainter allusion to the type with drawers is seen in several pieces in which the horizontal base stile is of a width that suggests a section in which a drawer could be placed. This impression is further strengthened in an armoire in the Quebec Provincial Museum, in which the base is comprised of a framework of side-by-side raised panels vaguely reminiscent of drawer fronts.

As with commodes, armoires show a great range of style influences, and, in view of the enormous facade of such pieces, lend themselves to every conceivable manner of decorative embellishment. Earliest examples exhibit Louis XIII features, evident in simple geometric (round or lozenge-shaped) panels, heavy mouldings, rectangular enclosures and a neat symmetry.

Louis XIV styling, despite its aristocratic source, does manage to make itself felt in a distant manner in the designs of some Canadian armoires. A particularly formal curved arch, rising toward the centre from horizontal insets at each end, perhaps a Renaissance architectural allusion, does appear on some armoires as the shape created by the top of the doors taken together, and is sometimes echoed by parallel mouldings or panelling in the space above.

The furniture type which served as locus for the freest spirit of Louis XV curvilinear design application was the armoire. The most conspicuous manifestations of Louis XV style occur in the dramatic curvature of raised panels, a detail which could only be expressed on the sides of commodes, whereas it determines the design value of the entire front in the case of armoires. Further Louis XV treatment occurs in the deeply carved shells of naturalistic inspiration (hence asymmetrical), as well as palmettes, floral embellishments and other *rocaille* elements. In some examples, armoires rest on cabriole feet.

The advent of Louis XVI elements, sometimes indistinguishable from British influences, notably in the style of Robert Adam, also became an important factor in decorative treatment of many armoires from the late 18th century and after. These Louis XVI or Adam features are especially apparent in the decorative patterning achieved by square (rather

than rectangular) panels, dentils under cornices, chiselling and reeding or fluting, especially as a framework around panelling, or in the introduction of certain carved details such as fans, ovals, festooned ribbons, cabling and other motifs, all of a controlled rather than exuberant nature.

After the first quarter of the 19th century, armoires become plainer in both form and surface treatment. Panels tend increasingly toward the rectangular, often as flat insets rather than fielded, and the external bracket skirt around the base becomes a common feature. In a sense, armoires become increasingly "English" in appearance, reflecting the impact of generations of incoming British woodworkers among the immigrations of the 19th century, and of American influences brought by Loyalists and their successors.

Few pieces generate as much aesthetic pleasure or make their presence felt as do French-Canadian armoires. Something of the armoire's peculiar role in defining particular and discreet space within the large space of the room or dwelling is suggested by the poet and philosopher Gaston Bachelard: "Does there exist a single dreamer of words who does not respond to the word *armoire?* . . . And to fine words correspond fine things, to grave-sounding words, an entity of depth. Every poet of furniture — even if one be a poet in a garret, and therefore has no furniture — knows that the inner space is also intimate space . . . In the armoire, there exists a centre of order that protects the entire house against uncurbed disorder" [32]

CUPBOARDS

Cupboards are more than boards for cups, even if our search for origins takes us to such early forms. Included here are kitchen cupboards, both glazed and open, as well as bookcases, pieces intended for the parlour or best room.

In the kitchen, a variety of cupboards served the various storage requirements for food, pots and pans and other utensils. One of the simplest means of constructing kitchen cupboards was to simply make frameworks attached directly to the walls, using the walls as backs. This technique was used both for wall cupboards and corner cabinets, and the latter were little more than doors set at an angle against the adjoining walls. The corner cupboard, known in Canada as an *armoire de coin* or *coincon* (sometimes simply shortened to *coin*) could be of solid-door or glazed-door construction. A panelled door served to hide from view the foodstuffs and ordinary kitchen utensils which were stored there. If the family possessed some attractive chinaware, its display could be effected by the use of a glass-paned door on the upper section. With second-generation prosperity, even if it amounted to little more than having the means to acquire a few "best plates," came the increasing motivation to replace the upper solid doors of kitchen corner cabinets with glazed ones in order to make a show of these simple but cherished possessions.

It is difficult to know whether the corner cupboard preceded the wall cupboard in the furnishing of the French-Canadian house, but a

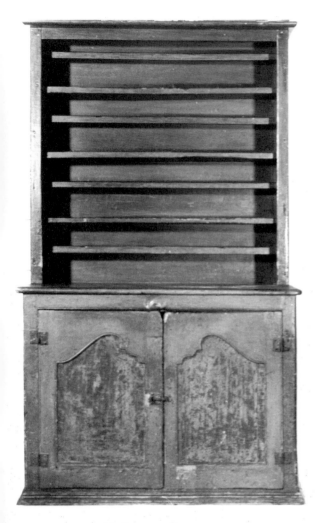

17. KITCHEN DRESSER, LATE 18TH CENTURY; PINE; 75"H X 21½"W X 43½"D.

While the upper section reveals similarities between dressers made in France and those of the British Isles, the bottom is thoroughly in the tradition of the French vaisselier *and reflects the creative synthesis of elements in French-Canadian furniture-making in the late 18th century and throughout the 19th century. The panels are in the Louis XV style found commonly on armoires and buffets of the period. The greatly attenuated curvature of the panels is highly unusual and intensely dramatic in effect. The blue painted finish is original.*

plausible argument suggesting that the corner cupboard came first is the fact that they were frequently built at the time of the construction of the home itself. Surviving evidence of this practice is seen in the architectural character of many corner cupboards, built as they were with the same mouldings and other details found through the house.

Wall cupboards were of several forms, reflecting usage and location. In the kitchen, the most common form in the earliest stages of settlement may have been of such rude construction that few escaped destruction or replacement. Most surviving French-Canadian dish dressers are of late 18th- or 19th-century manufacture, telling us rather little of the means of storage of kitchen utensils, plates and vessels from an earlier time. One suspects that the first kitchen dressers were the more primitive bucket-benches which survive in small numbers. Alternatively, the Renaissance food-locker (*garde-manger*), with bars or grills for ventilation, may have been a feature of early homes, made either as a freestanding cupboard or as a piece set into a wall niche. Among the best-preserved examples of this early form are in the Hôtel Dieu, Quebec; one of these dates from the 17th century.

The more commonly found alternative is the open dresser (*vaisselier*) and its glazed-door counterpart (*buffet vitré*). Like the kitchen corner cupboard, the wall cupboard performed a double function, hiding and showing, with the lower section for storage and the upper shelves for display. Plain wares, cutlery and utilitarian goods were kept out of view but also within easy access by placing them at ground level behind doors. Higher up, at convenient eye-level and for the benefit of guests seated at table, more costly items such as pewter or faience were shown to advantage.

Cupboards of the open (*vaisselier*) type are often of rustic make, but some reveal a degree of refinement, incorporating stylistic nuances of well-made panels in the recognizable styles of the 18th and 19th centuries (for an important example of Louis XV design, see fig. 17). Some pieces suggest an awareness of the English pewter cupboard, and others exhibit British or American influences in such neoclassical detailing as pilasters, arches, capitals, reeding and ornamental detail.

The glazed cupboard was for the most part a more elegant piece, and was likely to be found in more prosperous households. To be certain, some examples of the *buffet vitré* are of simple construction, but many more tend toward the stylishness associated with commodes and armoires. Early pieces exhibit Louis XV and Louis XVI elements in the shaping of panels and enclosures for panes on upper doors, while later glazed cupboards suggest Anglo-American influences with square panes, cove-moulded cornices, dentil and reeded details, and the enclosure of the stiles within an applied bracket base.

SEATING, BEDS

While the oldest seats in use in French Canada may very well have been the trunks in which passengers brought their possessions to their new

homes, the earliest seating forms known to have been made specifically for that purpose in Quebec are joined stools from the 17th century, some of which have survived as the furniture of churches, convents or monasteries. Stools were used for many purposes apart from leisure seating — as workbenches, stepping stools, work stools, or prayer stools (*prie-dieu*).

The backless bench can be seen as a modification of the stool, while the backed variety may derive from more than one source — perhaps from the stool, perhaps from the box, perhaps from the chair (itself a metamorphosis of the stool, an idea more clearly expressed in German, where the word for both stool and chair is *Stuhl*). Quebec benches with splats or spindles have a close affinity with Windsor-type chairs, while panelled benches call to mind the same construction used in the panelled chair.

The high-back settle, long popular in the British Isles, but of lesser importance in Central and Southern Europe, did not find its way to French Canada, although there do exist some medium-height solid- or panel-back benches whose domestic inspiration may be from church furniture.

Of considerable interest among French-Canadian furnishings is the bench-bed, or *banc-lit*. This very useful item served well the needs of the small house, the large family, or both, because it could be opened by night and closed by day. In Canada, "it was used as both a seat and a storage chest during the day and as a bed at night."[33]

The *banc-lit* was an extremely popular piece in French-Canadian households of the 19th century, before which time it seems not to have made its Canadian appearance. It has been said that no specimen of the *banc-lit* has been found in France.[34] And yet, this non-French form was of widespread use throughout the countryside of French Canada by the early 19th century. Where did this furniture form come from? It was virtually unknown in the American colonies, and it is by no means clear if American examples were made before or after those constructed in Quebec. Although a precise answer to the mysterious origins of this ubiquitous form may never present itself, a strong possibility is that it came to French Canada with the arrival of Irish immigrants in the early and mid-19th century. Clergy reports of 1790 and 1791 show a sizable Irish population, both Protestant and Catholic, living in the Lower Town of Quebec City, while during the late 18th and early 19th centuries, Irish settlers came to the poorer lands south of the St. Lawrence and migrated to French Canada in continuing streams during and after the Napoleonic Wars.[35] Given the common usage of the bench-bed in households throughout Ireland (where it was more typically called a settle bed) and the large influx of Irish settlers in Quebec just prior to the appearance of the first *banc-lits* in French Canada, the Irish role in the development of this form of habitant furniture may have been considerable. Whether the bench-bed did in fact come to Quebec by way of Irish settlement is difficult to establish with certainty, particularly in

view of differing chronologies offered. Palardy argues that the form was brought to Canada around 1800, thereby becoming part of the French-Canadian furniture inventory in the early decades of the 19th century.[36] This unfolding of events is at odds with Bernard Cotton's assertion that the settle was unknown in Ireland at such an early date, for he argues, "This type of bed appears to have been a later innovation, and may only have been made after 1850."[37] The earlier exportation of this form from Ireland to Canada suggests that Cotton's claim cannot be satisfied, and that more precise research is needed about this important French-Canadian furniture form and its antecedents.

In later times chairs became the most common form of household furniture, but they were not always found in the homes of those of ordinary or lesser means. Armchairs were a rarer form, reserved in medieval and earlier times for royalty or the master of the house. It is with regard to chairs that Palardy sees another of the innovations which distinguish life in French Canada from that in the old country: "Chairs were uncommon in peasant homes in seventeenth-century France, yet in Canada they were widely used to supplement benches and stools."[38] Among the earliest surviving Canadian examples are jointed chairs with open backs, similar to French Lorraine chairs, and also a group with panelled backs, found along the St. Lawrence settlements, and popularly called Ile d'Orleans chairs.

Other chairs had turned vertical spindles between horizontal slats which were straight or, more typically, shaped by means of decorative scrollwork on either the upper or bottom edges, or both. The turnings on these chairs, comprised of balls, vases and chamfered cubes, along with the open or panelled-back variations, are Canadian expressions of Louis XIII style.

In effecting a transition from the boxlike, rectilinear emphasis of the Louis XIII style toward more graceful lines, the scrolled stretcher, given the zoomorphic name *os de mouton* (sheep bones), began to appear on square-backed chairs in the 18th century. These chairs may originally have been the reserve of clergy and seigneurs (indeed, they were sometimes called *fauteuil du seigneur*), but they were imitated, as countrified versions found in habitant homes were to testify. With the evolution from the transitional into the full style, arms are shaped with comparable elegance, and particularly fine examples possess scrolled seat-rails and even stretchers.

A further development in the 18th century led to the "capucine" type of chair or armchair (*chaise* or *fauteuil à la capucine*), one of the most charming of Canadian country forms. The origin of the name is murky and is sometimes attributed to the purported resemblance of the shaped slats to a monk's cowl. The armchair form has as its prototype or parallel a similar chair made in the French countryside of the 18th century, described in studies of French provincial furniture as a *bonne femme* chair made in Orleannais and the Loire Valley. Despite close similarities, the Canadian form is innovative in the prolific use of certain

details, notably the chamfered cubes on legs and back posts.

Later Quebec chairs further interpreted or amalgamated 18th-century styles, but others adopted American influences (notably English slat-back or Windsor spindle types). Still other chairs, particularly ones of a more rustic nature, reflect great creativity and imaginative innovation of form and detail.

TABLES

Tables serve many functions in the household; they are used for eating, displaying, working, playing games, and as supports for items as varied as vases and lighting.

Among the earliest of French-Canadian tables are the large refectory tables used in convents and monasteries, many of which contain drawers for the cutlery, plates and bowls of those sitting at designated places. The long form of the refectory table eventually proved serviceable in domestic contexts, enabling the gathering of the family in early morning, possibly at noon, and always in the early evening. In his discussion of the ritual function of furnishings, Jean-Louis Flandrin calls attention to the importance of the dining table as an expression of emerging familial piety, sharing a meal over which there was the characteristic recital of a prayer, the Benedicite.[39]

According to Flandrin, all knew where they were to sit at the table (the father of the family at the head, by the fire; beside him was his wife; then came the children, and at the far end were placed the servants or other workers).[40] This placement and knowledge of location can be seen as the familial extension of the religious ritual of the cloistered community. In such cases, the transference of custom from church to home is paralleled in the case both of ritual and furniture.

The first tables made in New France, reflecting the Louis XIII taste, are characterized by such features as heavy turned legs with matching stretchers, or, in more affluent households, twisted spiral legs and stretchers.

Louis XV elements appear with the introduction of the cabriole leg on a wide variety of tables, mostly those used for serving prepared food in the dining room or the delicate dressing tables designed in the Régence manner. Such tables seem to represent another Canadian innovation with regard to social structure, in that, while they were found quite frequently in habitant households, they were virtually unknown among the French peasantry.[41]

Pedestal tables or candle tables, known in France as *guéridons*, were made and used widely in the 17th and 18th centuries. Typical of such tables is a central turned column resting on a disk or tripod base. Such tables were supports for lighting devices, but also served other functions as well, notably for the placement of display items.

A late (19th-century) evolution of the table is the washstand. Some of these were meant for the kitchen or the entryway to the kitchen, and others were intended for the bedroom or guest room. The former are

frequently of rustic make, while the latter are sometimes comparatively refined. In both cases, the late manufacture and homemade quality of many washstands assured the widest range of styles and interpretive devices. Some are painted or carved in a folk-art manner, and many are of unique design.

Other tables were formal in character and sophisticated in craft, and do not properly fall within the range of country furniture considered here. Notable among these are fine console tables, which in France were both church pieces and furnishings of the wealthy home, but in Canada were almost always confined to ecclesiastical settings.

From its beginnings to its later expressions, French-Canadian furniture revealed a design inspiration which ranged from Renaissance to Victorian, and from relatively pure French Provincial sources to English and American influences. Its variety of interpretation is impressive, and its endurance is the longest of any of the furniture-making traditions in Canada.

The Anglo-American Tradition in Quebec

Large-scale English settlement in Quebec came about in the wake of the British conquest of New France as the result of decisive military victories at Louisbourg in 1758 and Quebec in 1759. For several decades after 1760, a British governmental superstructure was imposed upon a French population, with comparatively little English migration to what had been declared a British colony by the Treaty of Paris in 1763. The English-speaking population of Quebec during these years was essentially a small group of British merchants and soldiers stationed in the urban centres of Montreal and Quebec City, but was gradually augmented by the arrival of a steady influx of Americans as well as English traders and merchants from New York and other trading centres in the American colonies.

Among events bringing large numbers of English settlers to French Canada, one of the most important was the American Revolution. In addition to the strong inundation of the Atlantic Provinces, an estimated 12,000 to 15,000 settlers crossed from New England into Quebec during the 1780s.[42] While most of these settled in the western region which after 1791 was to become Upper Canada, a small but significant English-speaking minority established itself around the major cities and in the Eastern Townships. They were to benefit from the structure of British institutions of law and government designed to represent English interests in French Canada. The development of English material culture, reflected in their architecture and furniture, was undoubtedly a consequence of the strong self-confidence of this powerful minority. "The British part of the colony was crucially strengthened in numbers and attitude, and although they remained a tiny minority, they felt themselves to be in possession of everything substantial."[43] Seeing their future in strengthened ties with other English-speaking regions of Canada, the

English-speaking minority was successful in obtaining government sponsorship or support for programs of modernization of roads and canals as well as economic institutions, hence achieving greater integration with the economic development of Upper Canada.

A dramatic expansion of English settlement in Quebec took place in the decade following the Napoleonic Wars, as postwar economic depression and high unemployment served to spur emigration. Along with poor Scots and Irish, many English families and individuals joined the shiploads of the hopeful. In 1819, approximately one-half the British subjects setting sail for British North America were English.[44] Tragic indeed are the accounts of English-speaking immigrants, many of them Irish, who found themselves in derelict circumstances on the docks of Quebec and Montreal in the 1830s and 1840s. Their desperate living conditions are the subject of works by writers and painters, perhaps none more powerful than Joseph Légaré's ghostly painting (1837) of Quebec City inhabitants struggling against the horrific cholera epidemic which claimed thousands of lives in Lower and Upper Canada during the mid-1830s.

While among the thousands of Scots who emigrated to Canada, there were settlers who found their way into the Eastern Townships, of even greater magnitude were the waves of Irish immigrants coming to French Canada. That there were significant numbers of Irish in the general area around Quebec City already in the late 18th century is made evident by the Bishop of Quebec's need to bring Irish priests and seminarians from Ireland to serve Irish parishes in the region. Both Protestant and Catholic Irish lived alongside French neighbours within Quebec City, with many of the Irish employed in the lumber business and other sectors.[45]

The inundation of Canada by Irish immigration was echoed in a similar pattern in Quebec, where the Irish were the most numerous immigrants in the population of Lower Canada throughout the 19th century.[46] The earlier large-scale migration of the period 1814–44, which peaked in the 1820s, was responsible for the Irish settlement of several regions of Quebec, located variously in County Beauce and in a district some forty miles southwest of Quebec City. These settlements experienced further growth when additional waves of Irish immigrants came during and following the catastrophic potato famine of 1845–49.

Thus, the demographic make-up of Quebec was a mixed one, with English-speaking enclaves in the major cities, particularly Montreal, Loyalists in the Eastern Townships, and a few Scots and many Irish near the cities and in rural areas to the south of Quebec City.

Anglo-American Furniture Types in Quebec

Some of Canada's most elegant Anglo-American-style formal furniture was made within the English-speaking community of Montreal,[47] and is comparable in expense and sophistication to the finest examples made in the Atlantic Provinces or Upper Canada. Elsewhere, country furniture

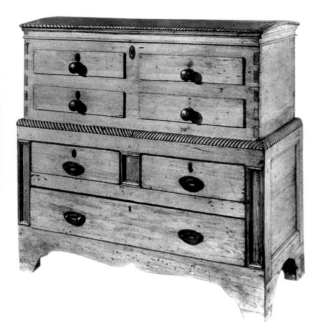

18. Storage Chest: 19th Century; Pine; 48¾"H X 49"W X 20½"D.

Evidence of Irish influence in French-Canadian furniture can be seen in the design of this chest-on-chest found at Beaumont on the south shore of the St. Lawrence River. Only the bottom three drawers are functional; the upper four are merely facades to promote aesthetic continuity. This piece falls into the category of transitional furniture in that it alludes to both the chest of drawers and the earlier trunk. Its form, with a domed top and rope-twist quarter-round mouldings, is virtually identical to that of examples made in Ireland, providing dramatic evidence of the influence of Irish forms and techniques following substantial Irish immigration to Quebec in the early 19th century.

makers produced for an English-speaking clientele an impressive and diverse range of pieces in pine, butternut or other woods. In other contexts, however, French-Canadian artisans, working primarily within French communities, made pieces which reveal an awareness of Anglo-American styles. Such pieces are sometimes almost indistinguishable from their British or American counterparts, but in other cases are highly creative syntheses of English and French elements.

CUPBOARDS

The preferred counterpart to the French *buffet à deux corps* in the English-speaking communities of Quebec was the glazed corner- or wall-cupboard. While such cupboards are not unknown in the French context, the more numerous English examples are distinguishable by plainer panelling and the presence of Chippendale or later English neoclassical influences in the treatment of bases, cornices or pilasters, as well as carved, painted, or applied ornamental detail. The English or American open pewter-dresser reflects both New England and British Isles backgrounds, and with its relative severity of style makes an interesting contrast to the more curvilinear panelling of the French-derived *vaisselier* (figs. 241 and 17).

TRUNKS, CHESTS OF DRAWERS

Flat-topped trunks on bracket bases made in the English-speaking settlements frequently reveal American or British influences, while several trunks-on-frame are virtual replications of a well-known Irish form (fig. 18). The principal clothes-storage case piece in French Canada is the commode, usually with three drawers, while in English-speaking areas it is the somewhat taller chest of drawers. That Anglo-American styles were sometimes emulated, or more accurately, creatively modified, by French furniture makers is dramatically disclosed by a large related group of chests of drawers from County Kamouraska, pieces made with tall, flared-out feet in the Hepplewhite manner, but given to French-Canadian interpretation of decorative detail.

TABLES, WASHSTANDS

Numerous tables made in the Eastern Townships and other regions are of Chippendale styling with square legs, sometimes chamfered, or of the simple country-Sheraton turned-leg variety popular across much of 19th-century Eastern Canada. The washstand was a staple form in both French and English communities of Quebec after mid-century. The French examples were frequently quite free-hand in interpretation, while English counterparts tended to resemble late Federal or American Empire forms with their more controlled scrollwork galleries.

SEATING

Chairs made in the English communities of French Canada represent the virtual gamut of late 18th-century and 19th-century influences, notable forms being the Chippendale arm or side chair, Windsor style spindle chairs, Regency-style chairs, and other later types, including "Boston" rockers. Again, an interesting form of bench is the *banc-lit*, a form of unclear origin but with seemingly more direct links to Ireland than to France.

SMALLER FORMS

In the making of simpler or smaller pieces — shelves, frames, utensils, keepsake boxes and the like — there is also seen the production of distinctively English forms, and again the situation in which pieces made by French-Canadian artisans incorporate Anglo-American motifs. A remarkable exemplification of this phenomenon is seen in a small storage box, which is virtually indistinguishable in form and painted decoration from New England examples, but is in fact clearly signed by its French-Canadian maker (fig. 19). Such pieces make evident the process of cultural borrowing, increasingly apparent in furniture made after the first quarter of the 19th century.

19. KEEPSAKE BOX: 1866; PINE; 5"H X 10⅜"W X 7"D.

Dramatically painted against a black background are several motifs: paired birds, lions at each end and an eagle on the top. On the reverse side is a depiction of a passenger ship with the English name Beaver, *here phonetically approximated as* Biveur. *In a rare instance of self-identification, the decorator of this box has written* Joseph Laurent pintre et voiturier 14 Mars 1866, *indicating his profession as a carriage-painter.*

ONTARIO

Early Ontario Settlement

THE LOYALISTS

The early history of British settlement of present-day Ontario is essentially the story of the arrival of Loyalists in parts of Canada west of Montreal in the 1780s. While a few individuals had preceded them, it was the Loyalists as a group who were to define the English-speaking presence of that vast region known after 1791 as Upper Canada. It has been estimated that, with arrival of these immigrants from the various New England colonies, the British minority in Canada increased in the period of a few short years from 4 or 5 percent of the total population to a figure of 10 to 15 percent.[1]

Settlement of Ontario proper must be seen historically as the settlement of that part of the province of Quebec west of Montreal, which was to be severed from Quebec and made a separate province with the establishment of Lower and Upper Canada by the Constitutional Act of 1791. By that time, most of the Loyalist migration had been completed, with some 12,000 to 15,000 British colonists having moved from New England to a thin band of lands fronting on the north shores of Lake Ontario and Lake Erie.[2] Nearly 80 percent of all Loyalists coming into Quebec settled in this western section.[3]

Other immigrants, less clearly motivated by loyalty to the British Crown, and more probably drawn by the offer of free land and the hope of new economic opportunity, came from various New England states during the 1790s and into the early 19th century. Of the 94,000 people resident in Upper Canada at the outbreak of war with the Americans in 1812, more than 50,000 were themselves of American background.[4] Later references to these immigrants included the ambiguous appellation "Late Loyalists."[5]

If war has historically been a cause for social disruption leading to mass emigration, its attendant economic instability has played a still greater role in such movements of groups and classes. Canada was to find itself again and again on the receiving end of many such an exodus, as was the case with the social turbulence in the British Isles in the early 19th century. Following the Napoleonic Wars, England emerged militarily victorious but economically crippled, as the decade after 1815 proved to be a period of soaring unemployment and industrial and agricultural stagnation. As has frequently been the situation in a postwar period, a vast segment of the population whose careers had been associated with international conflict — not only soldiers but people working in many domestic industries supportive of the effort — found themselves without work. It has been calculated that in this period the number of indigents in England may have exceeded 15 percent of the population, and that some 120,000 pauper children ran the streets of

London.[6] There were many critics of state support of programs for the poor, and many the supporters of the theories of Thomas Malthus, who argued that the best cure for these social ills was state-sponsored emigration of unproductive members of the population to other countries. The flow of emigration from England to Canada experienced a sustained acceleration through the 1820s and 1830s, with a peak figure of 66,000 British emigrants entering North America in 1832.[7] It is interesting to note during this period an intimate connection between furniture-making and human destiny: the demand for Canadian timber for building furniture in England (particularly as a consequence of the vast deforestation of Ireland) enabled the provision of cheap fares since ships could travel in an economically efficient manner both ways with full cargo; as the demand for Canadian pine intensified for making British furniture, so much greater was the motivation for offering cheap passage to Canada; many who came to Canada became the workers in a new land, producing furniture for a growing population on this side of the Atlantic.

THE SCOTS AND IRISH

It was among the United Empire Loyalists that the first significant groups of Scots appeared in the region of present-day Ontario. A group of Scottish Loyalists departed from the New England colonies and found their way to lands along the St. Lawrence River in what was then the province of Quebec. Partition in 1791 ceded this region to the new province of Upper Canada, and the small Scottish contingent took up farmsteads in the area today known as Glengarry County.

The early Glengarry settlement later became a magnet which attracted further settlement directly from Scotland. After the disbanding of a Roman Catholic regiment (the Glengarry Fencibles), members of their ranks emigrated to Canada in 1803, lured by a grant of 200 acres for each family.[8]

In the early decades of the 19th century, the British began to take seriously the vulnerability of their colony in North America, particularly the virtually unpopulated district stretching from just west of Montreal to the Detroit River. The reality of British anxiety in this matter is suggested by the claim that "the War of 1812 had demonstrated to Britain how tenuous was her hold on Upper Canada and the territory to the west."[9] To allay such concerns, steps were inaugurated to establish communities along Lakes Ontario and Erie, and to more adequately control the region, British leaders initiated policies of assisted immigration and settlement in Upper Canada. With modest sums provided by emigration societies and 100-acre grants in Canada, boatloads of Scots departed in waves during the 1820s to begin life in several regions of Upper Canada. Scottish settlers established several communities in Perth and Lanark counties, with nearly 1,200 Scots arriving in Lanark in 1820.[10] The entrepreneur Archibald MacNab established a settlement of his own clansmen in Renfrew County after his arrival from Orkney in 1823.[11]

A highly influential promoter was Colonel Thomas Talbot, who instituted settlements on Lake Erie in Southwestern Ontario. Talbot, an Irishman, succeeded in attracting thousands of settlers, many of them impoverished Scottish Highlanders. With his initial grant of 5,000 acres in 1803, he methodically carried through for the next thirty years his plan to establish a network of settlements loyal to British institutions. He recruited from sources far and wide, and was able to bring a group of Highlanders from New York State, as well as many from Scotland proper, especially from Argyllshire and Perthshire.[12]

Another organizer of consequence was the Scottish novelist John Galt, who in 1826 chartered an organization known as the Canada Company, with fellow Scotsman William "Tiger" Dunlop as a senior officer. The company was extremely important in its active recruitment of Scottish settlers for the newly emerging communities of Guelph, Galt and Goderich in Southwestern Ontario.[13] Also active at this time was William Dickson, a Scotsman who had emigrated to Upper Canada from Dumfries, and who in 1816 purchased the entirety of the Township of Dumfries on the Grand River. As a result of his recruitment activities, including a highly publicized series of letters on the virtues of emigration to Canada, he was able to bring out large contingents of Scottish settlers, soon resulting in a community of over 6,000.[14]

Irish immigration to Canada already had a long history before the first arrivals to the newly formed Upper Canada at the beginning of the 19th century; the Irish in Nova Scotia already comprised one-third of the population of Halifax by 1760.[15]

Large-scale Irish emigration to Upper Canada was precipitated by the familiar situation in which negative developments in the home country were joined with positive inducements offered in Canada. The disruptive Irish rebellion of 1798 had resulted in the emigration of small groups of families to America, but the trickle became a flow with general economic misery throughout Ireland and the catastrophic failure of the potato crop in the years 1823 and 1825. It was at this time the Irish government began to provide financial assistance to individuals and families willing to emigrate to Canada.

The single most important development regarding Irish emigration was the decision of Peter Robinson to bring out large numbers of Irish to Eastern Ontario. He initially selected and placed 600 immigrants between the Perth settlement and the Ottawa River. Later, after being made Commissioner of Crown Lands in 1827, Robinson brought another 2,024 Irish settlers, situating them north of Rice Lake near the emerging village of Peterborough (named after Robinson himself).[16]

The starvation years of the 1840s resulted in an enormous outpouring of destitute Irish immigrants. It is calculated that in the single year of 1847 some 80,000 poor Irish settlers came to Canada from Liverpool and eighteen Irish ports.[17] Another estimate, of 90,000 immigrants, attributes the exodus to a widespread famine throughout the British Isles, a spectre as threatening as the cholera epidemic which had already taken thousands of lives a decade earlier.[18]

At the time of Confederation in 1867, the Irish portion of the British population in Canada was the largest group, reflecting the extreme harshness of conditions at home and the willingness to give up familiar surroundings for a future largely unpredictable in a new land.

Where early years after 1815 had brought settlers mainly from the Highlands of Scotland, in subsequent decades the greater numbers were to come from Ireland. The numbers are staggering: it is estimated that fully a million emigrants came from the British Isles to North America during the first half of the 19th century.

Other factors contributed to this outward movement, among them the enclosure movement, which replaced open fields, commons and collective farming with compact individual openings, and the practice of dividing and subdividing farms into units too small to support their inhabitants. Ireland's population, in the opinion of historian Eli Halevy, had been reduced to "a vast proletariat, ignorant, miserably poor."[19] As was the case elsewhere in Britain, the Malthusian view was brought to government practice, resulting in assisted emigration for those willing to depart from Ireland and take their chances in Canada. Such persons, given the dubious title of "redundant population," were drawn to Canada by individuals and societies promoting the advantages of making a fresh start in Ontario.

Arriving after the earlier settlement of Loyalists and other Americans, the Irish had to settle for "back" lands, further removed from the Great Lakes or major river channels. Early Irish settlements were established in the valleys of the Ottawa and Rideau rivers, however, and others planted themselves farther west in Carleton and Lanark counties, on lands allocated by Peter Robinson in 1823.[20] Robinson followed the lead of Robert John Wilmot Horton, undersecretary of state for the colonies in the years 1821 to 1828, a British entrepreneur who had visited neither Ireland or Canada, but who undertook assisted emigration as an experiment to bring together the "redundant population" of rural Ireland and the empty lands of the colonies.[21] While Robinson had made an important beginning by bringing 550 settlers to Almonte in the Bathurst district in 1823, his major achievement was the enlisting of 2,024 dispossessed Irish immigrants (whom he described as "reduced farmers") to leave regions of Cork, Limerick, Tipperary, Waterford and Kerry to settle on lands comprising the Peterborough settlement near Rice Lake in 1825. The survival of this community in a new setting seems to have provided Robinson with a sense of having "brought Horton's experiment to a successful conclusion."[22]

Other areas of Irish settlement included the counties of Halton and Peel, north and west of Toronto, as well as Grey County, which absorbed second-generation Irish who had come to the Halton-Peel area. Closer to mid-century, waves of Famine Irish came to Canada, settling variously in barely arable townships of Renfrew and adjacent counties.[23]

Anglo-American Furniture

For nearly a century, from the late 18th to the late 19th century, the furniture of Loyalists, English, Scottish and Irish settlers reflected a mixture of tradition and contemporaneity, with remembered techniques and styles subjected to modification by present-day intercultural influences, the availability of materials and tools, and the individual resourcefulness of furniture makers.

Many traditional forms were preserved, notably the open dish-dresser as well as solid-door and glazed cupboards. Chairs and other seating commonly reflected styles well developed in the British Isles and American colonies in the late 18th and early 19th centuries, and a similar pattern can be observed with tables, beds, chests and smaller furniture forms. At the same time, however, other forms either disappeared or appeared in such rare instances as to mean only individual rather than communal preservation of particular tastes and usages. Among such vestigial forms are the press-bed, high-back settle, the corner chair and the cricket table, which occur rarely or in some cases not at all.

The predominance of four principal styles — Chippendale, Sheraton, Hepplewhite and Empire — is seen in the extremely late retention, into the late 19th century, of these designs in Ontario furniture-making. In a few instances there is the occasional throwback to Jacobean, William and Mary, or Queen Anne styles, faintly hinted at by the presence of a remembered detail rather than the whole.

TRUNKS

Among the earliest Ontario trunks are a few rare examples of the frame-and-panel type, a medieval form largely displaced in the 19th century by the so-called "six-board" type. There are many variations of the latter type. Some examples rest directly on the floor, or are supported by bracket bases or set on turned feet. Many trunks are fitted with drawers at the bottom, and a few examples are of the transitional variety, with both hinged lids and drawers, pointing toward the evolution from the storage chest to the chest of drawers.

CHESTS OF DRAWERS

Nowhere is the diffusion of British high styles more clearly stated than in the many chests of drawers made and used in English-speaking homes in 19th-century Ontario. While Chippendale elements are found in the design of early examples, most commonly exploited are the somewhat later Sheraton, Hepplewhite and Empire features, visible especially in the shape of feet, but also, in the case of Empire influences, exemplified by neoclassical applications such as columns and pilasters or scrolled backboards. Overt Chippendale features, notably profusely scrolled and moulded bracket feet, are an early English feature which, ironically, has its most obvious Ontario manifestation in the Pennsylvania-German furniture of the Niagara Peninsula.

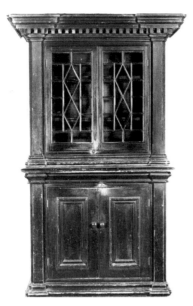

20. GLAZED CUPBOARD:
SECOND QUARTER 19TH CENTURY;
PINE; 83½"H X 44¾"W 22½"D.

From Unionville, an area which received both British and American settlers in the early 19th century, this well-crafted case piece was more likely intended as a bookcase than a dish cupboard. The glazing is taken from a Chippendale pattern, and the overall sense of the piece is one of formality, but accomplished by a money-wise imitation, since the wood is painted pine rather than the more expensive mahogany of its prototype.

CLOTHES STORAGE

The clothes cupboard was a necessity in the Ontario household before the introduction of the built-in closet in homes at the end of the 19th century. Such pieces took two principal forms: either the two-door cupboard with hooks for hanging clothing, or the more characteristically British clothes-press, which was comprised of doors above and a chest of drawers below.

CUPBOARDS

Early terms for cupboards indicate the ecclesiastical source of many pieces which eventually became part of the household inventory. Such is the situation with the cupboard, known in medieval descriptions as an *aumbry*, a church storage-piece with a possible etymological connection with the word alms. In the British context, the term "cupboard" is derived from a medieval usage, suggesting a board for the storage or display of cups and other pewter or chinawares. In time the word took on a broader signification, referring to virtually any case piece used for storage and display. In the kitchen, cupboards or dish dressers were open or closed and served as keeping-places for ordinary dishware as well as utensils. Other cupboards located in parlours or eating rooms had a loftier role in the display of good china or glassware. Still other cupboards were in fact bookcases. The design and use of kitchen cupboards in Ontario reflects earlier practice in the British Isles, with differentiation according to variations which were the rule in England, Scotland and Ireland. Ontario cupboards, including solid-door types, occasional reveal an indebtedness in their design to Welsh dressers. A notable instance of this relationship, even if a distant one, is the arrangement of Ontario wall cupboards with drawer-and-door arrangements faintly reminiscent of Welsh cupboards of the *tridarn* type. In his study of Ontario furniture, Howard Pain draws attention to the Scottish and Irish preference for relatively tall cupboards, especially open dressers, in comparison with the lower and deeper counterparts found in English settlements, and indicates the remarkably widespread use of glazed cupboards in this part of the world.

DESKS

More a characteristic of the second-generation home, rather than the initial modest cabin or cottage, the desk came to symbolize a degree of emerging prosperity. It was the desk which housed the account book, the ledger and other writing materials of the more affluent household, and it was used by those who had attained a significant degree of literacy. Some desks were little more than boxes resting on tables, or with attached frames, while more elaborate examples were case pieces in their own right, with fitted drawers and a hinged writing surface. Finer specimens were essentially cupboards with drawers below and a bookcase section above.

BEDS

Early Ontario beds undoubtedly feature high posts, and square or turned posts, and in some cases were fitted with a tester above. Surviving examples are rare, however. The most commonly found beds from the English-speaking settlements of Ontario are comprised of medium-height posts joined to form head- and footboards, connected by removable horizontal members, over which either stretched ropes or planks provided support for a tick or mattress. Sheraton and Empire turnings defined the style of most Ontario-English beds in the earlier and middle part of the 19th century.

Cradles were frequently made in the manner of earlier British examples, particularly the hooded type, although this form appears to have been more common in the Atlantic Provinces than in Ontario. Other cradles resembled Windsor-style chairs, particularly examples with sides comprised of crest rails and vertical shaped splats or turned spindles.

SEATING

The range of chairs made in Ontario is immense, and it is almost easier to indicate the British forms that were not made and used in the new context (the farthingale chair, the Yorkshire Dales chair, the high-back settle). Ontario-English households accommodated many forms, including the chair-table and the hutch-table (the latter constituted of table surface and storage box below), the carver chair constructed of turned posts and turned spindles, the ladder-back, the various Windsor chairs with spindles and splats, the country equivalents of the finer Hepplewhite and Sheraton chairs, as well as American-influenced chairs and rocking chairs. Settle benches were made in relatively small numbers, in comparison with the more common manufacture of Windsor-style benches with splats and spindles.

TABLES

Among the earliest tables are long, refectory types with box or medial stretchers, or smaller "tavern" tables with square tapered or turned legs. Many Ontario-English tables reflect the popularity of designs from the schools of Chippendale, Hepplewhite and Sheraton. The triangular cricket or collapsible "coaching" table is found occasionally. The comparative spaciousness of the New World home is reflected in the popularity of diverse table forms, with examples made for the parlour, kitchen and sleeping rooms. The washstand is a late modification of the table, with a gallery on three sides and an opening or lower shelf for storage of a basin and jug. This form did not become widespread until the mid-19th century, most likely concurring with the introduction of cast-iron heating stoves in Canadian bedrooms at this time.

SMALLER FORMS

The expression of distinctively national traits in the making of furniture is perhaps most seen in smaller items, such as shelves, frames, utensils

or storage boxes. Various examples in the present overview include an Orange Lodge frame (fig. 350) and Captain Alexander McNeilledge's "Rule Britannia" document box (fig. 313).

Germanic Communities of Ontario

THE PENNSYLVANIA GERMANS

The immigration of Pennsylvania Germans into Southern Ontario occurred over a period of approximately forty to fifty years, beginning in the mid-1780s, swelling at the turn of the century, and diminishing to a trickle by the early 1830s. The earliest arrivals settled in the Niagara Peninsula, just across the Niagara River from New York State. They fanned out along the shorelines of Lakes Ontario and Erie, settling in the present-day counties of Lincoln, Welland, Haldimand and Norfolk. The largest concentration was by far in Lincoln County. Smaller numbers continued west along Lake Erie to a point just south of Windsor and Detroit. Although those Pennsylvanians who took the more southerly route along Lake Erie were largely from Lancaster and nearby counties, the pioneers at "The Twenty" — Twenty Mile Creek near its entry into Lake Ontario — were primarily from Bucks County.

A second area of settlement reached only a decade later was upper York County, north of present-day Toronto. Following the arrival of Lutherans and others, large numbers of Mennonites from Lancaster and adjacent counties migrated to Markham Township, while Dunkers from southeastern Pennsylvania settled in Vaughan Township, immediately to the west.

The third and largest area of Pennsylvania-German settlement, established initially in 1800, was Waterloo County, the "inland wilderness" along the upper Grand River, sixty miles west of Toronto and seventy miles northwest of the settlement at The Twenty in Lincoln County. After an exploratory visit in 1800 by two pioneers, Samuel Betzner (b. 1770) and Joseph Shoerg (b. 1769), large numbers of settlers began to arrive in Waterloo County (then Waterloo Township). The majority of the Pennsylvania Germans to take up residence between 1800 and 1830 came from Lancaster County, Pennsylvania, but a small yet significant number also migrated from Montgomery County, with sprinklings of families from Berks and other counties.

THE CONTINENTAL GERMANS

Much of Ontario's German population is comprised of settlers who came directly from Europe, rather than from Pennsylvania. Among German settlers who found their way to Upper Canada in the 1780s, the earliest may have been discharged veterans of Butler's Rangers, several of whom in fact were European Palatines.[24] A sizable number of these established themselves in Eastern Ontario, particularly in Stormont and Dundas counties. Others took up lands in Southwestern Ontario, including such prominent figures as Jakob Bahl (later Anglicized to Jacob

Ball), who settled at The Twenty in Lincoln County, and whose large mill became the basis of settlement in the region.

A larger influx of Continental Germans occurred in 1794 when William von Moll Berczy (1744–1813) brought a group of 186 people to upper York County. Berczy's earlier attempt to bring the group from Hamburg in Germany to the Genesee Valley in New York State had proven unsuccessful, leading to a redirection of efforts and the subsequent movement of the group to German Mills, a little to the west of Markham in Upper Canada. This industrious community undertook the arduous task of building the early road southward to the lake shore, along the lines of today's Yonge Street in Toronto. The impact of the Berczy settlers was strong in this sparsely populated land, in part because they arrived as an organized community. Despite the fact that Berczy himself experienced financial difficulties and eventually moved to Montreal, where he died in 1813, the settlers who had arrived under his leadership did establish the first inland settlement in upper York County.

A much larger immigration of Continental settlers took place during the decade of the 1820s, involving several groups: Lutheran (*Evangelisch*) Germans, Swiss, Palatine or Alsatian Amish, and Palatine and Alsatian Roman Catholics. The Lutheran group settled just north of the Lake Erie shoreline in Welland and Haldimand counties, particularly near the towns of Port Colborne, Stevensville and Fisherville. Amish settlers came after arrangements had been made by their leader Christian Nafziger to assure land grants in Canada. Leaving southern Germany in 1824, they took up a new life in Wilmot Township, just to the west of lands already settled by Pennsylvania-German Mennonites along the Grand River in Waterloo and Woolwich townships. The Roman Catholic group established themselves in eastern Waterloo County, around the present-day village of Maryhill (originally known as Rotenburg and later New Germany, until 1941). Arriving in 1826, the first families in the area were the Fehrenbachs and the Scharbachs, who had come from Germany's Black Forest.[25] Other Catholic German immigrants founded the villages of St. Clements and St. Agatha in Waterloo County.

Another wave of immigration took take place over the three-decade period from the 1830s through the 1850s. By this time, most of the lands in Waterloo County had been taken up, shifting the destination of immigration largely to the north and west. While some immigrants stopped over briefly in Waterloo County, most moved on to the newly opening lands in Huron, Bruce and Grey counties. It was also during this time, particularly in the 1850s, that significant numbers of German immigrants established themselves in rough woodlands of Renfrew County (particularly such settlements as Palmer Rapids, Golden Lake, Augsburg and Germanicus) in Eastern Ontario, as well as in parts of Lennox and Addington County and Frontenac County.

The time of these later migrations coincides closely with the enactment

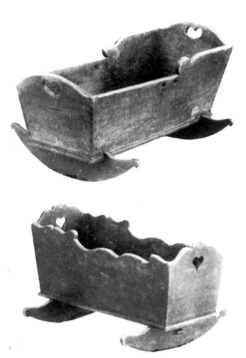

21. CRADLES, ST. JACOBS AND
MARYHILL: MID-19TH CENTURY; PINE.

*Two cradles provide an interesting
insight into distinctions between
Pennsylvania-German and Continental-
German furniture made in Waterloo
County. While these two pieces share
many features, what is more significant
is what distinguishes them. The
tendency in the Pennsylvania tradition
toward simplicity of line is seen in the
plainer profile of the top example, while
the Continental predeliction for a more
baroque ornateness is reflected in the
cradle below. The plainer example comes
from the Mennonite community near
St. Jacobs, while the exuberant one was
found in the Alsatian Catholic
settlement at Maryhill.*

of government policies in several German regions, particularly in the southwest German states of Würtemburg, Baden and Hesse. As in the British Isles, governments in Central Europe had become persuaded of the Malthusian view that much of social discontent was the consequence of overpopulation, and undertook measures to rid themselves of what they perceived to be a dependent (poor) element in their populations. Believing that social costs required for the maintenance of welfare, police services and the administration of criminal justice in economically depressed cities could be better used to promote the emigration of the economically destitute to North America, the governments of Würtemburg and Baden, as well as those of other German states, introduced in 1847 elaborate programs of publicly assisted emigration. The practice was continued into the 1860s, finally provoking the predictable complaint from an immigration official that the failure of Canada to challenge this policy amounted to "a tacit admission of right to inundate it with the refuse of foreign pauperism."[26] Changes in German policy after 1855 reduced the flow of emigrants, and in the late 1850s the settlement of German settlers in Ontario was virtually terminated.

Ontario-German Furniture

Ontario-German furniture exhibits a notable range of styles and techniques, reflecting at times the isolation of the Pennsylvania and Continental groups from one another, but at other times suggesting an intermingling of influences, particularly within the communities of Waterloo County, where commercial contact among groups was close.

The Pennsylvania Germans formed strong cultural, religious and craft traditions in the three principal areas of the Niagara Peninsula, upper York County and Waterloo County. The Pennsylvania Germans produced furniture which consisted in large measure of English forms with Germanic interpretation. In this respect, the furniture parallels the architecture of their settlements.

To be certain, some pieces of Pennsylvania-German furniture are traceable directly to German prototypes, as in the case of the large clothes-cupboard, or *Kleiderschrank*. Found commonly in the sleeping-rooms of both Pennsylvania- and Continental-German households, this large case piece with long doors over small drawers is strikingly different in form from the English-inspired linen press (short doors over a chest of drawers) which makes its appearance in Niagara furniture. The Continental-German wardrobe is given to greater elaboration of profile than its Pennsylvania equivalent, in the form of rounded corners or feet with curved elements. The Pennsylvania clothes cupboard is constructed according to the more rectilinear geometry of English examples. This juxtaposition of a Pennsylvania-linear and Continental-curvilinear emphasis can be seen in the comparison of the profiles of two cradles, shown in fig. 21.

There are further distinctions between Pennsylvania- and Continental-German furniture examples, having to do not only with form but also with function. The country couch, a comparatively elegant piece in that it was commonly made in the Biedermeier curvilinear style, is found variously among Continental-German communities of Perth County in Western Ontario, or Frontenac County in Eastern Ontario. The form is virtually unknown in areas of Pennsylvania-German settlement. The food locker, often made with an elaborately scrolled and decorated pediment in the German baroque-revival idiom, is found in significant numbers in Renfrew County, but does not appears to have been made within the Pennsylvania-German communities. Wall cupboards evidence such distinctions as well, with Continental-German examples sometimes having the feature of sides curved forward to the front of the pie shelf, unlike the simpler vertical emphasis of Pennsylvania counterparts.

CUPBOARDS

Among principal forms of dish cupboards, the glazed or panelled-door cupboard (*Kucheschrank*) was the mainstay of Ontario-German households, and the open dish-dresser occurred less frequently (a few rare examples are found, as in fig. 396).

The wall cupboard is common to all Ontario-Germanic traditions, and the feature of sloped or curved sides is a distinctive note of pieces of Continental-German influence. Stylistically, cupboards may exhibit aspects of a simple Pennsylvania-Georgian form, while later examples may reveal the heavy influences of Empire and Victorian styles, or, as in the example shown in fig. 395, elements of the German baroque-revival with its profusion of curved detail.

The corner cupboard (*Eckeschrank*) is sometimes found among Continental-German pieces, while within the Pennsylvania-German tradition, it is principally popular in the Mennonite households of Waterloo County.

Hanging cupboards, glazed or panelled, were used variously for storage of religious books, valuables or highly esteemed personal items.

A cupboard form unique to the Continental-German communities of Eastern Ontario was the food locker, with grilled or slotted doors for ventilation. The punched-tin version, long popular in Germanic settlements in Pennsylvania and Ohio, did not find its way into Ontario-German households. Food lockers made in Renfrew County typically feature elaborately scrolled pediments, often with a decorative rondel or other design as centrepiece, echoing architectural equivalents.

TRUNKS, WARDROBES

The most common piece of furniture in the Pennsylvania-German household was the storage chest (*Kist*) with a hinged lid and (often) small drawers below. The design of Ontario examples is virtually unchanged from earlier Pennsylvania counterparts, although frequently of somewhat simpler form and lighter construction. These trunks were

bedroom pieces, used for storage of bedding. It is the trunk which was most often associated in German custom with marriage. Trunks intended as keeping-places for the bride-to-be's dowry were sometimes personalized with the young woman's name painted, stencilled, inscribed or inlaid into the facade (for example, see Howard Pain, fig. 1103, a Niagara Peninsula box for Salome Emerich). A companion piece in virtually every household was the free-standing clothes cupboard (*Kleiderschrank*) or wardrobe, personalized examples of which served, like the trunk, as dowry pieces. These large case pieces were in most instances constructed in such a way that they could be easily dismantled for relocation. In most examples, there is a tall upper section with wooden pegs for hanging of clothes, set atop a unity of side-by-side drawers used for storage of other bedding. A variation, especially in Continental-German examples, divided the upper section in two, creating a unit for hanging clothes beside a section of shelves or internal drawers for horizontal storage.

CHESTS OF DRAWERS

Although the chest of drawers can be seen as an evolution from the storage trunk, by extending it in height and fitting it with banks of drawers, the transitional chest is not commonly found in Ontario-Germanic furniture. Indeed, throughout much of the 19th century, the bedroom in the Germanic household was the setting for three pieces of storage furniture — a trunk, a chest of drawers, and a clothes cupboard — which were in concurrent usage. Both Continental- and Pennsylvania-German traditions produced and used chests of drawers made within the mainstream of Anglo-American styles: Chippendale, Sheraton, Hepplewhite and Empire. The only Germanic nuances were those of detail, as in the common use of heavy lapped drawer mouldings, ebonizing, or ornamental embellishment by means of decorative paintwork, carving or inlay.

TABLES

The long kitchen table (*Tisch*) was a standard item in Germanic homes, and was used for eating, and also for working (baking, butchering, other functions of preparation). Hence, the term worktable admits of a wide range of uses. Kitchen tables were serviceable also for non-kitchen domestic tasks such as sewing and other textile-related activities. The typical kitchen table is of 5-foot length, or greater, to permit its use by the family at dinner. Many of these tables have two or three drawers for storage of eating utensils. Some tables, particularly those found in Continental-German settlements, have extendable sections which can be drawn out (hence, "draw" tables) to create a greater length, sometimes longer than 10 feet. It is in tables and chairs that the stylistic distinction between the two Germanic traditions becomes most apparent. While Pennsylvania-German tables are made with straight or turned legs, it is only within the

Continental-German context that one finds examples with cabriole legs, horizontal channelling or fluting, reminiscent of styles brought to Germany from France in the 18th century, or, at later dates, of the curvilinear forms of German Biedermeier furniture.

SEATING

Both bench and chair (*Stuhl*) are common in areas of Germanic settlement in Ontario. While the two forms may have served overlapping and interchangeable functions, each had its location primarily in the household. The chair might be used in virtually any room, but the bench was primarily a kitchen piece. Many benches are of approximately 6 feet in length, approximately the same length or slightly longer than the table, against which they could be positioned for eating. Other benches had simpler settings on verandahs, slip-rooms and summer kitchens, where their function was less explicitly constrained.

Most Ontario-Germanic benches are of the simple backless type, while a few rare exceptions have backs and multiple-use features, such as the combination box-bench shown in fig. 424. The sleeping-bench, although popular in French Canada as well as in the Polish settlements of Ontario, and among Mennonites, Hutterites and Ukrainians of Western Canada, has no equivalent place within Ontario's Germanic communities.

Chairs made in these communities are virtually indistinguishable from the typical Anglo-American forms in their various "Windsor" styles, but a few examples are of traditional Continental design. Notable among these are a few manifestations of the Germanic plank-chair (*Brettstuhl*), as illustrated in fig. 22, while others reveal their makers' knowledge of Biedermeier types (figs. 427 and 428) or of a generalized European country baroque tendency, as in the footstool in fig. 428. The use of the curvilinear in such Germanic forms tends to be regarded even in 19th-century descriptions as a "French" influence, as in the advertisements in *Der Deutsche Kanadier* (Berlin, Canada West) in which such a stylish example is labelled a "French chair" (*französischer Stuhl*).[27]

BEDS

The popularity of the Sheraton-style turned-post bed (*Bett*), including its later form with cannon-ball turnings, was as widespread in the Germanic settlements as it was among 19th-century Ontario communities at large. Several beds from Continental-German settlements as diverse as those in Grey and Renfrew counties (figs. 422 and 423) are of interest in that they reflect the tendency toward a Germanic Biedermeier neoclassical on the one hand, and a fanciful East European country baroque on the other. Two cradles (fig. 21) provide a dramatic indication of two design traditions, juxtaposing a simple Pennsylvania-German profile and the more elaborate scrolling of the Continental-German idiom.

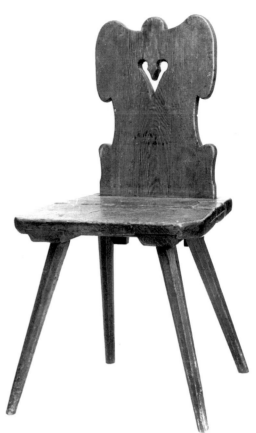

22. CHAIR: THIRD QUARTER 19TH CENTURY; PINE; 35"H X 17½"W X 15"D.

The peasant plank-chair, or Brettstuhl, *was made only rarely in Waterloo County. It is a chair made essentially of eight components — four legs and two cleats plus a seat and back, all joined together by mortise-and-tenon construction. While the Continental counterpart, made throughout all of the German-speaking regions from northern Italy through Switzerland, Austria and Germany to Poland, was frequently given to elaborate carved detail, a simple heart on this Renfrew County chair serves as a vestigial reminder of a rich decorative tradition.*

SMALLER FORMS

It is in the smaller household furnishings, particularly utensils of the kitchen and other household workplaces, that evidence of the Ontario-Germanic decorative practice is best seen. A painted dough-box (fig. 329) and a punch-decorated apple-peeler (fig. 324) are striking indications of the transference of decorative motifs from *fraktur* and textile arts, here found in the use of floral and geometric motifs in the aesthetic enhancement of these utilitarian articles.

The Polish in Ontario

The arrival of significant numbers of Polish immigrants to Ontario occurred during the very years that public debate and political initiative were centred around defining a new Canadian national unity. The Kashubs who came to the wilderness area of present-day Renfrew County were motivated by a combination of monetary and cultural incentives; they sought economic fortune and cultural self-definition within a newly emerging confederation, in which national policy as well as geographical isolation would enable their pursuit of both goals.

The first Polish immigrant is known to have made the crossing to Canada as early as 1752,[28] but very few other Poles followed during the coming century.

There were several groups of Polish immigrants to Canada, with two principal streams making their home in Ontario. One group came from Prussian-occupied areas of Poland to settle in Waterloo County around 1860, and while they retained their language and were centred around a single parish in Berlin (Kitchener) until well into the present century, there does not appear to have developed within this community a recognizable furniture-making tradition. Indeed, furniture found among Polish families in Waterloo County is frequently of factory-produced Victorian variety, or even of Ontario-Germanic manufacture, suggesting commercial interaction between the Polish and German communities.

The most fully developed Polish community in Ontario was that established in the Madawaska River Valley of Renfrew County after 1858. This group, known as the Kashubs, came from the Kaszuby region of northwestern Poland, partly driven by growing Prussian repression in their homeland. Kashuby (or Kashoubia) had been a part of Poland since A.D. 922 , having been subjugated by the German Teutonic knights around the year 1308. When the Poles overthrew their Germanic rulers in 1410, Kashuby enjoyed its cultural existence within a Polish framework for several centuries, but forfeited it again with the loss of Polish independence and the reimposition of German rule in the 18th century.[29] The Kashubs, long a minority culture within the broader Polish national self-identity, found themselves subjected to a particularly bitter persecution as the result of the attempts of Prussian authorities to Germanize them in the 19th century. Pushed from behind by political

repression, they were given further incentive by modest economic promise in Canada (they were offered work on construction of a new road into the Renfrew County region as well as 100 to 200 acres of land for settlement). From the modest group of seventy-six who departed from the port of Bremen and arrived in 1858 in Renfrew County, the Kashub community expanded with the arrival of subsequent waves of immigrants, so that by 1864 there were some five hundred Kashubs in the area.[30] By the 1890s there were more than a thousand settlers in the Renfrew County area.[31]

Further immigration was to augment the Renfrew County population at the end of the century, particularly as the result of active recruiting in Poland by the Wilno parish priest. His activities led to the arrival of 250 families over a four-year period in the 1890s, while another forty families came from the United States, where they have been living in financially difficult circumstances since the 1860s.[32]

The Kashub culture maintained its self-identity in religion, language and culture, as is strongly attested by its highly introverted outlook. The powerful inner cohesiveness of the Kashubs is suggested by parish records of Barry's Bay and Wilno, showing that only about 3 percent of community members intermarry with other groups.[33] This cultural identity is reflected even with respect to their relation with other Polish groups, such as that in Kitchener, a result of both geographical and linguistic factors: "The geographical isolation of the Wilno–Barry's Bay area from other centres where Polish immigrants lived retarded the development of contacts. Also, while the Kashubs claim Polish identity and background, they speak with a distinct dialect not easily understood by other Poles."[34]

Ontario-Polish Furniture

A strong village industry, furniture-making in the Polish settlements of Renfrew County appears to date from the early 1860s, only a few years after arrival in Canada, and to have continued until the first decade of the 20th century. Virtually all categories of simple furniture were constructed locally, using pine as the primary wood, with some other woods, such as ash or elm, for chairs.

Stylistically, "Wilno" furniture, as pieces from this region have come to be known in popular discussion, is decidedly conservative in design and surface treatment. A predilection for a strong East European baroque-revival design in complexly curved profiles and carved or painted details is evident in a full range of case pieces, as well as in items of simpler construction.

CUPBOARDS
The variation of forms is considerable, but in general, Ontario-Polish cupboards fall into two principal categories: open dish-dressers and glazed-door cupboards. In both types, there are three sections: a lower storage area with solid doors, an intermediate work area (sometimes

popularly called a "pie shelf" in descriptions of both Polish and Germanic furniture in Ontario), and an upper display section (open or with glazed doors).

Earlier cupboards are of heavier construction, with raised rather than flat panels. Sculptural depth is achieved more by carving and by the thickness of construction materials than by piled-up application of elements, a characteristic of later pieces. In both earlier and later examples, strong polychrome decoration makes these pieces uniquely colourful within the range of Ontario painted furniture.

One feature characteristic of certain case pieces, some of which have been attributed to the immigrant furniture-maker John Kozloski, is an elaborately and symmetrically scrolled pediment, comprised of stepped-down curved segments, flanking a centrepiece with a carved fan or leaf motif. This feature, commonplace in 18th- and 19th-century Eastern European furniture forms, serves as evidence of the remarkable perpetuation of long-established conventions within a community situated thousands of miles away from its homeland, a distance drastically reduced by the strength of memory.

TRUNKS, WARDROBES

The storage trunk (*skryzinia*) illustrates, perhaps more clearly than any other example, the cultural life-line maintained between the Old World and the New World with regard to furniture design. The painted decoration of "Wilno" chests, most often executed as stylized flower-in-vase motifs, but sometimes as a geometric device, is in its Ontario manifestation virtually indistinguishable from similar examples made in the Kashuby district of Poland itself.

The storage chest was a central fixture in the furnishings of the Ontario-Polish bedroom, where comparatively few examples of wardrobes (*szafa*) or chests of drawers have been found. Its painted treatment was rarely transferred to other furniture forms, a rare exception being the freehand floral decoration of the glazed-door cupboard in fig. 436.

CHESTS OF DRAWERS

While the number of chests of drawers made and used in the Polish community seems to be small as compared with the much larger quantity of known storage trunks, a few examples are known, and, because of design similarities, appear to be the work of the same furniture maker. Although their attached half-columns are reminiscent of the Empire style that made itself felt throughout Ontario in the second half of the 19th century, they may also be regarded as elements of a Biedermeier-influenced Polish neoclassical style. The strong exuberance of Polish country baroque expression is seen in the complexly scrolled profiles of the backboards of the chests of drawers shown in figs. 334 and 442.

TABLES

Tables (*stol*) from the Renfrew Polish community are distinctive when compared with other Ontario examples, but possess an intriguing design similarity to Mennonite tables made in Manitoba and Saskatchewan at the end of the 19th century. Characteristic of these tables is the tapered square leg and the placement of decorative brackets at the joints of skirt and legs. The Polish examples tend toward a somewhat greater complexity, with brackets not only shaped as to contour but also cut out. The tops of these tables, fitted with slotted splines to prevent warpage, are removable. Few small tables are known; nearly all examples are 5 to 6 feet in length, like Germanic kitchen tables, and serve a similarly wide range of functions.

SEATING

Although there are benches of many forms, both with and without backs, the most distinctive Ontario-Polish examples reveal the Biedermeier legacy brought to Canada in the memory of furniture makers who produced seating for the Renfrew community. The consummate Biedermeier-style bench or couch is designed according to a principle of reversed curves, with the shape of legs counterbalanced by that of arm-posts above. The widespread adaptation of this design principle can be seen in comparing this Renfrew-Polish couch (*zlaban*) with Western Mennonite examples made in Manitoba and Saskatchewan (compare figs. 336 and 479). The couch in fig. 447 is an expression of extraordinary flamboyance, with an endless profusion of arabesques offsetting the quiet dignity of its more conventionally curved leg and post profiles.

Chairs (*zydel*) made in the Wilno–Barry's Bay area are frequently of the late "stick-Windsor" variety common throughout the province, but a few pieces are reflective of a European neoclassical sensibility, as in the swept-back chair of Biedermeier inspiration in fig. 335.

BEDS

A few beds found in the Polish settlements of Renfrew County indicate an awareness of an earlier Polish baroque convention, revealed frequently in a free alternation of turned sections on posts and spirited scrolled edges of foot- and headboards. These qualities are to be found on a bed and cradle illustrated in figs. 338 and 449.

SMALLER FORMS

In addition to case furniture and comparatively large pieces that require a combination of joined and turned elements, other pieces made within the Ontario-Polish community retain close stylistic as well as functional connections with the European background of these settlers. An important instance of this retention is the shelf or cupboard made for religious purposes. The centrality of religion in the community and domestic life

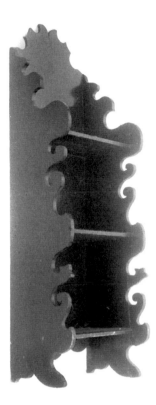

23. SHELF, RENFREW COUNTY: THIRD QUARTER 19TH CENTURY; PINE; 43"H X 30"W X 11"D.

On pieces whose profiles could be defined by the carving of the edge, rather than the shaping of an applied moulding, the baroque contours extended to more rococo extremes. This particularly exuberant compounding of curves can be seen on several pail benches, shelves, a cradle and the country couch (see figs. 447 and 449).

of the Renfrew Kashubians, like that of the villages of French Canada or the Ukrainian communities of the Prairies, meant that acts of spiritual devotion were by no means confined to the Sunday ritual at the parish church, but were also integral to daily home life. In Catholic and Orthodox traditions alike, the provision of a niche or shelf for a religious figure was common practice in most homes. The frequent reference to such shelves or cupboards as "reliquaries" is an erroneous understanding, since such domestic furniture was intended only for the display of a small statue (a relic being the possession of a church, not an individual). Such shelves were typically placed in bedrooms, although there is also a tradition of locating them in a "sacred corner" of the family sitting-room or its equivalent. While the Virgin Mary was the most popular of saints recalled in this manner, there were also statues of Joseph and Jesus, and parish, regional or national patron saints, to whom veneration took the varied forms of morning prayer, petition during times of calamity, or devotion on special feast days. Several shelves found in the Wilno area suggest this particular function, designed in the form of a niche, with a drawer which might contain candles, holy cards or other aids to prayer.

Other, more secular small items made in the region include kitchen shelving, hanging cupboards, frames, footstools and utensils. Many of these feature the elaborate scrollwork characteristic of Polish country furniture in both the European and Ontario context.

WESTERN PROVINCES

Defining the idea of Western Canada is in itself a challenging under-taking. For our purposes, Western Canada is both a spatial and a temporal phenomenon. This section examines furniture made in areas from the Red River in Manitoba to the valleys of the Kootenay Range in British Columbia, and from the approximate dates of 1875 to 1950. Our focus here, as in surveying Eastern Canada, is upon furnishings made in the traditional manner which reflect a continuity with first generations of settlement and with those things made (and occasionally brought along) by ancestors in their countries of origin. Particularly interesting are those groups with a strong retention of traditional cabinetmaking and related decorative arts. By the time of the opening of Western Canada to settlement, the major immigrations from Western Europe had diminished to a trickle. Although there were still occasional arrivals from these regions, the large influx of Germans, English, Irish and Scots was largely passed. Eastern Europe and the Far East were the new sources of immigrants, who came for widely differing reasons — some as victims of religious persecution, others as labourers recruited to till the soil or lay the railways. While there is a wide range of culturally diverse settlement in Western Canada, including Polish, Chinese, Japanese, Hungarian, Romanian, Icelandic, Scandinavian and others, this survey concentrates on the four large groups whose perpetuation of architectural and furniture traditions is especially evident: the Mennonites, Hutterites, Ukrainians and Doukhobors, who arrived in various waves of immigration throughout the late 19th and early 20th centuries.

These four groups are not altogether delineated by the same criteria. While the Ukrainians are a geographically defined group, the other three are recognized by their status as religious communities. Although techniques, designs and styles are never impervious to outside influences, even within groups defined by relatively narrow geographic contours, matters are further complicated with respect to religious groups who have for various reasons been compelled to live in more than one land. This is somewhat the case with regard to Doukhobors, who made a relatively direct migration to Canada. However, in earlier times, the Doukhobors found themselves uprooted and forced to move their homes from south-central Russia to the dry lands above the Black Sea. More pronounced is the situation regarding Hutterites and Mennonites. The Hutterites, or Hutterian Bretheren, were driven from homes in the Alpine valleys to take up life in Balkan regions to the east before eventually coming to the United States and Canada. The Mennonites found it necessary to make treks to Northern Europe, then Poland and Russia before eventually finding their way to North America.

One plain piece of furniture from the British Isles can tell us much about the nature of early furnishings and their necessarily flexible functions. A large pine trunk carried the possessions of John Robertson's

24. IMMIGRANT BOX, SCOTLAND TO MANITOBA: LATE 19TH CENTURY; PINE; 28¼"H X 42¼"W X 23"D.

The earliest pieces of furniture in Canada were often the very containers which carried possessions on the sea route to North American destinations. Many simple packing cases or trunks served both purposes until homes and furnishings of a more suitable nature could be purchased or made after arrival in the new land. This rudimentary crate, belonging to a late 19th-century Scottish immigrant, records name, destination and purpose in its painted inscription, John Robertson / Winnipeg, Man / Settlers' Effects.

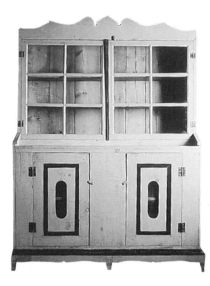

25. STORAGE CUPBOARD, MANITOBA:
LATE 19TH CENTURY; PINE;
82½"H X 62"W X 21"D.

Some kitchen cupboards may have retained an earlier function of food storage, or also served to keep utensils. A small number of cupboards have been found with openings in the lower doors to permit free flow of air and hence enable the storage of food, grains or other perishable items. This large piece is an outstanding example of the cupboard which doubles as a food-locker. The yellow painted finish with black trim is common to Mennonite furniture of the Prairie Provinces, while the enormous width of this cupboard distinguishes it from its many Manitoba and Saskatchewan cousins of tall and lean proportions.

family when he made the voyage by ship and rail to the eastern edge of the Manitoba plain in the last quarter of the 19th century. The first furniture was, not surprisingly, the humble trunk, because of all examples, it was the trunk which served both as furniture and as container for furnishings. Many are the stories of trunks having been used as tables and as chests in pioneer homes. The painted lettering on this particular trunk bears vital information about its owner, John Robertson, his intended destination (Winnipeg, Manitoba) and the function of the box itself as container of "Settler's Effects" (fig. 24). From this portable piece which housed possessions and had to suffice as rudimentary domestic furnishing we turn now to a consideration of the furnishings of four groups in Western Canada.

MENNONITES

Distinct from those earlier groups of Mennonites of Swiss-German origin who trekked northward from Pennsylvania in the late 18th century and early 19th century to establish themselves in Southwestern Ontario were the waves of co-religionists who came to Canada in significant numbers in 1874 and over the following several years.

The large-scale arrival of Mennonites became a reality when pressure from behind — the intensifying hostility of the Czarist government — and an invitation from the fore — the provision of blocks of land, or "reserves," in Manitoba meant a home awaited them in Canada — combined to facilitate the movement of some 7,000 people over the period 1874–76. Subsequent streams of settlers filled up the remaining Manitoba lands and led to the secondary settlement on similar reserves established in Saskatchewan, north of Saskatoon and southwest of Regina.

The group who came to Western Canada have frequently been described as "Russian Mennonites," a term which adequately describes little more than their place of domicile during the preceding century. There is rather little to be found in their architecture, furniture or decorative arts that can be considered "Russian," particularly among the immigrants who came in the migrations of the 1870s, in contrast to the group which remained behind for another forty years before having to flee because of persecutions following the October Revolution of 1917. The design of their homes and barns, as well as interior furnishings, is much closer to that of neighbours in the Netherlands and in the Vistula Delta of Poland, where Mennonites had lived and prospered during the later 17th and 18th centuries. Stylistic connections with Dutch, Flemish and Vistula Delta architecture and furniture have been most capably argued elsewhere.[1]

Mennonite furniture, like that of all groups in the Western Provinces, is almost entirely of pine or spruce construction, a not surprising situation given the scarcity of hardwood forest in these areas. Construction tends to be comparatively refined, and uses lathe turning, mortise-and-tenon

joinery, dovetailing, and finely worked mouldings extensively.

A consistent feature of Mennonite furniture is the tendency to place virtually all case pieces on bracket bases, suspending them several inches above the floor. Trunks, chests of drawers, storage cupboards and wardrobes alike are so placed on frames which typically have five tapered or flared feet, arranged three across the front and two at the back corners. Functionally, this practice served as a protection against the damage to both cupboard and contents from moisture – the consequence of resting directly upon damp floors. Such removable brackets, when damaged, could simply be replaced by new ones, leaving the piece of furniture itself intact. In this regard, they functioned in a manner similar to that of shoe feet used in the late 18th century or early 19th century and made in Irish and other settlements of Eastern Canada. Stylistically, the curved feet on these bases, sometimes echoed in crowns of corresponding design, imparted a degree of lightness and classical elegance such as that attained in aristocratic homes where high-style furniture was displayed on bases of metal or gilded wood.

Mennonite Furniture Forms

Mennonite furniture in Manitoba and Saskatchewan, which is similar to Mennonite furnishings in the American plains states, falls into several categories.

TRUNKS

A large number of trunks found in Mennonite households are of Russian manufacture, and were taken on board for safekeeping of family possessions during the long ocean voyages of the 1870s, from south Russia to Canada. To be sure, some trunks of similar design were made in the new land, but these tend to be recognizable by virtue of their smaller size and less sophisticated construction, and because they are generally lacking the elaborate ironwork hinges and handles or brass keyhole escutcheons of earlier examples. In their Canadian settings, such trunks held bedding and perhaps other household possessions. In some cases, but with diminishing frequency, they retained an earlier function of keeping dowry items for prospective marriages.

CHESTS OF DRAWERS

The chest is closely related in form and function to the trunk, a connection particularly evident in cultures where trunks were eventually fitted with drawers, or chests of drawers had hinged tops, hence commonly known as "transitional chests." Mennonite chests of drawers are usually of great width and depth to contain the large coverings used on large beds. These forms, like other case pieces, are set off the floor by detachable bracket bases, most of which have five feet in the same positions as those on trunks.

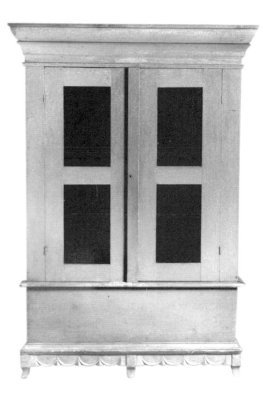

26. WARDROBE, MANITOBA: LATE 19TH CENTURY; PINE; 78⅝"H X 53⅞"W X 21⅞"D.

The transformation of the trunk into the wardrobe is seen in this competently made Mennonite piece, in which the lines of the trunk continue to remain visible within the wardrobe form. A neoclassical refinement is provided by the swag, or festoon, skilfully carved in relief along the undulating lower edge of the bracket base.

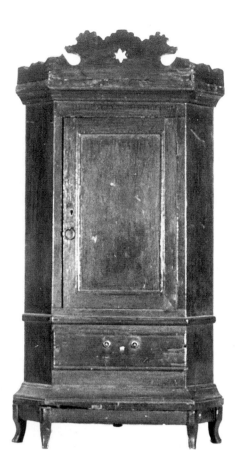

27. HANGING CORNER-CUPBOARD,
WESTERN CANADA: LATE 19TH OR
EARLY 20TH CENTURY; PINE;
43"H X 22"W X 14"D.

*This cupboard was found at La Crete,
Alberta, but may have been brought
there by Mennonites residing at an
earlier time in Manitoba or Saskatchewan.
The base is uncharacteristically plain,
but the cornice is given a most unusual
decorative treatment, faintly suggestive
of bird motifs or animal heads found in
heraldry.*

WARDROBES

Like the chest of drawers, the wardrobe also has an intrinsic connection in use and style to the trunk. Most wardrobes are fitted with doors in a tall upper section and drawers in the base. The lower section, taken by itself, closely resembles a trunk (see figs. 26 and 472). The upper section permits the hanging of clothes, in a form which predates the introduction of the built-in closet.

CUPBOARDS

There are three principal types of cupboards characteristic of Mennonite households: tall cupboards with doors and drawers, hanging cupboards, and corner shelf cupboards.

Tall cupboards served several functions and were situated in different rooms. Some were parlour pieces and had a display function, showing china or other valued possessions behind glazed doors in the upper section. Other cupboards merely met more mundane requirements for storage and were kept in the kitchen or in the closed passageway (*Gang*) between house and barn.

Corner cupboards were almost always of the so-called hanging type, with only a few free-standing tall examples known as exceptions to the rule (figs. 458 and 459). The few free-standing corner cupboards found in the Mennonite settlements of Western Canada are interesting to the degree that they reveal design associations with baroque forms made in German-speaking regions of Europe, particularly with either canted or ogival sections, faintly reminiscent of the more elaborately sculpted Germanic corner cupboard known variously as a *Tabernakelkommode* or *Tabernakelsekretär*, if functioning as a writing or bookcase cupboard.[2] The shorter Mennonite corner cupboards of Western Canada were nearly always panelled rather than glazed, and kept valuables or perhaps served an earlier Germanic custom of housing articles of religious significance (a carved figure, a Bible, a hymn book or other items). They are not truly hanging cupboards, but rather were placed on a triangular shelf which was itself secured to the horizontal dado trim or to special brackets at the joining of two perpendicular walls. Like large case pieces, these small cupboards rested on bracket bases. While they did not "hang," such cupboards frequently have holes in the back so that nails or screws could be used to stabilize their position against the wall.

BEDS, SEATING

Beds were of several varieties, with the multiple-purpose bench-bed surpassing in number the beds which served only as beds in early Canadian-Mennonite households. Spatial constraints were a continual reason for making furniture which could perform several functions and occupy reduced floor area when not in use. The common Mennonite solution to this problem was the use of the sleeping-bed (*Schlafbank*, *Schlupbank*), which could be used for seating by day and for sleeping by night. Its solid or panelled front could be pulled forward on separate

feet, doubling the width of the box beneath the seat and thereby providing additional sleeping quarters.

Some benches with backs had hinged seats which could be lifted, thereby enabling the storage of items in the box beneath. Others were of rigid construction and were benches only. Still others had no backs and could be easily moved about and used in several rooms.

It is in the design of bench-beds and benches that the greatest appropriation of Biedermeier style is seen. This borrowing did not include the Biedermeier preference for carefully selected veneers, since Mennonite furniture in Western Canada was made of solid pine or spruce, without the use of veneer decoration. It pertains rather to the profile design of such seating, with emphasis upon graceful curvature of both legs and arm sections, in which the lower section frequently follow a reversal of the upper line. While the word "Biedermeier" in the European context meant, linguistically, "everyman," it was in fact "a decidedly bourgeois Everyman"[3] (because of the use of veneers and refined construction). In Canada the "everyman" notion is relatively accurate, since that which was retained in the new context was the beauty of design without the lavishness of materials.

Chairs were of many types, and locally made seating was quickly displaced in Mennonite and other households by mass-produced hardwood chairs advertised in mail-order catalogues and easily purchased in the villages as well as larger centres such as Winnipeg or Saskatoon. Among surviving early examples are traditional "Dutch"-style chairs with splint, woven or plank seats and backs composed of posts and horizontal rails. A few rare examples of special chairs with carved decoration, perhaps made in pairs specifically to reflect traditional marriage customs, have been found (see figs. 493 and 524).

HANGING WALL-CLOCKS

So-called "Kroeger" clocks, long popular in Mennonite houses in Russia and, earlier, in the Vistula Delta in Poland, were found in Canadian homesteads as well. The highly decorated nature of such clock faces testifies to their importance among Mennonite furnishings, where clocks marked time, to be sure, but also enjoined the household to the recollection of spiritual values with regard to the responsible use of time.[4] A few such clocks, in greatly simplified form, continued to be made in Western Canada, notably by individuals such as Cornelius Ens (1884–1960) at Aberdeen, Saskatchewan, who fashioned faces and clockworks from ordinary materials at hand.[5]

CRADLES

Almost without exception, Mennonite cradles were given some form of decorative enhancement, the most frequently employed motif being the heart motif. The cradle in particular is the furniture of responsibility, in which the infant is attended to by the parent. It is the first experience of furniture by the child, and the place which offers comfort and

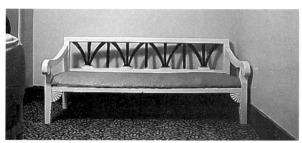

28. BENCH, MANITOBA: LATE 19TH CENTURY; PINE AND OTHER WOODS; 29"H X 74½"W X 26½"D.

This piece is undoubtedly by the same hand as the maker of that in fig. 480. An innovative feature in this bench is the introduction of the carved corner fan, a neoclassical motif which gained popularity throughout Europe in the late 18th and early 19th centuries.

protection as an artificial counterpart to the womb. The presence of the heart motif as a long-acknowledged symbol of love is particularly significant in the ornamental embellishment of this of furniture.

Mennonite cradles are essentially boxes on rockers; the rockers are made either of wood or iron. They differ from Hutterite examples, which typically rest on a separate base.

HUTTERITES

The arrival of the Hutterian Bretheren in Canada was a comparatively late phenomenon, occurring more than forty years after the coming of the first Mennonite immigrants to Manitoba. While large numbers of Hutterites left their East European homelands to settle in North America in the 1870s, in a migration more or less parallel to that of Mennonites, they made their first homes in the United States. The First World War and the rise of hostile attitudes toward Hutterites for their non-participation in United States military service led to the decision by some to migrate to Canada, as Pennsylvania Mennonites had done well over a century before. The first crossing of Hutterites into the Western Canadian provinces commenced in 1918, immediately upon the close of the war in Europe. They established settlements throughout Manitoba, Saskatchewan and Alberta, patterned after the communistic social organization of their earlier colonies in the United States and Europe.

Hutterite furniture bears strong resemblance to Mennonite pieces, reflecting a combination of factors, among them a shared European background, and the probable imitation by Hutterites of furniture made by their earlier co-settlers in Canada. Some furniture, however, is distinctive to Hutterite communities and in some cases reflects the more collectivized nature of Hutterite life.

Hutterite Furniture Forms

TRUNKS
Because of the late arrival of Hutterites in Canada, functions attributed to earlier migrations do not entirely fit this situation. Trunks had long since ceased to serve as means of conveyance on long ocean voyages, but their usefulness for storing bedding and other domestic articles continued to be valued in Canadian colonies. The design of such trunks is closely modelled after Mennonite examples, including the feature of a removable bracket base supported on five tapered or curved feet.

CHESTS OF DRAWERS
Hutterite chests of drawers are less common than Mennonite examples. This may also reflect their later arrival, because they would have had built-in cupboards and closets as part of newer designs in house construction. Known examples are similar in form to Mennonite pieces.

CUPBOARDS

Tall Hutterite cupboards are generally distinct from Mennonite counterparts, and known examples are frequently of simple slab construction resting directly on the ground, rather than elevated on bracket bases.

The hanging cupboard was and is common in Hutterite colonies. It is truly a cupboard which hangs on a peg or nail, rather than resting on a shelf, as is the case with Mennonite cupboards. The flat cupboard which hangs on a flat wall surface is the predominant form, rather than the corner cupboard, for which Mennonite households showed a strong predilection.

BEDS, SEATING

Particularly common in Hutterite furniture are rudimentary benches consisting of four simply turned legs set at a tapered angle to a plank. Tenoned completely through the seat, the legs are typically slit and wedged to tighten the join. Long benches are set alongside tables used in communal eating rooms, while shorter benches and chairs are found in individual living accommodations. Some seating also takes the form of box-benches or sleeping-benches with panelled backs.

CRADLES, TRAINING CHAIRS

A special category of furniture made specifically for children includes cradles and training ("potty") chairs. There are several forms of cradles, among them hanging varieties similar to Doukhobor examples, which are suspended from hooks in the ceiling by cords secured at the four corners. Another type is the open or (rarely) hooded cradle which rests on rockers, the whole placed on a bracket base.

In Hutterite colonies, children are reared communally. This early form of day-care accords well with the social structure of Hutterian life. A form of furniture associated with this early stage of childhood is the specially constructed toilet-chair with its removable enamelware bowl. Such chairs are distinguished by a single hinged door which can be fastened by means of a metal hook, securing the infant inside. These chairs, cradles and other Hutterite furnishings are made in large numbers and of virtually identical construction and design, indicating that furniture-making is a specialized profession within the Hutterite colony, along with metal-working, book-binding, and other skills developed to meet community needs.

Immigration in the 1890s and After

The immense influx of Ukrainians and Doukhobors in the late 19th and early 20th centuries was a factor both of homeland developments and Canadian immigration policy.

The increase in the population of the Canadian West assumed spectacular proportions after 1890. Whereas in 1891 only 5 percent of Canada's

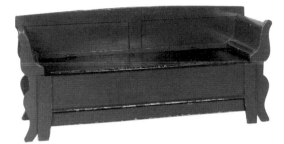

29. SLEEP-BENCH, ALBERTA:
EARLY 20TH CENTURY;
PINE AND OTHER WOODS;
36"H X 56"W X 20"D.

The sleep-bench, popular in Mennonite homes, was also a practical space-saving piece of furniture found in Hutterite colonies of the United States and Canada. The frame can be pulled forward, enlarging the box for the placement of additional bedding. This early example retains the original red and black painted finish. The back legs are an extension of the vertical stiles framing the backboard, and are cut from the same template as the front legs. An unusual feature is the manufacture of the arms: the customary turned or rolled bar joining front to back is here replaced by a solid panel which has been steamed and warped to follow the curved contour of the supports. This bench was donated to the Glenbow Museum by the MacMillan Hutterite Colony near Fort Macleod. The design, in the neoclassical German Biedermeier tradition, had a widely ranging appeal, as is evident in comparing this sleep-bench to the Mennonite and Polish examples in figs. 336 and 479. Glenbow Collection, Calgary.

the Ukrainian settlers, whose ancestry reached back to a much earlier period.

Recognizing the arrival of some individuals at an earlier time, it is nevertheless generally acknowledged that the later date is considered the pivotal one in the Ukrainian-Canadian experience: "With 1891 the mass immigration began, and with it, too, begins the connective history of the Ukrainian, sociologically integrated entity."[12]

Ukrainian Furniture Forms

TRUNKS, CHESTS
Many trunks found in Ukrainian households in Western Canada may have been made after arrival and settlement, but there must also be counted a large number which were made in their homelands and served the need for storage and conveyance of modest possessions to Canada. As was the case with immigrant trunks brought in the mid-19th century from Germany to Ontario, Ukrainian examples tend to be of relatively uniform construction and design. Several early 20th-century trunks are so similar, even with regard to their floral painted decoration (see figs. 30 and 502), as to suggest that a single workshop produced large numbers and probably offered them for sale to individuals and families preparing for emigration.

CLOTHES STORAGE
There are few known chests of drawers in early Ukrainian-Canadian households, the preferred bedroom storage form being the wardrobe or tall clothes-cupboard. The form of such storage case-pieces is somewhat similar to the Mennonite *Kleiderschrank* found in Ontario and the Prairie Provinces. In contrast to Ontario examples, which are usually fitted with double doors and double drawers, Ukrainian examples normally have one drawer or none at all. These tall cupboards permitted the hanging of clothes in upper sections and flat storage of bedding in the drawer or compartment below.

CUPBOARDS
Other cupboard types in Ukrainian homes in Manitoba, Saskatchewan and Alberta included dish cupboards, most of which had glazed upper doors for display and solid or panelled doors below for storage. Working within a relatively standardized framework of doors and (sometimes) drawers, makers of such cupboards demonstrated considerable imaginative ingenuity in the variety of decorative treatments. As the open dresser served as the focal point for ornamentation of a common furniture form in the Irish home, the glazed- or solid-door dish cupboard of the Ukrainian household played a corresponding role in Western Canada. By means of painted embellishment, incised and carved detail, or the heaping-up of applied ornament, Ukrainian-Canadian cupboards are as striking for their variety of decoration as for their continuity of

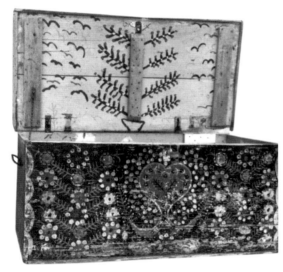

30. TRUNK
This Ukrainian trunk with painted floral decorative work and heart motif is virtually identical in design to that in fig. 502, indicating the practice of making such pieces in lots, rather than as singular expressions.

form. That highly descriptive British phrase (used also in Australia and New Zealand) "one-off" is particularly apt in the case of much of the Ukrainian furniture of the Canadian West, conventionalized at one level by its particular cultural ethos, while at another level highly individualized by the inventiveness of makers who probably made many of these pieces at home rather than in a workshop. Some groupings do, of course, suggest workshop production on a modest level, supported by demand in a small community.

In this second group are several cupboards with related details of panelling, applied mouldings, and carved pediments; they employ motifs taken from folk-traditional sources or high-style influences, including even neoclassical conventions of atlantes, caryatids and other details which a country cabinetmaker working in the Ukrainian background might have seen on the more sumptuous French-inspired (or -made) furniture belonging to the proprietor of a country estate. Neoclassical elements in Western Canadian country furniture are in considerable part derived from the strong neoclassicism of late 18th- and early 19th-century Ukrainian and Russian furnishings, brought to Russia by the actual importation of artists from France, Germany and the British Isles. David Roentgen, a maker of lavish furniture for the French courts, undertook no less than seven trips to Russia to supply pieces for Catherine the Great, while Charles Cameron travelled from Scotland to Russia to design palace interiors in the manner of Robert Adam.[13] After Napoleon's North African campaign, Egyptian ideas were widely disseminated through the publication in 1807 of Thomas Hope's *Household Furniture and Interior Decoration*.

In some instances, Ukrainian furniture reveals in its carved or painted decoration an indebtedness to the highly developed tradition of decorative textiles. The borrowing of folk motifs from such craft forms is probably at work in the appearance of birds, flowers, trees and geometric designs in the embellishment of several pieces of case furniture, notably the cupboard in fig. 499 and the secretary in fig. 507.

Hanging cupboards are found in Ukrainian homes, normally in kitchens or the best room or parlour-equivalent. Both open cupboards and solid-door versions were made, and may have served spiritual as well as ordinary functions in the home. The design of domestic hanging cupboards is often similar to that of some church furniture, and it is interesting that the painted interior of one such hanging cupboard, with stipple-painted geometric design work, is strikingly reminiscent of painted decoration on the religious shelf shown in fig. 31.

RELIGIOUS CUPBOARDS AND SHELVES

A furniture form found commonly in Ukrainian homes, perhaps more than in other cultural traditions in Canada, except among the French in Quebec, is the religious cupboard or shelf. While such pieces have frequently been called "reliquaries" in books and articles on Canadian furniture, this term is an improper one because it suggests a function of

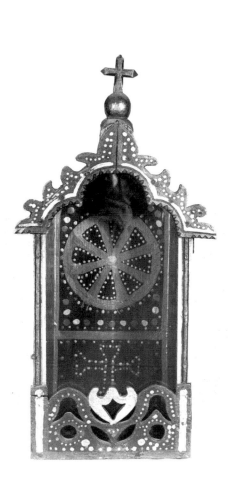

31. Hanging Cupboard or Shrine, Saskatchewan: early 20th century; pine; 20¼"H X 8"W X 6¾"D.

The scrollwork profile of this piece is a free-spirited (and freehand) interpretation of a more formal baroque design found on tabernacles and other ecclesiastical furnishings common found in Ukrainian churches of Western Canada. This piece is was most likely a niche for a religious figure, behind which the painted geometric design may have functioned in the manner of a nimbus, a symbol of saintly or divine status. The stippled effect here, carried through also on the exterior of the case, is similar to that on the interior of a simple domestic cupboard found in the same area.

the church, not the home. In certain traditions, notably Roman Catholic households in the French, German or Polish communities of Canada, as well as in the Eastern traditions (Ukrainian, Russian, Greek), it was common to have religious furniture in the home for the purpose of domestic prayer and devotion. Such pieces were not reliquaries (they did not house relics), but rather were shelves or cupboards for the placement of religious statues, vigil lights or holy pictures. Ukrainian furniture for such purposes included small hanging cupboards, shelves and frames, forms to be found in most homes of Canada's Ukrainian settlements.

SEATING, BEDS

Ukrainian homes contained a great variety of domestically made chairs, some revealing a distant awareness of high styles, even when examples are of primitive construction. Many chairs are made of a slab seat, simply turned legs, and backs composed of posts, a crest rail, and two or three slats, sometimes arranged diagonally for stylistic flair.

Especially interesting among specimens of Ukrainian furniture are the many sleep-benches made throughout Manitoba, Saskatchewan and Alberta. This space-saving form is almost the most recognizable of Canadian-Ukrainian forms, an example of which seems to have been found in virtually every home. The Ukrainian sleep-bench bears many design similarities to that made in the Mennonite communities of Western Canada, but there is an interesting difference, as well. The Ukrainian form pulls forward, as does the Mennonite counterpart, but lacks the feet which serve as supports for the latter. Instead, the Ukrainian bench-bed, when fully extended, functions more in the manner of a sliding drawer. Its support is merely the counterweight of the bench section, suggesting that an act of faith is required when overloading the bed with sleepers.

The range of decorative treatments given to such bench-beds is little short of extraordinary. Forms include open- and solid-backed types. The comparatively high proportion of well-constructed specimens suggests that many were made in workshops rather than at home. The variations are of interest, not so much as one-offs, but rather as interpretations which imply knowledge of traditional styles, including many elements from the inventory of the neoclassical movement of the late 18th and early 19th centuries. Where in one-offs variety has more to do with novelty, in the case of Canadian-Ukrainian benches it has more to do with archaism. Decorative detail in such pieces is almost limitless within a country neoclassical vocabulary, including fans, shells, sunbursts, acanthus motifs, heraldic designs, and even "Egyptian" anthropomorphic elements. Although as a group the Ukrainians who came to Canada were economically poor, there is tantalizing evidence that at least some furniture makers working in these pioneer communities had once been in the employ of Ukrainian estate-owners, whose more lavish furniture served as a distant influence, not in the making of the whole,

but in the use of the detail. The process of synthesizing formal and folk elements, and convention and personal invention in the making of Russian furnishings has been noted by Noel Riley in her description "furniture made by estate labourers, inspired partly by their own folk culture and partly from French imports."[14] This observation is, of course, especially pertinent to the situation of furniture makers in the Ukrainian and Russian settlements in Canada. Historians in their praise of the Egyptians as great world-travellers could have had little inkling of the even more impressive distances traversed by Egyptian design elements after Napoleon's visit at the end of the 18th century—an immense journey northward to the palaces of France, eastward to the courts of Ukraine and Russia, and westward to the villages and farms of Western Canada.

TABLES

Tables, both of the long "kitchen" type, and the smaller general-purpose kind, tend to be of simple construction. Most examples have square legs, sometimes chamfered, or (less commonly) given to ornamental shaping, and are essentially plank tops on frames. These tables are much different in appearance from Doukhobor examples, in which the turned-leg variety predominates. Rudimentary attempts at curvilinear grace can be seen in rather naïve executions of the cabriole leg, usually accomplished by simply cutting out a shape from flat planks and setting it either perpendicular or at a 45-degree angle to the front apron of the table. Some tables have deep skirts, occasionally rendered as a gallery in the manner of more formal neoclassical tables. Other occasional tables with square and round or oval tops demonstrate the design variations of which Canadian furniture makers were capable.

DOUKHOBORS

The names by which we come to know certain groups are frequently imposed by the outside world, rather than by the desire of the groups themselves. The terms "Lutheran" or "Calvinist," and for that matter, "Christian," were in effect labels of derision given by authorities wishing to demean the higher values of these groups. So, too, the word "Doukhobor" was born of a mean-minded outlook. The term, coined in 1785 by a highly placed cleric in the Russian Orthodox Church, Archbishop Amvrosii Serebrenikov, means literally "spirit-wrestlers," suggesting the notion that this was a garrulous sect bent on fighting against the Holy Spirit. In time, Doukhobors found a means of accommodation to their apparently adverse appellation, coming to see themselves in the positive role of "spirit-fighters," for whom the spirit was not the oppositional but rather the motivational factor in their spirituality. Quaker author Joseph Elkington, whose writings express his sympathy with Doukhobor values, puts it this way: "Doukhobors accommodated themselves to this name by the argument that, in fact, they wrestled by the aid of the Holy Spirit, and not with carnal weapons."[15]

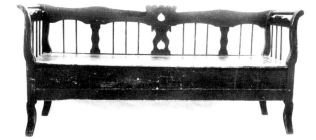

32. SLEEP-BENCH, SASKATCHEWAN: EARLY 20TH CENTURY; PINE AND OTHER WOODS;
36½"H X 79½"W X 22½"D.

An open-backed form, this bench-bed exhibits Biedermeier influences in the profiles of feet and upper posts. This generalized neoclassical style is embellished with the folk element of an inverted heart-motif cut through the central back splat, similar to the treatment of this detail on the crown of the cupboard top in fig. 553.

The emergence of the religious group known as Doukhobors has no precise historical beginning, but can generally be traced to a localized religious movement among peasants in the early 1700s in the Ukrainian province of Karkov. The group emphasized simplicity of religious life, in contrast to the complex ritualized nature of Orthodoxy. In matters of belief, Doukhobors have held an immanentist understanding of God; their life and work have historically been defined by principles of brotherly love, communal work, collective ownership and pacifist conduct. These values were certain to set them on a collision course with Russian institutions. Their eschewal of priesthood, sacraments and icons brought the Doukhobor group into conflict with the Russian Orthodox Church; their refusal to swear public oaths or participate in military service likewise invited hostile reaction and severe punishment from the central government.

A history of harsh persecution of Doukhobors had dramatic geographical consequences, as they were forcibly moved from location to location. A process of investigations and mass trials led to their being dispersed to peripheral regions of the Russian Empire in the 1790s. For approximately a third of a century they experienced the comparatively tolerant policy of Czar Alexander I (ruled 1801–25), during which period the Doukhobors were transplanted as a group to a place of asylum along the Molochna River (known in English as the Milky Waters). During this rare period of relative calm, they enjoyed the benefits of working the soil of a fertile region near the Black Sea. It is of interest that at this time and in this locale they were neighbours of Mennonites who had migrated there previously from the Vistula Delta of Prussia (now Poland), the very group who were to be their geographical neighbours in Western Canada at the end of the 19th century.

The modest prosperity and religious tolerance of these decades was soon to be displaced by a a cycle of oscillating fortunes, vacillating between the cruel treatment by Nicholas I during the period from 1825 to 1855 and the more liberal disposition of Alexander II between 1855 and 1881. The golden age of Doukhobor culture had a brief flowering in Russia during the 1860s and 1870s. In this short period the strong spiritual leadership of the group's only female leader, Lukeria Kalmakova, contributed to unsurpassed growth and stability. Among her many achievements, a significant one was her decision in 1882 to take under her tutelage the young Peter V. (Lordly) Verigin (1859–1924), who was later to become an outstanding spiritual leader among the Doukhobors of Western Canada.

The most severe treatment of Doukhobors in Russia took place in the 1880s and 1890s, under the reign of Alexander III, when imprisonment and exile became the norm. Due to enormous efforts outside Russia to publicize their sufferings, pressure was finally brought upon government authorities to permit emigration. Of particular importance was the Society of Friends (Quakers) in England, as well as supporters in the United States and Canada, whose endeavours succeeded in

bringing Doukhobors out of Russia. The journey to Canada was filled with uncertainties and entailed a transitional stay in Cyprus (then an English colony), where a temporary haven was provided before their journey across the Atlantic Ocean. Among those sympathizers who rallied to the support of this project, an especially notable figure was author Leo Tolstoi, who personally contributed the proceeds of his novel *Resurrection* to the Doukhobor migration fund.[16]

By late 1898 final arrangements had been completed by Quakers and Tolstoyans in England for co-ordinated immigration to Canada. On January 23, 1899, the first shipload of Doukhobors arrived at the Port of Halifax. Their ranks numbered in excess of 7,500, slightly exceeding that of the Mennonite migrations to Manitoba in the mid-1870s. The Doukhobors settled on newly opened lands near Yorkton, Saskatchewan, in 1899, and developed several settlements. Principal settlements included two in the Yorkton–Canora–Pelly area and others near Blaine Lake.

Over the first several years of adjustment to difficult conditions on the Saskatchewan prairie, a significant number of Doukhobors found themselves faced with the possibility of yet another case of uprooting and exodus. Following disagreements with the Canadian government over oaths and compulsory individual land registrations, which many Doukhobors considered to be a contravention of the principle of collective ownership, settlers were evicted from their lands in 1907. Some members made partial accommodation or virtual capitulation to government claims, but others found it necessary to seek new opportunity elsewhere. This latter group migrated westward in 1907 to the Kootenay and Boundary regions of British Columbia, establishing the fourth geographical area of Doukhobor settlement.

Within the larger group are three smaller divisions, including the Orthodox group, the Independents, and the Sons of Freedom, reflecting a diversity of outlook from conservative-collective to modern-adaptive to a zealous radicalism. Inordinate media treatment of this last subgroup has impeded a more profound public understanding of the Doukhobors as a religious group within the context of Christian chiliasm (realizing the Kingdom of God within human history) and mysticism (encountering a deeper realm of meaning behind the normal world of superficial experience).

Furniture and Related Decorative Arts

The study of Mennonite culture indicates that, like the Mennonites, Hutterites and Ukrainians of Western Canada, the Doukhobors retain highly conservative tastes, which, along with their Russian language, dress, food, and certain customs served to preserve a cultural distinctiveness in the new Canadian homeland. In recent years, this distinctiveness has been blurred by gradual assimilation into the surrounding culture. Modification should not, however, be seen as only a product of

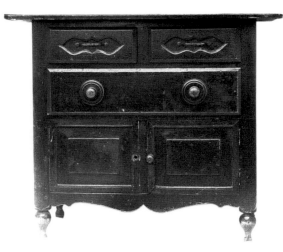

33. COMMODE:
SECOND QUARTER 20TH CENTURY;
PINE; 30"H X 36¼"W X 23¼"D.

A bedside commode with three drawers over two doors. Many of these pieces were made of pine, but painted or stained a reddish-brown, giving the appearance of a more costly hardwood. The dramatically oversized knobs are a feature seen also in a table from the region, illustrated in fig. 658.

encounters with a new, officially English culture, since adaptation of form and style had been evident for several decades in the work of Doukhobor artisans. For example, Doukhobor rugs can sometimes be seen as dramatic visual evidence of this adaptation process, as in the case of a 1923 woven rug which integrates the motifs of stylized camels from the south Russian-Turkish background with Canadian elk motifs.[17] In the case of furniture, Doukhobor furniture reveals borrowed elements from sources as diverse as French Louis XV style to Biedermeier to Canadian catalogue examples!

Of all traditions of furniture-making among Western Canadian cultural groups, it is the Doukhobor examples which are given to the most sumptuous forms of decorative treatment, particularly in the art of carved ornamentation. In contrast to the relative plainness of Mennonite and Hutterite furnishings, Doukhobor and Ukrainian examples are vastly more exuberant in decorative impact. While the strength of Ukrainian country furniture is its painted embellishment, that of Doukhobor furniture is its profusion of carved detail. What the Ukrainian aesthetic achieves by colour the Doukhobor attains by sculpture. This is not to deny the role of the wood-carver in the making of Ukrainian furniture, but to acknowledge that, while Ukrainian carved ornament is that of profile, Doukhobor decorative work is that of relief. The Ukrainian bench in fig. 579 is lavishly scrolled, providing a dramatically shaped contour; the Doukhobor bench in fig. 646 is carved in relief, resulting in greatly variegated surface detail.

Elements of Doukhobor decoration can be classified along the lines of several considerations, including traditional or parallel furniture styles, floral design, zoomorphic elements, and geometric ornament.

The highly decorative nature of Doukhobor furniture is like the tendency to impart rich carved or painted embellishment to architectural elements in the traditional Russian country house or cottage (*izba*). The Russian peasant's *izba* was often given to extensive decoration, with floral motifs and other elements from nature or symbols from ancient mythology as ornamentation. Certain structural elements were especially popular as surfaces for such folk-art embellishment. Barge-boards (*prichelini*) concealing the log-ends were frequently carved or painted, as were vertical boards (*polotensa*) hanging like drop finials from the apex of the gables. Shutters and lintels or narrow panels (*nalichniki*) over windows were also so decorated, often with carved sun motifs. This particular image has been found on windows of Canadian Doukhobor houses in Saskatchewan (figs. 595 and 597). Flower petals, rosettes, foliate scrolls, horse heads and other animal elements, the sun, geometric designs — all are found in both architecture and furniture.

With regard to furniture style, an examination of representative Doukhobor furnishings shows that furniture makers were aware of high-style Russian furniture, which was itself influenced by the French grand styles imported into Russia during the reign of Catherine the Great and afterward. Such influences are seen in the adaptation of the cabriole leg,

complexly scrolled sequences of inverted S- and C-curves, or baroque details such as acanthus-like or shell cartouches based on the *rocaille* design-work of Louis XV furniture (see figs. 185 and 186).

The process of adapting and borrowing, evident in both early and late examples, extends to other sources as well. Biedermeier lines are sometimes found in the scrolled legs or posts of chairs and beds, while closer-to-home Canadian sources are evident in the borrowing of details from catalogue furniture such as that advertised in turn-of-the-century Eaton's catalogues.[18]

Floral design-work is one of the most distinctive features of Doukhobor furniture, and it occurs both as profile and relief detail. The most characteristic floral device is the three-lobed petal, found especially on the skirts of tables and frames, but also on smaller items such as carved ladles. Other floral motifs include tulips and rosettes, carved or painted on items as diverse as a coat rack (fig. 517) or a hanging cradle (fig. 630). More abstract leaf and plant imagery appears as carved or painted detail, while the very Canadian subject of stylized wheat motifs is seen in the decoration of a table and cupboard by Wasyl Zubenkoff (figs. 512 and 603).

Zoomorphic elements are found in various guises — sometimes in the form of birds (see storage chests such as in figs. 514, 515, 679), horse heads (a cupboard or spool-holder, figs. 617 and 682), or heraldic lions (the cupboard in fig. 601). A striking example is the two-headed eagle, a motif with an ancient history of use in the Holy Roman Empire and the Austro-Hungarian Empire before it was brought to Russia as an emblem of imperial rule in the time of Catherine the Great. This motif, with its Czarist associations, may seem a somewhat anachronistic choice for the aesthetic enhancement of Doukhobor furnishings, but it makes its appearance nonetheless in the elaborately carved crests of two large mirror frames made in 1907 by Wasyl Zubenkoff (figs. 518 and 702).

Geometric decoration is widespread on Doukhobor pieces and is especially common on the earliest form brought to, as well as made in, Canada, storage trunks of various sizes with boldly drawn six-point compass stars (see fig. 670 and others). The heart is essentially a geometric design, drawn symmetrically, and appears occasionally on Doukhobor furnishings (see sideboard in fig. 612 and frame in fig. 695). Other geometric designs include demi-lunes and fans, used to decorate the borders or corners of large facade areas (as in the storage chests in figs. 514 and 679).

The rich ornamentation of Doukhobor furniture, parallelled in textiles, is a long-sustained perpetuation of the ancient Russian love of rich patterning in all fields of applied art, or *uzorochye*.[19] While in its early form such craft was often of a sophisticated nature, employing costly materials and for the benefit of the aristocratic few, the practice of decorative embellishment was expanded to the world of domestic arts and utilitarian objects, finding its way into the homes of those with modest economic means but no less love for the beautiful.

Doukhobor Furniture Forms

TRUNKS

The provenance of Doukhobor trunks (*sunduki*) is difficult to ascertain, but their popularity is indisputable. There are many hinged-lidded storage chests that were used to house bedding and valuables on board ship as well as in Canadian Doukhobor households. Trunks with elaborate iron strapwork are probably of Russian manufacture, since the existence of a network of village crafts appears not to have existed in the first years of Canadian settlement. Canadian examples are also of competent construction, some with tinwork substituting for forged iron details.

CHESTS OF DRAWERS, WARDROBES

These forms are not common in Doukhobor homes, suggesting that their storage functions were adequately provided by the trunks found in great numbers. A characteristic Doukhobor form is a small case of drawers, set on turned legs, with overhanging top.

CUPBOARDS

The principal expression of Doukhobor craft is the hanging cupboard, of which many were made for walls and corners. Typically, such cupboards had glazed upper sections and panelled lower compartments, or featured a door arrangement with glass above and panelling below. A smaller number of standing floor cupboards, most of these panelled rather than glazed, served to store kitchen cutlery, crocks, serving wares and utensils.

BEDS

Few beds have survived, as in other cultures where their frequent replacement by newer pieces is a common occurrence. Doukhobor beds tend to have scrolled head- and footboards, set into turned corner-posts. The hanging cradle, suspended from the ceiling (or, in some cases, from a specially constructed framework), was usually of pine construction with either a wooden or canvas bottom. Photographic records show these cradles suspended at the four corners.

SEATING

Chairs reflect both backward-looking stylistic considerations and borrowings from mass-produced kitchen chairs of the late 19th and early 20th centuries. In the former category are chairs with elaborately scrolled legs, reminiscent of the neoclassical *klismos* type. Such chairs are frequently notable also for their gracefully swept and curved backs. In the second group are chairs which bear strong resemblance to common "press-back" chairs advertised in furniture catalogues,[20] but with decoration that is hand-carved, rather than machine-made, and using traditional Doukhobor floral designs.

The bench (*skamya*) is a common seating form, made almost always

with a back. Some examples have crests and spindles, while others are composed of rails and splats. Many of these benches have hinged lids or even drawers to permit storage of such items as footwear, and have been commonly called "boot-benches." Another Doukhobor bench form is a structure made up of long narrow slats attached to trestles, resembling the large benches found commonly in waiting-rooms of train stations, from which their design was probably borrowed.

TABLES

Possibly the most distinctive of all Doukhobor furnishings are the tables, which appear in various shapes and designs. One group includes long tables, sometimes 10 feet or more in length, used as work tables in residential communities in the Kootenays. Another group, medium-sized tables averaging about 5 feet in length, served a domestic function but also provided a platform for the placement of bread, salt and water used in spiritual services (*sobranie*) held either indoors or outdoors. This second group often features elaborate carving, a combination of fretwork, profile shaping, and bas-relief carved detail, generally employing the vocabulary of stylized floral motifs used widely in Doukhobor decorative work. Other, smaller tables functioned variously as bedside pieces or as plant stands, some of the latter set on pedestals with tripod legs, and fitted with such unexpected details as "bird cage" supports between base and top.

SMALLER FORMS

The proclivity toward carved and painted ornamentation is most pronounced on small wall-pieces which lend themselves quite naturally to decorative treatment. Indeed, it is with regard to the small pieces such as shelves or frames (*ramka*) that one often finds the most intense concentration of Doukhobor folk decoration. Utilitarian articles or common household utensils associated with food preparation or spinning and weaving are in many cases the object of such decorative enhancement. The familiar Doukhobor petal-motif is carved, incised or painted on items as diverse as ladles, mangles or flax-combs.

ENDNOTES

On Furniture as an Object of Study

1 Witold Rybczynski, *Home: A Short History of an Idea* (New York: Viking Press, 1987).

2 Donald B. Webster, *English-Canadian Furniture of the Georgian Period* (Toronto: McGraw-Hill Ryerson, Limited, 1979), p. 11.

3 Clifford Craig et al, *Early Colonial Furniture in New South Wales and Van Diemen's Land* (Melbourne: Georgian House, 1972), p. 7.

4 Catharine Parr Traill, *The Canadian Settler's Guide* (1854; reprint, Toronto: McClelland and Stewart, 1969), p. 28.

5 Walter L. Peddle, *The Forgotten Craftsmen* (Newfoundland: Harry Cuff Publications Limited, 1986), p. 9.

6 See Bernard D. Cotton, "Irish Vernacular Furniture," in *Regional Furniture: The Journal of the Regional Furniture Society*, vol. 3 (Burnley, Lancashire, England, 1989), pp. 1–26.

7 Reinhild Kauenhoven Janzen and John M. Janzen, *Mennonite Furniture* (Intercourse, Pa.: Good Books, 1991), p. 208.

8 Claudia Kinmonth, *Irish Country Furniture 1700–1950* (New Haven and London: Yale University Press, 1993), p. 99.

9 John T. Kirk, *Early American Furniture* (New York: Alfred Knopf, 1974), p. 9.

10 Quoted in Holger Cahill, *American Folk Art: The Art of the Common Man in America 1750–1900* (New York: The Museum of American Art, 1932), p. 5.

11 Gerard Brett, *English Furniture and Its Setting* (Toronto: University of Toronto Press, 1965), p. 53.

12 Webster, *English-Canadian Furniture*, pp. 44, 45.

13 Noel Riley, *World Furniture* (Secaucus, N.J.: Chartwell Books, 1980), p. 134.

14 Riley, *World Furniture*, p. 111.

15 Brett, *English Furniture*, p. 51.

16 Traill, *The Canadian Settler's Guide,* p. 18

17 Ibid., p. 18

18 Ibid., p. 19.

19 Ibid., pp. 18–19.

20 Jean Palardy, "French Canadian Furniture," in Donald B. Webster, ed., *The Book of Canadian Antiques* (Toronto: McGraw-Hill Ryerson, 1974), p. 12.

21 George MacLaren, "Nova Scotia Furniture," in Webster, *The Book of Canadian Antiques*, p. 80.

22 See Michael Bird, "Perpetuation and Adaptation: The Furniture of John Gemeinhardt 1826–1912," *Canadian Antiques and Art Review* (March 1981), pp. 19–34.

23 Howard Pain, *The Heritage of Upper Canadian Furniture* (Toronto: Van Nostrand Reinhold, 1978), p. 28.

24 Henry Dobson and Barbara Dobson, *A Provincial Elegance* (Kitchener, Ont.: Kitchener-Waterloo Art Gallery Exhibition, May 31–July 11, 1982).

25 Kirk, *Early American Furniture*, p. 9.

26 Webster, *English-Canadian Furniture*, p. 11.

27 David Knell, *English Country Furniture: The National and Regional Vernacular 1500–1900* (London: Berrie and Jenkins, 1992), p. 8.

28 J. Russell Harper, *A People's Art: Primitive, Naive, Provincial and Folk Painting in Canada* (Toronto: University of Toronto Press, 1974).

29 Dean A. Fales, *The Furniture of Historic Deerfield* (Deerfield, Mass.: Historic Deerfield, Inc., 1981), p. 248.

30 Knell, *English Country Furniture*, p. 8.

31 Noel Riley, Foreword to *World Furniture*, p. 7.

Atlantic Provinces

1 George MacLaren, *Antique Furniture by Nova Scotian Craftsmen* (Toronto: Ryerson Press, 1961), p. 5.

2 Webster, *English-Canadian Furniture*, p. 21.

3 Ibid., p. 21.

4 Ibid., p. 22.

5 Peddle, *The Forgotten Craftsmen*, p. 10.

6 George MacLaren, in Webster, *The Book of Canadian Antiques*, p. 26.

7 Peddle, *The Forgotten Craftsmen*, p. 10

8 Ibid., p. 6.

9 Ibid., p. 6.

10 G.G. Campbell, *A History of Nova Scotia* (Toronto: The Ryerson Press, 1948), p. 149.

11 MacLaren, in Webster, *The Book of Canadian Antiques*, p. 75.

12 Webster, *The Book of Canadian Antiques*, p. 25.

13 Ibid., p. 26.

14 See Webster, *English-Canadian Furniture*; for English styles, see figs. 22, 30, 51; for Scottish influences see figs. 12, 33, 38, 39; for American influences see figs. 3, 28, 54, 55.

15 Ibid., p. 28.

16 Kirk, *Early American Furniture*, p. 16.

17 Traill, *The Canadian Settler's Guide*, p. 33.

18 Samuel Raj, *The Canadian Family Tree* (Don Mills, Ont.: Multiculturalism Directorate, 1979), p. 85.

19 D.C. Harvey, *The French Regime in Prince Edward Island* (New Haven: Yale University Press, 1926), p. ix.

20 J.A. Cochrane, *The Story of Newfoundland* (Boston: Ginn and Company, 1938), p. 36.

21 W.S. MacNutt, *The Atlantic Provinces: The Emergence of Colonial Society 1712–1857* (Toronto: McClelland and Stewart), p. 8.

22 Andrew Clark, *Three Centuries and the Island: A Historical Geography of Settlement and Agriculture in Prince Edward Island* (Toronto: University of Toronto Press, 1959), p. 27.

23 Ibid., p. 2.

24 MacNutt, *The Atlantic Provinces*, p. 6.

25 Harvey, *The French Regime*, p. 112.

26 Campbell, *A History of Nova Scotia*, p. 126.

27 Ibid., p. 127.

28 Huia G. Ryder, "New Brunswick Furniture," in Webster, *The Book of Canadian Antiques*, p. 91.

29 Ibid., p. 91.

30 Campbell, p. 139.

31 See Winthrop Bell, *The 'Foreign Protestants' and the Settlement of Nova Scotia* (Toronto: University of Toronto Press, 1961), p. 99.

32 Riley, *World Furniture*, p. 21.

33 Walter Peddle, *The Traditional Furniture of Outport Newfoundland* (St. John's, Nfld.: Harry Cuff Publications, 1983), p. 99.

34 Riley, *World Furniture*, p. 39.

35 For a magnificently embroidered novelistic treatment of the story (and a most atmospheric description of the chest and its ancient contents), see Peter Ackroyd, *Chatterton* (London: Penguin Books, 1987), pp. 82–5.

36 John Mannion, *Irish Settlements in Eastern Canada: A Study of Cultural Transfer and Adaptation* (Toronto: University of Toronto Press, 1974), pp.153–8.

37 Riley, *World Furniture*, p. 22.

38 See Howard Pain, *The Heritage of Upper Canadian Furniture*, p. 44.

39 Riley, *World Furniture*, p. 22.

40 See discussion in Kinmonth, *Irish Country Furniture* (pp. 52–9).

41 Kinmonth, *Irish Country Furniture*, pp. 52–59.

42 Cotton, "*Irish Vernacular Furniture*," p. 6.

43 Peddle, *The Traditional Furniture of Outport Newfoundland*, p. 79.

Quebec

1 Paul Cornell et al, *Canada in Unity and Diversity* (Toronto: Holt, Rinehart and Winston, 1967) p. 21.

2 J.J. Finlay, *Pre-Confederation Canada: The Structure of Canadian History to 1867* (Scarborough, Ont.: Prentice-Hall Canada, Inc., 1990), p. 11.

3 Ibid., p. 47.

4 Craig Brown, "Colonization and Conflict," in *The Illustrated History of Canada* (Toronto: Lester and Orpen Dennys, 1987), p. 107.

5 Cornell, *Canada in Unity and Diversity*, p. 22.

6 Ibid., p. 24.

7 Brown, *The Illustrated History of Canada*, p. 117.

8 Jean Palardy, *The Early Furniture of French Canada* (Toronto: Macmillan of Canada, 1971 [1963]), p. 376.

9 J. Russell Harper, *Painting in Canada: A History* (Toronto: University of Toronto Press, 1977), p. 13.

10 Palardy, *The Early Furniture of French Canada*, p. 378.

11 Harper, *Painting in Canada*, p. 8.

12 Ibid., p. 6.

13 Harper, *Painting in Canada*, p. 13.

14 Harper, *A People's Art*, pp. 3–11.

15 Palardy, *The Early Furniture of French Canada*, p. 25.

16 Estimates given by, respectively, Craig Brown (*The Illustrated History of Canada*, p. 219), J.L. Finlay (*The Structure of Canadian History*, p. 79), Samuel Raj (*The Canadian Family Tree*, p. 11), and David Bell (in J.M. Bumstead, ed. *Canadian History Before Confederation: Essays and Interpretations* [Georgetown, Ont.: Irwin-Dorsey Limited, 1979], p. 209).

17 Raj, *The Canadian Family Tree*, p. 2.

18 Ibid., p. 3.

19 D. Aidan McQuillan, "Beaurivage: The Development of an Irish Ethnic Identity in Rural Quebec," in Robert O'Driscoll and Lorna Reynolds, eds., *The Untold Story: The Irish in Canada* (Toronto: Celtic Arts of Canada, 1988), p. 263.

20 Palardy, *The Early Furniture of French Canada*, p. 392.

21 Harold Osborne, ed. *The Oxford Companion to the Decorative Arts* (New York: Oxford University Press, 1975), p. 350.

22 See Kinmonth, *Irish Country Furniture*, pp. 147–9.

23 Palardy, *Early Furniture of French Canada*, p. 299.

24 Ibid., p. 299.

25 Ibid., p. 300.

26 Ibid.

27 See Lewis Hinckley, *A Directory of Antique Furniture* (New York: Bonanza Books, 1953), p. xiii.

28 Riley, p. 25.

29 Ibid., p. 29.

30 Ibid., p. 22.

31 John Gloag, *Guide to Furniture Styles: English and French 1450 to 1850* (London: Adam and Charles Black, 1972), p. 76.

32 Gaston Bachelard, *The Poetics of Space* (New York: The Orion Press, 1964), pp. 78–9.

33 Palardy, *Early Furniture of French Canada*, p. 201.

34 Ibid.

35 Marianna O'Gallagher, "The Irish in Quebec," in O'Driscoll and Reynolds, *The Untold Story*, p. 257.

36 Palardy, *Early Furniture of French Canada*, p. 201.

37 Cotton, "Irish Vernacular Furniture," p. 5.

38 Palardy, *Early Furniture of French Canada*, p. 213.

39 Jean-Louis Flandrin, *Families in Former Times: Kinship, Household and Sexuality* (Cambridge: Cambridge University Press, 1976), p. 103.

40 Ibid., p. 104.

41 Palardy, *Early Furniture of French Canada*, p. 260.

42 Raj, *The Canadian Family Tree*, p. 72.

43 J.L. Finlay and D.N. Sprague, *The Structure of Canadian History* (Scarborough, Ont.: Prentice-Hall Canada, Inc., 1989), p. 80.

44 Raj, *The Canadian Family Tree*, p. 73.

45 Gallagher, "The Irish In Quebec," p. 257.

46 McQuillan, "Beaurivage," p. 263.

47 Webster, *English-Canadian Furniture*, p. 123.

Ontario

1 Cornell, *Canada in Unity and Diversity*, p. 165

2 David V.J. Bell, "The Loyalist Tradition in Canada," in J.M. Bumstead, ed. *Canadian History Before Confederation* (Georgetown, Ont.: Irwin-Dorsey Limited, 1979), p. 209.

3 Finlay and Sprague, *The Structure of Canadian History*, p. 79.

4 Raj, *The Canadian Family Tree*, p. 2.

5 Ibid., p. 2.

6 Brown, *The Illustrated History of Canada*, p. 222.

7 Raj, *The Canadian Family Tree*, p. 2.

8 Ibid., p. 192.

9 Stanford W. Reid, ed. *The Scottish Tradition in Canada* (Toronto: McClelland and Stewart, 1976), p. 56.

10 Raj, *The Canadian Family Tree,* p. 193.

11 Ibid.

12 Reid, *The Scottish Tradition in Canada*, p. 62.

13 Raj, *The Canadian Family Tree*, p. 193.

14 Reid, *The Scottish Tradition in Canada*, p. 64.

15 Raj, *The Canadian Family Tree*, p. 124.

16 Ibid., p. 125.

17 Ibid.

18 Ibid., p. 3.

19 Brown, *The Illustrated History of Canada*, p. 222.

20 O'Driscoll and Reynolds, eds. *The Untold Story: The Irish in Canada*, 2 vols., (Toronto: Celtic Arts of Canada,1988), p. 311.

21 Ibid., p. 343.

22 Ibid., p. 350.

23 Ibid., p. 311.

24 George K. Weissenborn, "The Germans in Canada: A Chronological Survey," *German-Canadian Yearbook* (1978), p. 26.

25 Albert Hess, "Deutsche Brauche und Volkslieder in Maryhill [Waterloo County]," *German-Canadian Yearbook* (1973), p. 222.

26 Gerhard P. Bassler, "The 'Inundation' of British North America with 'the Refuse of Foreign Pauperism': Assisted Emigration from Southern Germany in the Mid-19th Century," *German-Canadian Yearbook* (1978), p. 101.

27 *Der Deutsche Kanadier* (Berlin, Canada West: January 2, 1845), p. 4.

28 Henry Radecki and Benedykt Heydenkorn, *A Member of a Distinguished Family: The Polish Group in Canada* (Toronto: McClelland and Stewart, 1976), p. 1.

29 William Boleslaus Makowski, *History and Integration of Poles in Canada* (Niagara Falls: The Canadian Polish Congress, 1967), p. 54.

30 Radecki and Heydenkorn, *A Member of a Distinguished Family*, p. 21.

31 Raj, *The Canadian Family* Tree, p. 175.

32 Radecki and Heydenkorn, *A Member of a Distinguished Family*, p. 21.

33 Ibid., p. 22.

34 Ibid.

Western Provinces

1 Reinhild Kauenhoven Janzen and John M. Janzen, *Mennonite Furniture* (Intercourse, Pa.: Good Books, 1991), p. 59.

2 For related prototypes, see Noel Riley, *World Furniture*, p. 60.

3 Riley, *World Furniture*, p. 162.

4 See Janzen and Janzen, *Mennonite Furniture*, p. 39.

5 See Michael Bird and Terry Kobayashi, *A Splendid Harvest: Germanic Folk and Decorative Arts in Canada* (Toronto: Van Nostrand Reinhold, 1981), p. 191.

6 Finlay and Sprague, *The Structure of Canadian History*, p. 252.

7 Brown, *The Illustrated History of Canada*, p. 384.

8 Michael H. Marunchak, *The Ukrainian Canadians: A History* (Winnipeg, Man.: Ukrainian Free Academy of Sciences, 1970), p. 20.

9 Ibid., p. 20.

10 Ibid., p. 23.

11 Ibid., p. 24.

12 Ibid., p. 26.

13 Riley, *World Furniture*, pp. 26, 29.

14 Ibid., p. 65.

15 Joseph Elkington, *The Doukhobors* (Philadelphia: Ferris and Leach Publishers, 1903), p. 4.

16 George Woodcock, *The Doukhobors of Canada* (Toronto: McClelland and Stewart, 1977), p. 19.

17 See Michael Bird, *Canadian Folk Art: Old Ways in a New Land* (Toronto: Oxford University Press, 1983), p. 60 and cover.

18 See The T. Eaton Company Fall and Winter Catalogue (no. 47), 1901–1902 (Toronto: T. Eaton Company, 1901), notably figs. 81, 92, 275.

19 See B.A. Rybakov, *Russian Applied Arts of the Tenth–Thirteenth Centuries* (Leningrad [St. Petersburg]: Aurora Art Publishers, 1971), p. 5.

20 See The T. Eaton Company Fall and Winter Catalogue (no. 47), 1901–1902, especially figs. 6, 40, 70.

ATLANTIC PROVINCES

34. DOORWAY, NOVA SCOTIA: EARLY 19TH CENTURY.

Removed from an early home in Pictou, this elaborately articulated doorway exhibits decorative elements of the Georgian architectural style as it influenced Scottish vernacular architecture and furniture. The vase finials and spiral-rope carving are neoclassical features popular during the first half of the 19th century. Nova Scotia Museum.

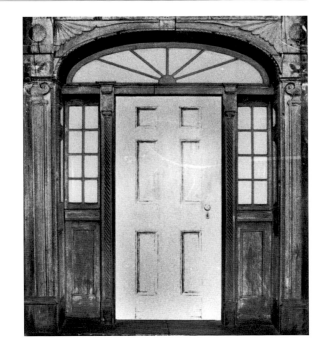

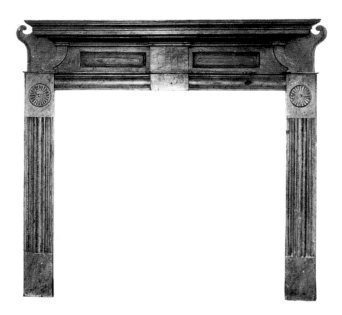

35. MANTEL, NOVA SCOTIA:
EARLY 19TH CENTURY; PINE;
57"H X 61"W X 7½"D.

From Annapolis Royal, this mantel reflects the stylishness of the finer Georgian homes constructed by Loyalists and their predecessors in the Annapolis Valley. Its carved scrolls are expressions of the English baroque, translated to late 18th-century New England colonial architecture and brought to Canada in the following decades. It retains the original abstractly veined green-and-black painted finish, skilfully executed to resemble marble.

36. WALL CUPBOARD, NOVA SCOTIA: 1784;
59 ½"H X 49 ½"W X 10½"D (ABOVE DADO MOULDING).

The house in which this inset cupboard was built has connections with Ireland and New England. Desiree Cohoon, born in Harwich, Massachussetts, married Samuel Mack, a Connecticut trader and mill operator, settling at Medway Mills (today, Mill Village) (Heritage Trust of Nova Scotia, *South Shore: Seasoned Timbers*, vol. 2, p. 76). His sudden death left her widowed in 1783. Two years later she married Patrick Doran, newly arrived from Waterford, Ireland. The mantels and cupboards, finely reeded, panelled, and, in this case, embellished with possibly the only known shell-back form in Canada, are reminiscent of late 18th-century New England design, and in fact are reputedly the work of a Connecticut cabinetmaker. The cupboard is integrated into a heavily panelled wainscotting which runs around the entire parlour and an adjacent room.

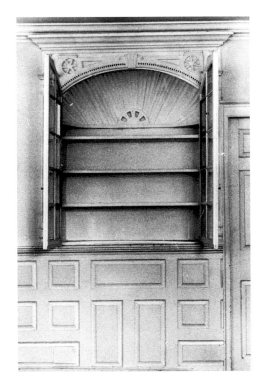

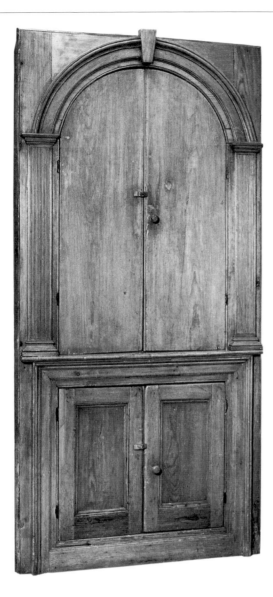

38. CORNER CUPBOARD, NOVA SCOTIA: LATE 18TH OR EARLY 19TH CENTURY; PINE.

From the southwest shore of the province, this large corner cupboard with a single glazed door is an exceptionally crisp statement of neoclassical refinement. It is also an interesting manifestation of the hybridization process, as a piece made in an age accustomed to classical-revival styles and experiencing the growing popularity of Gothic-revival elements in architecture and furniture. The reeded pilasters, arched cornice and keystone reflect the former style, while the gracefully articulated door with its fan tracery (which establishes a pattern somewhat at odds with the logic of the vertical line of the keystone) indicates awareness of a new style which was to become popular in English Canada over the next half century. Nova Scotia Museum.

37. CORNER CUPBOARD, NOVA SCOTIA: LATE 18TH OR EARLY 19TH CENTURY.

The elegant and clean lines of Georgian architecture were frequently exploited by cabinetmakers who fashioned pieces for finer houses in New England and the Canadian Atlantic Provinces. The moulded arch, keystone and fluted pilasters on this pine corner-cupboard with paired solid doors are of the same style as entryways, passage arches and architectural niches in homes or public buildings of the time. Nova Scotia Museum.

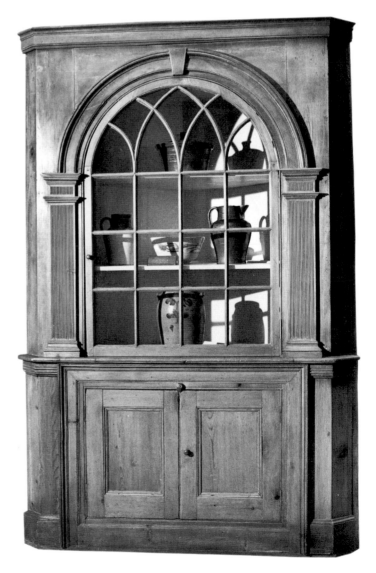

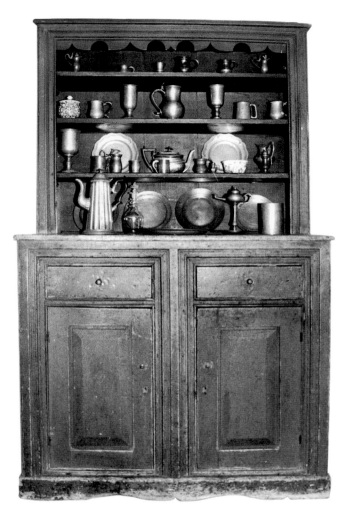

39. DISH DRESSER, NEW BRUNSWICK:
CIRCA 1800; PINE; 81"H X 49"W X 26"D.

The two-drawered and two-doored cupboard, in both its open-dresser or closed-door forms, is kin to the court cupboard popular in England after the Renaissance and through the Jacobean period. The open upper section served to display wares in the kitchen or dining room. The boxlike character of this piece from Sussex is emphasized by panelling and the rectangular arrangement of picture-frame mouldings, but modified by an effective scalloped edge along the top of the interior. Rose-headed nails are used throughout, and the dresser retains its two-tone colouration of red exterior and blue-green interior.

40. DISH DRESSER, NOVA SCOTIA:
LATE 18TH CENTURY; PINE; 87¼"H X 65½"W X 19½"D.

This large dresser from Rawding in Hants County features a scalloped top, which suggests an Irish influence, but the deep base is more characteristic of Scottish dressers. This well-made cupboard exhibits numerous complexities of construction: the case is dovetailed, and there is a removable bonnet-extension (also dovetailed) which seemingly permitted its movement from one house to another. The shelves and plate-rails are mortised through the sides. The well-worn dark green finish is original.

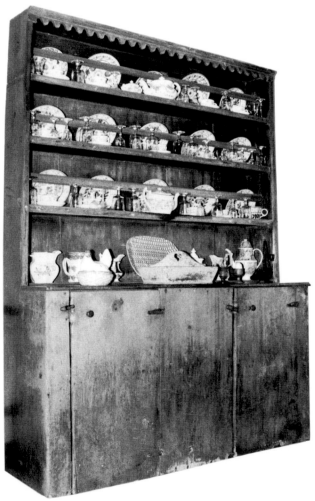

41. DISH DRESSER, NEWFOUNDLAND: EARLY 19TH CENTURY; PINE; 74½"H X 52¾"W X 14¾"D.

Harmonious proportions and internal division of space, fluted pilasters, and complex mouldings contribute to the provincial refinement of this early kitchen dresser. Its doors and drawers (the middle one is a panel simulating a drawer) are arranged evenly according to a tripartite distribution of equal space, and a pleasing three-to-one ratio is achieved in the arrangement of three upper shelves and the vertical ratio of drawers and doors. From the outport village of Keels, Bonavista Bay, this dresser has design and construction elements characteristic of Irish dressers, notably in the continuous ends and the way the work surface projects beyond the stiles, and in the shallowness of the dresser, which contrasts with the vastly deeper dressers of Cape Breton's Scottish settlements. Newfoundland Museum.

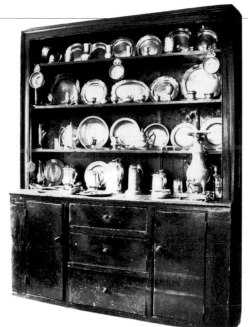

42. DISH DRESSER, NOVA SCOTIA: LATE 18TH OR EARLY 19TH CENTURY; PINE; 81¼"H X 63¾"W X 17½"D.

Typical of early Nova Scotia dish dressers is this arrangement of a vertical bank of three drawers between large flat-panelled doors, with an open upper section. This early dresser is fitted with horizontal grooves near the back of the shelves and a bar at the front for the upright display of pewter or chinaware. Beaded moulding runs along the edge of the vertical backboards and stiles as well as around the doors and drawers, and an applied raised moulding provides a framework around the open upper section.

43. DISH DRESSER, NOVA SCOTIA: MID-19TH CENTURY; PINE.

Horizontal rails, grooves, and notched shelves allowed display of plates and cutlery. The decorated frieze, featuring whirling-sun motifs and intersecting demi-lunes, reflects an earlier treatment found in Irish and Scottish country furniture. Channel designs on the lower stiles create the impression of panels, while the upper stiles are given visual interest by means of moulded detail along the inner edges. This piece was found near the village of Margaree in Cape Breton, and, despite the uncharacteristic absence of drawers, is closely related to several other pieces made in this region of Scottish settlement.

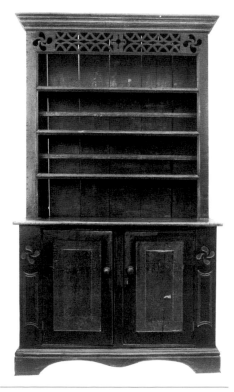

44. Dish Dresser, Nova Scotia:
MID-19TH CENTURY; PINE; 81½"H X 53½"W X 21½"D.

This open cupboard, although similar in form to the example in fig. 14, differs in a number of interesting details. Its design is somewhat simpler, lacking panelling and the channelled designs of the former. As in other dressers from Cape Breton (this one was found at Iona in the Bras d'Or Lakes region) and from the British Isles, the frieze is enhanced by a fretwork decoration, here featuring a central heart flanked by joined demi-lunes and pinwheels.

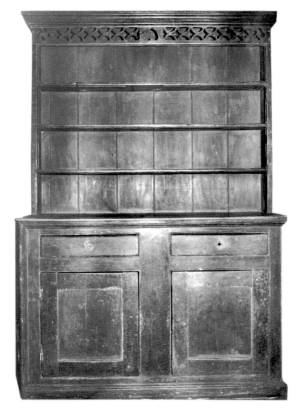

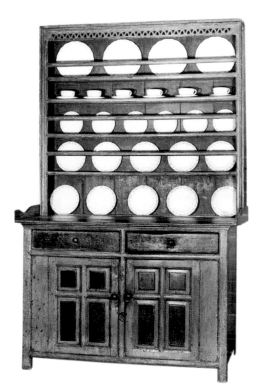

45. Dish Dresser, Nova Scotia:
MID-19TH CENTURY; PINE; 81½"H 51"W X 26¾"D.

The concept of a dish dresser functioning also as a sideboard or server is demonstrated in this Nova Scotia cupboard. Instead of the small work-area found on most pieces, an enormous countertop with a surrounding gallery actually extends well beyond the ends and front of the lower cupboard. For a distantly related Ontario example, note the York County dresser in fig. 262.

46. Dish Dresser, Nova Scotia:
MID-19TH CENTURY; PINE; 87"H X 59"W X 22½"D.

The cutouts on the side stiles of this large dresser are common in English practice, and may reflect Chippendale fretwork designs or an earlier country tradition. In this particular case, the shaping of the sides is akin to that of barge-board decoration and may echo the mid-century predilection for Victorian-Gothic architectural decoration which reached a particularly impressive degree of popularity throughout Nova Scotia. Its use here and the retention of the original green and white painted scheme make this a cupboard of charming folk character.

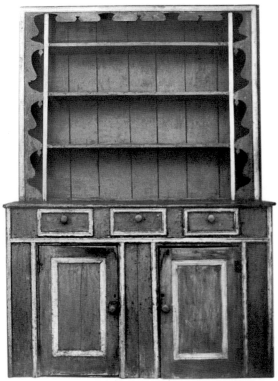

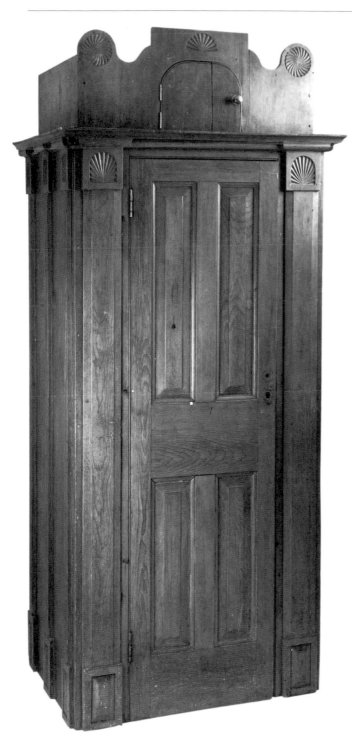

47. ARMOIRE, NOVA SCOTIA: 19TH CENTURY.

A free-standing closet for hanging clothes was a necessity in the master or guest bedroom of early Maritimes homes, predating the period of built-in storage areas and the expanded range of clothing in Victorian and post-Victorian times. To provide a counterpart to the bases beneath the pilasters, the upper blocks are of rectangular shape with carved fans within stilted-arch arcades. Carved whorls appear in the upturned ends of the upper unit, which may have been a later add-on for storage of hats.

48. DOOR, NOVA SCOTIA:
CIRCA EARLY 19TH CENTURY; PINE; 25¼"H X 21½"W.

This cupboard door from Salt Springs, located at the foot of Mt. Thom near New Glasgow, is remarkable in its wealth of carved embellishment. The motifs cut into the raised panels, used here in an unusual context. are found more typically on butter prints and other carved treenware, a likely direct source of inspiration for their use here.

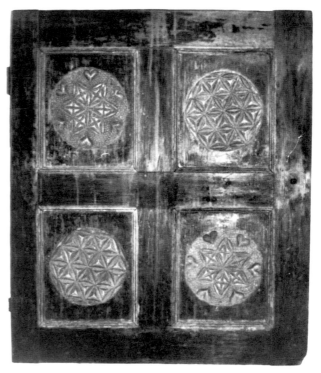

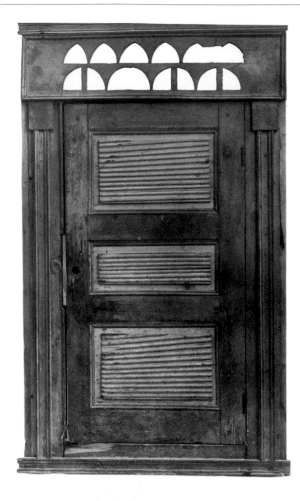

49. HANGING CORNER-CUPBOARD,
PRINCE EDWARD ISLAND:
EARLY 19TH CENTURY; PINE; 50½"H X 30"W X 20¼"D.

The use of a rough plane and chisel to fashion rudimentary fluting on the door of this cupboard provides considerable sculptural interest and patterning. The semicircular cutouts are more commonly found in the interior frames and friezes of dish dressers from the British Isles, but are used here on the exterior facade of this unique cupboard.

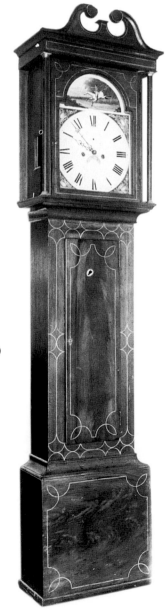

50. TALL-CASE CLOCK: NOVA SCOTIA:
EARLY 19TH CENTURY, PINE; 87½"H X 17¾"W X 3¾"D.

A rare signed example, this imposing clock was made in the workshop of John Geddie (1778–1843), who operated a manufactory at Pictou from before 1820 until shortly before his death in the 1840s. This painted pine case is finely constructed; the painted stripe motif serves as a skilful alternative to the inlay-work of formal furniture, no doubt familiar to him from his pre-1817 apprenticeship and early cabinetmaking career in Scotland. Like many Canadian clocks, a locally made case houses English brass works.

51. HANGING WALL-BOXES, NEWFOUNDLAND AND NOVA SCOTIA: LATE 18TH CENTURY.

(LEFT) HANGING WALL-BOX, NEWFOUNDLAND: LATE 18TH CENTURY; PINE; 11¼" H X 11¼"W X 4½"D.

Found on the northeast coast of the Avalon Peninsula, this two-tiered wall box was decorated by incising the side boards and then painting the indentations a red colour to contrast with the black finish. The whirling-sun motif is found elsewhere in Newfoundland furniture (the hanging wall-box in fig. 98). Forged-nail construction suggests an early date.

(RIGHT) HANGING WALL-BOX, NEW BRUNSWICK: SECOND HALF 18TH CENTURY; PINE; 25"H X 17¾"W X 5¼"D.

The early date of this wall box, suggested by form and construction, places it at the beginning of Anglo-American settlement in New Brunswick. Found at Cambridge Narrows, it was likely made within the pre-Loyalist communities which arrived in small numbers during the 1780s. Its form and decoration have counterparts in the British Isles, but it bears a particularly striking resemblance to similar pieces made in the American colonies. The geometric decoration is dramatized by the deepness of the carving, and the piece retains its original red colour.

52. HANGING WALL-BOX, NOVA SCOTIA: MID-19TH CENTURY; PINE; 8¼"H X 14"W X 6"D

From Cape Breton Island, this wall box is highly decorative. Its compass-star and whirling-pinwheel motifs are cut and carved out from the backboard, and the designs are intensified by the two-colour painted finish.

53. CHEST OF DRAWERS, NOVA SCOTIA: MID-19TH CENTURY; PINE; 41¼"H X 42¼"W X 19¼"D.

In form, this chest of drawers is quite ordinary, made along conventional Hepplewhite lines. In decorative paintwork, however, it is outstanding. Its entire surface is emboldened by the use of sponge-painting to impart an abstract patterning throughout. In contours, it closely resembles those more formal Nova Scotia examples made of figured maple and other hardwoods, but its painted surface places it within the range of more exuberant country counterparts.

54. CHEST OF DRAWERS, NOVA SCOTIA: MID-19TH CENTURY; PINE AND HARDWOODS.

The heavy American Empire style made itself felt in the design of many chests of drawers made through English Canada. Characteristic of the style are the add-on bonnet drawers at the top, and an overhanging upper section resting on massive turned columns. The striking innovative feature of this example is found in its smoke-grained decorative finish, which produced a dramatically variegated surface in playful contrast to the solidity of this monumental form. Nova Scotia Museum.

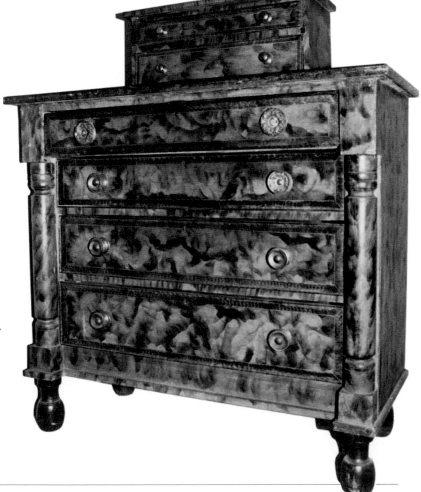

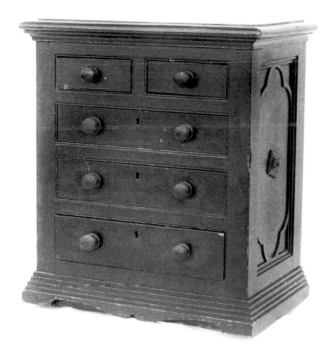

55. MINIATURE CHEST OF DRAWERS:
PRINCE EDWARD ISLAND: MID-19TH CENTURY;
PINE; 18¾"H X 15¼"W X 9¼"D.

This scaled-down chest, possibly made as a sales example but more likely a child's piece, loses little of the sound proportions of a full-sized equivalent. The moulded patterning of the ends reveals the growing interest in medieval elements as the Gothic revival made its mark in mid-century Canadian architecture and furniture.

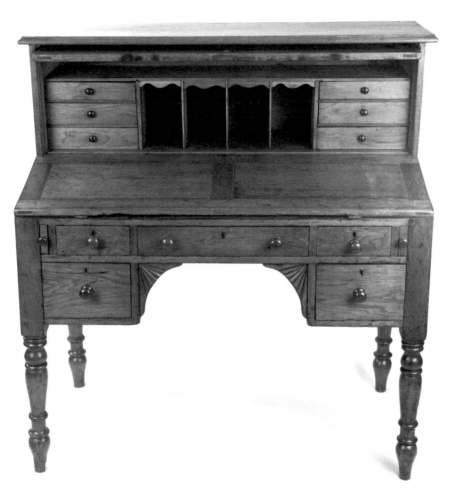

56. DESK, NEW BRUNSWICK: EARLY 19TH CENTURY; BUTTERNUT.

This countrified counterpart to a more sophisticated desk of stylish Sheraton design is constructed of relatively inexpensive butternut readily available in unlimited supply from New Brunswick's densely wooded river valleys. What its original painted finish may have been is now a matter of conjecture, but it is possible that it may have been given a *faux* finish to resemble contrasting hardwoods. Its fan-carved corner details have their formal antecedents in inlaid designs used widely by Thomas Sheraton and his school. New Brunswick Museum.

57. SIDEBOARD, NOVA SCOTIA:
EARLY OR MID-19TH CENTURY.

Unlike work which is done more whimsically or abstractly, as in the chest of drawers in fig. 53, the painting of this sideboard from the Halifax region represents an attempt at imitation. Its darker border and treatment of the legs is a spirited attempt to simulate mahogany, while the interior sections of the top and drawer fronts are a good imitation of figured maple. The overall effect is that of a more formal Hepplewhite piece made of expensive primary and veneer woods.

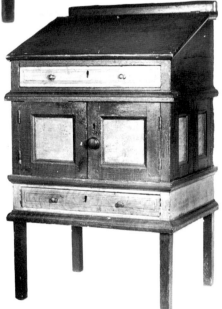

58. DESK, NOVA SCOTIA: MID-19TH CENTURY; BIRCH, MAPLE, PINE; 38½"H X 27½"W X 24"D.

This is a finely constructed framed desk of the slant-top form. It was found in Pictou County and is believed to have been made by a member of the McIntosh family, who were well-known for their beautiful spinning wheels. Contrasting hardwoods (flamed birch, bird's-eye maple) are used effectively in the strong decorative embellishment — a flowering plant, inlaid into the front surface, accented further by a heart-shaped ivory keyhole escutcheon. Sides, top and bottom are held by dovetailed construction, as are the three pine interior drawers.

59. DESK, PRINCE EDWARD ISLAND: SECOND HALF 19TH CENTURY; PINE; 44½"H X 26¼"W X 19½"D.

Small writing-desks became popular in the Victorian era and afterward, with increased literacy and the growing practice of letter writing, so this piece of furniture was commonly included in the furnishings of the parlour. A number of panelled desks found on Prince Edward Island are likely the work of one workshop, including this example from Souris with its effective painted finish, which suggests contrasting light and dark hardwoods.

60. WASHSTAND, NOVA SCOTIA: EARLY 19TH CENTURY;
BIRCH AND PINE; 30"H X 12½"W X 12½"D.

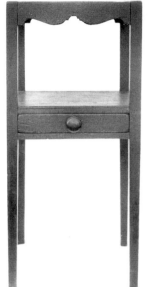

An unusual degree of elegance characterizes this country Chippendale basin-stand found at Berwick in Kings County. The tapered legs and delicate profile, combined with the use of thinly cut birch, give a light refinement to a piece made by a competent artisan with a sound knowledge of English formal furniture. The joinery of the drawer consists of a single large dovetail at front and back, a feature of 18th-century construction. A dark red paint (original) has been applied to the birch frame.

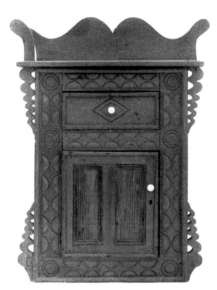

61. WASHSTAND, NEWFOUNDLAND:
LATE 19TH CENTURY; PINE; 37"H X 31¼"W X 17¾"D.

The maker of this piece from Lower Island Cove, Conception Bay, showed considerable resourcefulness in meeting the challenge to harmonize the rigidity of the rectilinear with fluidity of the curvilinear. The effect is that of containing the rigid within the fluid. The profile breaks the line of the straight sides by means of elaborately scrolled wings which taper toward the centre, while the surface is enlivened by roundels and semicircles (themselves echoed by the half-round applied mouldings on door, drawer and stiles). CMC (CCFCS).

62. WASHSTAND, NEWFOUNDLAND: EARLY 20TH CENTURY;
PINE AND VARIOUS OTHER WOODS; 40"H X 33 ⅝"W X 18 ¼"D.

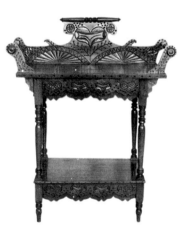

Virtually no space has been left untouched in this exuberantly decorated washstand from Port de Grave on Conception Bay. It was made shortly after the turn of the 20th century by John "Happy Jack" Mugford, whose deft use of chisel and punch is evident in the profusion of fans and hearts cut into its front surfaces. Fishermen's Museum, Hibb's Cove Collection.

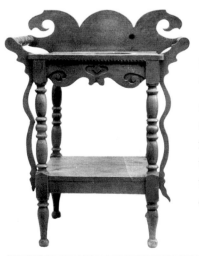

63. WASHSTAND, NEW BRUNSWICK: MID-19TH CENTURY; PINE; 34"H X 25¼"W X 16¼"D.

The fancifully scrolled gallery make this washstand a striking folk form, with decorative interest well exceeding functional requirements. An interesting design dynamic is set into motion by the juxtaposition of contrasting movements. The backboard is given a centrifugal movement by the outward thrust of curves set on either side of a convex centre lobe, while the front of the table apron has a centripetal orientation, with in-turned curves flanking a concave centre section. The painted finish is a salmon-orange colour.

64. WASHSTAND, NEWFOUNDLAND: LATE 19TH CENTURY.

Not content with the more restrained decorative effect of backboards which are merely scrolled, the maker of this unique Newfoundland washstand has left no ornamental possibility untried. A profusion of motifs — hearts, tulips and birds — have been executed by means of shapes incised, carved, and cut out to produce this elaborate confection. CMC (CCFCS).

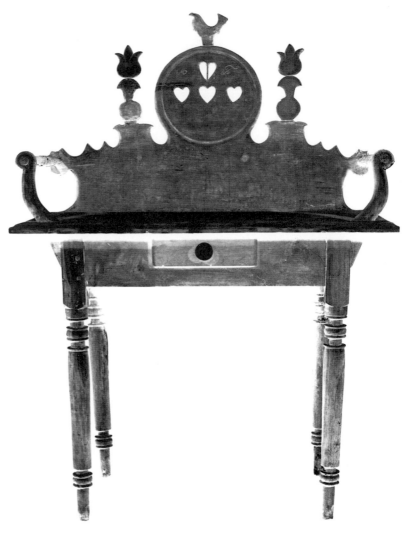

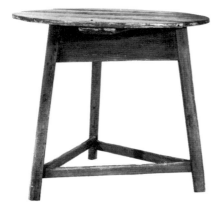

65. TABLE, NEW BRUNSWICK: EARLY 19TH CENTURY; PINE AND HARDWOODS.

The three-sided base over which was placed a round top was a popular form throughout the British Isles, where it was commonly called a "cricket table." On both sides of the Atlantic it may have served a public function, as it was frequently found in taverns during the 18th and early 19th centuries. Tables of this type have been found only occasionally in Canada. A similar example from Ontario is illustrated in Pain (fig. 27). This table with square tapered legs and stretchers is an early New Brunswick example. Kings Landing Historical Settlement.

66. TABLE, NOVA SCOTIA: EARLY 19TH CENTURY; PINE AND HARDWOODS.

This table is a round-legged counterpart to the one in fig. 64. It may be of slightly later, but still pre-1850 construction.

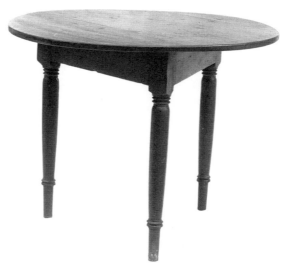

67. TABLE, NEWFOUNDLAND: EARLY 19TH CENTURY; BIRCH BASE, PINE TOP; 26¼"H X 29½"W.

In its lines this table is a capable country interpretation of Chippendale style with its square legs and proportions. The carved fans are well-established components of the design inventory employed by the major British cabinetmakers, notably Thomas Sheraton. An original painted finish was removed some time after the middle of the 20th century. ROM (Canadiana Department).

68. TABLE, NOVA SCOTIA: MID-19TH CENTURY; BIRCH; 28½"H X 20½"W X 20½"D.

One-drawer tables or stands served many functions and were placed in nearly all rooms of the 19th-century home. Here, the turned legs are well executed within the Sheraton style, and neoclassical themes are given a countrified interpretation through the sunburst or fan decoration of the corners. Sponged decoration on the sides and top provide an abstract decorative effect in red and yellow on this small table found in Cumberland County.

69. TABLE (NEW ENGLAND), PAINTED IN NOVA SCOTIA: LATE 18TH AND EARLY 19TH CENTURY; MAPLE AND PINE; 29¼" HIGH X 36" DIAMETER.

A finely constructed and designed American tilt-top table most likely brought to Canada by Loyalists settlers in the 1780s. While its many fine qualities include a well-turned pedestal and flared feet in the Queen Anne manner, this table can also be appreciated as a spirited interpretation of the 19th-century formal style, simplified somewhat by abandoning the dished-top or carved detail of its prototype. The painted finish may have been an attempt to simulate the formality of crotch-grained mahogany, although its free-form execution tends to be more imaginative than realistic, and was perhaps applied in the early 18th century when Regency taste led to painting furniture, even that of earlier manufacture.

70. TABLE, NOVA SCOTIA: SECOND QUARTER 19TH CENTURY; PINE; 27¼"H X 31"W X 14"D.

This unusual table is complexly conceived in its lines — the dramatically undulating curvature of the top — and its ornamental enhancements. Of particular Nova Scotia interest is the floral motif, which is deeply carved into the front centre and accentuated by paint outlining its details. The table was found at Old Barns, between Truro and Maitland.

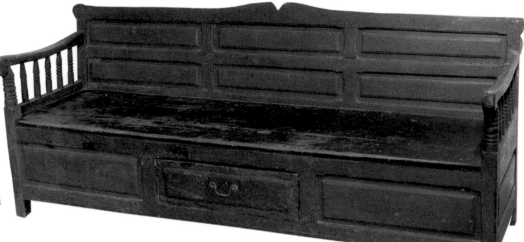

71. BENCH, NEWFOUNDLAND: EARLY 19TH CENTURY; PINE; 31⅜"H X 74¼"W X 24⅜"D.

Found at Hant's Harbour on Trinity Bay, this rugged bench with lift-top is of the type known in the British Isles as a settle, and is closely related to Scottish examples. This settle form may have evolved from the chest by extending the rear stiles upward and including a back as a practical means of retaining heat from the hearth, near which such seating furniture could be placed. The form is not common in Newfoundland, particularly with its elaborately panelled back and apron. The centre lower panel is actually a drawer, permitting storage beneath the seat. The original hardware (ball-and-bail handle) suggests the early date of this piece. Newfoundland Museum.

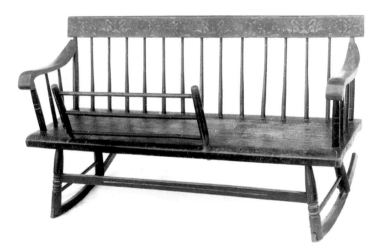

72. BENCH: NOVA SCOTIA: MID-19TH CENTURY; PINE SEAT AND HARDWOODS; 27"H X 47¾"W X 14½"D.

Benches with removable rails at the front permitted the rocking of an infant while the mother sat alongside. The scooping of the seat and turned spindles indicate the connection between the bench-form and the Sheraton-style Windsor chairs of the period. This bench retains its original stencilled and painted finish.

73. COUCH, NEWFOUNDLAND: 19TH CENTURY; PINE.

Newfoundland couches are of immense variety and vividly demonstrate the astute nature of their makers, who drew inspiration from formal prototypes of earlier construction as well as catalogue furniture of the late 19th century. While these later pieces could be capably enough copied, at least at a superficial level, the locally executed pieces almost invariably exhibit elements of creative adaptation, depending upon such diverse factors as a maker's skills, the availability of construction materials, and the requirements of the homes for which they were made. The reverse-curved flat posts of this pine couch are a neoclassical form, associated with early 19th-century "Madame Recamier" couches as well as with later furniture made in the American Empire style.

74. CHAIR, NEW BRUNSWICK: LATE 18TH CENTURY.

The phenomenon of *retardataire*, the perpetuation of styles beyond their vogue in urban centres, is evident in this chair made in New Brunswick at the advent of Loyalist emigration in the 1780s. The turnings on the back posts are reminiscent of Queen Anne stylistic features of the mid-18th century, while the robust turnings of the front legs suggest an even earlier William and Mary influence. The inverted-vase shaping of the back splat is also a Queen Anne motif. The appearance of such design features on a chair of late 18th-century making reveals the conservative nature of country cabinetmaking, particularly in remote areas of the Canadian Atlantic Provinces. New Brunswick Museum.

75. CHAIR, NEWFOUNDLAND: EARLY 19TH CENTURY; PINE; 36"H X 17¼" X 15½"D.

The influence of Thomas Chippendale in the distant countryside of Canada can be seen in many early chairs made in the Atlantic Provinces. This example, made of pine, is remarkable in its lightness of execution. Replacing the broader solid or piercework splat of more formal counterparts are three delicate turned spindles, radiating outward from a point at the centre of the back, echoed by a triangular fan-motif carved in the crest. The popularity of this three-splat design can be seen in its late perpetuation, as in a Canadian-Ukrainian example made a full century later in Saskatchewan (see fig. 584). ROM (Canadiana Department).

76. CHAIRS, NEWFOUNDLAND: LATE 18TH CENTURY; BIRCH; 36"H (SEAT 16½") X 20 ¼"W 14½"D.

The maker of this pair of chairs was reasonably attuned to the Chippendale idiom in the establishment of proportions, the slight taper of upper posts, the curved backward raking of back legs, and the bracketed skirt and curved back splat. The upper crest rail is somewhat flat and narrow in comparison to the formal counterpart, while the cutout hearts and whorls (a dangerous compromising of the strength of the chair back) are a uniquely regional or personal modification of an established style. These birch chairs were found at Belle Isle, off the northeast coast of Newfoundland.

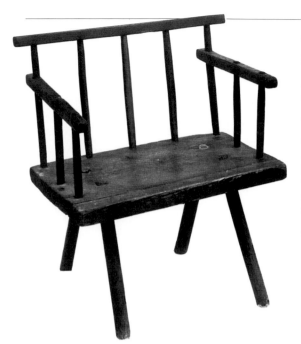

77. ARMCHAIR, NEW BRUNSWICK: EARLY 19TH CENTURY; PINE AND HARDWOODS.

A primitive armchair, more in the tradition of the Irish "hedge-chair" than of the supposed English Windsor type, this interesting example simply disregards the characteristic curvilinear nature of the style, a shortcut which does pay the price of reduced comfort. Flared legs are dowelled through a heavy board seat and secured by wedges driven into slots in the ends. The spindle-ends are visible through the arms and crest. The practice of interlocking the outermost spindles or posts through the arms is found in some regional Irish chairs.

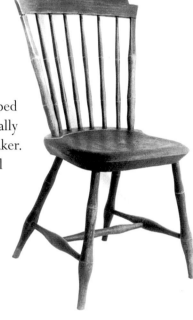

78. CHAIR, NOVA SCOTIA: CIRCA 1830; PINE SEAT AND HARDWOODS.

The bold red-and-black graining is reminiscent of furniture found near Mahone Bay in Lunenburg County. On the underside of the seat is stamped the designation *G. Gammon / Warranted*. This is one of a set of six identically decorated side chairs found near Cole Harbour. All are signed by the maker. The stepped-down design of the crest is executed in a somewhat unusual manner, but one which is distinctive to the Gammon firm.

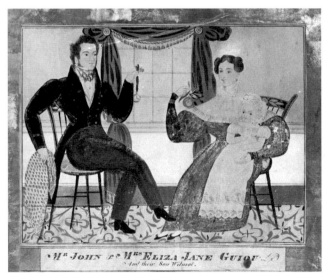

79. THOMAS MACDONALD, JOHN AND ELIZABETH GUIOU AND THEIR SON WILMOT; 1837; INK AND WATERCOLOUR ON PAPER; 8½"H X 10½"W.

The itinerant watercolour artist Thomas MacDonald (1784/5–1862) painted portraits of families and individuals who lived along the St. John River from near Fredericton to some distance below Gagetown. Of particular interest in this stylized domestic setting are the rod-back Windsor chairs with stencilled or painted decorative motifs. The attention drawn by the artist to this detail suggests its importance, along with the draperies and painted or woven floor coverings, in the modestly affluent homes of the early 19th century. It is possible that MacDonald had a close acquaintanceship with cabinetmakers, from which he would have a first-hand knowledge of painted furniture; indeed, he is listed in the 1851 census as a lodger at the home of Joseph A. Fowler, a carpenter and furniture maker at Upham Parish, King's County. Whether he may have also been a furniture-painter is unclear.

80. CHAIR, NOVA SCOTIA: EARLY 19TH CENTURY; PINE SEAT AND HARDWOODS ; 34"H X 17¾"W X 17½"D.

A Windsor-style side chair with a good mix of turnings — the legs are bamboo-shaped, but the front stretcher is of robust proportion with strong turnings of late 18th-century style, while the short spindles beneath the back rail are more characteristic of early 19th-century work, and the crest is rolled and turned in a manner that anticipates neoclassical elements in chairs of the second quarter of the century. This is one of a few rare examples bearing the Vinecove signature. It is interesting that the imprint (*Warranted / Halifax / J. Vinecove*) is rendered by two techniques, with the upper two lines branded into the underside of the seat, and the bottom line written on paper. Little is known about this chair maker (his name does not appear in the extensive lists compiled by George McLaren), but the handful of chairs bearing his paper label are of sound construction and fine proportion.

81. CHAIR, NOVA SCOTIA: EARLY 19TH CENTURY; BIRCH.

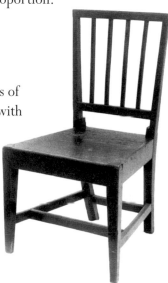

Thomas Sheraton designed an extremely popular chair whose copies and adaptations must be among the most numerous of all country interpretations of English formal furniture. Particularly favoured was the square-legged chair with four narrow splats set in a squared framework of posts and horizontal rails. The posts are an extension of the back legs, and the characteristic carved setback just above the seat permits a narrowing and hence lightening of the upper framework. This Nova Scotia example with inset wooden seat is a sturdy country version of this widespread English form, made in especially great numbers in areas of Scottish settlement.

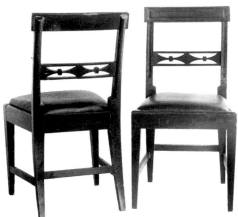

82. CHAIRS, NOVA SCOTIA: SECOND QUARTER 19TH CENTURY; BIRCH.

From a set of six, these side chairs from Pictou County exemplify the sensitivity with which country Sheraton chairs could be fashioned by early Canadian country furniture makers. They are related to the example in fig. 81 by the step-backed posts and tapered square legs, but aspire to a greater formality with the channelled and beaded posts and crest rail, as well as the delicately executed ribbon-like motifs cut through the lower rails. Such chairs are found in Pictou County, a region settled by Scottish immigrants after 1772.

83. CHAIRS, NOVA SCOTIA: CIRCA 1880; PINE SEATS AND HARDWOODS; 34"H X 17"W X 14"D.

Some of the most readily recognizable of Eastern Canadian country chairs are those made by the Sibley Brothers company in the village of Wittenburg in Nova Scotia's Colchester County. They are stamped *Sibley Bros / Lower Stewiacke*. Manufactured in Wittenburg, the Sibley chairs were shipped from the railway station at Lower Stewiacke. The earliest chair-manufacturing activity began with Joseph Sibley and his son Michael. The gracefully humped horizontal rails and mushroom caps on the stiles are a familiar Sibley earmark.

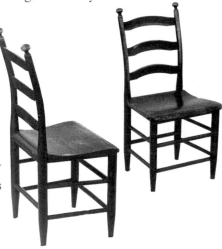

84. CHAIR, NOVA SCOTIA: THIRD QUARTER 19TH CENTURY; PINE SEAT AND HARDWOODS.

A chair made with a wooden seat, and hence believed to have been of second-generation Sibley manufacture, this example reveals great sensitivity to form. The back legs are thinned and curved backward just above the seat, achieving remarkable gracefulness and refinement. Indeed, these simple chairs are capable expressions of curvilinear elegance, reflected in the sculptural treatment of the seat and gently bowed profile of horizontal slats.

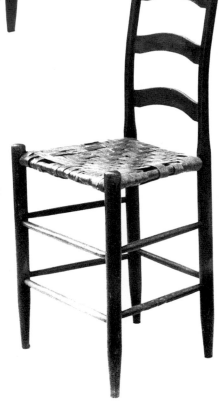

85. CHAIR, NOVA SCOTIA: THIRD QUARTER 19TH CENTURY; PINE SEAT AND HARDWOODS; 39½"H X 18"W X 14"D.

The heightened placement of the seat on this chair, most likely of Sibley manufacture, indicates that it was made to serve a particular function. Chairs for the purposes of weaving typically had such high seats, as did those used at high slant-top writing desks, hence their popular descriptions as weaving or desk chairs.

86. CHAIR, NOVA SCOTIA: 1860S; HARDWOOD WITH QUILLWORK SEAT AND BACK.

A fad in the British Isles and Canada for furniture made with panels of quilled birchbark resulted in the production of unusual chairs and other items from the 1840s to the end of the century. While most of the this furniture was made in Great Britain, using panels imported from Canada, this particular chair is a local product. It is possibly the work of George Newcombe, a Halifax manufacturer who exhibited such chairs in the 1867 Paris Exhibition. Nova Scotia Museum.

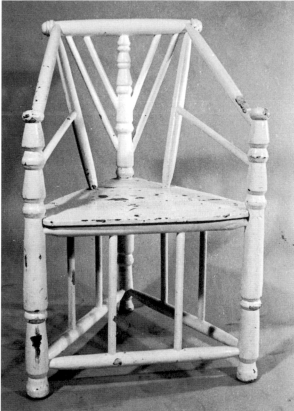

87. CHAIR, NEWFOUNDLAND:
19TH CENTURY; MAPLE; 33¼"H X 21⅛"W X 18¾"D.

The corner chair constructed of massive, thrown (turned) posts was already passing out of fashion when Jacobean taste was giving way to William and Mary influences in the 17th century. Such styles remained popular, however, in certain parts of Atlantic Canada and Newfoundland, where this remarkable corner chair was made, no earlier than mid-19th century, as indicated by circular saw marks. Another indication of its later date is the introduction of simple vertical dowel-like rods rather than the more complexly turned stretchers and balusters of earlier examples.

88. CHAIR, NEWFOUNDLAND: 19TH CENTURY.

The row of spindles set between horizontal turned members slotted into the back posts retains much of the appearance of the Newfoundland armchair, while the delicacy of the turnings is in keeping with early 19th-century tastes for lighter styles developed by Thomas Sheraton. This example retains its original woven-bark seat and has numerous early and stylistically varied features. The front arm-supports extend through the seat and are dowelled through the upper stretchers, a late 19th-century practice, while the outwardly curved arms suggest an awareness of the design of Chippendale armchairs, from which this detail was probably borrowed.

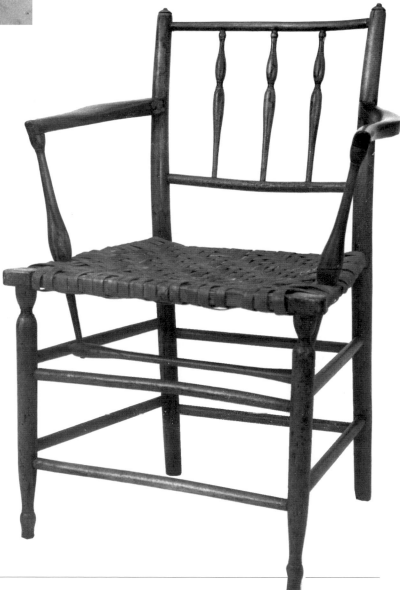

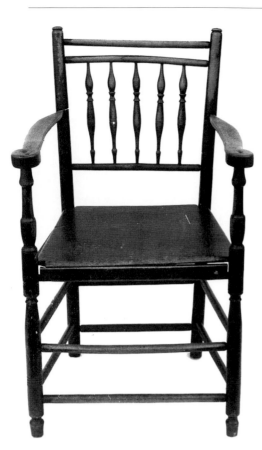

89. ARMCHAIR, NOVA SCOTIA: CIRCA 1810–20; BIRCH FRAMING, PINE SEAT.

An early 19th-century chair with a row of five turned spindles between horizontal slats, this piece was found at Pictou, an area which experienced the first significant wave of Scottish settlement in Nova Scotia in 1772. Like other chairs from Pictou County, it has a hardwood seat and flat scrolled arms resting upon turned posts.

90. CHAIR, NOVA SCOTIA: EARLY 19TH CENTURY; PINE SEAT AND HARDWOODS; 34½"H X 18¼"W X 16¾"D.

A continuous-arm Windsor chair of fine proportions and strongly defined turnings. This specimen is stamped *J. Humeston / Halifax / Warranted*. While the legs are of the bamboo-turned variety, the spindles are more slender with only slight swellings to suggest this popular "Chinese" influence. Documented Canadian continuous-arm Windsor chairs are uncommon, and this is a finely articulated example.

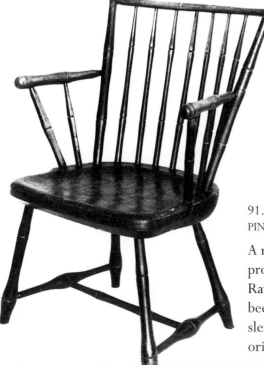

91. CHAIR, NOVA SCOTIA: EARLY 19TH CENTURY; PINE SEAT AND HARDWOODS; 31"H (SEAT 14¾"H) X 17¼"W X 14¾"D.

A rod-back Windsor armchair, branded *G. C. / Warranted*, which probably refers to George Cole, who worked at Halifax and Centre Rawdon in Hants County. Bamboo turnings define legs (which have been shortened), medial stretcher and spindles as well as arms, all of slender proportions with low-relief profile. This chair retains its original black painted finish.

92. MANTEL, NOVA SCOTIA:
SECOND QUARTER 19TH CENTURY; PINE;
87½"H X 69½"W X 6¾"D.

With its carved corner fans and other geometric details, this mantel-with-overmantel is an outstanding Canadian country expression of the designs of Robert Adam or Thomas Sheraton. This remarkable piece was orginally installed in an early home near the village of Orangedale, in central Cape Breton. The house, abandoned in recent years, no longer exists, but the mantel was removed and kept in storage until brought to light in 1993. The painted decoration, an early but secondary finish, is complexly applied with a mixture of brushwork and sponge-daubing. The pattern of abstract line and colour is carefully controlled to achieve symmetry of design.

93. MANTEL, NOVA SCOTIA:
MID-19TH CENTURY; PINE;
64½"H X 56½"W.

A mantel constructed at approximately the same period as the example in fig. 92, this piece looks backward to the Regency rather than forward to the incoming Victorian design tastes pervading Nova Scotia architecture and furnishings at the time. The earlier style is particularly evident in the suggestion of fluted pilasters (achieved by application of mouldings) and built-up capitals. Its vivid painted decoration is in part an attempt at realism (the imitation of three-coloured marble) and abstraction (the painted designs on the architrave look less like stone than clouds!).

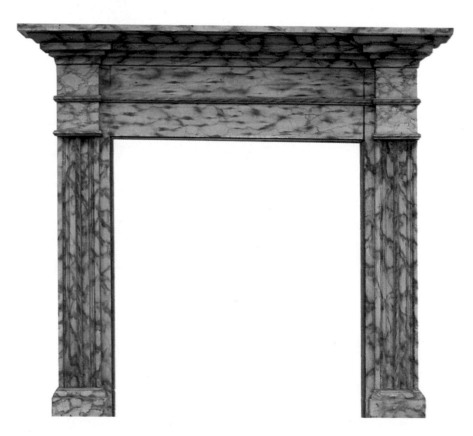

94. DISH DRESSER, NEWFOUNDLAND: CIRCA 1800; PINE.

The open-top dish dresser is a form long popular in the British Isles, perpetuated in many settlements in Eastern Canada. Certain details of this early dresser suggest that the maker of this piece was an amateur craftsperson, notably the somewhat tentative sense of proportion and the seeming inverted position of doors. A most unusual and striking decorative feature is its chip-carved detail, which is similar to that found on the desk-box in fig. 10. The profusely carved frieze and reeded stiles are exceptional among Newfoundland examples.

95. DISH DRESSER, NEW BRUNSWICK: LATE 18TH OR EARLY 19TH CENTURY; PINE; 83½"H X 59¼"W X 18"D.

This outstanding country dresser from St. Martin's in southern New Brunswick is spectacularly decorative in its carved and painted embellishments. A modern overpaint was taken down to reveal its original five-colour decorative finish in intact condition. The interior fretwork design relates this piece to more formal furnishings from the British Isles, particularly those of Chippendale design. Notable decorative points are the corner fans, fluted recessed blocks in its base and cornice, and the piercework decoration of the frieze, and the interior pilaster-like stiles.

96. DISH DRESSER, NOVA SCOTIA: MID-19TH CENTURY; PINE; 86¼"H X 53"W X 18"D.

One of a group of related dressers found in Cape Breton, this example from the Margaree Valley is of sturdier construction and more expansive proportions than the preceding pieces. Its comparatively great depth links it more to Scottish examples than to the typically shallow Irish dressers (although in Cape Breton, such distinctions may have paled gradually through mingling of peoples and craft techniques). This robust cupboard is given a high degree of surface decorative embellishment, with both flat and raised panels, and inset lozenges, channelled upper pilasters, and a complex cornice with dentils.

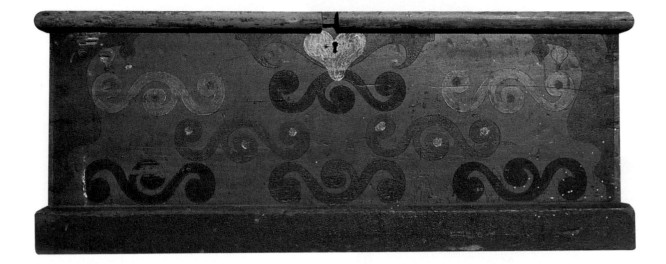

102. STORAGE CHEST, NOVA SCOTIA:
19TH CENTURY; PINE.

This storage chest from Lunenburg
County may have few counterparts
within its category, but it does,
interestingly enough, have a
correspondence in the decoration
of another form, notably the desk
in fig. 137. The reversing scrolls
and heart motif added to the desk
as applied ornaments are here painted
directly onto the surface of the chest.
Similarity of decorative treatment extends
even to the matter of colouration, in both
cases a juxtaposition of green and a distinctive
reddish-pink.

103. TABLE, NOVA SCOTIA: MID-19TH CENTURY;
PINE; 29"H X 19½"D.

An overcoat of white enamel was removed from
what appeared to be a standard mid-19th-century
pedestal table to uncover its original and striking
decoration. Against a dark blue background is
painted a faceted star, a marine motif which
is found also on painted sailcloth mats and
parcheesi boards made along the South
Shore. The pedestal and scrolled feet
reflect competing Sheraton and
Victorian "Empire" influences.
CMC (CCFCS).

104. TABLE, NOVA SCOTIA: 19TH CENTURY;
PINE AND HARDWOODS; 29"H X 28½"W X 20¼"D.

Several stylistically related examples have led to the description of this and similar pieces as "Mahone Bay-type" tables. Its red-and-black brushwork is accentuated by cream-coloured banding around the top and skirt, and gold-ochre triangle motifs where the bottom of the corner posts meets the uppermost portion of the turned legs. JSH (CMC).

105. LAST-LOOK MIRROR, NOVA SCOTIA: EARLY 20TH CENTURY;
PINE; 26"H X 11½"W X 4"D.

Closely related in size and profile to the example in fig. 145, this Lunenburg County mirror employs painted geometric detail and faceted stars in its bold decorative treatment.

106. STORAGE BOX, NOVA SCOTIA: 19TH CENTURY; PINE; 14"H X 28¾"W X 14½"D.

The skilfully rendered decoration and construction details of this small box suggest that it served duty keeping important personal possessions. The painted whorls occur both in Germanic and Scottish settlements of Nova Scotia, and are a prominent decorative motif on this piece found in Lunenburg County. The motif occurs also on treenware, splint boxes and painted sailcloth mats made from the early 19th to the mid-20th century in the Lunenburg region.

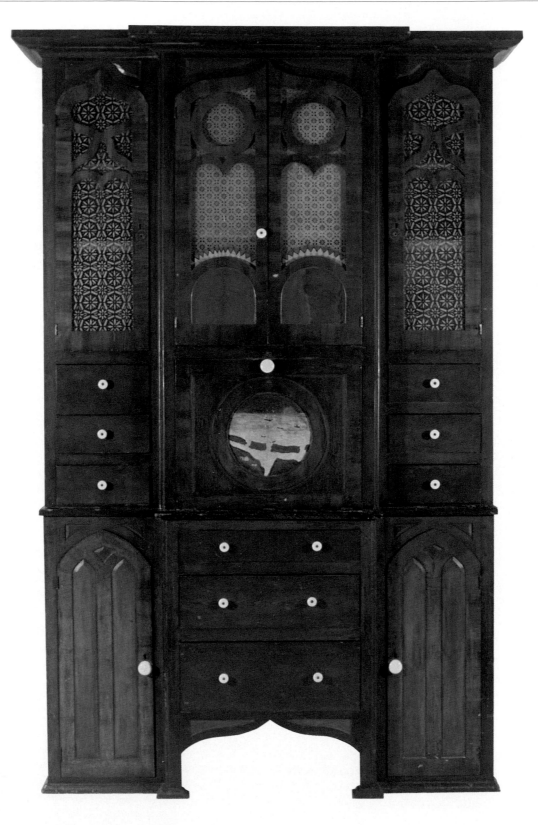

107. SECRETARY, NEW BRUNSWICK: CIRCA 1904; PINE.

From Northern New Brunswick, and probably from one of the Acadian communities along the Baie de Chaleur, this secretary represents new heights in country furniture design. The vertical thrust of this extremely tall piece is further accentuated by columns and attenuated Gothic arches in the lower and upper sections. The Moorish character of the glazed doors is in keeping with architectural and furniture designs of the late Victorian and Eastlake periods. The surface is greatly lightened by vibrant grain-painting. Pasted onto the backboards of both sections are pages from 1904 Montreal newspapers. Kings Landing Historical Settlement.

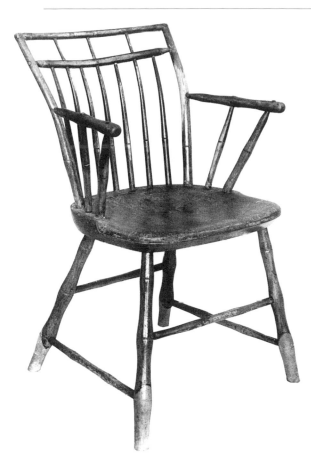

108. Chair, Nova Scotia: Early 19th Century; Pine Seat and Hardwoods; 33"H x 17½"W x 16¼"D.

The bird-cage Windsor is in effect the extension of the rod-back or fan-back chair, with a double rail and short spindles comprising a section above the larger, long-spindled arrangement of the back. As with most examples, the shorter spindles are fewer in number and are situated above alternating lower members. This bamboo-turned armchair has had extensive repairs to the legs. It carries the branded mark *J Cole / Warranted*.

109. Armchair, Nova Scotia: Early 19th Century; Pine Seat and Hardwoods; 34"H (Seat 17½"H) x 18"W x 17"D.

This early armchair is identified by a paper label attached to the underside of the seat with the handwritten signature *Vinecove*. The curvature of arms and raked back is gracefully executed, while the delicate carved scrollwork turns of the ends of the arms are superbly rendered. The grained red-brown finish is original. There also exists another armchair virtually identical to this fine example; it, too, is marked by a handwritten ink signature on paper attached to the underside of the seat, *J. Vinecove / Halifax Warranted*. Like the side chair above, this example reflects the integration of competing stylistic elements, some from an earlier Sheraton Windsor form and others (notably the rolled crest rail) from the incoming Regency tastes.

110. Chair, Nova Scotia: Early to Mid-19th Century; Pine Seat and Hardwoods; 34"H x 19"W x 17½"D.

This extraordinary chair synthesizes formal and folk elements in a delightfully unexpected manner. In form, it is a classic Windsor armchair, made by the Gammon firm of Halifax and Cole Harbor, whose name is branded on the underside of the seat. The heart motif below the crest is associated with a particular story concerning this chair, that it was made as a marriage presentation piece for a member of the Gammon family.

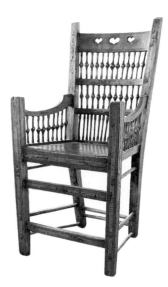

111. HIGH CHAIR, NEW BRUNSWICK:
LATE 18TH CENTURY; BIRCH FRAME,
PINE FOOTREST;
34½"H X 12"W X 12"D.

This child's high chair is notable
for its fine turnings and finials
reminiscent of late 18th-century
New England design. As was
often the case in the construction
of such chairs, the legs are
dramatically splayed, a wise
stabilizing feature given the
problem of a high centre of
gravity and
unpredictable energy
displays. Through an
old black overpaint can
be seen what is most
likely the original red
painted finish. The chair
still retains its ash splint
seat.

112. ARMCHAIR, NOVA SCOTIA:
CIRCA 1800; PINE SEAT AND BIRCH;
36"H X 21"W X 17"D.

From Berwick in Kings County,
this sturdy chair exhibits Sheraton
elements in the rake of the back
and curvature of the back legs. The
curvature of the arms suggests
possible English or French formal
influences. The hardwood seat is
original and is fitted into a recess
framed by the skirt and posts.

113. ARMCHAIR, NEWFOUNDLAND:
EARLY 19TH CENTURY; BIRCH;
37¼"H X 18"W X 14½"D.

This remarkable birch armchair
is the result of a busy lathe,
despite its heavy squared posts.
Found in Harbour Grace, on
Conception Bay, it defies
stylistic classification. Its
massive throne-like form
contrasts with the lighter feel
imparted by rows of turned
spindles and the three heart-
motifs cut through its crest rail.

114. CHAIR, NEWFOUNDLAND: LATE 19TH
CENTURY; MIXED WOODS; 38½"H X 22"W X 27"D.

The unusually commodious nature of
this uniquely designed chair suggests
a mid- to late 19th-century date.
The back is made up of several
vertical splats set close together,
with rosettes cut in rows to give
decorative effect. The curved
arms rest on posts which are
spiral-carved downward to the
join with the seat.

115. Writing-Arm Windsor, Nova Scotia:
CIRCA. 1820–30; PINE SEAT AND HARDWOODS;
36"H (SEAT 18"H) X 38"W X 31"D.

This chair with a writing-arm carries the branded imprint of George Cole, early chair maker in Halifax and Centre Rawdon, Hants County. The finely executed decoration features stencilled motifs against a red-and-black grained background. It provides storage by means of a drawer situated beneath the writing surface.

116. Rocking Chair, New Brunswick:
MID-19TH CENTURY; PINE SEAT AND HARDWOODS.

This chair possesses both Acadian and Irish characteristics, the former particularly reflected in the curvature of the seat and scrolled edge of the upper slat. Squared stretchers are mortised through the posts, and the rockers are slotted and dowelled into the legs. The finish is an old ochre paint. Kings Landing Historical Settlement.

117. Rocking Chair, Nova Scotia:
THIRD QUARTER 19TH CENTURY; BIRCH, WITH ASH SPLINT SEAT;
41"H X 23¼"W X 15"D.

The scalloping of the upper slat on this Sibley rocker contributes to the already-light construction of the chair. The family from which the chair was acquired in the 1970s indicated that it had been a wedding piece. The seat is constructed of splint ash, woven in two directions, a sign of an early date of construction, from before Sibley chairs were made with wooden seats.

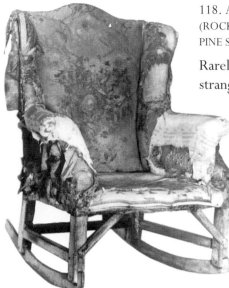

118. ARMCHAIR ROCKER, NOVA SCOTIA: EARLY 19TH CENTURY
(ROCKERS POSSIBLY ADDED SOMEWHAT LATER);
PINE SEAT AND HARDWOODS; 45½"H X 28"W X 21"D.

Rarely does somber formality encounter casual inventiveness with stranger results than this modification of an earlier form for later use.

This heavy Chippendale-style wing chair has been so converted and de-formalized by the addition of rockers. A nearly identical example is shown in fig. 12.

119. HUTCH-TABLE, NOVA SCOTIA: LATE 18TH CENTURY;
PINE; 28"H X 48½"W X 33"D.

Found at Centreville in Kings County, this early table with a storage hutch beneath is made with rose-headed nails, and the front is notched in for strength. The tops of both this and the following table are secured by splines running through a channel on the underside of the tabletop, while hoe feet stabilize the slab legs. The painted finish is an old or original red colour. The splined two-board top and the seat board are removable.

120. HUTCH-TABLE, NOVA SCOTIA: LATE 18TH OR EARLY 19TH CENTURY;
PINE WITH BIRCH FEET; 26½"; BASE: 19"W X 15½"D; TOP: 43"W X 33"D.

Many furniture forms were joined in varying combinations to save space in the smaller homes of the European peasantry. Such forms continued to be used in the American colonies, and did not necessarily disappear when later generations enlarged or built more commodious houses. Among such combinations frequently found in Eastern Canada were the chair-table and also the hutch-table, which had storage space in a box supporting the table top. The shoe foot is an early feature of this Nova Scotia example. The two wide boards that make the top are amply secured by narrow pieces ("breadboard ends") slotted into the ends and running against the grain of the centre, as well as by splines set into channels on the underside.

121. FOOTSTOOLS, NOVA SCOTIA: THIRD QUARTER 19TH CENTURY; PINE,
(LEFT) 4¾"H X 13¼"W X 7¾"D; (RIGHT) PINE, 5¼"H X 13¾"W X 8¼"D.

This pair of oval footstools, with competently painted names and initials of owners, was likely made for a married couple, here identified as *L.M. K.*(eith) and *Mrs. C. Keith*. Of late 19th-century manufacture, they may have been made by Donald Keith (1832–1918) of the Gordon and Keith firm, cabinetmakers and furniture manufacturers on Dundonald Street and later Barrington Street in Halifax. The footstools were found in Annapolis County. The painted finish is yellow lettering and striping over a dark red base.

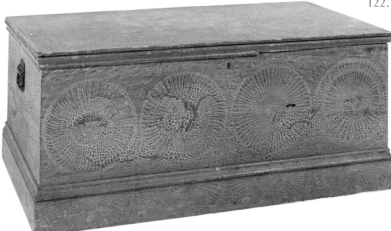

122. STORAGE CHEST, NOVA SCOTIA: THIRD-QUARTER 19TH CENTURY; PINE; 17¼"H X 40½"W X 22"D.

Found on the South Shore, this storage trunk is given strong visual impact by a decorative painted format achieved by moving crinkled paper in circles while the second-layer paint application is still wet. By working outward from the centres, a sunburst effect results. Similar decoration is found on some chests of drawers and other boxes of various types. ROM (Canadiana Department).

123. DOCUMENT OR DITTY BOX, NOVA SCOTIA: MID-19TH CENTURY; PINE; 6¼"H X 12¾"W X 6¼"D.

Like the decoration of the large trunk in the previous illustration, the sunburst effect here has been achieved by means of crinkled paper or a similar device, producing a decorative pattern against a background of contrasting colour. The embellishment is particularly dramatic since it is concentrated on a small surface. The box was found in Lunenburg County.

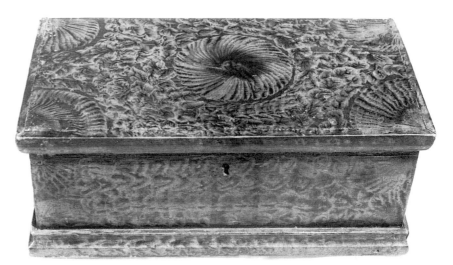

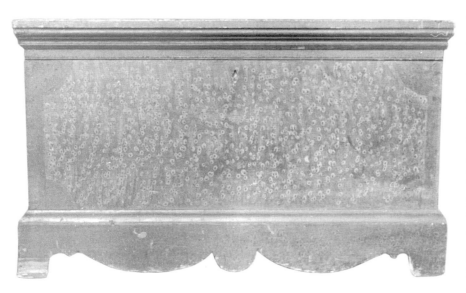

124. STORAGE CHEST, NOVA SCOTIA: MID-19TH CENTURY; PINE; 24"H X 38"W X 21"D.

While many Nova Scotia storage chests had simple base mouldings like those on trunks carried on ships, others took on the more stylish character of domestic chests founds in households in the British Isles, with gracefully shaped bracket bases. This was also a functional feature; it lifted the chest from damp floors and permitted the storage of bedding and items of a fragile nature. This pine trunk has been skilfully painted to create the illusion of bird's-eye maple and other hardwoods.

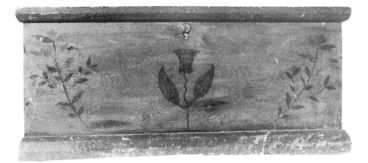

125. STORAGE CHEST, NOVA SCOTIA:
MID-19TH CENTURY; PINE; 14¼"H X 32"W X 16¼"D.

Many of Cape Breton's Scottish communities came
into being when eviction of Scottish Highlanders
spurred emigration to this part of Nova Scotia
in the early 19th century. This six-board lift-top
box found at Cape North was made for Robert
Campbell, whose name is painted on the lid. The
front surface is decorated with painted vines,
flowers, and the Scottish thistle.

126. STORAGE CHEST, NOVA SCOTIA:
MID-19TH CENTURY; PINE; 16¼"H X 36"W X 16"D.

Many a plain sea-chest offers up a pleasant
surprise when opened, for the interiors of lids
were frequently decorated by means of a
signature, carved detail, or painted nautical
motif. This example from the South Shore
features geometric designs, a sailing ship, flags
and ensigns.

127. STORAGE CHEST, NOVA SCOTIA: MID-19TH CENTURY; PINE; 15¼"H X 41"W X 15½"D.

A painter of considerable provincial competence has transformed this simple form into a work
of strong aesthetic appeal. The subjects on the front and top are quite different from
one another. The front depicts stylized sailing ships flanking a central floral
design. The painted decoration on the lid appears to have been inspired
by motifs in hooked rugs or other textiles, with a sampler-like array of
hunters, flowers and two large birds at the centre. Elaborate and even
naturalistic painting of this quality is a rare occurrence in the decoration
of Canadian furniture, and calls to mind the Renaissance tradition of
Italian *cassoni* which were frequently painted by highly acclaimed artists
(the result being the later practice of breaking up such chests and selling
the decorated panels as individual paintings in their own right).

128. STORAGE BOX, NEW BRUNSWICK:
19TH CENTURY; PINE; 10¼"H X 27⅞"W X 14¼"D.

Chip-carving is a centuries-old technique used in the
ornamental embellishment of furniture and treenware.
The carving on the top, ends and front of this trunk
found in the St. John River Valley is competent and
controlled, resembling "Friesian" work on woodenware from
coastal areas of Northern Europe. The geometric designs are intensified by
contrasting painted colouration in ochre against a dark red-brown background.

129. MANTEL, NOVA SCOTIA: LATE 18TH
CENTURY; PINE; 59"H X 65"W.

The lozenge-panelling on the stiles of
this mantel from the Hamm House near
Blockhouse in Lunenburg County
is related to architectural details
elsewhere in the house and in other
homes of the area. This feature is
more clearly associated with country
furniture of the German background of
Lunenburg County settlers than are the
more formal classical-revival elements
of reeding and dentil details.

130. BUILT-IN NICHE CUPBOARD, NOVA SCOTIA:
LATE 18TH CENTURY; PINE; 82½"H X 33"W X 16½"D.

Also situated in the Hamm House is this built-in
cupboard, set into a wall perpendicular to the mantel
in fig. 129. Like the mantel, it is highly ornamented,
featuring an impressive array of applied mouldings and
reeded sections, and also lozenge panels. It and the
mantel retain their original green painted finish.

137. DESK, LUNENBURG COUNTY, NOVA SCOTIA:
MID-19TH CENTURY; PINE;
33"H (EXCLUDING FINIALS) X 39⅛"W X 19¼"D.

Some furnishings made in Lunenburg County
reveal the cross-fertilization of design ideas from
the Germanic and Mi'kmaq cultures living close
to one another in the region. The scrolls are
similar to those found on Mi'kmaq decorated
boxes and other items, while the star is a familiar
element of the Germanic design vocabulary of
Lunenburg furniture makers and other artisans.
For a design similarity, see fig. 102.

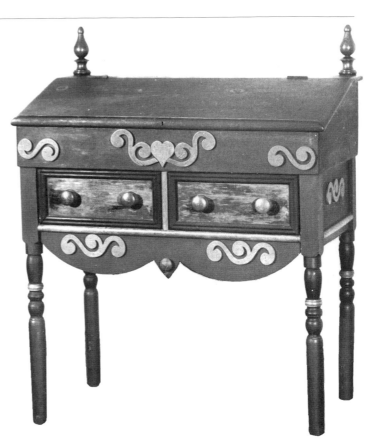

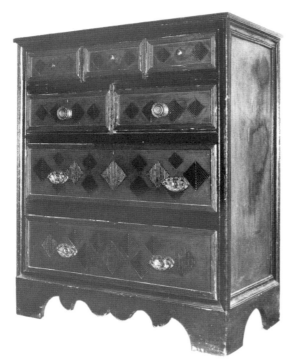

138. CHEST OF DRAWERS, NOVA SCOTIA: MID-19TH CENTURY;
PINE; 45½"H X 39"W X 19½"D.

The contours of this desk from Lunenburg County are in the
Hepplewhite idiom which had become popular throughout
Eastern Canada in the first half of the 19th century. Reeded
details are used to create patterned designs on the drawer
fronts, and the surface is finished in the dark red and black
colours found elsewhere in Nova Scotia Germanic households
and furnishings.

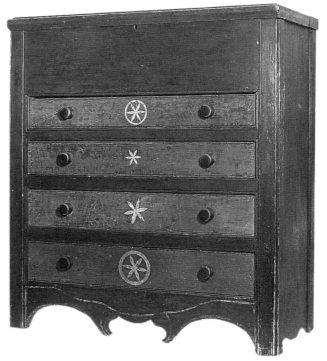

139. TRANSITIONAL CHEST, NEW BRUNSWICK:
19TH CENTURY; PINE; 42½"H X 38¼"W X 16¼"D.

This interesting piece integrates an Anglo-American
form (lift-top chest and drawers) with Germanic design
influences, an amalgation also found widely in
Pennsylvania-German furniture made in both
Pennsylvania and Ontario. The chest is strikingly
painted in red, blue and ochre.

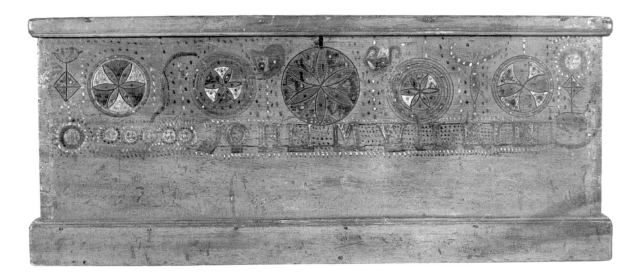

140. STORAGE CHEST, NOVA SCOTIA: 19TH CENTURY; PINE.

Found at Rhodes Corners in Lunenburg County, this sea chest is almost Celtic-like in its stippled decoration, with letters and dots making up a band bearing the name John M. Wilkin. (Did its maker study pages from the Lindisfarne Gospels? Was he descended from Eadfrith?) The array of compass stars, however, here rendered in five incised variations, in brown and cream colour against an orange painted finish, is strongly within the Lunenburg County Germanic decorative tradition.

141. TABLE, NOVA SCOTIA: MID-19TH CENTURY; PINE.

Black-and-red paintwork is common on furniture up and down the Atlantic seacoast, found commonly in Nova Scotia as well as in Maine. While in many cases such work is done in imitation of mahogany, rosewood or other costly woods, the highly flamboyant painting on this table can hardly be considered graining, a controlled and tightly worked treatment achieved by careful brushwork; here the design is free and almost skitterish in effect.

142. TABLE, NOVA SCOTIA: MID-19TH CENTURY; PINE; 28"H X 43½"W (TOP FLAPS UP) X 25"D.

This piece shares with most of the tables in this group of tables found in the Mahone Bay – Lunenburg – Martin's River area the bold red-black painted decoration typical of the region. While most of these tables have turned legs and straight-bottomed skirts characteristic of Sheraton styling, this example is unusual in retaining the curved profile of the earlier Queen Anne period.

148. CHILD'S ROCKER, NOVA SCOTIA: MID-19TH CENTURY; BIRCH; 25¼"H X 13½"W X 10"D.

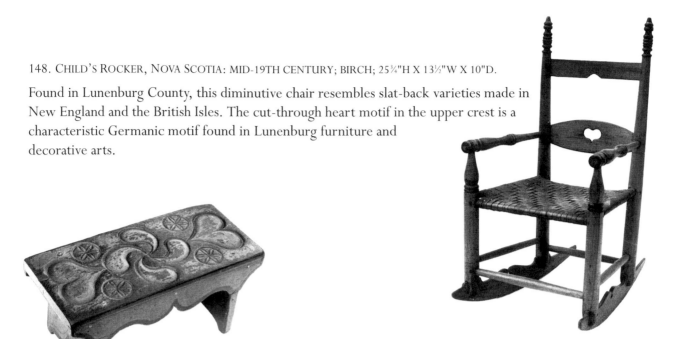

Found in Lunenburg County, this diminutive chair resembles slat-back varieties made in New England and the British Isles. The cut-through heart motif in the upper crest is a characteristic Germanic motif found in Lunenburg furniture and decorative arts.

149. FOOTSTOOL, NEW BRUNSWICK: 19TH CENTURY; PINE; 8¼"H X 16¾"L X 7⅝"W.

An extraordinary rarity in North American painted furniture is this highly colourful footstool found in the St. John River Valley of south central New Brunswick. It is emblazoned with a sampling of strongly Germanic folk motifs, including hearts, whorls and six-point compass stars. The side and ends are painted and stencilled.

150. PLANT STAND, NOVA SCOTIA: LATE 19TH CENTURY; PINE; 28"H X 35½"W X 16½"D.

From Lunenburg County, this unusual three-tiered flower-pot stand shows the extent to which a humble form can be dramatically transformed into a richly elaborated pattern work. Motifs carved through the sides and back panels embellish an already complex scalloped profile. The dark red and green colouration used here to emphasize geometric details is used frequently in the decoration of sailcloths and various utilitarian furnishings in Nova Scotia's Germanic settlements.

151. HANGING SHELF, NOVA SCOTIA: 19TH CENTURY; PINE; 19"H X 16½"W X 5"D.

Wall shelves of this type are faintly reminiscent in miniaturized form of the Irish clevy or other shelving which hung above the kitchen mantel or a worktable. Characteristically Lunenburg in appearance, its decorative treatment consists of an array of sixteen six-point compass stars cut through the sides.

152. TRINKET BOX, SECOND QUARTER 19TH CENTURY; PINE; 7⅛"H X 9⅛"W X 6¼"D.

Small boxes were sometimes decorated because they had a personal significance, used as they were for the keeping of documents, jewels or other items of importance. In Lunenburg County, the decoration of such boxes, along with other articles, became especially popular in the late 19th and early 20th centuries. This piece is an unusually early example. Against a red background are painted twelve-point compass stars on the top and sides, along with quarter-lunettes rendered in black at the corners. On the underside is the inscription, *Abraham Hirtle, First South, Lunenburg, N.S.* ("First South" is the crossroads and village just below the town of Lunenburg.) JSH (CHC).

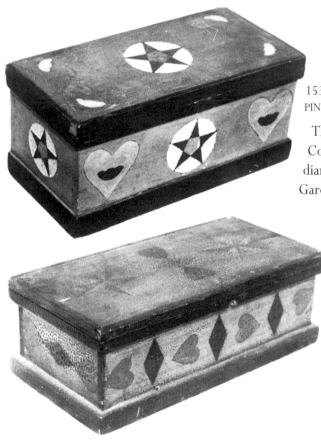

153. TRINKET BOXES, NOVA SCOTIA: LATE 19TH OR EARLY 20TH CENTURY, PINE; (TOP) 4¼"H X 12¼"W X 5¼"D; (BOTTOM) 5"H X 12"W X 5¼"D.

The vocabulary of folk motifs used repeatedly in Lunenburg County decorated furnishings is composed primarily of hearts, diamonds and stars, all of which are found on a small box found at Garden Lots (top). These motifs are painted in red and black against a yellow background. The faceted five-point stars incised and painted on the lower box are a motif employed also in the decoration of painted game boards and sailcloth mats from the region.

154. CUTLERY BOX, NOVA SCOTIA: EARLY 19TH CENTURY; BIRCH; 5⅛"H X 13"W X 6¾"D.

This decorated utensil tray was found near Liverpool, in Queens County. The carved hearts and geometric designs on this box are closely related to those on other domestic utensils found along Nova Scotia's South Shore. An unusual feature is the intensification of the incised heart motif by its concentric repetition. The box is made of birch, joined by wooden pins. JSH (CHC).

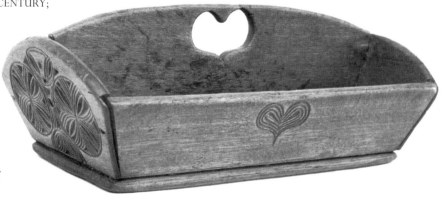

155. GAME BOARD, LUNENBURG, NOVA SCOTIA: EARLY 20TH CENTURY; PINE; 22"H X 22⅛"W X 1¼" THICK.

The rise in popularity of the game of parcheesi saw the appearance of commercially printed game boards in many households by the end of the 19th century. Partially in imitation of these boards, some artisans made versions decorated by means of painting or inlay-work. In the Atlantic Provinces, the ready familiarity with geometric decorative motifs used earlier in furniture and other small utilitarian articles meant easy transference of these designs to the empty spaces at the four corners of the parcheesi board, as in this notable example made by a member of the Mason family in the town of Lunenburg.

ACADIAN

156. BUFFET, NEW BRUNSWICK: 19TH CENTURY; PINE; 35½"H X 57"W X 17¼"D.

This pine sideboard or buffet from New Brunswick may have been made along the eastern shore or the Baie de Chaleur. While fully developed diamond-point panelling is widely found in the early furniture of French Canada, a lighter Acadian counterpart may have been intended in the applied diagonal moulding arrangements on the doors and one end (the other end fits snugly against the wall in a corner) of this distinctive piece.

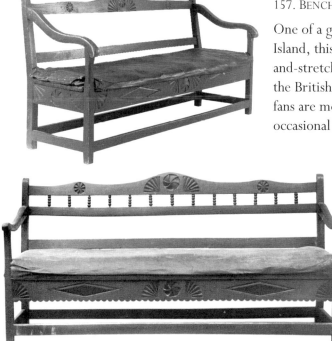

157. BENCH, PRINCE EDWARD ISLAND: 19TH CENTURY; PINE.

One of a group of three such benches discovered on Prince Edward Island, this example retains its original red painted finish. The leg-and-stretcher arrangement is characteristic of furniture design from the British Isles, but its scrolled arms, back, and carved whorls and fans are more closely allied to Acadian folk elements found on occasional surviving pieces of furniture from the Atlantic Provinces.

158. BENCH, PRINCE EDWARD ISLAND: 19TH CENTURY; PINE; 31½"H X 61¼"W X 15½"D.

Closely related to the example in fig. 157, this bench is distinguished by spool-turnings on the back spindles. These suggest an awareness of the growing popularity of the convention in mid-19th-century chairs and other furnishings, but possibly also a recollection of 17th- and early 18th-century turnings made in both English and French areas of settlement in North America.

159. CHAIR, PRINCE EDWARD ISLAND: MID-19TH CENTURY; BIRCH AND PINE; 36"H X 17"W X 15"D.

The canted back and framework construction (albeit with the extra feature of central rail in chair back) are faintly reminiscent of French-Canadian chairs of the Ile d'Orleans type, while unusual precaution against potential calamity has been taken in the diagonal bracing of the seat. This chair is unusual in another respect: possibly unique in chair-making is the provision of a shoe-foot attachment to front and back legs on each side. The red painted finish is original.

160. CHAIR: 18TH CENTURY; BIRCH FRAME, OAK STRETCHERS, PINE SEAT; 47¼"H X 24¼"W X 18¼"D.

Found in the Evangeline Trail district of Nova Scotia, from which many Acadians were evicted in the 1750s and to which they returned only gradually in the 19th century, this chair has a robustness associated with the substantial furnishings which might have been used by the permanent staff of French fortifications such as those at Cape Royale (today Annapolis Royal) and Louisbourg. Its large splat set into a heavy framework may be an evolution from earlier panel-backed chairs found in the English settlements of the American colonies and French communities in Canada. The curvature of the arms is similar to that of Louis XIII armchairs of French Canada.

161. CHAIR, NOVA SCOTIA: MID-19TH CENTURY; BIRCH; 30½"H X 15¼"W X 15¾"D.

This chair was found at Gabarus, on the southeastern shore of Cape Breton, and resembles others from Acadian settlements sprinkled throughout the island. It exhibits design and construction similarities with Irish *súgán* chairs, particularly in the shaping of slats and the way visible ends of tenons are inserted completely through mortises on square posts. The closeness of returned Acadians and newly arrived Irish settlers may have been the basis for mutual influences in architecture and furnishings among these communities throughout Nova Scotia, New Brunswick and Prince Edward Island.

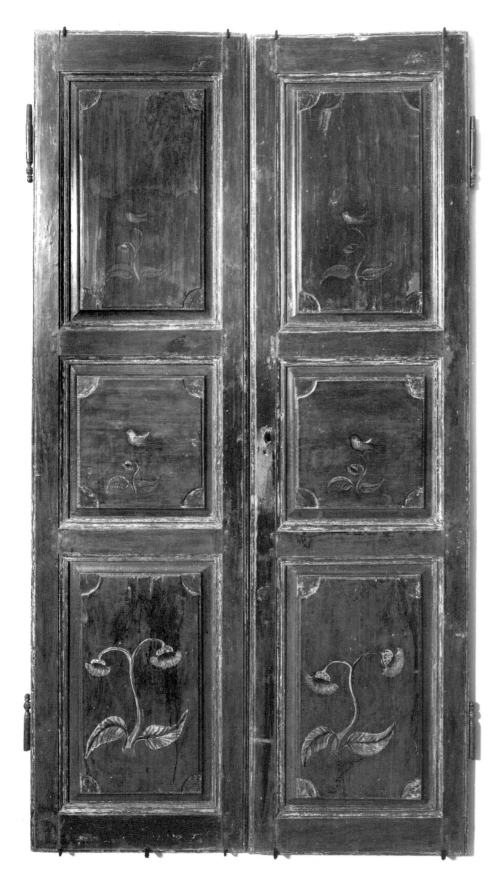

165. DOORS: QUEBEC:
LATE 18TH CENTURY; PINE;
76¼"H X 20¼"W.

This pair of doors, possibly from a built-in armoire, is highly decorative not only in the style of panelling but also by virtue of their painted decoration, which consists of floral motifs and birds against a dark blue background. Such painted treatment is uncommon, even in French Canada, where exuberant carved decoration is found on doors and panels of case furniture. Museum of Fine Arts, Montreal.

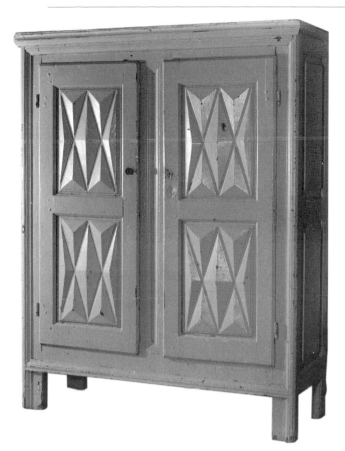

166. ARMOIRE: LATE 18TH CENTURY;
PINE; 59¾"H X 46"W X 17"D.

The tapering of panels to form low pyramids results in the form known as diamond-point, in contrast to lozenge-panelling, which is accomplished by diagonal channelling. This armoire retains suggestions of the earlier *buffet deux-corps*, with two tall doors replacing the four in the buffet.

167. ARMOIRE: 18TH CENTURY; PINE.

Related to the example in fig. 200 and most likely from the same workshop, this extraordinarily decorative armoire was found at Yamachiche. The device of two horizontal rails and a narrow insert to separate the lower and upper panels is unusual. Geometric carving is executed here in a varied array of interpretations — simple rosettes on the sides, concentric arrangements on the upper diamond points, and clustered designs on the lower panels. Quebec Museum of Civilization.

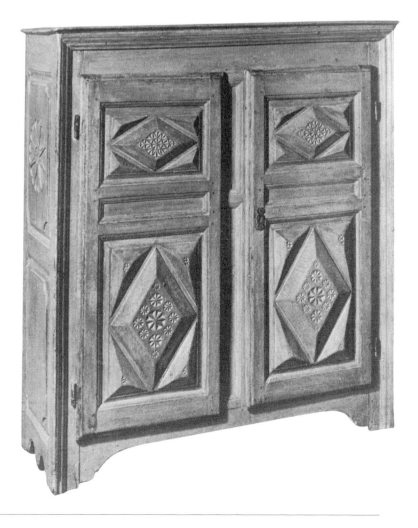

171. ARMOIRE: LATE 19TH OR EARLY 19TH CENTURY;
PINE; 85¼"H X 57⅜"W X 19¼"D.

Several related armoires, a desk, and other pieces of
furniture found in Charlevoix County attest to the work of an
extraordinary carver or team of carvers at a workshop in that
region. The most sumptuous expression of this manufactory
is this extravagantly carved armoire, found at Chateaugay.
Virtually every available surface space serves as a background for
densely compressed floral motifs. The form is Louis XV,
expressed particularly in the asymmetrical serpentine panel
framing. Traces of remaining pigment indicate the probability
that the surface was originally painted in several colours,
perhaps accented by gilding. Canadair Collection.

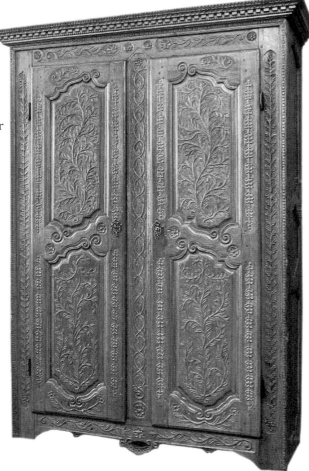

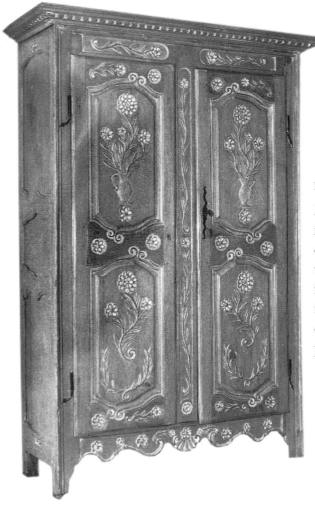

172. ARMOIRE: LATE 18TH OR EARLY 19TH CENTURY;
PINE; 83⅝"H X 52"W X 18¾"D.

Most likely a product of the same shop as the piece in
fig. 171, this armoire conveys less of the intricacy of that
example, but at the same time gives higher prominence to
the singular floral arrangements in each panel. The skirt
is finely shaped with reverse curves and carved rosettes
flanking a central shell. Remains of gesso or a similar
composition suggest that this armoire was gilded and
perhaps given a polychrome finish.

173. ARMOIRE: EARLY 19TH CENTURY; PINE; 82"H X 50¼"W X 15¾"D.

Rectangular panelling and moulding on the sides of this armoire suggest some English influences, notably from the Adam school, and hence a somewhat later date than that of the preceding examples. Its panelled doors reflect both the symmetrical Louis XIV and asymmetrical Louis XV styles. Unrelated to any of the cabinet-directory influences, however, is the thoroughly provincial treatment of the frieze and centre stile, with relief-carved vines, flowers, trees, rosettes, birds and several beasts of uncertain identity. This is a remarkable armoire, bringing together into an uneasy equilibrium elements of classical formality and rustic folk expression. ROM (Canadiana Department).

174. ARMOIRE: LATE 18TH CENTURY; PINE.

Several armoires and buffets from the Lotbinière region along the St. Lawrence River just west of Quebec City share common design features. Notable among these distinctive features is the vertical channelling of fielded panels and inset panels in stiles and rails. The appearance of this treatment on an armoire imparts an unusually heightened sense of vertical elongation. ROM (Canadiana Department).

175. TWO-TIERED BUFFET:
LATE 18TH OR EARLY 19TH CENTURY; PINE;
84"H X 48"W X 19"D.

The lozenge panel has in this case attained its zenith as a decorative technique, with panels carved by means of grooves deeply cut into the four doors of this exceptional buffet, and further accentuated by the device of double-moulding at panel edges and stiles. That the buffet, in contrast to the dresser, was intended from early times as a showpiece is proved by the sophistication of design and construction of this outstanding example. In proportion and composition this piece is a direct descendant of the Renaissance *buffet deux-corps*.

181. BUFFET: LATE 18TH CENTURY; PINE, 54¾"H X 58¾"W X 23¼"D.

It is most unusual that a buffet should function also as a writing desk, but such is the case here — the inclined top permits writing from a standing position, and it is hinged, giving access to utensils and paper stored inside. The panels are symmetrically composed, with an interesting folk treatment in the form of relief-carved hearts in the upper corners. Quebec Provincial Museum.

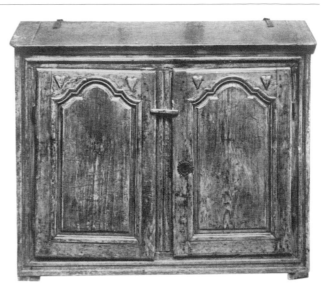

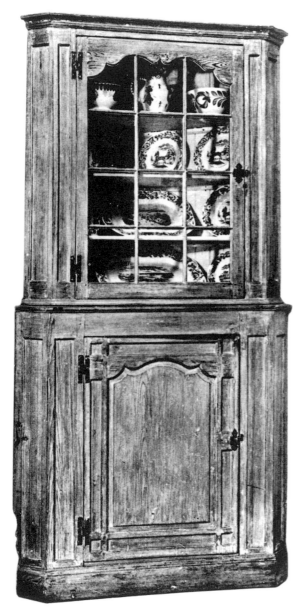

182. ARMOIRETTE: LATE 18TH CENTURY; PINE; 23½"H X 15¼"W X 7½"D.

This tiny one-door cupboard is a rare form among French-Canadian examples. It may have functioned as a hanging cupboard, or, alternatively, one set upon a shelf, to house a religious sculpture or personal possessions of considerable importance. The door features a finely wrought panel carved in the symmetrical Louis XIV style, and the cupboard is finished in its original green painted colouration.

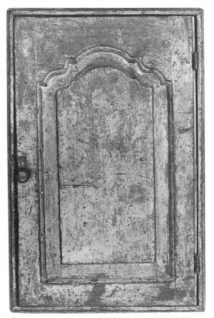

183. CORNER CUPBOARD: LATE 18TH CENTURY.

Corner cupboards, particularly when placed in the area where the household dined, enabled the family to make public display of their finest chinawares. Such cupboards were sometimes stylish, commensurate with their contents. This example from Verchères, east of Montreal, is of superb construction, with unusually complex framing and panelling of stiles, and intricately shaped panels and arches in the lower and upper doors. Quebec Provincial Museum.

184. CORNER CUPBOARD: 18TH CENTURY.

While few arched Quebec corner cupboards are known (a notable example in the English tradition within Quebec is shown in fig. 239), cupboards with rounded or vaulted interiors are extremely rare indeed. This Renaissance-inspired piece features architectural details on its facade, notably fluted pilasters and a central keystone. The barrel-form interior is constructed of several pieces, with applied ribbing to convey the illusion of a shell-carved back. Museum of Fine Arts, Montreal.

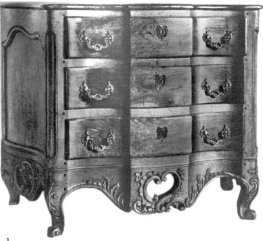

185. COMMODE: LATE 18TH CENTURY; BUTTERNUT; 33¼"H X 34"W X 20¾"D.

The boldest manifestations of the Canadian rococo Louis XV style are found in several serpentine-fronted commodes made in the region of St. Geneviève de Pierrefonds near Montreal. This example is notable for its finely executed *rocaille* carving; there is asymmetrical cutting of the cartel through the front and side skirts and relief-carved acanthus and floral carving along the bottom edges and area surrounding the openwork design. Similar carved elaboration extends also to the curved feet. It has been suggested by Palardy that the forward-projecting centre section may indicate an influence from American block-front furniture, but the existence of such blocking in European furniture, particularly from areas of Germany and the northern countries, may broaden considerably the range of possible design sources for this phenomenon in French Canada. ROM (Canadiana Department).

186. COMMODE: 18TH CENTURY; BUTTERNUT; 30½"H X 36½"W X 21¼"D.

A three-drawer butternut commode, this interesting piece is a simpler version of the previous example. The openwork carving on the end skirts is symmetrical, hence less emphatically in the Louis XV style. The carved shell at the lower front is similarly balanced, completing the symmetry of the double sweeping curve which begins at the base of the feet, follows the apron, and meets at the bottom of the projecting centre section. The blocking of the drawers and case is highly pronounced. ROM (Canadiana Department).

196. ARMCHAIR: LATE 17TH CENTURY; BIRCH; 49½"H X 25½"W X 21"D.

Reputedly made originally for Jean Talon and used in his large house near Charlesbourg, this commodious chair is of Louis XIII styling with chamfered feet and panelled back. The curvature of the arms is unusually pronounced; an upward scroll near the back precedes the downward curve to the front posts. Museum of Fine Arts, Montreal.

197. ARMCHAIR: LATE 17 OR EARLY 18TH CENTURY, MAPLE AND BUTTERNUT; 31"H X 21"W X 19"D.

This heavy armchair is one of the earliest of Quebec forms. Its posts and stretchers are comprised of turned sections and chamfered cubes, very much a Louis XIII feature. The back is a complex structure of a framed panel above which three finely defined balusters are flanked by turned extensions of the back stiles. The original black finish can be seen through the worn old red colour. ROM (Canadiana Department).

199. SIDE CHAIRS: LATE 17TH OR EARLY 18TH CENTURY; MAPLE; 38"H X 14"W X 13¾"D.

These maple side chairs, from the Hospice of the Grey Nuns in Quebec City, feature finely turned stretchers and legs in the Louis XIII manner. The backs of the chairs, with their arrangement of five turned balusters between plain slats and scrolled crests, are given a slight backward cant. ROM (Canadiana Department).

198. TWO CHAIRS: EARLY 19TH CENTURY; BIRCH; (TOP) 30½"H X 12¼"W X 14¼"D; (BOTTOM) 29"H X 15½"W X 13"D.

Seen directly from the front, these chairs would be indistinguishable from the popular Ile d'Orleans type made widely throughout the 18th century; from the side, however, they reveal the cross-fertilizing influences of various styles which continually brought changes to country furniture in French Canada. The sturdy, boxlike proportions of the lower structure are of traditional Louis XIII design, while the curvature of the back posts gives evidence of Régence influence, which saw the introduction of gentle curves, marking a transition to the more flamboyant design of the Louis XV style.

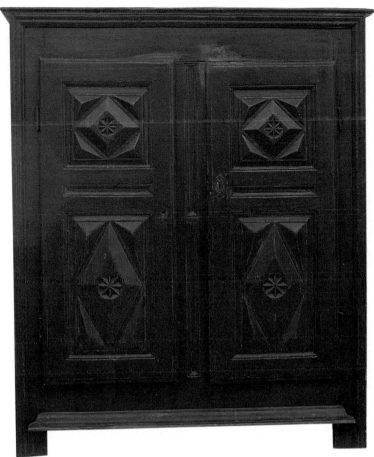

200. ARMOIRE: 18TH CENTURY;
PINE; 61¾"H X 51½"W X 20"D.

Armoires and buffets of Louis XIII style are generally of simple design and symmetrically composed, with linear profiles dominant in both the whole and in detail. Here the severity of the characteristic Louis XIII diamond-point patterning is modified by finely carved compass stars. This carved device relates this piece to several other armoires, notably those illustrated in figs. 167 and 168. The finish is a very old dark red over the original blue paint.

201. ARMOIRE, LATE 18TH OR EARLY 19TH CENTURY; PINE; 58½"H 47½"W 19½"D.

Intersecting diagonal channels producing a St. Andrew's Cross motif are used to capable effect on the front and sides of this interesting armoire. The use of carved demi-lunes at the outer edges of the raised panels is an unusual innovation, creating a lively interplay of circular and linear movements within each of the large rectangles defining the geometry of the piece. Original *fiche*-hinges and painted finish make this an appealing expression of French-Canadian country furniture.

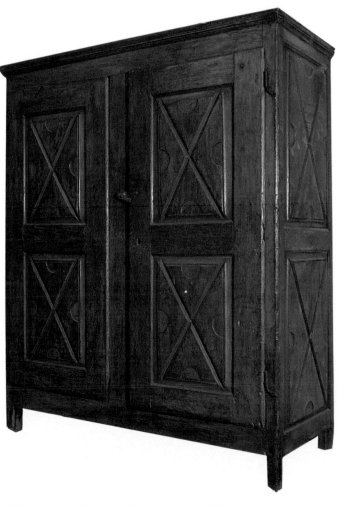

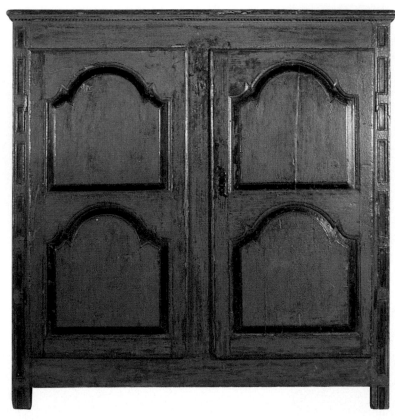

202. ARMOIRE: LATE 18TH CENTURY; PINE; 52"H X 50¾"W X 17"D.

This beautiful and unusually short armoire (only marginally higher than it is wide) is strongly symmetrical in its design arrangement, with four raised panels, each carved in Louis XIV style. Similar panels on the sides are surmounted by St. Andrew's Crosses. Dark ochre panels and stiles with deep-blue coloured channels provide dramatic contrast in this rare armoire which is rich in both its painted and carved ornament.

203. ARMOIRE: EARLY OR MID-19TH CENTURY; PINE; 53¾"H X 33"W X 18"D.

One-door armoires are sometimes called *bonnetières*, alluding to a use more common in France than in French Quebec. In Quebec they rarely served the purpose of storing bonnets, but functioned rather as small armoires. The zigzag incisions, accentuated by colour contrast of green and cream, is highly reminiscent of designs found on objects known to have been made or decorated in Native communities in Quebec. This piece was found at Loretteville, and is most likely the work of a French-Canadian furniture maker attracted by the aesthetic potential of such indigenous geometric design-work.

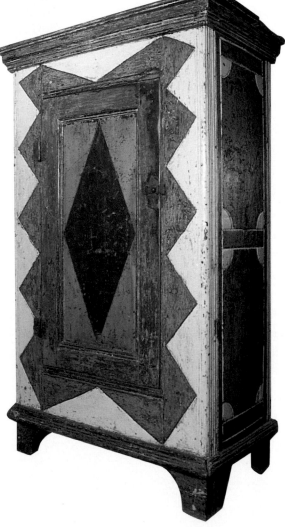

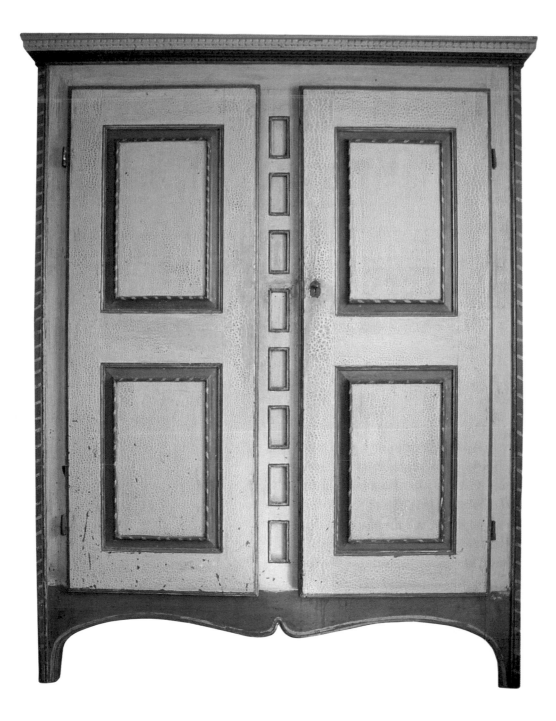

204. ARMOIRE: MID-19TH CENTURY; PINE; 71¼"H X 56"W X 21½"D.

This armoire is striking in its chasteness of line. A double-curved bracket base constitutes the single deviation from the rectilinear emphasis of case, doors and panels. Its painted treatment, completely original, is particularly dramatic. The strong yellow-ochre finish of the doors, frieze and stiles provides bold contrast to the alligatored deep blue colour of the base, edge mouldings, lower cornice and panel surrounds. These intense fields of colours are enclosed within a framing device achieved by the painting of pink-vermillion diagonal stripes along the moulding edge of the case. This armoire is a rare specimen of polychromed Quebec case furniture, many examples of which have undoubtedly been lost in the process of stripping the original finish or over-enthusiastic taking away of later layers to reveal what is believed (sometimes mistakenly) to be a monochrome original finish.

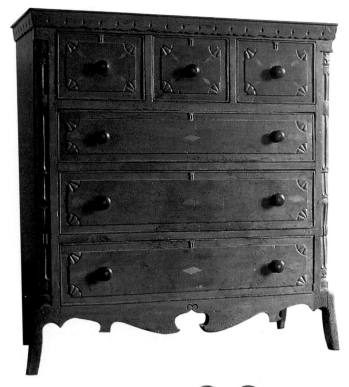

215. CHEST OF DRAWERS: MID-19TH CENTURY; BUTTERNUT; 49"H X 47"W X 19"D.

Several chests of drawers found in the County of Kamouraska and elsewhere east of Quebec City appear to be products of the same workshop. Most of them are made of butternut and are distinguished by carved or inlaid decorative treatment. This piece with simple rounded corner columns is given dramatic impact by its placement on high, flaring feet, such "French" feet being a notable English phenomenon in French Canada! The carved corner fans, although executed primitively, place this chest within the broad range of neoclassicism which affected architecture and furniture design well into the 19th century, before the onset of the Victorian fascination with baroque and rococo elements.

216. TALL CLOCK, MONTREAL: MID-19TH CENTURY; PINE.

The firm of Ira Twiss and Company, previously active in New England, made tall-case clocks in Montreal in the early 19th century. The works here and on other Twiss clocks are English, with cases made at the Montreal establishment. Late 18th-century Chippendale design characterizes most tall-case clocks made in Quebec, the French *bombé* form having no Canadian counterpart. The bold feather-graining and abstract painting is a typical Twiss feature. Upper Canada Village.

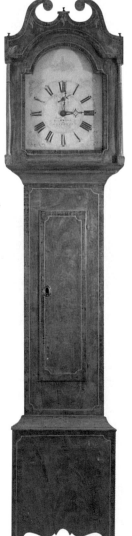

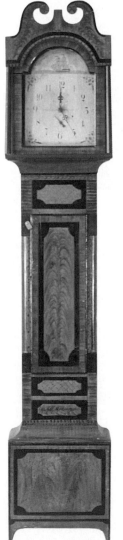

217. CLOCK: CIRCA 1809–1813; PAINTED PINE.

Made by Seth Thomas and Silas Hoadley during their brief partnership at Plymouth, Connecticut, this tall clock was reputedly purchased for the newly-built home of Loyalists living at Stanstead in Quebec's Eastern Townships. The painted decoration is a veritable sampling of colours and techniques. The clock was recently owned by Henrietta Banting, wife of the co-discoverer of insulin, Frederick Banting. Other Thomas-Hoadley clocks found within 20 miles of Stanstead suggest the presence of an active salesperson in the area at that time.

218. CHAIR: 18TH CENTURY; BIRCH.

The high-backed chair of the early French-Canadian home, particularly the relatively grand chairs owned by the well-to-do householder, provided protection against cold drafts when the occupant faced the hearth. In this respect it performed the function of the high-backed settle. Eighteenth-century chairs of Louis XIII style are solid in their rectilinear design. Stretchers and posts are complexly articulated, being composed of a series of alternating turned and squared sections. These are usually rendered as ball- or trumpet-turnings in juxtaposition with chamfered cubes. The single concession to gracefulness (and comfort) is the characteristically curved arm resting on front or medial posts. Their design is similar to English William and Mary chairs of the same period, a fact which likely accounts for the mistaken illustration of this Canadian chair as an American piece in Wallace Nutting's *Furniture Treasury* (fig. 1966). The leather covering is a Victorian updating of the traditional earlier fabric of 18th-century practice.

219. CHAIR: 18TH CENTURY; BIRCH.

Rectilinear severity gradually gave way to a baroque elegance in the design of French-Canadian chairs as Louis XIII style eventually yielded to the styles of Louis XIV and XV in the middle and later decades of the 18th century. Scrolled arms, legs and stretchers replace the more static alternating-components approach of the earlier style with the emerging popularity of the *os-de-mouton* (sheep-bone) motif. As a profile, the *os-de-mouton* curve exhibits similarities to the *arbalète* (crossbow) curve used on the facades of commodes and some buffets. That such chairs were originally the property of the higher-ranking officials and owners is borne out in the early Canadian custom of referring to them as *fauteuil du seigneur*.

220. CHAIR AND FOOTSTOOL: MID-18TH CENTURY; BIRCH;
CHAIR: 42½"H X 26"W X 21"D;
FOOTSTOOL: 15¼"H X 26"W X 19½"D.

This well-articulated *os-de-mouton* armchair is accompanied by a footstool of similarly graceful design, made all the more dramatic by virtue of its compression within a small space. The chair had undergone some modification to serve as a "potty," necessitating the removal of the centre stretcher (since restored). This example is a charming provincial rendering of a more sophisticated form made in the cities of both France and New France. The footstool, with its original black painted finish, is a rare manifestation of the *os-de-mouton* form.

221. ARMCHAIR: EARLY 18TH CENTURY; BIRCH; 39"H X 19"W X 17½"D.

The extraordinary proliferation of turnings on legs, post and stretchers of this maple chair from the Montreal region shows how far the Louis XIII style could be taken. The slender lines make this is an especially elegant example. The distinctive shaping of its slats, a double curve on top and carved returns below, in combination with a rush seat, earns for these chairs the appellations of "salamander," or chairs *à la capucine*, a form Jean Palardy has called one of the most beautiful in Canada. ROM (Canadiana Department).

222. ARMCHAIR: 18TH CENTURY; MAPLE; 43½"H X 22"W X 17½"D.

Of somewhat later construction, this armchair reveals the competing stylistic options available to a chair maker of the day. The alternating ring-turnings and chamfered cubes are of Louis XIII influence, but the turnings of the stretchers are greatly simplified and stand somewhat in contrast to the overall design of the chair. There is some evidence of a falling-off from the graceful curvilinear character of the preceding example in the general flattening-out of arms and slats. A remarkable feature of this chair is the upward thrust of the back, in which the normal arrangement of three salamander slats is here replaced by five. ROM (Canadiana Department).

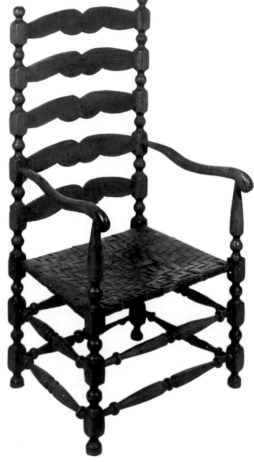

223. CHAIRS: LATE 18TH OR EARLY 19TH CENTURY;
(LEFT) BIRCH; 37¼"H X 18½"W X 13½"D;
(CENTRE) BIRCH, WITH ELM BARK SEAT; 30½"H X 10½"W X 10½"D;
(RIGHT) BIRCH, WITH PINE SEAT; 31"H X 12¼"W X 12¼"D.

The country chairs of Quebec show striking inventiveness in their borrowing of construction or design details from many sources. While it is not altogether clear what has inspired the lobed additions to the back posts of the *capucine*-style armchair at right, a possible parallel is the English or American Chippendale wing chair. The example at left is probably a child's chair, but possibly intended even for a doll; this dimunitive chair *à la capucine* is well designed to accommodate rugged use, with outwardly splayed legs and a heavy footrest.

224. ROCKING CHAIR: MID-19TH CENTURY; BIRCH;
38"H X 21¾"W X 13"D.

The structure is essentially that of the rustic 19th-century Quebec *fauteuil*, but the widening of the back at the top is a later stylistic development. The slats are an interesting combination; the bottom one has a double curve similar to the upper edge of slats on *à la capucine* chairs. The paired heart cutouts on the upper slats are an appealing personal interpretation on this charming rocking chair found in Belchasse County.

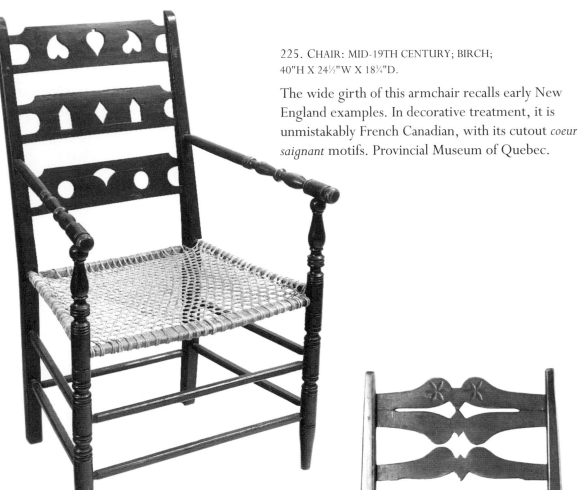

225. CHAIR: MID-19TH CENTURY; BIRCH; 40"H X 24½"W X 18¾"D.

The wide girth of this armchair recalls early New England examples. In decorative treatment, it is unmistakably French Canadian, with its cutout *coeur saignant* motifs. Provincial Museum of Quebec.

226. ROCKING CHAIR: 19TH CENTURY; BIRCH; 36"H X 19½"W X 14"D.

A rocking chair with a scrolled crest of vaguely "salamander" design. Incised six-point compass stars provide a geometric embellishment within the curves of the horizontal rail.

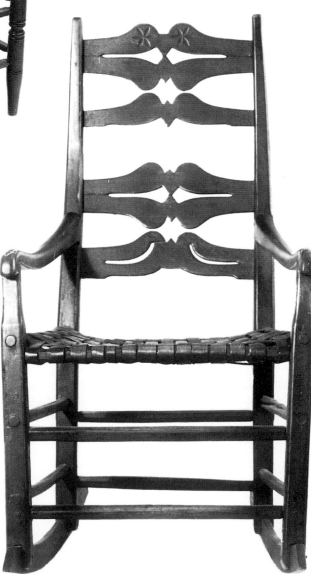

227. PAIR OF ARMCHAIRS: 19TH CENTURY; BIRCH;
(LEFT) 39¼"H X 20"W X 15¾"D;
(RIGHT) 39¼"H X 20"W X 16"D.

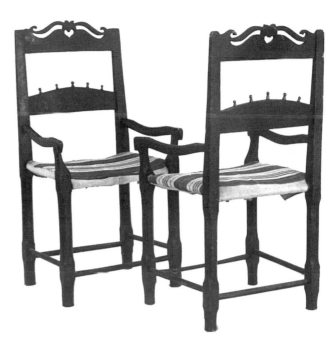

While the essential form of these chairs may be a blend of English Sheraton (particularly the horizontal rails) and French (the curvature of the arms) designs, its decorative motifs are fanciful and beholden to no set tradition. The piercework hearts and ribbon motifs are highlighted by colour; the red interior of the cutouts contrasts with the black finish on the front surface. Gold paint functions almost in the manner of traditional gilding, giving a metal-like appearance to applied wooden turned balls and finials.

228. STOOL: 19TH CENTURY; BIRCH; 20"H X 11½"W X 17½"D.

Made in Lotbinière County, earlier than the erection of Gustav Eiffel's tower in Paris, this delightful stool (from which the French bridge-designer so clearly drew his inspiration) is expertly designed to counter the danger of capsizing. Especially remarkable is that it is fashioned in its entirety from a single massive block, placing it more in the category of *sculpteur* than *menuisierie*.

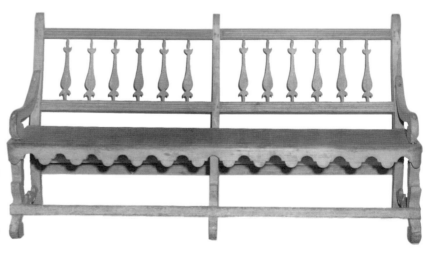

229. BENCH: MID-19TH CENTURY; PINE;
36"H X 68½"W.

Although of rustic construction, this bench pays homage to late 18th-century stylistic refinements found on chairs, armoires and other case furniture. The naïvely scrolled stretchers make faint allusion to the *os-de-mouton* type found on commodious armchairs spanning the Louis XIII and Louis XIV styles, while the scalloped front resembles the bases of armoires of the late 18th century. The heavy cyma-curved feet are planted firmly in the sturdy Empire taste of the mid-19th century, indicating the rather late manufacture of this interesting bench. Detroit Institute of Arts (Founders Society Purchase, Elizabeth and Allan Shelden Fund).

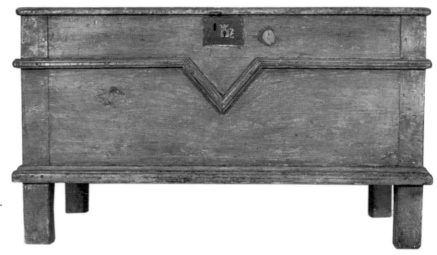

230. STORAGE CHEST: 19TH CENTURY; PINE; 24½"H X 40½"W X 21½"D.

The breaking of the horizontal line of applied mouldings to form a V was a commonly used device in the construction of chests, a French-Canadian variation of a European convention in which the V was sometimes pointed up. The finish on this chest is the original dark blue paint.

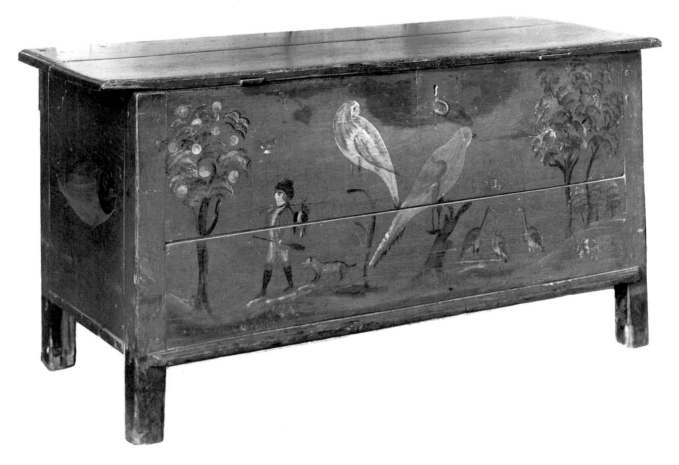

231. STORAGE CHEST: LATE 18TH OR EARLY 19TH CENTURY; PINE; 22"H X 44"W X 19"D.

The form of this pine chest is similar to that of the preceding examples, but the painted decoration is unique. On each end is painted a fish, and the front depicts trees, a hunter, and two stylized birds at the centre, a motif possibly adapted from textiles or lithographs of the time. This extraordinary painted decoration, itself very old, is likely an early afterthought and was executed directly over the original underpaint. Museum of Fine Arts, Montreal.

232. SMALL CHEST: EARLY 19TH CENTURY; PINE; 15½"H X 26"W X 13"D.

Such small chests and boxes were sometimes made by request for special occasions such as baptisms and betrothals. The paired hearts with flames as love symbols suggest the strong possibility that this piece was intended as a token of affection in courtship or even a marriage presentation-piece. Carving of the bottom of the stiles suggests ball feet, while the central relief-carved detail and cartouche are derived from the French rococo and its allusions to rocks, shells and other elements of gardens and grottoes.

233. ALMS BOX: LATE 18TH OR EARLY 19TH CENTURY; MAPLE.

Associated with the Feast of St. Geneviève, the legendary saviour of Paris when the city was threatened with starvation in the 5th century, bread-shaped alms boxes were used in churches of French Canada as an inspiration to charity. In old Quebec, an annual religious festival involved baking tiny loaves of bread to be brought to the church and distributed to the needy.

234. KEEPSAKE TRINKET BOX: MID-19TH CENTURY; PINE.

The chip-carved cross-hatching of this small domed box makes it resemble tooled leather, a covering used on trunks and other containers. The basket containing a plant and a carved heart escutcheon are rendered in red, yellow and green colours, providing strong contrast to the black background of the top and sides.

235. PHARMACIE: 1920; PINE; 26"H X 16½"W X 8"D.

An interesting piece, this medicine chest resembles the bonnet of a tall-case clock, a design on which it may be based. The cabinet is given architectural character by a pyramidal pediment and rope-twist columns which taper from their centres to both ends. Its date and medicinal function are unambiguously indicated by applied numbers and letters on the frieze. It is finished with a red stain.

236. CRADLE: EARLY 19TH CENTURY; PINE AND BIRCH; 26"H X 22½"W X 17"D.

The cradle comprised of four turned posts joined by connecting slab sides and ends is a common French-Canadian form. Setting this particular cradle apart is a painted scheme of variegated stylized flowers against a cream background. The decorative motifs may be of native inspiration. The cradle was found at Caughnawaga. Château Ramezay.

237. CRADLE: EARLY 19TH CENTURY; PINE AND BIRCH; 27"H X 42¼"W X 19"W.

An unusual treatment, lozenge and sun-ray motifs are carved over the entirety of this cradle's ends and sides. ROM (Canadiana Department).

238. MANTEL AND CORNER CUPBOARD, EASTERN TOWNSHIPS: LATE 18TH OR EARLY 19TH CENTURY; PINE.

These remarkable matching pieces were found at the village of North Hatley in the Eastern Townships. They retain their original painted finish of green, dark blue and red. The red lower section of the mantel and cupboard corresponded with wainscott panelling in the rooms where they were situated. The rectangular geometry and fan carving are an English design background, filtered through the American Federal style familiar to the many United Empire Loyalists who crossed into Southeastern Quebec in the 1780s. A most interesting feature is the combination of such English elements with rows of primitively carved shells, more akin to a French baroque interpretation of the motif, along the lower section of the mantel cornice.

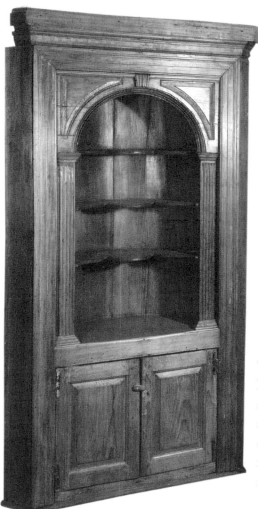

239. OPEN CORNER CUPBOARD: EARLY 19TH CENTURY; PINE; 86"H X 49"W.

The arched cupboard found at Saint-Charles de Bellechasse comes highly recommended in the design books of English cabinetmakers at the end of the 18th century, and was widely made in England and America as a furniture form to emulate the details of Georgian architecture. This greatly simplified cupboard of late Chippendale inspiration retains fluted pilasters, keystone and panelling as its modest show of neoclassical indebtedness. CMC (History Division).

240. Corner Cupboard: Early 19th Century; Pine; 88½"H X 64½"W.

The English influence in Quebec architecture and furniture is most strongly felt in parts of Montreal and also in the Eastern Townships, which received many settlers from New England after the American War of Independence. Its influences were even more widespread geographically, however, as in the case of this corner cupboard from Ste-Lucie, near Rimouski. This piece is a pleasing country interpretation of a formal Adam-style cupboard, reflected in the use of fluted pilasters (including the sophisticated detail of stop-fluting), dentil details on the cornice, and an inset frieze panel. The faintly incised six-point compass stars on the door panels are an informality not expected in the case of the formal prototype but quite at home in a provincial adaptation. CMC (History Division).

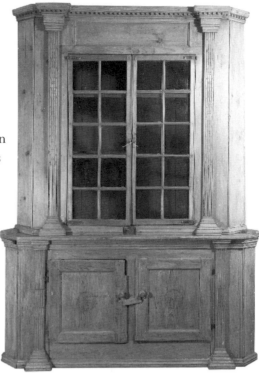

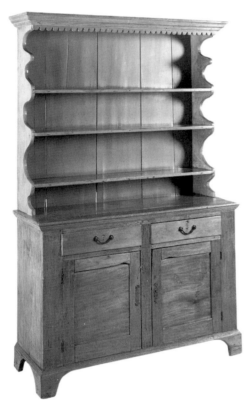

241. Kitchen Dresser: Early 19th Century; Pine; 73½"H X 56½"W X 18¼"D (BASE) (10½"D TOP).

The kitchen dresser, with open top and closed bottom, was an extremely useful form, situated normally in the kitchen where pewter or china was displayed on top and cooking utensils stored in the bottom. In the British Isles, such dish dressers typically had open shelves with straight or scalloped sides, perhaps a modification of an earlier arrangement of hanging shelves above a buffet or table. This example exhibits British or American influences in the carved treatment of its overhanging cornice and reversing curves of the sides. Its English simplicity is in marked contrast to the richly curved panelling of the French-inspired *vaisselier* in fig.17. ROM (Canadiana Department).

242. Settle Bed: Mid-19th Century; Pine; 37¾"H X 76¼"L X 20¼"D.

Found near Hemmingford, in the southwestern corner of Quebec, close to the Ontario and New York borders, this settle has a strong American resonance. While the bottom is essentially a panelled box, the back and arms can be seen as an extended form of the Windsor-style spindled chair. This piece is finished in a dark blue colour.

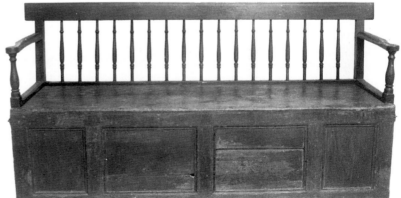

243. Settle Bench: Early 19th Century; Pine; 41"H X 69½"W X 25"D.

It sometimes suggested that the idea of the settle bench was brought to French Canada by Irish immigrants, a claim worthy of further examination. The arrangement of inset panels is indeed highly reminiscent of high-backed settles popular throughout the British Isles, and the unusual framing of the base of this piece appears to be derived from the high-bracketed storage chest of Anglo-American design. ROM (Canadiana Department).

244. Chair: Circa 1800; Maple and Butternut, with Pine Seat; 29½"H X 13½"W 13¼"D.

This chair dramatically illustrates not only amalgamation of styles but also integration of beauty and function. The cutout for the commode appears to be original, and not a later adaptation. Seen from the side, this is very much a French-Canadian chair, with curved arms sloping downward to rest on tapered square posts. Seen from the front, it is a classic country English Chippendale chair, with the pierced splat, scrolled crest and carved ears associated with that school. While such attention to style is to be expected in the making of a dining-room or parlour chair, it is quite surprising to encounter such sophistication in a chair reserved for more discreet occasions. This chair, of maple and pine construction, retains its worn blue painted finish. ROM (Canadiana Department).

245. Washstand: Mid-19th Century; Pine; 43"H X 33½"W X 21"D.

A predilection for figured maple and for neoclassical (particularly American Empire) design is evident in much mid-century furniture made in the English-speaking communities of the Eastern Townships and in Montreal. This table amalgamates Hepplewhite elements in its tapered squared legs with the American Empire scrollwork of the gallery. The *faux*-maple finish is expertly executed to the extent that even the ripples of figured maple are given tactile expression in the painted surface.

246. CHEST OF DRAWERS: 1852; BUTTERNUT AND MAPLE.

Within the group of closely related chests of drawers shown in figs. 15, 215 and 247 are several pieces with quarter columns at each side of the front, usually ebonized and sometimes embellished with rope-carving. This piece, with plain, ebonized quarter columns, features maple inlay decoration set into a darker butternut background.

Considerable refinement is imparted to the chest by virtue of its elegantly scrolled skirt and flared French feet, reflecting perhaps a Hepplewhite influence in its design. Inlaid details include escutcheons, banding, stylized trees and the date. ROM (Canadiana Department).

247. CHEST OF DRAWERS: MID-19TH CENTURY; BUTTERNUT.

This Kamouraska County chest, with barley-twist corner columns and carved initials *FS*, is a refreshingly provincial adaptation of English styles as interpreted within a French-Canadian context. The carved oval fans, most successfully articulated in the designs of Adam and Sheraton, seem to have exercised undue influence upon the maker of this piece, who used the motif eight times, then provided further echoes of it in corner fans and even the design of tree-like motifs.

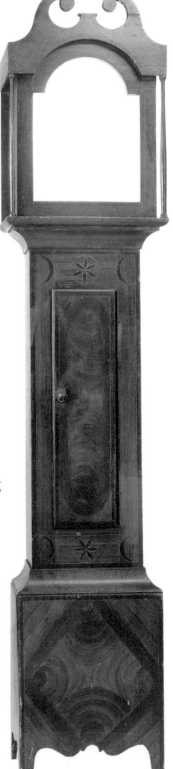

248. TALL CLOCK, MONTREAL: MID-19TH CENTURY; PINE.

Many of the clock cases made by the Twiss company of Montreal are finely painted, usually as paint-grained imitations of exotic hardwoods or *faux-*marble. This outstanding clock case features a variety of feathered and grained techniques, and the unusual elements of quarter moons and six-point compass stars.

ONTARIO

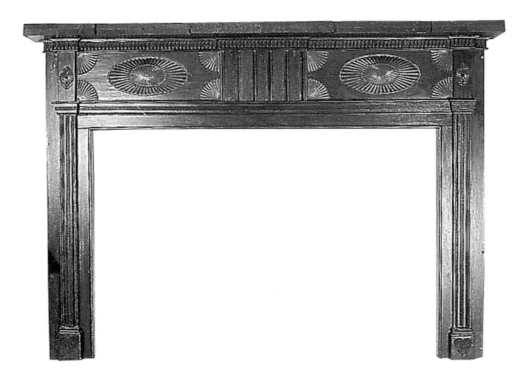

249. MANTEL: 1805; PINE.

That highly competent cabinetmakers and other artisans came to Upper Canada in the ranks of the Loyalist immigration in the late 18th century is made more than abundantly apparent by the high quality of furniture and architectural detail found in settlements from the St. Lawrence to the shores of Lake Ontario and Lake Erie. This mantel from the Niagara region (removed from an 1805 house in Louth Township) is in the best of the Sheraton and Adam styles, with carved ovals, fans and other refinements. The carved-out channels are precisely rounded and finished, and the arrangement of elements is one of consummate design sensibility. An early feather-grained painted treatment covers the original blue finish.

250. MANTEL: EARLY 19TH CENTURY; PINE; 48"H X 78"W.

A group of cupboards and architectural details made in Lennox and Addington County have been given the alliterative title "Napanee Neoclassical" (see Pain, p. 178). The carving of the central oval motif is less sophisticated but of bolder profile than the carving in the preceding example. The fluted columns, mounted in pairs, correspond to a format used on many cupboards from this region, including one found in the same house with the mantel (fig. 251).

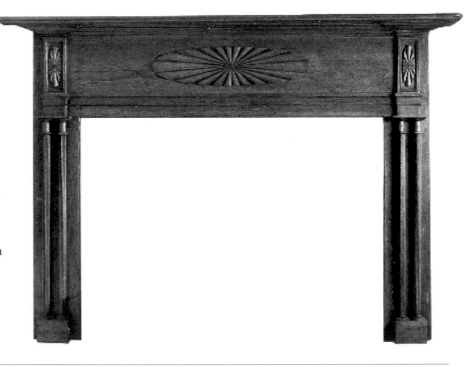

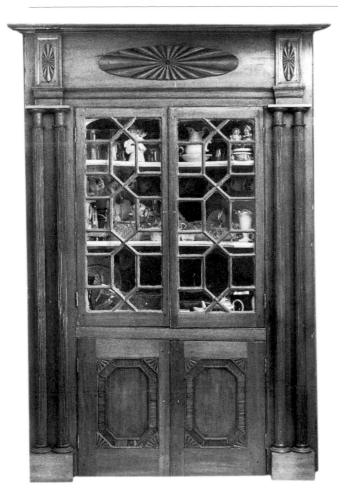

251. CORNER CUPBOARD: EARLY 19TH CENTURY;
PINE; 95"H X 48"W.

This imposing corner cupboard by the maker of the
mantel in the preceding illustration is thoroughly
architectural in its conception, with free-standing
paired columns and a decorative frieze. Reeded
borders with canted corners establish the panel
design on the lower doors, vaguely echoing the
diagonal glazing above. The architectural theme is
continued in the interior, with carved corner fans
flanking an arch supported on short reeded square
columns.

252. CORNER CUPBOARD: EARLY 19TH CENTURY;
PINE; 88½"H X 54"W.

This corner cupboard from Odessa in the Napanee area
uses the conceptual framework of the cupboard in fig. 251
but approaches the design of the whole with a different
execution of detail. While the canted-corner bandwork is
used once again on the lower doors, carved ovals in the
panels draw attention to the centre of the composition.
Parallel channels replace the paired columns in
establishing continuous vertical movement toward the
heavily moulded cornice. In contrast to the uninterrupted
horizontal lines of the top of the cupboard in fig. 251,
the cornice here is blocked to emphasize the sculptural
quality of the pilasters, and to provide a dynamic
interplay of foreground and background. This deliberate
interruption of the horizontal in favour of the vertical is
further intensified by the placement of rectangles and
squares across the frieze and capitals, so that each detail is
related to pilasters and doors below.

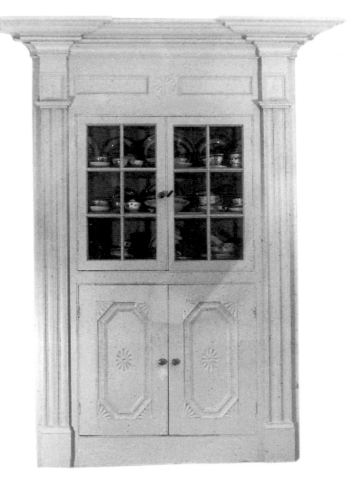

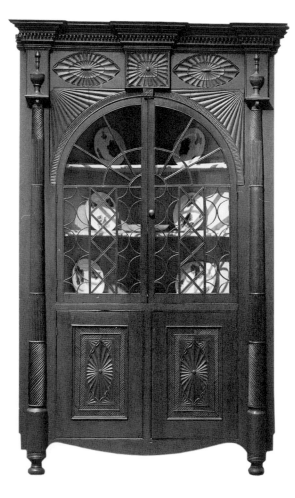

253. CORNER CUPBOARD, FRONTENAC COUNTY:
EARLY 19TH CENTURY; PINE; 88"H X 50"W.

An outstanding example of the Ontario vernacular interpretation of high style is seen in this corner cupboard from the Napanee area. It is one a group of related pieces, but it represents the culmination of this maker's predilection for carved detail. The fans and shells are in the mainstream of designs developed in the tradition of Thomas Adam, probably seen elsewhere on more formal furnishings, and mantels or as architectural embellishments. The applied columns provide a sampler of carving and fluting. The lightness of the turned feet and serpentine skirt seem somewhat out of place on an architectural cupboard; but such is the freedom of spirit which characterizes provincial adaptation of classical furniture forms. ROM (Canadiana Department).

254. CORNER CUPBOARD: EARLY 19TH CENTURY;
PINE; 83"H X 58"W.

Not to be outflanked is this broadly neoclassical corner cupboard from upper York County, north of Toronto. The cupboard has two plain glazed doors, temporarily removed at the time of the photograph. No effort has been made to compress the visual girth of this large piece: reeded pilasters have unusually wide margins on either side, and the doors are of extreme width without a centre stile. The channelling of the radiating fans or sunbursts is deep and vigorous; the three-dimensionality extends even to showing the curvature of the folds of these segments where they meet the arch. In its old ochre, plum and other colours, this corner cupboard is a dramatic expression of provincial cabinet-making.

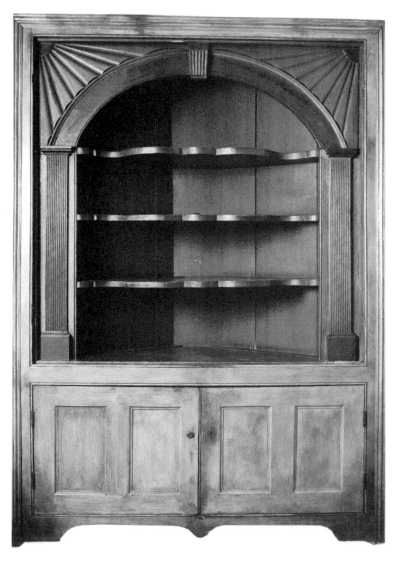

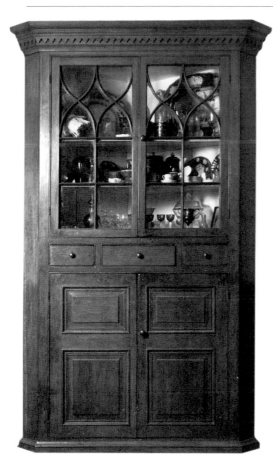

255. CORNER CUPBOARD: SECOND QUARTER 19TH CENTURY; PINE; 75"H X 51"W.

In another context, it was once suggested by a Canadian architectural historian that while America went neoclassic, Canada went Gothic (Anthony Adamson, *The Gaiety of Gables*, pp. 16–17). In furniture, both forms were readily accepted in early Ontario households. This immensely pleasing corner cupboard is lightly graceful in contrast to the stolid character of neoclassical forms. The glazing of the upper doors is defined by double Gothic tracery, with identical ogee arches set in opposite directions to provide an elegant pattern of intersecting curves.

256. GLAZED CORNER CUPBOARD: SECOND QUARTER 19TH CENTURY; PINE; 82⅜"H X 71¼"W X 34½"D.

A very large corner cupboard, of butternut construction, but painted dark green. This cupboard comes with considerably more than the average history. An inscription on a drawer reads, *This cupboard has been made by Charles C. Joynt for Henry Polk and his wife Letticia, April 1863.* Little has been spared in the decorative vocabulary here. Embellishments include vertical reeding, diagonal reeding, chip-carving, moulding, channelling, saw-carving and every manner and arrangement of elements, side-by-side or applied one on top of the other. The vast breadth of this piece is only slightly tamed by the doubling of columnar elements (flat pilasters and reeded half-round supports) in combination with open (unglazed) and panelled doors. The Polks resided in Bastard Township, Leeds County, and the cupboard is reported to have been passed down through the Joynt family, descendants of the original owners, and moved to a home in Portland. Nearly a century later, removal of the cupboard required the partial destruction of the house in which it rested (or rather, the cupboard upon which the sagging ceiling of the house had eventually come to rest). CMC (CCFCS).

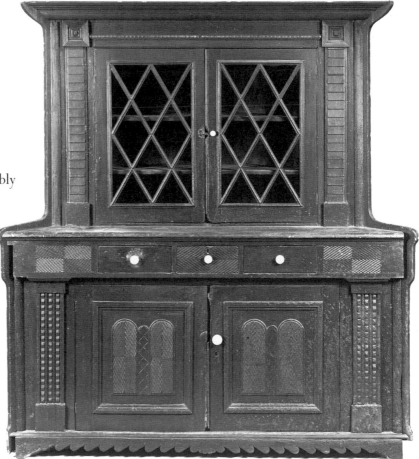

257. GLAZED CUPBOARD: SECOND QUARTER 19TH CENTURY; PINE; 83"H X 42"W.

Very much in the British tradition of the parlour corner cupboard, this piece from Georgetown is intended to be displayed as good furniture just as its contents are meant to be good china. A hinged panel permits its further use as a secretary. The diagonal glazing and fretwork band applied to the frieze are Chippendale motifs used on formal furniture and interpreted here very capably in this country piece of pine construction. One variation from the traditional English cupboard of this type is the division of doors into eleven sections, rather than the customary thirteen glazed sections.

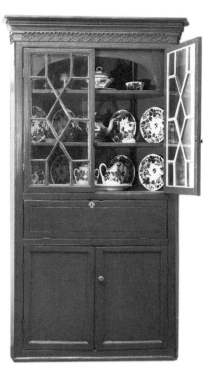

258. DISH DRESSER: EARLY 19TH CENTURY; PINE; 72"H X 48"W X 19½"D.

With shelf intervals of varied heights, the upper section of this dresser can accommodate a mixture of wares, from cups to plates stood on end and leaned forward against the narrow plate-rails. Vertical beaded boards are used in its construction. The scrolled edge that leads from the back to the projecting work surface and lower section, as well as the arched front, impart considerable style to this utilitarian piece. The openwork section provided storage and easy access to pots and pans or other utensils.

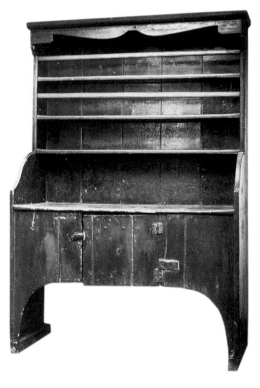

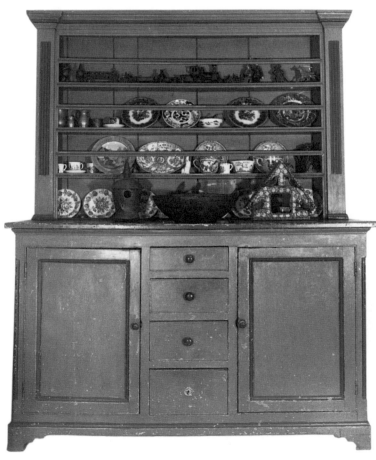

259. DISH DRESSER: EARLY 19TH CENTURY; PINE; 88"H X 70½"W X 24"D.

Ontario dish dressers rarely possess the strong neoclassical character of this dresser from near Crief at the juncture of Wentworth, Waterloo and Wellington counties. An impressive architectural interpretation is effected by means of fluted pilasters, with bases, capitals and entablature. This striking dresser retains an old polychrome finish which accentuates the generous sculptural detail.

260. DISH DRESSER: EARLY OR MID-19TH CENTURY; PINE.

An interesting variation is found in this Central
Ontario dresser with its unusual panelling, featuring
ovals over rectangles.

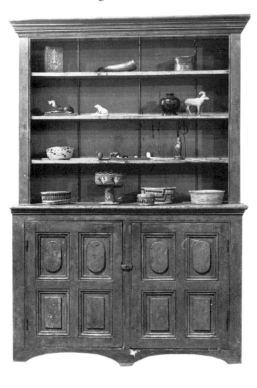

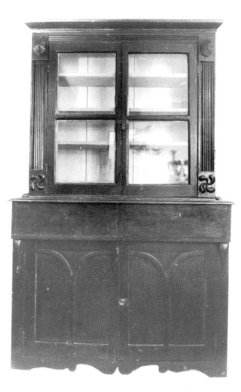

**261. GLAZED CUPBOARD: THIRD QUARTER 19TH CENTURY;
PINE; 81½"H X 49"W X 22"D.**

While such geometric decoration is unusual in Anglo-
Ontario furniture, the whirling-pinwheel motif
applied here as a high-relief detail may reflect an Irish
background, where such enhancements appeared as
fretwork motifs on dressers. The eclectic mixture of
design elements in this interesting glazed cupboard
include Adamesque ovals in the upper corners and
Gothic banding of the lower door panels. A dark
brown painted finish imparts a suggestion of formality
to this pine cupboard from Prince Edward County.

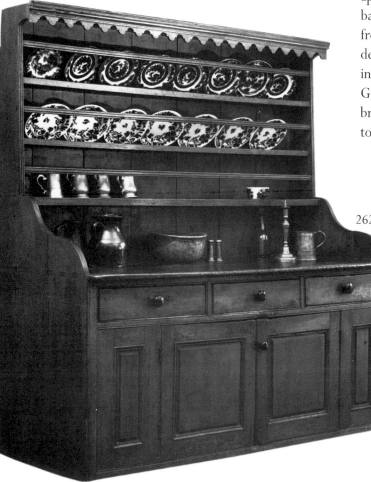

**262. DISH DRESSER: EARLY 19TH CENTURY; PINE;
81½"H X 72"W X 32"D.**

The extraordinarily generous proportions of
this dish dresser from York County are in the
English or Scottish tradition, in contrast to the
shallower Irish dresser. While the early kitchen
dresser in the British Isles evolved from what
was essentially a wall shelf hung over a table,
this Canadian example resembles more the
amalgamation of shelving with the sideboard.
Style has become no less important than utility
in this grandly conceived piece.

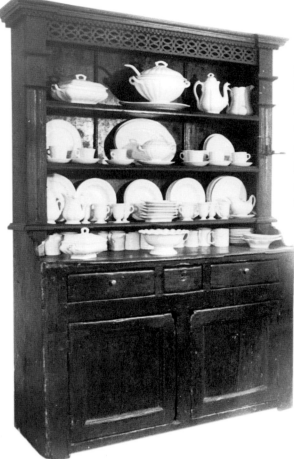

263. DISH DRESSER: EARLY 19TH CENTURY;
PINE; 82"H X 59"W X 19"D.

An architecturally influenced dresser from Peterborough County (Douro Township), this example is strongly Irish in character. Like prototypes from Ireland, the fretwork frieze is highly decorative. In the Canadian context, it bears strong resemblance to dish dressers found in the Margaree Valley of Cape Breton (see figs. 43, 44, 96), another area of Irish and Scottish settlement. This large dresser is striking evidence of the perpetuation of traditional forms in the Irish settlement established by Peter Robinson near Rice Lake in 1825.

264. CUPBOARD: SECOND QUARTER 19TH CENTURY;
PINE; 85¼"H X 50"W X 15½"D.

This solid-door cupboard was found in the Black family home, a Regency stone house at the border of Brant and Waterloo counties, between Ayr and Paris. Unlike Germanic furniture from a few miles to the north, this cupboard is constructed with flush doors and drawers more typical of British cabinetmaking. It is a capably constructed piece with fine dovetailing and edge-beading on drawers and doors. The dark red painted finish is original to the piece.

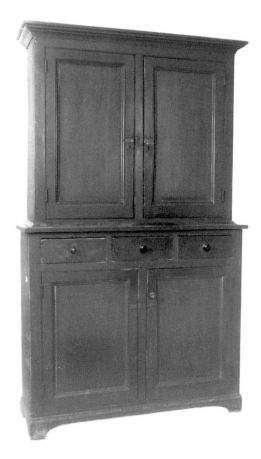

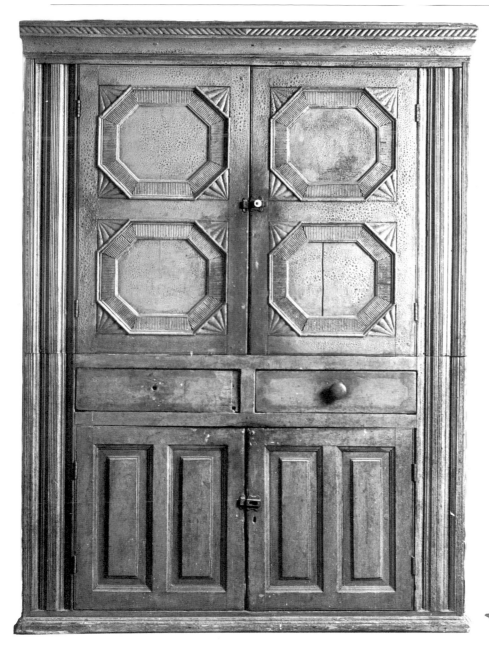

265. CUPBOARD:
MID-19TH CENTURY; PINE;
70"H X 51"W X 17"D.

Found at Woodville in Victoria County, this stout kitchen cupboard is rich in Irish traditional design characteristics, themselves an interpretation of the English neoclassical style developed by Adam and popularized by Sheraton. In form, this piece hearkens back to the Renaissance cupboard, including the two-piece *buffet à deux corps*. The neoclassical details include octagonal panels with surrounding bands of reeding, carved corner fans, vertical channelling of stiles, and a rope-turned horizontal strip, with its two sections juxtaposed to create a chevron effect just beneath the shallow cornice (cut off at each end). The old blue-grey paint covers an original brown finish.

266. CUPBOARD: SECOND QUARTER 19TH CENTURY; PINE.

This unusually elegant cupboard was found at St. George in Brant County. While beaded mouldings along stiles and at the corners provide a pleasing continuity of line, this cupboard is also appealing because of variations between sections. Panels are fielded on the bottom and flat on the top section, square rather than rectangular, and plain rather than enclosed within moulded frames. The cornice is striking in its exceptional projection. The interplay between fluidity and the dynamic of contrasts indicates a maker with strong sensitivity to design possibilities.

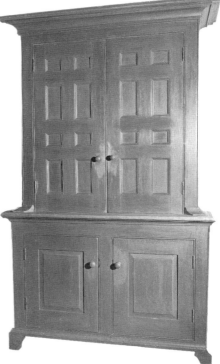

271. STORAGE CHEST: EARLY 19TH CENTURY; BUTTERNUT;
40"H X 37"W X 18"D.

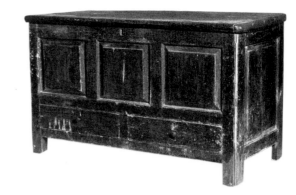

This chest is of an early form that precedes English settlement in Upper Canada by as much as two centuries. Frame-and-panel construction was an early joiner's technique, used in England and elsewhere from Renaissance times. This heavily constructed example, whose similarities to the English "mule-chest" have been pointed out by Howard Pain, features bold fielded panels and square stiles extending beneath the bottom to form feet, all characteristics of late 18th- and early 19th-century construction. It was found in Ontario County, east of Toronto.

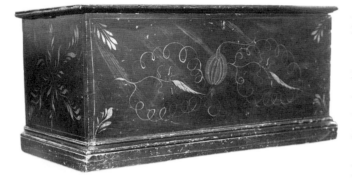

272. STORAGE CHEST: SECOND QUARTER 19TH CENTURY;
PINE; 19"H X 37½"W X 18"D.

Simple in form, the aesthetic strength of this piece from Prince Edward County is its painted decoration. Against a grain-painted background is a composition of pomegranates, leaf and floral motifs, and delicate flourishes, likely the work of an accomplished wagon- or sign-painter. A similar treatment is found on the hanging wall-box in fig. 349.

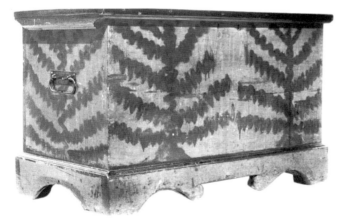

273. STORAGE CHEST: SECOND QUARTER
19TH CENTURY; PINE; 24¾"H X 40"W X 20¼"D.

Much different from the light, thin-line execution of motifs in the chest in fig. 304 is the rustic forcefulness in the decoration of this box from Iona Station near the Lake Erie shoreline in Southwestern Ontario. The bold series of tree-like motifs painted around the front, sides and even back of this storage chest is emphatic in its expression.

274. STORAGE BOX: SECOND QUARTER 19TH CENTURY,
PINE AND TULIPWOOD; 11"H X 26"W X 13"D.

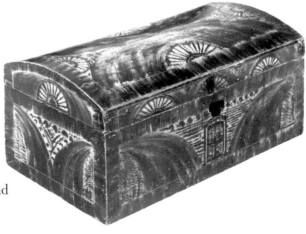

This box was handed down through many generations of descendants of Secord settlers in the Niagara area. Its decorative treatment has much in common with other examples, but the inclusion of carefully painted fans is distinctive, suggesting an attempt to imitate inlaid motifs on Regency furniture of a slightly earlier period. Most of these boxes are constructed of two woods: pine for the top and sides, and tulipwood, which grows in a narrow band along the shore of Lake Erie, for the bottom.

275. STORAGE CHEST: EARLY 19TH
CENTURY; PINE; 30"H X 37"W X 19"D.

In form, what might be considered
a transitional chest, this piece
retains the hinged lid and panelled
construction of early forms, but by
inclusion of an external drawer is a
forerunner of the full-fledged chest
of drawers. While there is a common
tendency to think in terms of
sequential chronology, it is also true
that the drawered storage chest
retained its usefulness in rooms of
limited space. This chest was
reportedly constructed by an Irish
furniture maker in Moscow, Ontario.

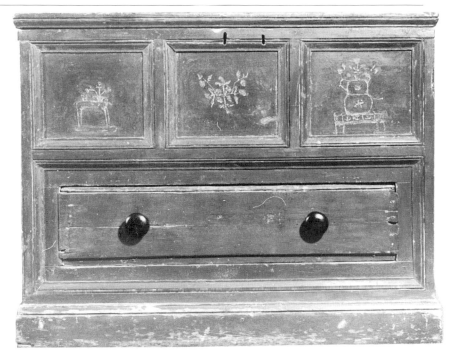

276. CHEST OF DRAWERS: SECOND QUARTER 19TH CENTURY; PINE; 43"H X 43¼"W X 15¼"D.

While the decoration of the so-called "rainbow" boxes and other pieces is almost an exercise
in art-for-art's-sake, in other instances painting was an earnest effort at imitation, namely in
the simulation of expensive hardwoods. In this splendid specimen from Prince Edward
County, the *faux*-mahogany and maple painting is so convincing as to make the distinction
from the hardwood original no small challenge.

283. DESK AND TABLE: SECOND QUARTER 19TH CENTURY; PINE; 39⅝"H X 24"W X 22⅛"D.

Early simple desk-boxes were portable and could be set upon tables or frames; the lift-top desk eventually became an integration of these upper and lower components. The lift-top desk could be used either while standing or while sitting on a high-seated chair. Storage could be accessed through a hinged panel on top. Some desks were also fitted with exterior drawers. The standard form has been highly personalized in this case by elaborately painted motifs, all of which have counterparts in textiles or graphic arts. The undulating grape-pattern on the sides is similar to sampler and quilt borders, and the basket of flowers on the lid resembles theorem designs. It is possible that these designs were worked by the owner of the desk, Eliza McLean, whose name is painted on the back of the gallery.

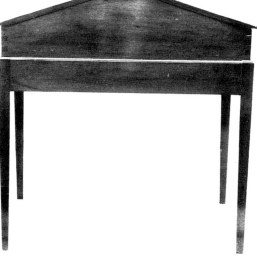

284. DESK: EARLY 19TH CENTURY; WALNUT; 39½"H X 37"W X 24¼"D.

Many of the original furnishings of a commodious house built before 1825 on the shoreline of Lake Erie at Tyrconnell have survived intact. Among these early pieces is this double desk, with identical hinged lids and interior galleries on each side. The desk is of Hepplewhite design, constructed of indigenous walnut and tulipwood, both of which continue to grow in the region (and on this very homestead) today.

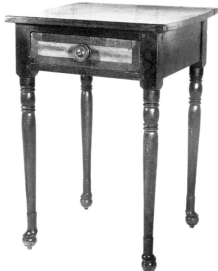

285. TABLE: MID-19TH CENTURY; PINE.

Among Waterloo County pieces exhibiting Anglo-American inspiration, this table is a striking example (a nearly identical table is illustrated in Dobson and Pain publications). The upper turnings are typical of 19th-century Sheraton styling, but the club- or "Dutch" foot is a dramatic throwback to the early or mid-18th century Queen Anne style popular in England and America, but with only occasional expression in Canada. An interesting folk-art variation is found in the snake motifs painted on both sides of the drawer.

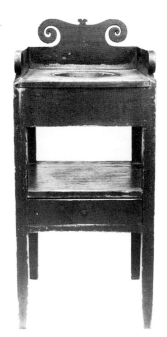

286. WASHSTAND: SECOND QUARTER 19TH CENTURY; PINE; 36"H X 16"W X 16"D.

With the gradual introduction of stoves in place of the earlier hearth, and the consequent heating of bedrooms, the washstand made its appearance in Upper Canadian homes in the first quarter of the 19th century. Most are, in fact, of mid- or late19th-century construction. While early examples show Sheraton or Hepplewhite influence, the Canadian washstand is most often an Empire-style piece. This example from Portland (Leeds County) is a good expression of the form and style with its exuberantly scrolled backboard.

287. CHAIR: EARLY 19TH CENTURY; BIRCH AND ASH; 41"H X 21"W X 16"D.

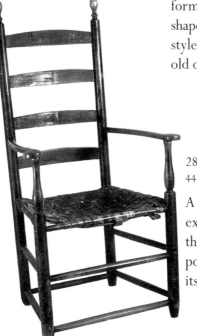

Chairs which make extensive or almost exclusive use of turned posts in their construction, long popular in England, have been termed "carver" chairs in the United States. While the form is an early one, associated with the so-called Pilgrim period (the 17th century), it continued to be popular in areas of Newfoundland and Upper Canada. In this Oxford County example, only the arms are flat; everything else is turned, with one diameter used for posts and another used for stretchers, spindles and horizontal back rails.

288. CHAIR: EARLY 19TH CENTURY; VARIOUS HARDWOODS; 45¼"H X 22"W X 19"D.

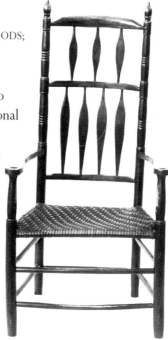

Related in principle to the former example, and to carver chairs in general, this piece found in Toronto is of considerable interest as an example of transitional furniture. The profile is similar to English and American 18th-century forms, and the turnings on the posts and arm-supports also look backward. The shape of the splats, arranged in two tiers, can be seen as flattened spindles, inspired by earlier forms, but also as an anticipation of the arrow-shaped splat popularized in Sheraton and other styles in the 19th century. This chair retains an old or original red painted finish.

289. CHAIR: EARLY 19TH CENTURY; HARDWOODS: 44½"H X 20½"W X 15¼"D.

A tall slat-back armchair from Eastern Ontario, this example is distinguished by graceful turnings beneath the arms and robust mushroom-finials capping the back posts. This chair is at once simple and imposing, given its unusual height of nearly four feet.

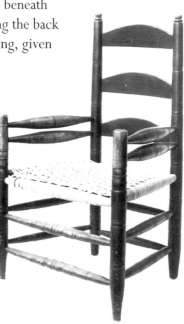

290. CHAIR: SECOND QUARTER 19TH CENTURY; VARIOUS HARDWOODS; 39½"H X 24"W X 18½"D.

The slat-back arrangement is conventional, but the spindled arms are unique to the work of the chair maker who produced several related examples in Northumberland County. Turnings on the posts are of shallow depth, giving them a controlled austerity, while the Graf Zeppelin-like shaping of the double spindles is a surprising deviation from a familiar form.

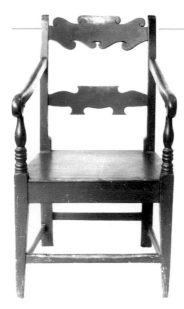

291. CHAIR: SECOND QUARTER 19TH CENTURY; BIRCH AND PINE; 34"H X 19"W X 18"D.

Of birch construction, with a pine-plank boarded seat, this unusual chair is the product of mingled design influences. The scrollwork crest and rail are more in keeping with French-Canadian chair backs, and it has been argued that the sloping arms are in that cultural tradition. The tapered squared legs and narrowing of the back posts just above the seat are identical to that seen on chairs found in Lanark County and other Scottish settlements in Ontario.

292. CHAIRS: SECOND QUARTER 19TH CENTURY; CHERRY; 34"H X 17¼"W X 14 AND 34"H X 17¼"W X 14½"D.

The square-backed chair of Sheraton inspiration was a popular form in Scottish settlements in Ontario, particularly in Lanark and Wellington counties, located in Eastern and Southwestern Ontario respectively. Seeking to emulate the delicacy of 18th-century neoclassical chairs, these Wellington or Waterloo County examples feature finely curved back legs, reeded splats, and narrowing of the back posts just above the seat (a point marked here by a distinctive upward hook), achieving considerable lightness of proportion and profile.

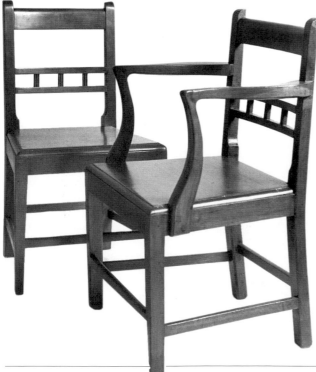

293. CHAIRS: SECOND QUARTER 19TH CENTURY; WOODS; (SIDE CHAIR) 35"H X 19"W X 15"D; (ARMCHAIR) 35"H X 21"W X 17"D.

These chairs from Wellington County are made of cherry, a popular Ontario hardwood which frequently substituted for more expensive imported hardwoods (and which is termed elsewhere "poor man's mahogany": see Donald B. Webster, *Georgian Furniture in Canada*, pp. 44–5). They are strongly in the Scottish Sheraton/Regency style in the composition of their back elements, paired rails and thinned posts.

294. CHAIR: LATE 18TH CENTURY; PINE SEAT AND HARDWOODS; 36"H (SEAT 16¼"H) X 20¼"W X 15"D.

The discovery of several related, early Windsor chairs in Frontenac County shows how American chair-making techniques and styles came with the immigration of Loyalists to the Canadian side of the Great Lakes. This outstanding five-spindle sack-back Windsor armchair from Kingston is the work of a competent artisan, reflected in the unusual grace of turnings, tapering, and finely defined transitions from thick to thin elements. In form and proportions, in the "slippers" on the crest rail where it enters the arm rail, the flattening of the elliptical seat at the front, and in the articulation of the pommel (shaped from beneath as well as above), this chair is closely related to a group of sack-back Windsors made in Lancaster County, Pennsylvania, around 1765 to 1780, from where this capable chairmaker may have migrated to Eastern Ontario.

295. CHAIR: SECOND HALF 19TH CENTURY; PINE SEAT AND HARDWOODS; 29"H X 18"W X 17½"D.

Public meetings of fraternal organizations required large numbers of serviceable and durable chairs. As the popularity of these groups grew throughout the 19th century, there emerged a demand for chairs of the period, typically of the late Windsor-armchair variety. Painted on the collar of this chair, one of a group from Niagara Falls, is the three-link emblem of the Independent Order of Odd Fellows, symbolizing adherence to the virtues of faith, hope and charity.

296. CHAIR: SECOND HALF 19TH CENTURY; PINE SEAT AND HARDWOODS; 30"H X 26½"W X 17¾"D.

The late Windsor armchair, sometimes nicknamed "firehall Windsor," found its way into lodges, church halls and public meeting rooms throughout the second half of the 19th century. This chair, from a larger group, exhibits Empire influences in the shape and roll of the crest which is dowelled onto a flat continuous arm. The heavy turnings of the front stretcher and spindles are of a later type. The compass and rule of the Masonic emblem are painted in white against a dark blue background on this chair and five others found together at Port Perry.

297. CHAIRS: FIRST QUARTER 19TH CENTURY; VARIOUS HARDWOODS; 35½"H X 17½"W X 15"D.

Two of a set of six painted fancy chairs found in Hastings County. The Prince of Wales motif had appeared commonly on late 18th-century English Sheraton chairs, primarily as a carved device. It found its way into the vocabulary of American chair-painters, where any anticipated visit by the Prince would be little cause for celebration, and appeared occasionally in Canadian variations of the fancy chair. These examples, made at Belleville (Hastings County), are a fine statement of the art of the carver (the *guilloche* and shaping of the crest rail) and of the painter (striping, *paterae*-like floral motifs, crown and feathers, rendered in several colours against a dark green ground). Upper Canada Village.

298. ROCKING CHAIR: SECOND QUARTER 19TH CENTURY;
PINE SEAT AND HARDWOODS; 44"H X 19¼"W X 17¼"D.

Exceptional painted decoration, with floral motifs and striping against a black
background, are related to early American examples before the mass production
of fancy chairs after the opening of
Lambert Hitchcock's chair factory in
Connecticut in 1818. The maker of
this chair has used a broad vocabulary
of embellishments, including
grouped ring-turnings on posts,
stretchers and supports, bevelled
edges on the chair seat and arrows,
and a sweeping upward thrust in the
attenuation of splats and expansion of the
crest rail, perhaps in replacement of an
early tradition of an attached comb at the
top. Upper Canada Village.

299. ROCKING CHAIR:
SECOND QUARTER 19TH
CENTURY; PINE SEAT AND
HARDWOODS; 39½"H X 21½"W X 21"D.

Lavishly stencilled by means of various
metallic powders on a black painted background, this chair
is a uniquely sumptuous expression of Ontario decorated
furniture. Its motifs include intertwined foliage borders, a
long-tailed bird perched on a twig, and figures in a tableau
reminiscent of those depicted in Japanned furniture in
England and America in the early 18th century. The
contours of the seat, arm and crest are in the American
Empire idiom. An outstanding painted chair of the Boston
rocker type, it was found at Dunnville, where the Grand
River flows into Lake Erie in Haldimand County.

300. ROCKING CHAIR: SECOND QUARTER 19TH CENTURY; PINE SEAT AND HARDWOODS;
39"H X 20½"W X 18½"D.

Somewhat simpler in design and decoration than the example in fig. 299, this Boston
rocker from Burford in Brant County is painted in vibrant colours, with red, yellow and
green birds and strawberries against a grain-painted background. The scrolling of arms,
seat and crest is more subdued than that of the previous piece, but the boldness of its
decorated finish is unique in Ontario examples.

301. CORNER CUPBOARD: EARLY 19TH CENTURY; PINE; 99¾"H X 46"W.

From Rose Hall in Prince Edward County, this imposing piece preserves the vertical emphasis of English parlour corner cupboards. Its refinements are many: the shelves are aligned with the horizontal glazing bars of the upper doors, the boldly stated cornice is made of layered rounded and concave cove mouldings, the stiles and rails are beaded, and the door enclosure is effectively framed within built-up decorative mouldings. The blue and yellow colours are entirely original.

302. CORNER CUPBOARD:
EARLY 19TH CENTURY; PINE; 86"H X 50"W X 39"D.

This cupboard is believed to have been originally located in a stone house just east of Napanee in Eastern Ontario, having since been relocated to another early home. It possesses certain stylistic and construction relationships to the previous example, with a reversal of blue and yellow (here the blue, rather than yellow, is the framing colour). The emphasis in this case is strongly architectural, with pilasters and block capitals flanking lower and upper doors. A central capital completes the upward thrust established by the line at which the doors come together.

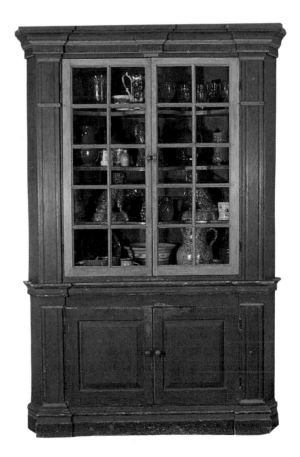

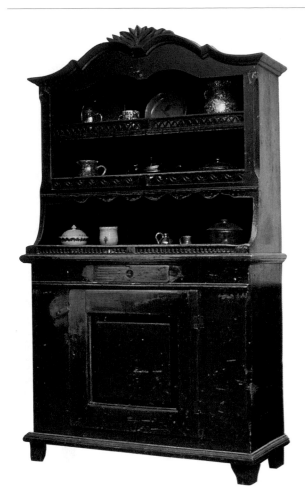

331. DISH DRESSER, RENFREW COUNTY: THIRD QUARTER 19TH CENTURY; PINE; 78"H X 43"W X 16"D.

A distinctive body of furniture was produced by Polish immigrants who arrived in Ontario after mid-century, settling in remote woodland southeast of Ottawa. Because they established a village here named Wilno, after the district in Poland from which many of them came, the furniture of this region is popularly called "Wilno." Unlike the clean, even severe lines of much furniture made by English or American settlers, pieces made in the Wilno area retain a strong East European baroque design, evident here in the elaborately shaped crown moulding, surmounted by a carved floral-motif, as well as in the forward sweep of the sides of the pie shelf and the intricate series of reversing curves on the decorative strip beneath the lower shelf. The fretwork decoration varies, with intersecting lunettes on the top strip, an undulating ribbon motif at the centre, and serial keyhole motifs along the bottom. The dark red-brown finish is original.

332. DISH DRESSER: THIRD QUARTER 19TH CENTURY; PINE.

This finely constructed cupboard (*kredens*), simplified but of related form to the preceding example, is given strong visual appeal by the use of bold colours, in this case, deep orange, green and black. The feet are typical in being shaped from the wide plank of the flanking stiles, visually separated by an applied rail around the base. As on several other examples, the centrepiece of the baroque pediment is a foliate fan motif, comprised of stylized leaves. The open dresser form with enclosed lower section permitted storage below and display above.

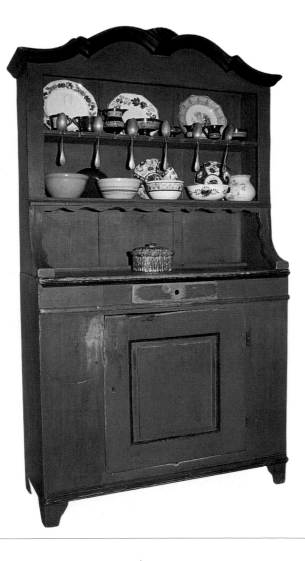

333. STORAGE CHEST: THIRD QUARTER 19TH CENTURY; PINE; 27"H X 44"W X 21"D.

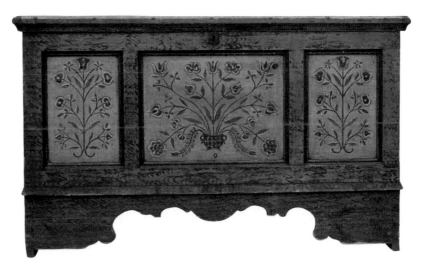

This chest is of similar construction, design and decoration as the piece in fig. 441. Some variety of visual appearance is achieved by differing combinations of colours, in this case the highly unusual use of a cream background rather than red to set off the floral motifs. The elaborately scrolled bracket feet are typical of a form made extensively in Poland throughout the 18th and 19th centuries.

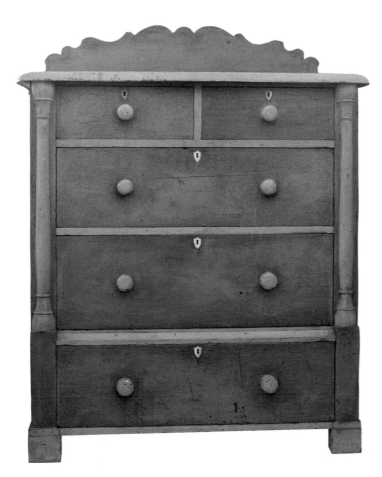

334. CHEST OF DRAWERS: THIRD QUARTER 19TH CENTURY; PINE; 53"H X 41"W X 23"D.

The chest of drawers is not commonly found in the Polish settlements in Wilno County, since its function was adequately performed by storage chests made in the area. The stylistic relationship between the chest of drawers (a similar example is shown in fig. 442) and the wardrobe in fig. 439 is revealed in the placement of bottom drawers and collonettes at the corners. The columns on the chest of drawers are set upon square bases, a feature possibly derived from American Empire-style chests of drawers made in abundance throughout Eastern Canada after the middle of the 19th century. The exuberantly scrolled backboard seems an afterthought, and resembles the end boards of the shelf in fig. 23. The green and light blue is an early painted finish.

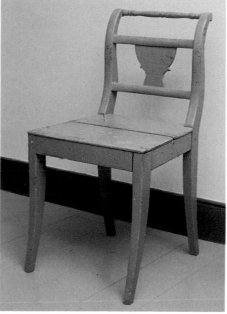

335. CHAIR: THIRD QUARTER 19TH CENTURY; PINE; 32"H X 16½"W X 14½"D.

Relatively few distinctive chairs have been found in the Wilno area, the ubiquitous factory-made press-back having gained widespread use in Polish homes there by the late 19th century. This specimen is of interest in its neoclassical elements (*klismos* legs, urn-shaped splat, serpentine back). Although it is a rare example, the profile of the back post is a popular Biedermeier form which resembles the bench in fig. 337 and is stylistically related also to the contours of Mennonite sleep-benches made in Manitoba and Saskatchewan.

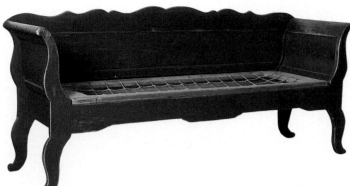

336. BENCH: THIRD QUARTER 19TH CENTURY; PINE; 33"H X 70"W X 21"D.

This bench or country sofa is a fine articulation of the Biedermeier form which spread from its early 19th-century German origins to gain popularity throughout Northern and Eastern Europe in the ensuing decades. The scrolled back is typical of the country baroque shaping of much furniture in these regions, while the shaping of legs and arms (here in perfect symmetry, both from side to side and top to bottom) is a particularly elegant expression of Biedermeier design in its non-baroque, restrained form. The red painted finish is original. It can be seen from this form's nearly identical counterparts in both Hutterite and Mennonite communities of Western Canada that this form had widespread acceptance throughout many lands of Eastern Europe (see fig. 479).

337. SLEEP-BENCH: THIRD QUARTER 19TH CENTURY; PINE; 34¾"H X 74¾"W X 25½"D.

In the early decades of the 20th century a sizable number of Wilno-area settlers moved to Kitchener in Southwestern Ontario in hope of finding economic opportunities not available in the countryside of Renfrew County. This bench and other Polish-Ontario pieces have been found in Kitchener, all brought from the Wilno settlement. It is similar

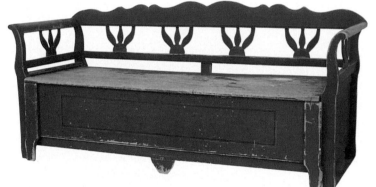

to another known example (Pain, fig. 1249), with an arrangement of back-splats comprised of tripartite leaf designs (for a related Western Mennonite example, see fig. 480). The box pulls forward to convert the bench to a bed. The scrolled arm is like the arm in fig. 336 and the chair back in fig. 335, reflecting the Biedermeier style brought to Canada by these Polish settlers. The painted finish, original to the piece, is a dark red, with dark green and black striping and highlighting of details.

338. BED: THIRD QUARTER 19TH CENTURY; PINE; 40"H X 75"W X 43"D.

This panelled bed from near Wilno is a comparatively chaste expression of the Polish country baroque, a style mostly confined to the scrolled top edges of the end boards. The posts are chamfered to produce an octagonal upper section, below which are turnings more in the generalized Sheraton style popular in nearly every region of Europe and North America by the mid-19th century. The finials are a variation of the mushroom form also popularized by neoclassical designs, occurring frequently also on chair posts. This form of this bed is similar to one of Russian stylistic background made in the Doukhobor community of Saskatchewan (fig. 629).

339. CHAIR: SECOND QUARTER 19TH CENTURY; PINE SEAT AND HARDWOODS; 40"H X 19"W X 17½"D.

Although it is not at all uncommon to find that chair makers integrate more than one style in the completion of the whole, rarely has there been such an outspoken marriage of diverse elements as seen in this example from Frontenac County. The maker performed multiple marriages: this is but one of a group of similar known examples. The mixing of the Windsor collar-chair form with rockers is unusual; the crowning of the collar with the upper section of a Boston rocker back, with no attempt to line up spindles, is an adventure into eclectic extremity, giving new meaning to the notion of transitional furniture.

340. WAGON SEAT: EARLY 19TH CENTURY; WOODS; 29¾"H X 35¼"W X 15"D.

An Eastern Ontario slat-back wagon seat. For durability, the turned centre post is of unusual width. The woven-bark seat is original, as is the dark red painted finish. The easy portability of such furniture would make it useful at home, and it would provide a modicum of comfort when travelling.

341. SETTLE BED: EARLY 19TH CENTURY; PINE; 42"H X 74"W X 18"D.

The settle bed was a practical piece in the modest peasant home because it could serve more than purpose. Since the seat was hinged and the box was constructed so that it could be pulled or tilted forward from the base, the piece could be immediately made over as a bed. The scalloped ends and panelled back are reminiscent of the English high-settle, while the multipurpose form was particularly common in Ireland and found in Canada in both Irish and Scottish regions. As in Quebec, settle beds are found most frequently in areas of Irish settlement. This early, heavy panelled type with original red painted finish was found in Lanark County.

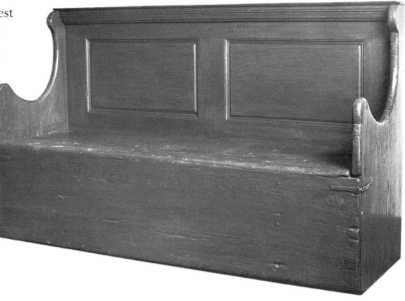

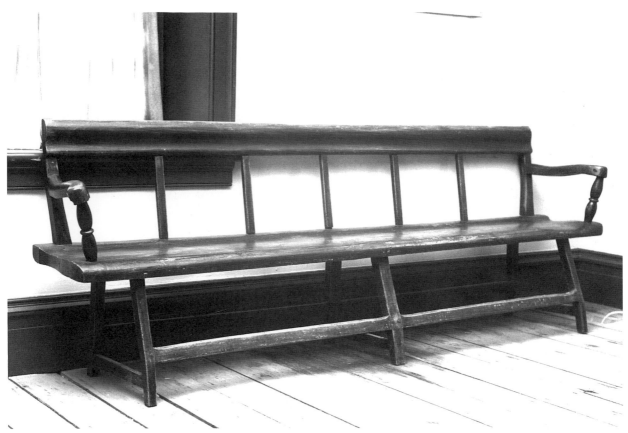

342. BENCH: SECOND QUARTER 19TH CENTURY; BIRCH AND PINE; 33½"H X 93½"W X 16"D.

Here, the tilted and horizontally scrolled arms on canted supports are in the tradition of English Windsor chairs and benches, while the base of squared posts and stretchers is a rudimentary structure of indigenous make and no particular style. Neoclassical influences can be seen in the scrolled seat and crest rail. The piece retains its original dark green painted finish. Montgomery's Inn, Toronto.

343. BED AND TRUNDLE BED: SECOND QUARTER 19TH CENTURY; WOODS; (BED) 35"H X 81" L X 51½" W; (TRUNDLE BED) 16¾" H X 54" L X 40½" W.

A low-post bed from Prince Edward County, this Eastern Ontario piece is a good example of the country Sheraton bed made widely throughout English Canada. Also shown is a trundle or truckle bed, also of Ontario provenance. Both pieces were made close to mid-century, and both retain their original red painted finish.

344. BED: MID-19TH CENTURY; BUTTERNUT; 41½"H X 78½"L X 52"W.

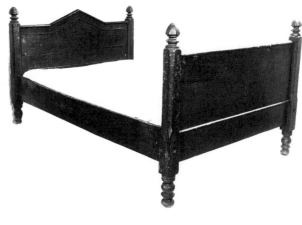

Found in Rama Township of Simcoe County, a few miles east of Orillia, this bed has Scottish antecedents (Carrick family), with restrained neoclassical lines and a slight Gothic overtone to the shaping of the posts and finials. The pediment on the headboard is accentuated by crown mouldings and applied decorative moulding strips. The unexpected interruption of similar strips on the footboard suggests that it, too, was originally surmounted by a triangular pediment, a detail seemingly removed at early date. The well-worn blue painted finish is original to the piece.

315. COT: 19TH CENTURY; HARDWOOD.

Simple cots were among the earliest bed forms in pioneer homes, but they are not necessarily confined to the first generation of settlement. In later times such primitive forms continued to be used in lesser rooms for work hands, transients and others who were not immediate members of the household. This rare surviving example from Eastern Ontario is a simple framework of squared posts mortised through by rails whittled from tree branches. No less remarkable is the survival of the original sleeping surface made of woven birch splints. Upper Canada Village.

346. CRADLE: SECOND QUARTER 19TH CENTURY; VARIOUS HARDWOODS, WITH PINE SEAT; 30"H X 34"W X 22"D.

Many cradles were essentially boxes with rockers, but occasional examples are derived from more stylish chair-forms. The arrow-back Windsor chair or settee has been named as a design source for this cradle from Fenelon Falls (Victoria County). Like chairs of the time, it is given a red-and-black grained finish, over which very worn stencilled motifs can be seen. Historical, Naval and Military Establishments, Penetanguishene.

347. KEEPSAKE BOX: LATE 18TH OR EARLY 19TH CENTURY; CHERRY SIDES, PINE BOTTOM; 8⅜"H X 4¼"W X 2¼"D.

Boxes carved in the form of books were often intended as tokens of remembrance, given by makers to loved ones during periods of absence, or merely as statements of affection, to be treasured as would be a special leather-bound book. This highly decorated example, with relief-carved whirling pinwheels and compass stars, was found in Ernestown Township, Lennox and Addington County, where it had passed down through Smith family descendants.

348. FRAME: EARLY 19TH CENTURY; PINE; 35¼"H X 21¼"W.

The form is high style, taken from the baroque-inspired mirror frames made in enormous quantity by followers of the Chippendale school, but the unusual feature of carved-through geometric motifs is a personal decorative enhancement of a traditional form. The double-pediment motif is also reminiscent of an earlier Queen Anne convention. This remarkable frame was found in the Ottawa Valley and could be from either Quebec or Ontario.

349. WALL BOX: SECOND QUARTER 19TH CENTURY; PINE; 13⅜"H X 11¼"W X 5¼"D.

The designs on this wall box from Lindsay in Peterborough County suggest the work of a sign- or coach-painter, for whom such motifs and stencilled motifs were familiar. The rendering of pomegranates and flourishes relates this piece to the painted storage chest in fig. 272.

350. FRAME : MID-19TH CENTURY; WOODS.

The Orange Lodge was a social meeting-place for Irish Protestants and others throughout the 19th century in Ontario, where its popularity rivalled that of the group in Newfoundland. As in other other fraternal associations, a distinctive body of furniture was made for ritual use. No Orange Hall was without a picture of King William of Orange. The Empire-style frame contains a mid-century Currier and Ives print of the hero on the occasion of his military victory over Catholic forces at the Battle of the Boyne in 1690. The popular phrase "True Blue" and the always-to-be-remembered glorious date are painted on this frame, along with the lodge number.

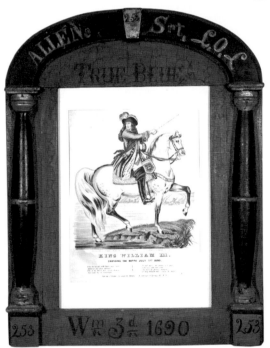

351. TABLETOP: MID-19TH CENTURY; PINE, 34⅛"H X 55⅝"W.

This painting is remarkable for several reasons, including the fact that it is a picture of King William III painted directly onto a tabletop, the base of which was removed and discarded years ago. This piece of furniture was reportedly a ceremonial table used in the Orange Hall in Orangeville. The depiction had by this time become highly conventionalized, and was likely taken from a popular Currier and Ives print which had attained wide distribution by the middle of the century.

352. CORNER CUPBOARD, WATERLOO COUNTY:
SECOND QUARTER 19TH CENTURY; PINE.

The exterior frame of this corner cupboard, painted dark
red, is identical to the frame in fig. 315, and the glazed
doors could actually be exchanged for one another. The
lower doors are relatively tall in this piece, which, along
with the horizontal stile just below the waist, serves to
define the space occupied by short doors and drawers
in the corresponding cupboard. Stylish enhancements
include cut-corner raised panels, applied mouldings and
a dentillated frieze.

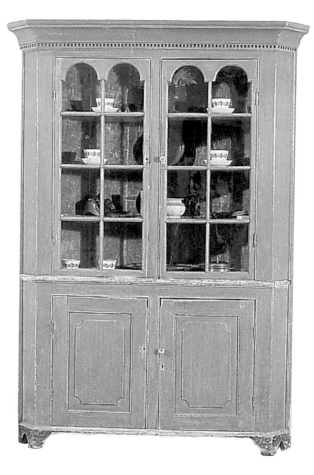

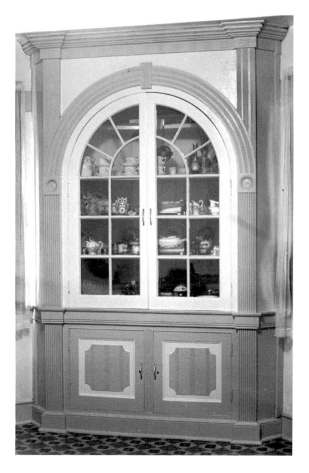

353. CORNER CUPBOARD, WATERLOO COUNTY: 1837; PINE.

English furniture influences were sufficiently
widespread throughout eastern North America that
other cultures appropriated the designs of Chippendale,
Adam, Sheraton and Hepplewhite. Just as such English
styles emerged in certain examples of French-Canadian
furniture (figs. 238, 239), they appear in this built-in
corner cupboard made in 1837 for the home of Samuel
Weber, a Pennsylvania-German Mennonite who
migrated to Ontario and settled on the bank of the
Grand River between Waterloo and the village of
Conestogo.

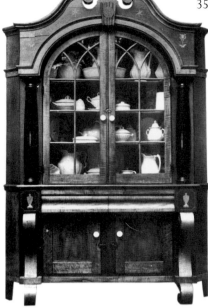

354. CORNER CUPBOARD, WATERLOO COUNTY: MID-19TH CENTURY; CHERRY, MAPLE, WALNUT AND PINE; 99"H X 72"W.

A handwritten note inside reads: *this cupboard was made to order and all made by hand for Jacob Bricker — son — in the year 1854 by Abraham Latschaw. Total cost about $68.* The scrolled pediment, keystone and fan doors derive from earlier Chippendale designs, while its mid-century manufacture probably accounts for the "updating" by use of cyma-curve pilasters, drawers and feet, as well as massive free-standing columns — all au courant uses of the heavy American Empire style. The neoclassical inlaid urns are similarly juxtaposed with inlaid star and tulips, motifs taken from the Pennsylvania German folk tradition. CMC (History Division).

355. CORNER CUPBOARD, WATERLOO COUNTY: MID-19TH CENTURY; PINE; 100"H X 65"W.

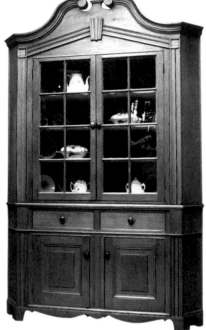

While most Waterloo County scrolled-pediment cupboards tended rather heavily to the Empire (and new) style, this piece looks back to the late 18th century, using elements of the Chippendale and Hepplewhite schools. The blending of details from the cabinetmaker's vocabulary can be seen in this cupboard, particularly as compared with other examples. The curved broken pediment is identical to that on the cupboard in fig. 354; the bracket base with its French foot relates closely to the base in fig. 316, and the channelled pilasters (here extended diagonally to a central keystone) and corner blocks resemble those on the architectural cupboard in fig. 315.

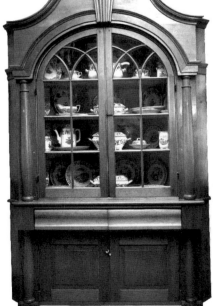

356. CORNER CUPBOARD: MID-19TH CENTURY; PINE; 98"H X 62"W.

A comparatively soft-spoken example of the Chippendale-gone-Empire corner cupboard, this piece is heavy in profile but surprisingly delicate in detail. The Gothic fan tracery is refined, and is comparable to that found on late 18th-century architectural furnishings, recalling the Nova Scotia corner cupboard in fig. 38. The keystone is similar to that on the previous two examples, but the curvature of the pediment is slightly flattened here. Thinning of the columns and the use of these rather than ogee brackets imparts a quieter and less massive sensibility to this well-crafted cupboard. The feet are missing.

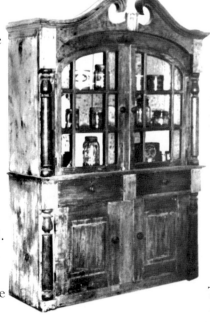

357. WALL CUPBOARD: MID-19TH CENTURY; PINE.

Possibly a once-only endeavour, this scrolled-pediment piece is a wall cupboard, not a corner cupboard. It is massively neoclassical in its thick applied half-columns, which have been ebonized for contrast, and the low curvature of the pediment and arch. The centre scrolls have a particularly dramatic hook, a free-spirited and playful element in a cupboard of serious proportions. The feet (now missing) may have been scrolled, in keeping with the Empire features of the cupboard, or simply turned.

358. Wall Cupboard;
Mid-19th Century; Pine.

This outstanding panelled cupboard
was discovered in the Niagara
Penisula, but is related in design to
forms made in Waterloo County.
A template or stencil or even a
stamp may have been used in the
execution of stylized floral motifs
against a polychrome painted finish.

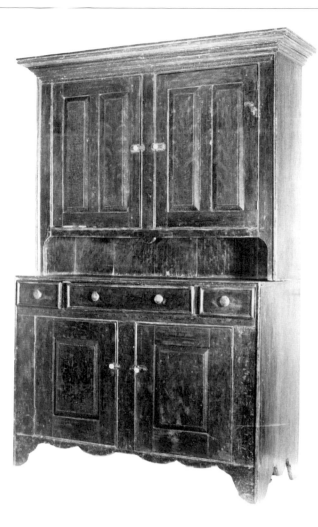

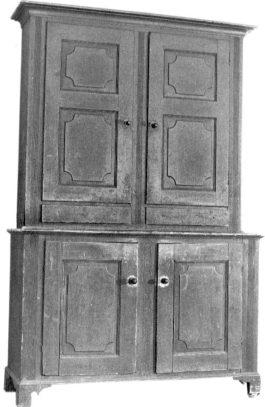

359. Wall Cupboard, Niagara Peninsula:
Second Quarter 19th Century;
Pine; 89"H X 56¼"W X 18¼"D.

This closed-door cupboard shares many stylistic
qualities with other Niagara examples, but it is
given further refinement by the feature of fluted
stiles and cut-corner panelling derived from
Chippendale designs. Where a formal high-style
piece would use the subtleties of stop-fluting
before the stile reached the frieze, on this
country cupboard the fluting simply ends when it
ends — at the counter surface and beneath the
cornice. The panelling is handled with great
sensitivity to diminishing size, with an ascending
three-stage movement from vertical through
nearly square to horizontal emphasis. Its green
painted finish, completely original, is a notable
variation from the customary blue or red of
Niagara pine cupboards.

360. WALL CUPBOARD: SECOND QUARTER 19TH CENTURY;
PINE; 86½"H X 59"W X 20¼"D.

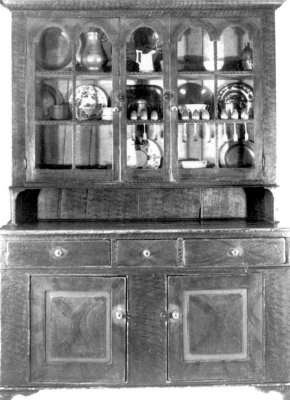

This is one of two known Waterloo County dish cupboards with moulded Chippendale bracket feet, relating them to the wardrobes in figs. 368 and 369. These pieces are among a group of furnishings that may well have come from the workshop of the Pennsylvania-German cabinetmaker Abraham Latshaw (1797–1870) who worked in Berks County, Pennsylvania in his youth, and then in Waterloo County after migrating to Canada in 1822. The robust feet, heavily fielded panels and applied mouldings on the base relate this piece closely to late 18th-century Pennsylvania furniture-making, while the flat mullions of the upper section are more in keeping with mid-19th-century Ontario cupboards. There is restoration to paint and replacement of the left door of this outstanding piece. JSH.

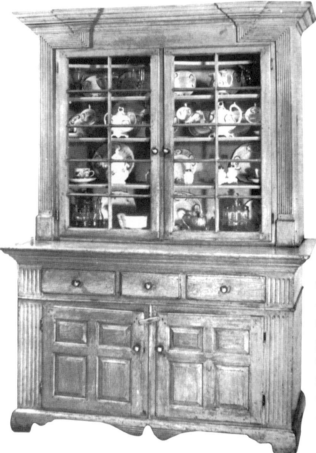

361. WALL CUPBOARD: SECOND QUARTER 19TH CENTURY; PINE.

Recalling 18th-century examples, this cupboard from upper York County is unusually robust, a quality emphasized by wide fluted pilasters, a complex cornice, lapped drawers, and a projecting counter surface. The wide doors and correspondingly proportioned panes are typical of several cupboards found in northern areas of York and Ontario counties. Author Philip Shackleton described this piece as a good example of bending a style. The cupboard is in refinished condition; the original paint was removed in the 1960s.

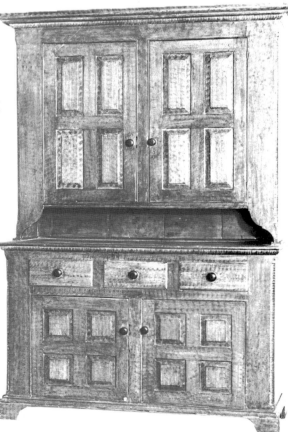

362. WALL CUPBOARD: SECOND QUARTER 19TH CENTURY; PINE.

A large piece whose massiveness is amplified by its sixteen raised panels, lapped drawers and heavy bracket base, this pine wall cupboard was found in Ayr, southwest of Kitchener, in Waterloo County. The paint is largely restored, but the original structure is intact. The spooled quarter columns applied at the corners and beneath the projecting cornice are similar to the half-round mouldings on the waist of the corner cupboard in fig. 316, and the arrangement of raised panels and lapped drawers establishes a further connection between these two pieces.

363. WALL CUPBOARD: SECOND QUARTER 19TH CENTURY; PINE; 89"H X 60"W X 21"D.

A few Pennsylvania-German cupboards made in Southwestern Ontario are noteworthy for an arrangement in which a vertical bank of drawers is located between flanking panelled doors. This composition is reminiscent of the English dresser and its Canadian counterparts made in Nova Scotia. The flanking drawers are also retained, integrating elements of the British dresser and the Pennsylvania kitchen cupboard. There has been extensive restoration to the painted finish on this cupboard, and the pie-shelf area and cornice have been replaced, but it remains an extremely rare and important example of Pennsylvania-German furniture made by Mennonites in Waterloo County.

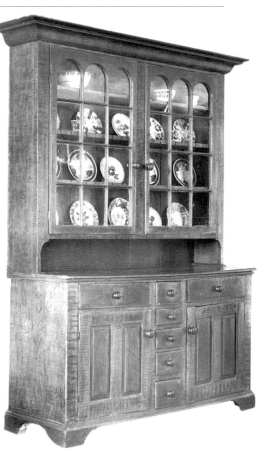

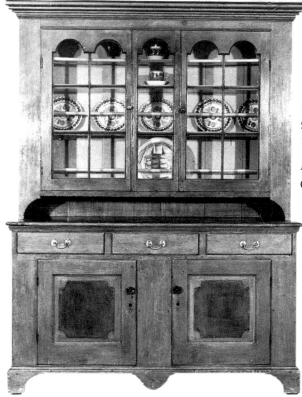

364. WALL CUPBOARD: SECOND QUARTER 19TH CENTURY; PINE.

Although this remarkable cupboard was still in an Old Order Mennonite (Sittler) household until the late 1970s, its original red paint had been removed by the time it came to auction. Three drawers define the width of this broad cupboard, and an unusually wide centre stile and a glazed mid-section separate doors in the lower and upper sections. Cut-corner panels are an unusual variation in Waterloo County furniture, linking this piece to the corner cupboard in fig. 352.

365. SIDEBOARD OR JAM CUPBOARD: MID-19TH CENTURY; WALNUT.

Corresponding to the *buffet-bas* in French Canada, the low cupboard with doors and drawers was found variously in the parlour, bedroom and dining room of the Pennsylvania-German household. It was probably originally placed in the dining room, where it could be used for storage of dinnerware, cutlery and other food-related items. This Niagara Peninsula example is made of black walnut, but the wood itself is here merely a base for a vigorously painted decorative scheme. Comb-grained paintwork defines stiles and serves to frame the exuberant feather-motif painted on the door panels.

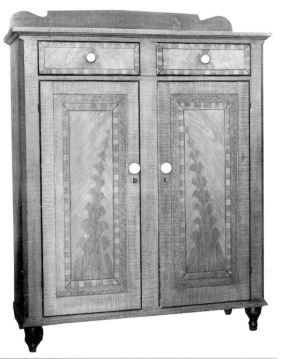

366. LINEN PRESS: EARLY 19TH CENTURY; WALNUT; 77½"H X 48"W X 20"D.

The linen press is a well-developed English form which gained popularity in the Atlantic states, particularly New Jersey, and found its way to Ontario through the agency of a small group of craftsmen who came from eastern Pennsylvania to the Niagara Peninsula after 1786. Although Mennonite cabinetmakers — Jacob Fry and John Grobb — were usually associated with these presses, it is clear that their furniture was inspired by both English and Germanic design traditions. This piece, like most others from the area, is made of walnut, but is distinctive in the use of ink brushed diagonally and vertically to produce an abstract design on the drawers and doors.

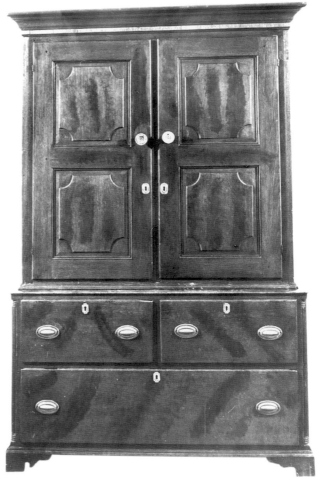

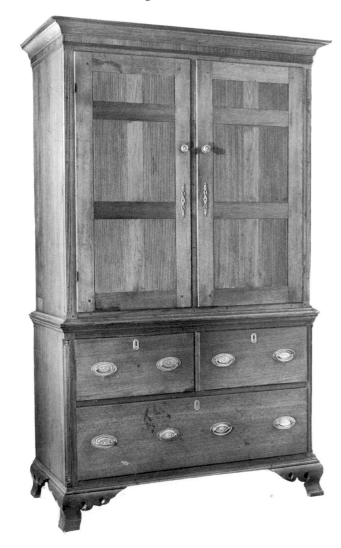

367. LINEN PRESS: EARLY 19TH CENTURY; WALNUT; 81"H X 51¼"W X 22½"D.

Among the finest Niagara examples are several walnut linen presses with extraordinarily elaborated Chippendale-style bracket feet, and finely reeded inset panels, frieze banding, and barrel-stopped reeding of the quarter columns. This piece, found in Ohio, is nearly identical to other examples found near Jordan and Vineland, and bears the signature *Jacob G. Kulp,* written in pencil on the top side of the lower section.

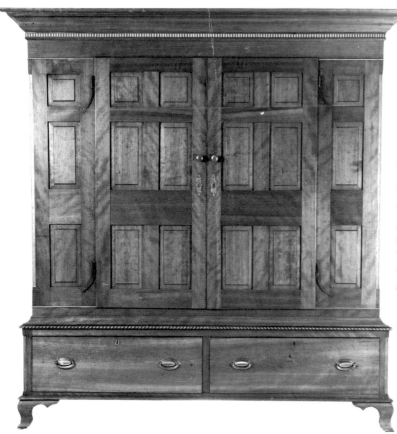

368. WARDROBE, WATERLOO COUNTY:
SECOND QUARTER 19TH CENTURY;
CHERRY AND VARIOUS INLAID WOODS;
82"H X 73"W 23¾"D.

The free-standing clothes-cupboard (*Kleiderschrank*) is frequently described in the German communities of Ontario simply as a *Schrank*. Typically, as in this example, it is constructed in sections that permit dismantling. The top and bottom are separate components, while doors can be lifted off the pins that hold them in place at the hinges. The sides and back panels are removable, as are the doors, whose hinges are simply pins resting in cast-iron supports attached to the stiles. This unusually elegant piece is most likely the work of Abraham Latschaw, who may also have made the dish cupboard in fig. 360. The distinctive moulded ogee bracket feet are unique to his work, and the exceptional refinement of this large case piece extends even to the careful selection and placement of dramatically figured cherry to emphasize the design symmetry.

369. WARDROBE: SECOND QUARTER 19TH CENTURY;
PINE; 83"H X 66½"W X 32"D.

Following common practice, the Latschaw workshop produced both hardwood and pine versions of similar pieces, undoubtedly in response to differing demands from clients and also the higher price of hardwoods. Cupboards, chests of drawers, desks, wardrobes — all were made in cherry or painted pine, and in some instances the design and construction techniques are virtually indistinguishable. Some of the softwood furniture is painted in imitation of more costly hardwoods, but in the case of this wardrobe, also likely by the Latschaw shop, the painted finish is more abstractly executed with a mixture of feathering, graining, sponging and solid-colour treatments. JSH.

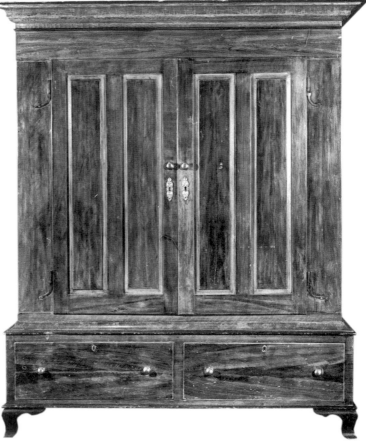

370. STORAGE CHEST: SECOND QUARTER 19TH CENTURY; PINE; 30"H X 50¼"W X 24"D.

Chests with hinged tops and sliding drawers provided two kinds of storage: more frequently required

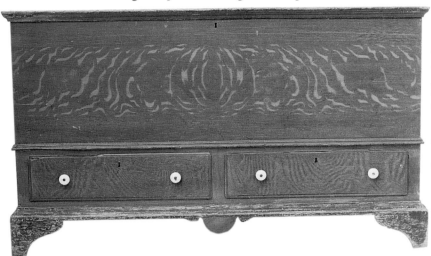

items were kept in the drawers and the top served for longer-term storage. This early example has well-articulated feet based on the principle of the reversing ogee-curve, and exhibits such earlier construction features as applied mouldings and cove-moulded overhanging lids. This is a vibrantly painted chest with ochre graining on the case and dark green bracket feet and transitional and applied waist mouldings.

371. CHEST OF DRAWERS: SECOND QUARTER 19TH CENTURY; PINE; 72"H X 48"W X 22"D.

In the Germanic communities of Ontario the transitional chest is virtually unknown. Instead, the full-fledged high chest of drawers was made at the same time as lower bracket-based blanket chests. Early chests of drawers in these areas are often tall, with six ranks of drawers. In the Niagara Peninsula such chests were generally made of black walnut; in Waterloo County the preference was for cherry or pine. This exceptional example from Waterloo County is fitted with lapped drawers and given a stylish character by the application of a reeded strip in the frieze, an elaborately scrolled base, and flared French feet. The surface of this pine piece is enhanced by an abstract painted finish.

ROM (Canadiana Department).

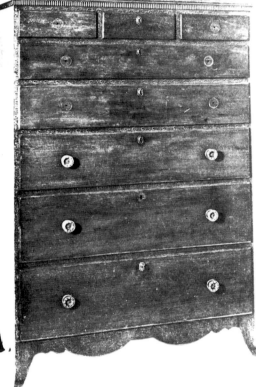

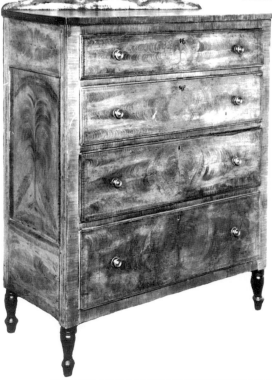

372. CHEST OF DRAWERS:
SECOND QUARTER 19TH CENTURY; PINE; 61"H X 44½"W X 21¼"D.

Because so many examples have been overpainted, saving original finishes is far from easy and it is difficult to know how many early chests of drawers were given decorative painted treatments rather than monochrome finishes. Good fortune attended this piece, however, because, although it was found with a modern black stain finish, the vivid decorated finish was so strong that the stain could be removed by means of undiluted ammonia without damage to the original. The drawers and inset end panels are vibrant, with bold feather-grained motifs and swirls enclosing a central motif of willow trees enclosed within hearts. A dark red is brushed over an underlying yellow to produce a decorative impact seldom rivalled in Ontario-Germanic furniture. JSH (CHC).

373. STORAGE CHEST: SECOND QUARTER
19TH CENTURY; PINE.

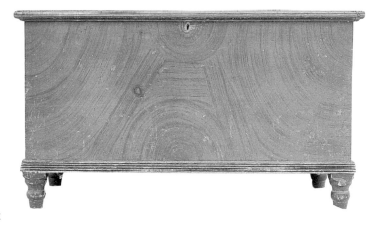

Blanket chests set on turned feet are less
commonly made in Waterloo County
and may reflect a generalized Sheraton
influence incorporated in the design of
chests of drawers. The abstract feather-
decoration on this example, accomplished
by black brushwork over a dark red base
colour, is seen on other locally made chests
of early construction. The chest descended
through Shantz settlers before appearing
at a country auction near Phillipsburg, west
of Waterloo.

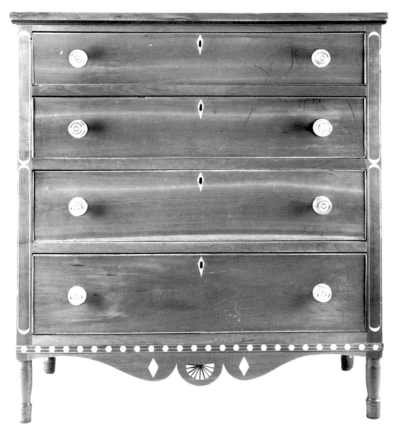

374. CHEST OF DRAWERS:
SECOND QUARTER 19TH CENTURY;
CHERRY AND MAPLE; 45½"H X 42"W X 22½"D.

Cherry, sometimes augmented with
veneered or inlaid maple and other
materials, was a favoured wood for
making hardwood furniture in Waterloo
County. This four-rank chest of drawers
in the country Sheraton idiom bears the
stamp of an early neoclassical decorative
treatment (known in its American form as
Federal style) with inlaid line-and-dot
banding on the skirt. The fan is
assembled from triangular maple
segments placed in hot sand to lightly
burn the edges and thereby accentuate
the ribbing effect when it is inlaid into
the cherry case of the chest.

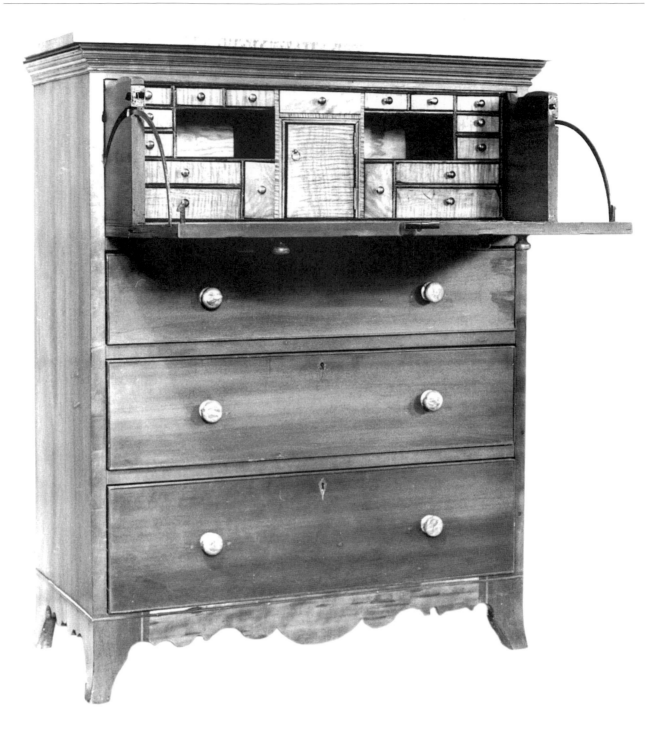

375. DESK: SECOND QUARTER 19TH CENTURY; CHERRY AND MAPLE.

Perhaps yet another piece from the workshop which produced the chests in figs. 320 and 374, this tall case-piece is of a type popularly known as a butler's desk. The top drawer is really a hinged panel which folds down to serve as a writing surface, revealing a hidden bank of drawers and compartments. The maple-veneered drawers relate this piece to the chest-on-chest in fig. 320, and the stout "French-footed" skirt with elaborate scrolling is found on numerous Waterloo County tall chests and desks.

376. DESK: 1817; CHERRY AND OTHER WOODS; 50¼"H X 40⅛"W X 20"D.

It seems probable that Moses Eby (1799–1854) was not only the owner but also the maker of this remarkable desk, making him one of several Eby artisans who made furniture in Waterloo and adjacent Wellington County. Intricate inlay work includes line-and-diamond banding along the base, ribbed banding up the chamfered corners, simple line inlay patterns on the drawer fronts, and the ribbed and banded lining in the shape of a heart on the hinged desk-front. These details and the faceted star are comprised of finely cut wood veneer, but the name and date are a compacted sawdust compound pressed into incised letters and numbers. The interior is also intricately inlayed, and the piece is competently constructed with dovetailed, mitered and pegged joinery. A plywood panel replaces the missing backboards. This important piece is sadly in need of proper restoration of the disfigured base and the inappropriate turned feet of later date. Doon Heritage Crossroads.

377. CLOCK: EARLY 19TH CENTURY; PINE, 96½"H.

Although this clock has been repeatedly given a Waterloo County provenance, it is stylistically a loner in that furniture-making milieu.

An inscription reads *John Alberth Clagmacher* [clockmaker] *Baden*, but that the reference is to the village in Ontario rather than to a locale in Germany needs further demonstration. The case, most likely of Canadian workmanship, displays closer affinity with furniture made in the Niagara Peninsula than with that made in Waterloo County, and the clock has been located in the Niagara district for as long as museum records provide information on this piece. It is a splendidly naïve interpretation of the Chippendale style, with a most awkwardly scrolled pediment. The wood is pine, with an early or original abstract grain-painted finish. Jordan Museum of The Twenty.

378. CLOCK; MID-19TH CENTURY; CHERRY AND MIXED WOOD VENEERS.

Among a handful of pieces with direct family connections to the workshop of Abraham Latschaw is this clock case made in 1850 for his son-in-law, Amos Shantz. It is constructed of cherry, with maple, walnut and other wood veneers used as inlay. The scrolled pediment is identical (on a miniature scale) to that on the corner cupboard in fig. 354, while the inlaid fans are related to those on the chest-on-chest (fig. 320), even to the point of the sand-burning technique used in their colouration. The feet are missing.

379. TABLE: MID-19TH CENTURY; WALNUT.

Black walnut was the favoured wood of the Niagara artisans who made many tables for the homes of early generations of Mennonite settlers in the Jordan-Vineland area. Kitchen dining tables in the Niagara Peninsula closely resemble their Pennsylvania antecedents, but are somewhat lighter in construction. The style remained almost unchanged from the beginning to the middle of the 19th century, as evidenced in this comparatively late example (1847) signed *T. Houser, Maker*. Among early features retained are the long turned segment swelled at the centre, the placement of three drawers in the case, and a medial stretcher.

380. TABLE AND BENCH: MID-19TH CENTURY; PINE; (TABLE) 29"H X 59"W X 39"D; (BENCH) 17½"H X 66"W X 14½"D.

This table and bench were found together in the kitchen of a Mennonite home northeast of Elmira in Waterloo County, with the bench pushed against the wall in traditional fashion, and the modern adaptation of chairs placed on the open side of the table. Both table and bench are of dark ochre colour, an old paint covering the original red finish. The flush drawers are a typical (but not exclusive) Waterloo County treatment, in contrast to the more frequent use of lapped drawers on tables from the Niagara Peninsula. The scrolled front board of the bench and shaped feet are unusually elaborate. CMC (CCFCS).

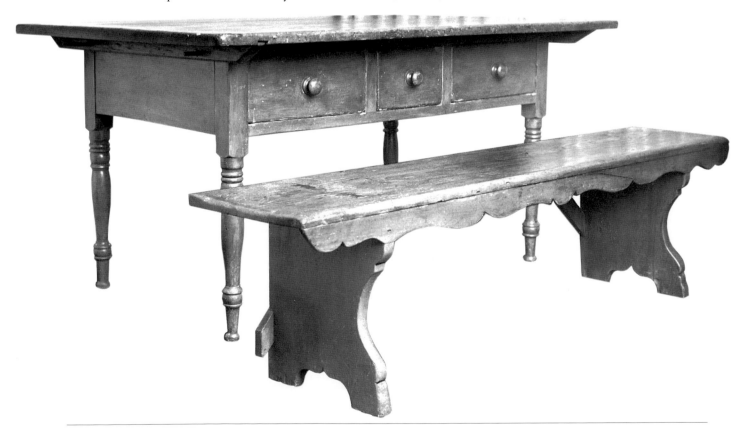

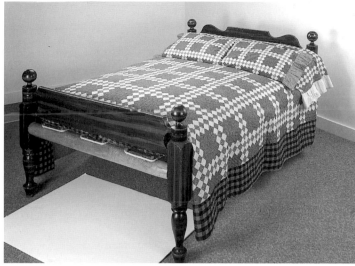

381. BED: MID-19TH CENTURY;
MAPLE AND PINE; 37"H X 49"W X 70"L.

Found near Elora, this low-post bed has descended through many generations of the Shoemaker (Schumacher) family, of Pennsylvania-German background. The ball-turnings and scalloped end-boards are elements of the American Empire style which held sway in Ontario. The bed has a bold red-and-black painted finish, likely in imitation of a strong-grained hardwood such as mahogany or rosewood. JSH.

382. CHAIR: EARLY 19TH CENTURY;
VARIOUS HARDWOODS; 39"H X 18"W X 13"D.

Pennsylvania-style slat-back chairs were made in the Niagara Peninsula in large numbers, in contrast to the smaller quantities of this style in the Mennonite settlements of York and Waterloo counties. Most have rush or elm-bark seats, woven and looped over stretchers on the four sides. Alongside those chairs painted in a single colour are found a few notable exceptions, such as this example with polychromatic floral and geometric decoration against a red-brown base.

383. CHAIRS: THIRD-QUARTER 19TH CENTURY;
PINE AND HARDWOODS; (LEFT) 33"H X 15¼"W X 15"D;
(RIGHT) 32¼"H X 13½"W X 15"D.

These two chairs are of Sheraton form but are painted in the manner of Pennsylvania-German decorated pieces. The half-spindle Windsor chair is painted in a dark red-black graining, with painted floral sprigs and pin-striping; the stylized grapes and other details on the rails are stencilled, using metallic powders. The decoration on the arrow-back Windsor is done entirely in brushwork against a yellow background. The sprigs are rendered in freehand manner and templates were probably used to create the floral motifs on the crest rail.
JSH (CHC) and private collection.

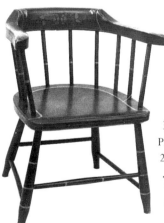

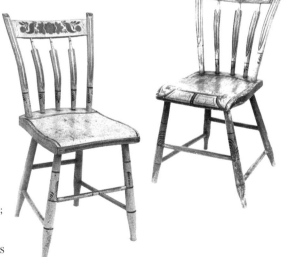

384. CHAIR: MID-19TH CENTURY;
PINE SEAT AND VARIOUS HARDWOODS;
29"H X 19"W X 18"D.

This low-back Windsor armchair is simple in construction and rich in surface ornamentation. The spindles are little more than rods, and legs and stretchers are given little elaboration other than simple incised turnings at wide intervals. The painted decoration is, by contrast, boldly executed, with black over red to provide a dramatic grained effect, highlighted by yellow striping and metallic-powder stencilling of the collar. Under the seat is affixed the label, *W. H. Woodall, Maker, / Hagerman's Corners, / Markham, C. W.* JSH.

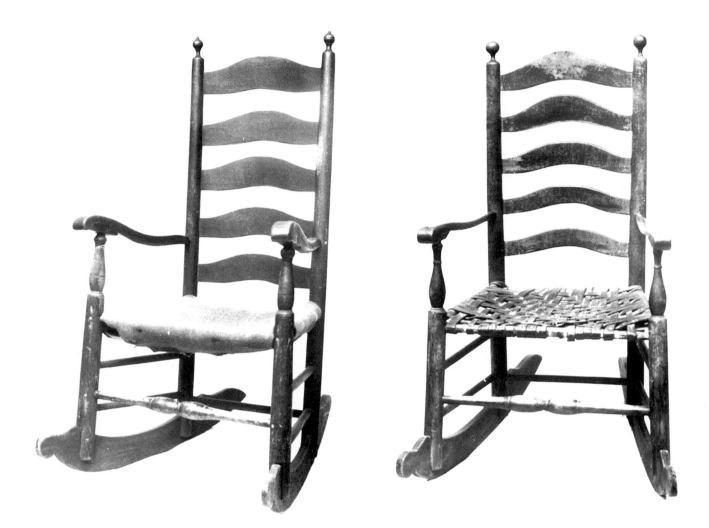

385. ROCKING CHAIRS: SECOND QUARTER 19TH CENTURY;
VARIOUS HARDWOODS; (RIGHT) 45½"H X 22½"W X 16"W.

The Pennsylvania slat-back-style rocking chair was given a singularly
robust interpretation by the maker of these two chairs from the Niagara
Peninsula. Undoubtedly from the same hand, strongly similar with
respect to turnings on front stretchers, posts and finials, as well as in the
shape of rockers and curved slats, both have elm bark seats (the one at
the right being possibly an early replacement). It is likely that they were
made as a pair, intended as a gentleman's chair and a lady's chair.

386. FOOTSTOOL: CIRCA 1855; PINE; 7¾"H X 8¾"W X 5¼"D.

Stencilled names frequently indicate the presentation nature of pieces of furniture, whether as dowry items, marriage gifts or specialty items made for children. This small footstool for Mary Shuh probably falls into the last category, likely made for her by her father, Jacob Shuh (1831–75), a cabinetmaker in Berlin (Kitchener). JSH (CHC).

387. HANGING CUPBOARD: MID-19TH CENTURY; PINE.

Small hanging wall-cupboards were usually kitchen pieces, but in the late 19th century they sometimes found a place in the parlour to display china, timepieces or other items. The small number of such cupboards in Ontario-Germanic communities may well indicate their superfluous role in relation to free-standing wall and corner cupboards, to which they bear stylistic resemblance. This example, with "fish-tail" bracket and lower shelf, retains its well-worn original blue painted finish.

388. CLOCK-SHELF: THIRD-QUARTER 19TH CENTURY; PINE; 46¼"H X 35"W X 6½"D.

By mid-century, the tall-case clock had been largely supplanted in Canadian households by the shelf- or mantle-clock, of which many variations were manufactured in substantial quantity. Although the clocks were mass-produced, the shelves made to support them were both factory-made and homemade. This shelf was found in the 1970s still mounted on a kitchen wall in New Hamburg, where it had hung for more than a century. The fanciful treatment of the top, with its variation of Gothic crenellation, is balanced by a traditional Germanic folk decoration in the form of an incised compass-star and tulips. The dark green paint is original. JSH (CHC).

389. WASHTUB: 19TH CENTURY; HARDWOODS; 7½" HIGH X 18½" DIAMETER.

Among wooden washtubs found in the Mennonite countryside of Waterloo County, this decorated example with heart cutouts is a rarity. It has been suggested that such a tub might have a specific purpose, notably for the Mennonite service of foot-washing, a possible use which needs further verification. JSH (CHC).

390. DOOR: CIRCA 1830.

The entry to an inn known from earlier times as the "Goetz House" in Rotenburg (now Maryhill) welcomed visitors and travellers in this Waterloo County Alsatian community for many decades. The decorative treatment of this door has its parallel in a wardrobe from the same structure (fig. 408). Heavy rolled moulding serves as base and also capital for the lower panels, defining their status as double pilasters. Strong Continental ornamental detailing includes lozenge and polygonal raised panels, alternating chiselled indentations, and carved *guilloches* along horizontal and vertical framing members.

391. CORNER CUPBOARD: MID-19TH CENTURY; PINE; 91"H X 61"W.

Found east of Tavistock, near the juncture of Waterloo, Perth and Oxford counties, this cupboard shows similarities to the scrolled-pediment examples above, but exhibits a Continental air in its use of the continuous curved cornice and carved fan motif, features found rarely in Germanic furniture from Southwestern Ontario. This exceptional piece is boldly coloured, retaining its original dark green-blue finish.

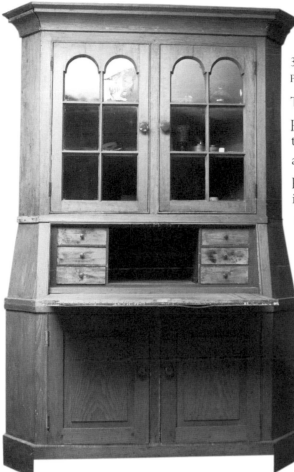

392. CORNER CUPBOARD/DESK: MID-19TH CENTURY;
PINE; 85½"H X 58"W.

The evolution of the cupboard into the desk is a common
phenomenon with regard to wall cupboards. The marriage of
the corner cupboard with the writing desk has south German
antecedents, but is virtually unknown in Ontario. A hinged
panel can be lowered to serve as a writing surface, and the
interior is fitted with galleries and six small drawers. The
canting of the mid-section is similar to treatments found
in Bavaria and Austria, and can be seen as a straight-line
simplification of the German baroque form which used
the *bombé* form with its curvilinear extravagances.

393. CORNER CUPBOARD: MID-19TH CENTURY; PINE.

Germanic furniture in Ontario frequently reveals
its background by its recourse to profile distinctive
of Pennsylvania or Continental influences.
Pennsylvania-German furniture generally has a
more "English" rectilinear appearance, in keeping
with the simple Georgian architecture popular
in Pennsylvania and extending into Ontario.
Continental-German furniture, on the other hand,
is likely to be defined by a more complex country-
baroque curved contour. This large corner cup-
board of Continental-German inspiration differs
from its Pennsylvania-German counterpart in the
elaborate scalloping of the crown, which expands
on a theme echoed on the bracket base. A similar
treatment is seen on the wall cupboard in fig. 326.

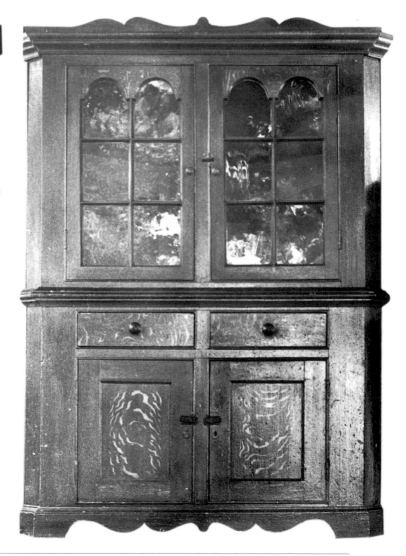

394. WALL CUPBOARD, NIAGARA PENINSULA: SECOND QUARTER 19TH CENTURY; PINE.

In the Niagara region, cupboards of virtually identical design were made alternatively of walnut or pine, the pine characteristically painted in a single colour. The original finish on this example is red. Unlike the Germanic cupboards of Waterloo or York counties, Niagara examples were typically constructed without a pie shelf between top and bottom, and with drawers set into the upper rather than lower section. The lozenge panels are a variation from the customary rectangular forms used on most cupboards of this type.

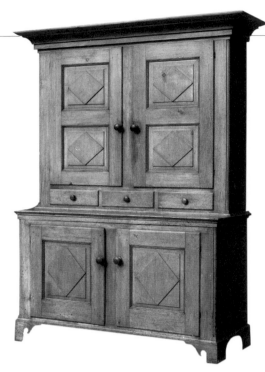

395. WALL CUPBOARD, RENFREW COUNTY: THIRD QUARTER 19TH CENTURY.

Germanic artisans in Renfrew County produced furniture whose forms bear closer continuity with European prototypes than that of Pennsylvania-German makers who followed English influences already widespread in the eastern United States. Such continuity is evident in the modest "baroqueizing" tendencies seen here in the shape of the cornice and scallops on either side of the pie shelf and skirt. This folk cupboard is notable for the applied compass stars and hearts carved into the framing of the doors. CMC (CCFCS).

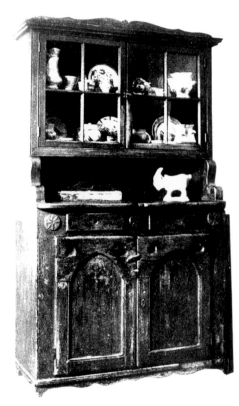

396. OPEN DISH-DRESSER: MID-19TH CENTURY; PINE; 75½"H X 59¾"W X 21"D.

Germanic open dish-dressers are not common in Ontario, although occasional simple versions and tantalizing fragments have been found in Waterloo and Perth counties. One of the most interesting examples known is this piece found near Stratford. Despite its name, Stratford was an area of strong Germanic settlement throughout much of the later 19th century. This pine cupboard is made with beaded-board stiles and back. A neoclassical theme is suggested by dentils on the cornice, while a folk-art grace note is added with the applied heart at the top of the centre stile.

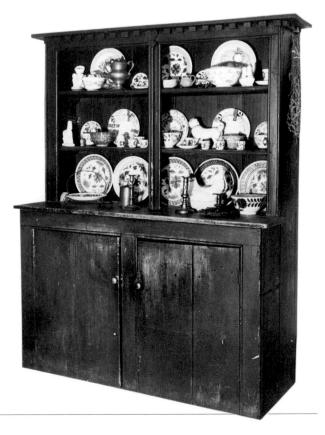

397. OPEN CORNER CUPBOARD, GREY COUNTY: THIRD QUARTER 19TH CENTURY; PINE; 74"H X 24"W.

Not all country furniture was made in workshops. This rustic corner-dresser is of the "made-at-home" variety, most likely cut with a simple handsaw. Its scalloped sides, faintly suggestive of a more skilfully executed baroque profile, are in effect whittled, and the hinges are crudely applied to the front of the door and stile. The outstanding feature is the folk-art painting of a bird on potted tree, set between zigzag borders. This cupboard was found in an area settled by German-speaking immigrants on the Wellington-Grey County border. JSH (CHC).

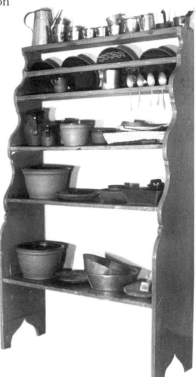

398. DRESSER: SECOND QUARTER 19TH CENTURY; PINE; 70½"H X 42"W X 15½"D.

The height of this piece suggests that it was not a bucket-bench, with which it shares some affinity, but rather was a dish dresser, open from top to bottom. There are slots for spoons and restraining bars for displaying plates on the upper shelves, while pots and crocks fit in the taller lower ones, as in the Irish open-based dresser. The sides are scrolled in a casual country-baroque idiom. Passed down through Eidt family descendants at Phillipsburg, an area of Continental-German settlement in Waterloo County, it retains an old or original yellow painted finish. JSH.

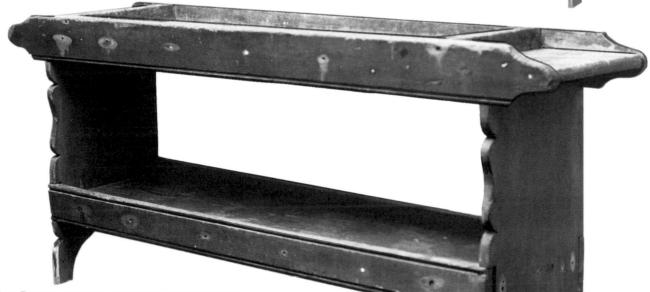

399. PAIL BENCH: SECOND QUARTER 19TH CENTURY; PINE; 29¼"H X 66¾"W X 18¼"D.

This elaborately scrolled bucket-bench from the Wettlaufer family, who settled west of Philipsburg, is competently made, with the upper shelf dovetailed into the end supports. It is constructed in a manner reminiscent of a dry sink, with the upward-projecting ends, front and back producing a shallow well. The plum-red painted finish is original. JSH (CHC).

400. DRY SINK: 1846; PINE; 32"H X 44"W X 20"D.

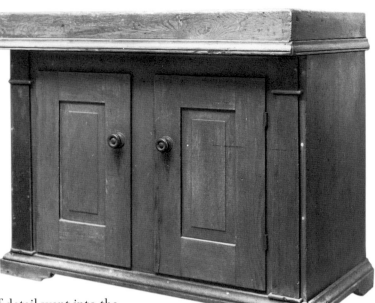

It is extremely rare for a dry sink to survive to this day without having been overpainted. This noteworthy exception is unusual also for its architectural details, which give a sophistication normally reserved for parlour furniture. Found in Maryhill (its earlier names were Rotenburg and New Germany), an area settled by Alsatian Catholic immigrants after 1828, its decoration includes tiny fleurs-de-lis stencilled on the flat pilasters, as well as the date painted in tiny numerals above the centre stile. The finish is original, with dark blue-green pilasters against a feather-grained red base. Considerable refinement of detail went into the construction of this piece, with applied concave mouldings, pegged and dovetailed joinery, finely raised panels, *faux*-painted escutcheons, and elaborate wood turning to give the impression of brass door pulls. JSH (CHC).

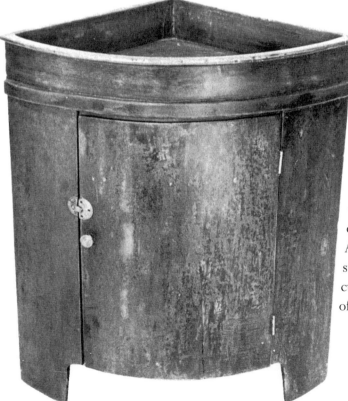

401. DRY SINK: MID-19TH CENTURY; PINE; 27½"H X 28"W.

The bow-front dry sink, a highly unusual Ontario-Germanic form, is reminiscent of neoclassical interpretations seen as widely as in the English Sheraton corner washstands and German Biedermeier corner cupboards and desks. This Perth County sink is from an area, of Alsatian settlement, and reflects the long-sustained use of Louis XV and Louis XVI curvilinear profiles in the furniture tradition of that region.

402. FOOD LOCKER, RENFREW COUNTY: THIRD QUARTER 19TH CENTURY; PINE; 73"H X 40"W X 20"D.

That the German settlers of Renfrew County and their Polish neighbours used similar design features can be seen in the decorative moulding strip across the bottom and the shaping of feet carved directly from the stiles (for comparison, note the Polish dish dressers and wall cupboards in figs. 331 and 332). The cornice, elaborately scalloped includes a central roundel with painted folk motif.

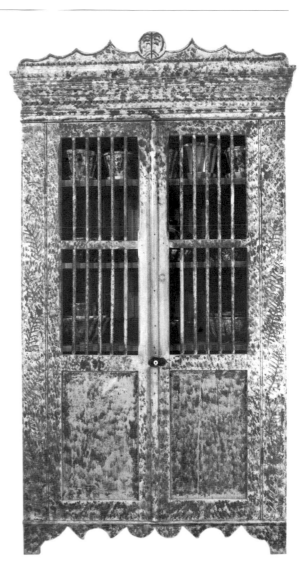

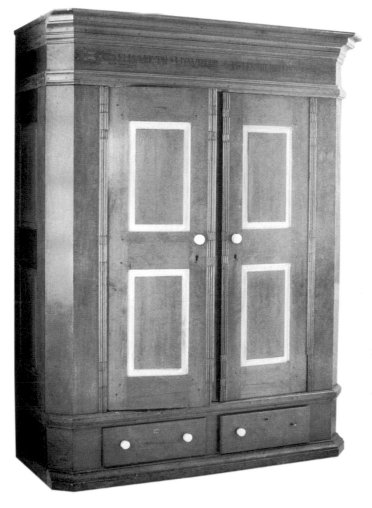

403. WARDROBE: 1852; PINE.

A group of wardrobes found in the Petersburg and Baden area of Waterloo County are closely modelled after the Swiss or Alsatian prototypes in lands from which settlers of this region came after 1823. The canted corner is typical of simple Swiss forms, and the stencilling or painting of the name and date continues a long-standing dowry tradition in which a piece of furniture was personalized and brought to the marriage. Made in the Amish-Mennonite community of Wilmot Township, this wardrobe bears the date 1852 and the name Elizabeth Littwiller.

404. WARDROBE, BRUCE COUNTY: CIRCA 1875–80; MIXED HARDWOODS.

John P. Klempp (1857–1914), son of a German immigrant from an area of Germany near today's border with the Czech Republic, combined cabinetmaking with several other means of livelihood in Bruce and Grey counties in Southwestern Ontario. Although he produced several painted pieces, he is noteworthy for his meticulous workmanship in the execution of elaborate inlaid work in some two dozen wardrobes, chests, desks, cupboards and picture frames. His wardrobes typically feature the use of alternating triangles to frame doors and drawers, and traditional folk motifs — hearts, tulips and compass stars in this case — to decorate panels and stiles. As with most of his pieces, Klempp used cherry or butternut for the large surfaces, and inset maple or walnut pieces to achieve maximum colour contrast. CMC (History Division).

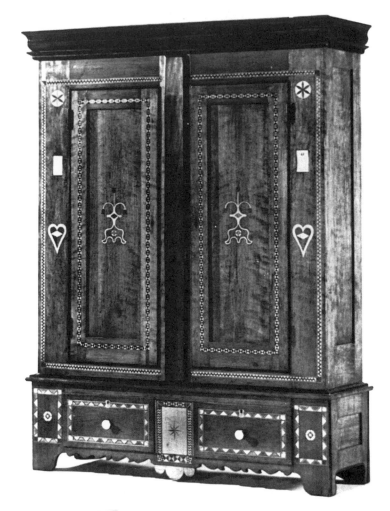

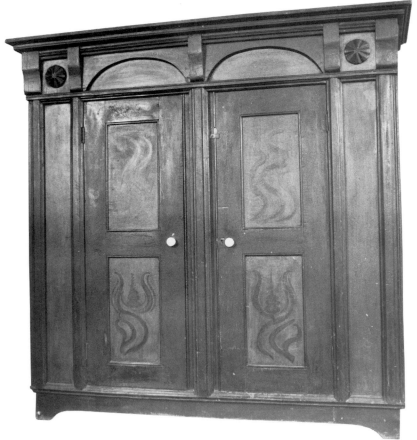

405. WARDROBE, BRUCE COUNTY: CIRCA 1875–85; PINE.

The work of an as-yet unidentified maker, this massive clothes cupboard was found in the Germanic settlement near Chesley, in Bruce County. Its ponderous nature is further emphasized by the panelled stiles flanking the doors, and heavy brackets beneath its protruding cornice. Folk elements in its decoration include applied rosettes in the upper corners and painted tulip motifs on the door panels.

406. WARDROBE, WATERLOO COUNTY: SECOND QUARTER 19TH CENTURY; PINE.

Only rarely does Waterloo County Germanic furniture feature painted floral designs, reminiscent of work found more commonly in either the Pennsylvania or Continental background. This solitary wardrobe, sadly reduced in 1970 to one half its original size (the whereabouts of the discarded half are presently unknown), was made within the Amish community of Ontario, probably near the village of Petersburg. The door frames are stained pine, and stiles and door panels have been given a solid-colour background over which leaves and baskets of flowers have been painted. This particular Amish settlement migrated to Canada from the Rhenish Palatinate, where such decoration (and more elaborate treatments) is found in abundance.

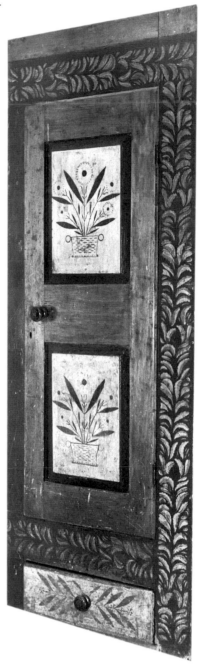

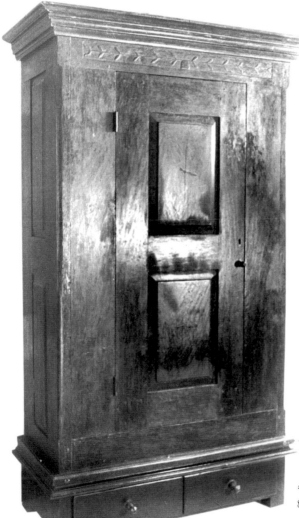

407. WARDROBE: SECOND QUARTER 19TH CENTURY; PINE; 83½"H X 50½"W X 24½"D.

Frequently the furniture made in the Alsatian communities of Waterloo County exhibits certain "French" design features, such as the simplified Louis XV panelling of the wardrobe in fig. 409. In a few instances, even construction techniques bear resemblance to French-Canadian workmanship. The stiles of this panelled wardrobe from St. Agatha continue through the base to the floor, as in the construction of a Quebec buffet or armoire. The deep blue painted finish is original. The carved decoration in the form of a double vine and tulip extending from the centre to the terminal points of the frieze is a rare feature in Waterloo County Germanic furniture. JSH (CHC).

408. WARDROBE, WATERLOO COUNTY:
SECOND QUARTER 19TH CENTURY; MAPLE.

Furniture made in the Maryhill area of Waterloo County has a unique character in Ontario, and reflects the architectural and furniture design influences of the Alsatian background from which these Roman Catholic settlers came. The lozenge panel, unknown in Pennsylvania-German furniture, is found with some regularity among the Alsatian settlements of eastern Waterloo County and areas of the province farther northwest. The diamond and five-sided panels on the doors of this maple wardrobe are identical to those on the door of the home in which this piece was found (see fig. 390).

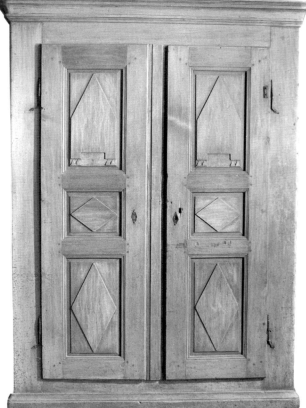

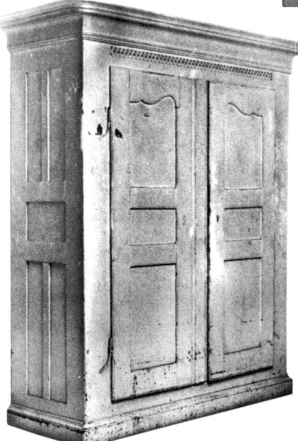

409. WARDROBE, WATERLOO COUNTY:
CIRCA 1830–50; PINE; 80½"H X 62½"W X 22½"D.

Many of the German artisans in Ontario came from the Alsatian district of eastern France, the culturally mixed region on France's border with Germany (and at various times under German control). On occasion, furniture from this community is said to appear as much French as German in style. The shaping of the upper panels of this wardrobe is a greatly simplified version of Louis XV styling found on much late 18th-century furniture made in French Canada (see fig. 17).

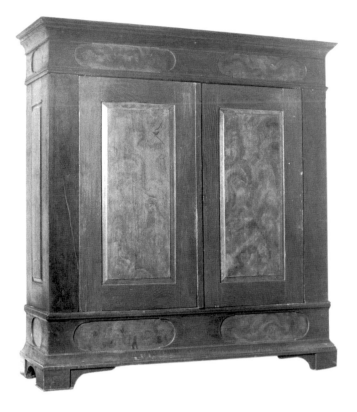

410. WARDROBE, WATERLOO OR PERTH COUNTY: MID-19TH CENTURY; PINE; 83½"H X 72"W X 22"D.

The considerable girth of this massive clothes cupboard, as well as the placement of single large panels in doors and additional recessed panels in the framework, are features of the Continental-German design tradition brought to Ontario after the first third of the 19th century. Abstract painting on panels against a dark red-and-black grained field provide strong visual impact on this imposing case piece.

411. DESK. THIRD QUARTER 19TH CENTURY; VARIED HARDWOODS.

Immigrant cabinetmaker John Gemeinhardt (1826–1912) produced a general line of furniture for local clients in the Bayfield area, and also a small group of pieces for personal use and for several family members. These special examples are often eclectic amalgamations of neoclassical, early Victorian and even Eastlake elements, but some are almost pure expressions of the distinctively German classical-revival style (Biedermeier) which attained immense European popularity throughout much of the 19th century, and was retained to a much later date by settlers arriving in North America after mid-century. Biedermeier design emphasized, among other things, the beauty of the wood surface (hence the choice and arrangement of aesthetically pleasing solids and veneers), and used classical architectural motifs in furniture design. Both themes are strongly articulated in this butler's desk made of butternut and finished with varied hardwoods, and an inner colonnaded compartment with wood carved in imitation of masonry blocks.

412. Table: Mid-19th Century; Pine; 29¼"H X 49"W X 36"D.

The draw-table is an expandable form which permits varied use as the rituals of the day may dictate. It may function at one time as a work-surface, and at others as a dining table. This table and an identical example were found in the town of Wellesley, an area of Amish-Mennonite as well as Continental-German Protestant settlement (with a most un-German place name). Following the form of such tables made throughout Central and Northern Europe from medieval times, it really has two tops on one set of legs. The lower layer can be drawn out and is ingenuously mounted on supports which cause the extended ends to rise flush with the centre section. The old dark red paint is original.

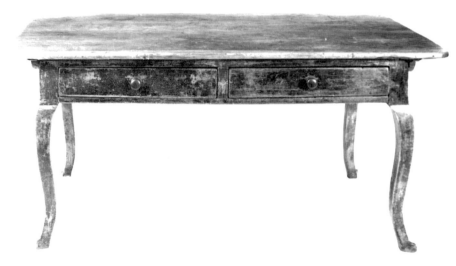

413. Table: Mid-19th Century; Pine, with Maple Legs; 30"H X 69"W X 35½"D.

Cabriole-leg tables are unknown in the Pennsylvania-German communities in Ontario, but occur relatively frequently in areas of Continental-German settlement, notably in the St. Clements–Bamberg area of Waterloo County, and in the counties to the west and north. Many of these settlers came from regions subject to French influences, including the Louis XV style, which made the cabriole leg a trademark of fashionable furniture. This exceptional Waterloo County example has well-articulated cabriole legs with dramatic outward and inward curvature and a strongly flared-out foot.

414. Table: Mid-19th Century; Cherry.

The horizontal channelling of the square leg, generally considered a signature feature of the Louis XVI style, reflects an interest in the linear and the curvilinear, and in the aesthetic value accorded to the part as opposed to the Louis XV preoccupation with submerging detail within the whole. Where the curvilinear shape was often used to disguise the points at which legs and arms joined the framework, the interruption of lines in the Louis XVI style served to emphasize, even exaggerate such divisions, junctures and transitions. This two-drawer table from Perth County provides an interesting stylistic contrast to the previous two examples.

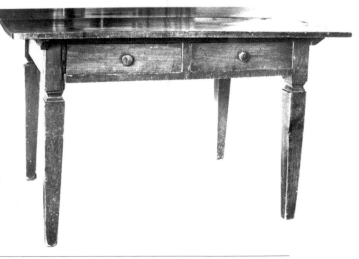

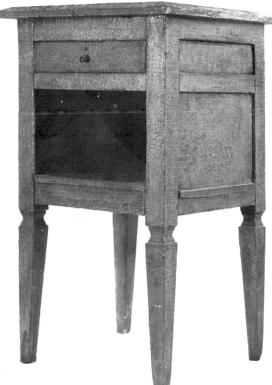

415. TABLE: MID-19TH CENTURY; PINE; 27"H X 15½"W X 17"D.

A small group of furnishings found near the village of Verona in Frontenac County suggest the work of a Germanic artisan in that area of Eastern Ontario. This small table, in a very old or original green paint, has not only a drawer but also an open side for storage. In this respect it resembles a tambour table, although there is no evidence that the opening ever had an enclosure of any sort. The horizontal channelling of the legs is rarely found in Eastern Ontario furniture, and is carved in a manner like that of the two-drawer Perth County table in fig. 414.

416. WASHSTAND: MID-19TH CENTURY; CHERRY; 34"H X 23"W X 18"D.

Two virtually identical stands of this type have been found at St. Clements, an Alsatian-Catholic settlement in Waterloo County. Both are distinguished by tambour doors made of wooden strips attached to canvas to produce a

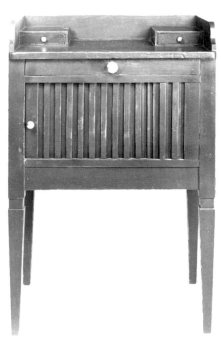

flexible panel. The influence of Louis XVI style in the design of the legs is evident, as in the fact that this piece is related to the small ladies' tables which became popular in France in the reign of Louis XVI. Its relationship to the *poudreuse* has been insightfully pointed out (Henry and Barbara Dobson, *The Furniture of Ontario and the Atlantic Provinces*, fig. 191), suggesting the degree to which high-style forms continually find their way into the design vocabulary of country furniture makers. The gallery and drawers have been restored to markings and surviving fragments of the original, and the dark red colour has been similarly restored.

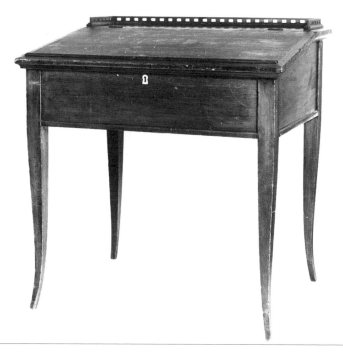

417. DESK: MID-19TH CENTURY; PINE; 35"H X 33"W X 26"D.

Another Ontario-Germanic piece inspired by dainty ladies'-furnishings introduced in the periods of Louis XV and XVI is this remarkably delicate lift-top desk from Perth County. The simple elegance of the tapered legs gently flared at the bottom is a fine provincial interpretation of Louis XV style. Made of local pine, the piece has been given a dark stain, perhaps an allusion to the more expensive mahogany or other hardwood of a formal counterpart. The gallery has been restored according to shadows and remnants still visible.

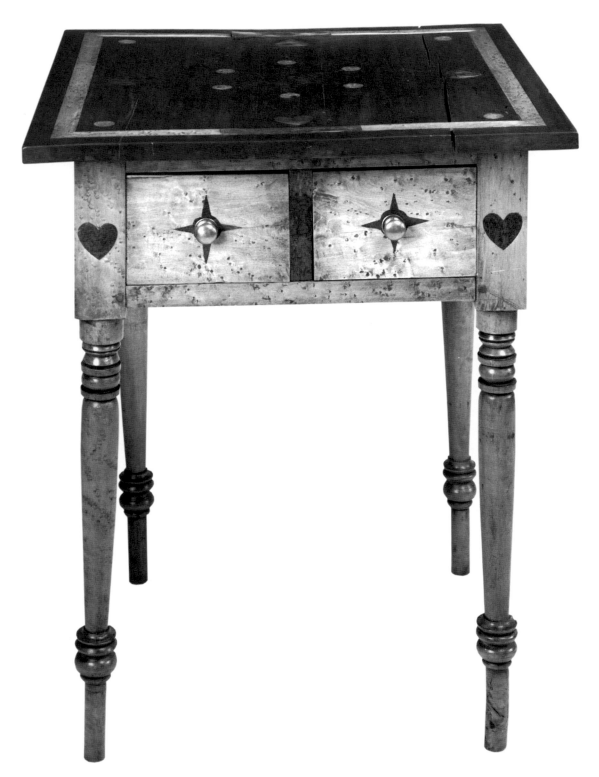

418. TABLE: SECOND QUARTER 19TH CENTURY; MAPLE WITH DARK WOOD INLAY; 29"H X 16"W X 16½"D.

Two tables found at Erbsville in Waterloo County may have been made for the same purpose for different members of a single family. This ladies' worktable, a specialty piece for the marriage of a daughter, was reportedly constructed around the year 1830 by a cabinetmaker from the Palatinate named Schweitzer. It is competently made, with fine turnings, dovetailed drawers, and elaborate inlaid details, including hearts, stars and circles within a bandwork frame.

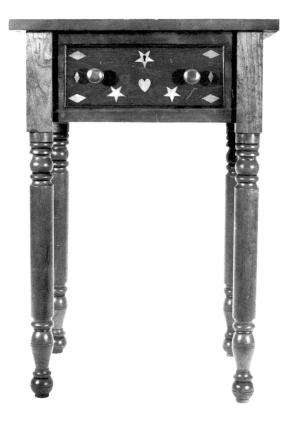

419. TABLE: SECOND QUARTER 19TH CENTURY; CHERRY WITH LIGHT WOOD INLAY; 29¼"H X 20"W X 16"D.

Most likely made by the same artisan who produced the previous example, this table found at Erbsville (the place name is inscribed in pencil on the interior) is somewhat less refined, with a long undefined leg-segment between turned upper and lower areas. It is no less dramatic in its visual effect, however, using a reversal of wood-colours. Where the first table employs a format of dark woods set against a light bird's-eye base, this table uses an arrangement of light woods inlaid against a dark figured-cherry ground. JSH (CHC).

420. TABLE: THIRD QUARTER 19TH CENTURY; HARDWOOD, WITH HARDWOOD INLAY; 29"H X 26½"W X 20½"D.

The form is complex in that many influences may be at work in the design of this unusual table from Grey or Bruce County. The curvature of the leg suggests the Louis XV cabriole leg, but may also reflect the 19th-century German neoclassical revival (Biedermeier), or even North American mid-Victorian taste. The lozenge-shaped pull is a Germanic detail found on pieces from Continental-German settlements in Southwestern Ontario. The curved cross-stretcher supports a small wooden sewing basket, an important feature of a lady's worktable.

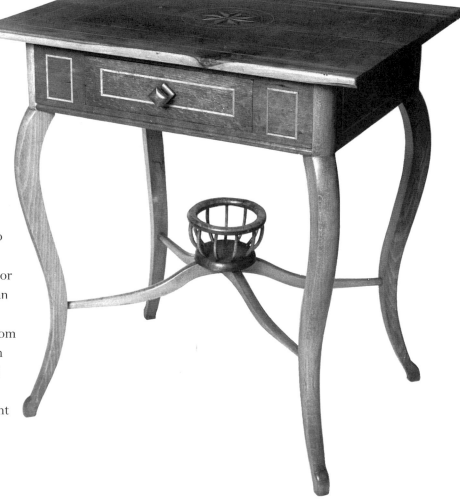

421. TABLE: LATE 19TH CENTURY; PINE; 30"H X 32"W X 24¼"D.

This table found in the Ottawa Valley is derived from the heavy trestle-type table made widely in German-speaking regions of Europe, and is related to the Wilno-area saw-buck table in fig. 430. A pine scrubbed top rests on scalloped board-feet, themselves mortised into elaborately stepped-down brackets. Decorative appeal is provided by the wide hearts cut into the legs. This extremely interesting table retains its well-worn original red painted finish.

422. BED: THIRD QUARTER 19TH CENTURY; WOODS.

The prevalence of Biedermeier influences on Ontario-Germanic furniture is particularly evident in the neoclassical pediments and curved forms found on several pieces made in Bruce and Grey counties, lands which were settled by largely destitute German immigrants who arrived in Canada during the 1850s. This child's bed is a good example, with its architectural rendering of end boards, with centre crests and even small caps on the corner posts. It was found in Normanby Township, Grey County, and retains its well-preserved original dark red painted finish.

423. CHILD'S BED, RENFREW COUNTY: THIRD QUARTER 19TH CENTURY; PINE; 32"H X 43½"W X 25½"D.

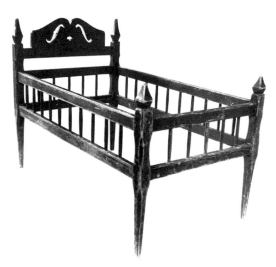

From the Continental-Germanic settlement of Eastern Ontario, this child's bed suggests a blend of Biedermeier and personal interpretations. The scrolled pediment of the headboard, chamfered legs, carved finials and spindled gallery come from neoclassical influences. Of particular interest is the decorative cutwork, a folk interpretation of musical motifs which were used in Biedermeier designs. This charming country piece retains its original dark red painted finish.

424. BOX-BENCH: MID-19TH CENTURY; PINE; 34"H X 70"W X 15"D.

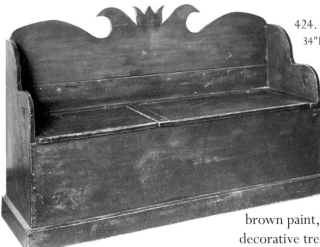

The combination bench-chest, popular in peasant households in German-speaking lands on the Continent, rarely found expression in Ontario. This notable exception, however, is one of several made in the Amish-Mennonite community west of Wellesley. It has two hinged lids, permitting storage of wood or other items, and was most likely a kitchen piece. It is made of pine, with an old red-brown paint, and it distinguished by several folk motifs in its decorative treatment, a large tulip carved from the crest, and small hearts cut through the end boards.

425. BENCH: MID-19TH CENTURY; BEECH; 29"H X 70"W X 23"D.

Alois Schwager, an immigrant German craftsman living at Ardock in Frontenac County, produced several examples of both sofas and chairs, strongly reflective of his Germanic background. This bench and an almost identical counterpart are of late 19th-century make, but can be classed as *retardataire* examples because they preserve stylistic elements long gone out of fashion. Indeed, the neoclassical designs used by Schwager had been central Biedermeier motifs perhaps a half century before the date of these sofas. The fretwork back may be the result of even earlier design sources, such as those promoted and popularized by Chippendale and his followers, while the curvature of the ends, uniting feet and arms in a continuous sweep, is a Biedermeier characteristic found widely in the design of Mennonite benches from Western Canada.

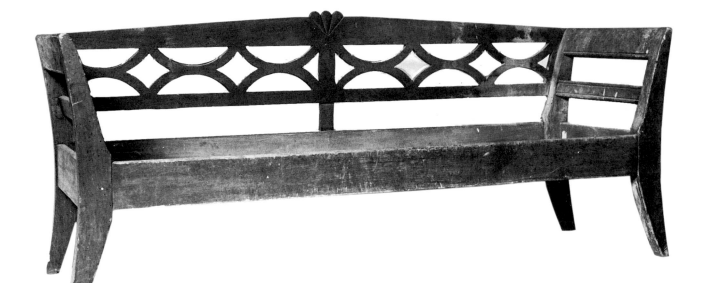

426. BENCH: MID-19TH CENTURY; HARDWOOD; 27"H X 72"W X 24"D.

This unique Ontario-Germanic bench was found in Perth County, north of Stratford, but had travelled there when Riehl family members moved to that area from Erbsville in Waterloo County early in the present century. This form was shown by various English designers, notably Sheraton and Hepplewhite, where it was a high-style window seat in the exotic form known as a *turquoise*, here intended to serve more as a daybed. The curvature is more in the early English or French form which found its way to Germany in the late 18th century, much earlier than those forms which make up the Biedermeier style. It is attributed by present-day family members to Valentine Riehl, an Alsatian settler living variously in the St. Clements, Waterloo and Erbsville areas.

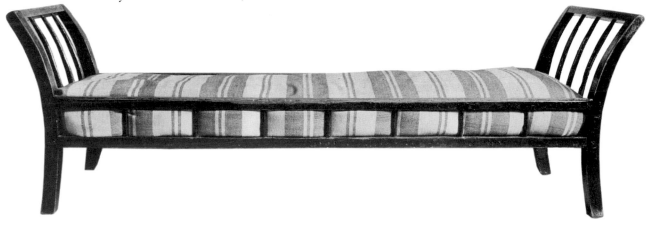

427. Chair: Mid-19th Century; Woods; 32"H X 15¾"W X 15⅜"D.

Possibly the work of Alois Schwager, maker of the bench in fig. 425, this chair exhibits strong elements of the classical revival which pervaded furniture design throughout the first half of the 19th century. The legs, while less swept back than the typical *klismos* of English Regency chairs, are nonetheless "Greek" in spirit. The band of intersecting circles, or *guilloche* pattern around the sides of the chair, is seen variously in an Anglo-Ontario chair (fig. 297) and in Ontario-Germanic architecture and furniture (fig. 390).

428. Chair and Footstool: Late 19th Century; Various Hardwoods.

In a style reminiscent of Duncan Phyfe in the United States, but with German antecedents in early Biedermeier furniture, immigrant cabinetmaker John Gemeinhardt made four lyre-back chairs for family members in the closing decades of the 19th century, some fifty or more years after the style had gone out of vogue in high-style circles. The chair is given a formal sensibility by a painted treatment which resembles burled hardwood, and the lyre motif is painted black, suggestive of *ébénisterie*. The swept-back legs of the chair are of neoclassical derivation, while the scalloped profile and cabriole legs of the footstool are part of the pervasive Louis XV style in country furniture by Continental artisans.

429. HANGING CUPBOARD: SECOND QUARTER 19TH CENTURY; PINE; 37½"H X 30"W X 16½"D.

This solid-door hanging cupboard was found near Maryhill, and is related to other Alsatian furniture made in that area. Notable is its triple-raised panel — a lozenge superimposed upon a rectangle, itself placed over a larger rectangle, the contrasts further emphasized by three variations of a blue-green painted finish. Below the fully enclosed upper section is a shelf for the display of small articles.

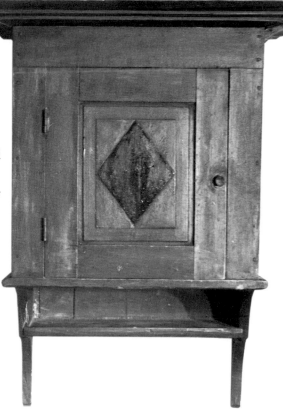

430. WATCH-HOLDER: LATE 19TH CENTURY; PINE.

Both the practical importance of the small clock or watch as well as its monetary and aesthetic value meant that such pieces were often placed in secure and attractive display cases. Immigrant cabinetmaker John Gemeinhardt provided a wooden counterpart to a formal architectural clock-case; the original would likely be made of expensive hardwoods and metals. This small temple structure is strongly in the Biedermeier neoclassical tradition. The curvature of the pediment is less Greek than baroque, and has its larger domestic parallel in the corner cupboard shown in fig. 391.

This piece has been mostly stripped, but traces of an old dark stain remain.

431. FRAMES: (PETERSBURG 1867) PINE, 12½"H X 11"W;
(CHRISTIAN SCHWARZENTRUBER 1869) PINE, 20"H X 16"W.

Several pieces of furniture with stencilled names have been found in the Amish-Mennonite settlement at Petersburg, west of Kitchener (see the Elizabeth Littwiller wardrobe in fig. 403). Some pieces were undoubtedly made as dowry furniture, but the dates 1867 and 1869 on these stencilled frames may simply denote ownership or possibly be the imprint of the maker. Both are subtly grain-painted, over which bronze or other metallic powders are employed in the stencilling of name, place and year.

432. CHEST LID: MID-19TH CENTURY;
PINE; 17¼"H X 33¼"W.

Only the lid survives (the box, deemed ordinary because it was without decoration, was discarded in recent years), but it is rich in embellishments. Found in an Amish-Mennonite home in Waterloo County, it bears the name of its owner, *Joseb Gingric* (a phonetic spelling based upon German pronunciation), and a grouping of motifs — trees and six-point compass stars — painted in yellow against a black background. JSH (CHC).

433. CROKINOLE BOARD: 1875; PINE; 26⅜" DIAMETER.

Eckhardt Wettlaufer (1845–1919) was a wagon-maker and carpenter at Sebastopol, a little south of a line between Kitchener and Stratford, and his competent brushwork painting is known on several surviving pieces. In 1875 he made a crokinole board for his son Adam's fifth birthday. The surface is finished in four colours — dark green, black, light red and medium red — over which is painted the Germanic folk motif of four stylized tulips radiating outward from the centre. JSH (CHC).

POLISH

434. WALL CUPBOARD: THIRD QUARTER 19TH CENTURY; PINE.

The glazed dish-dresser, possibly of somewhat later derivation than the open cupboard, became a staple in Wilno-area households by the end of the third quarter of the 19th century. Most are comprised of two sections, with glass doors above and panelled doors below, with a space in-between to accommodate one or two drawers. Glazing bars are generally set at the same intervals as shelves, providing places for display rather than mere storage. Like other examples, the cupboard is fitted with a decorative cornice, designed as a a pair of double-segmented curves flanking a carved shell- or leaf-motif. Green colour accentuates the baroque scrollwork of the cornice, set against an orange painted finish on the case of the cupboard. Many of these cupboards and related pieces, particularly those with distinctive cornices, are believed to be the work of John Kozloski, a furniture maker in the Wilno area.

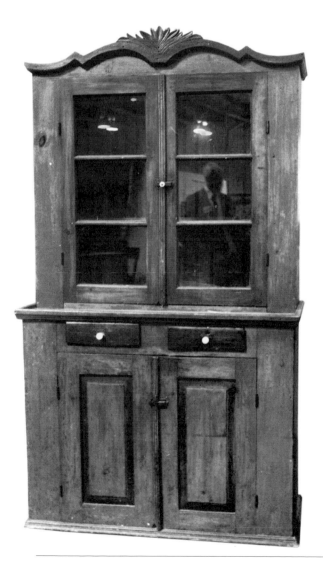

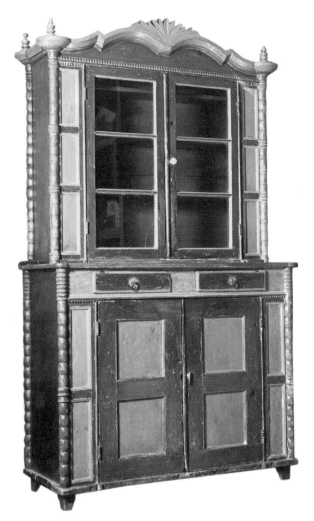

435. WALL CUPBOARD: THIRD QUARTER 19TH CENTURY; PINE; 86"H X 48"W X 19"D.

The traditional Polish country baroque elements relate this wall cupboard closely to the dish dressers in figs. 331 and 332 with its complexly curved crown moulding and fan or leaf motif. The turned columns may be a provincial mimicking of a Renaissance architectural motif of turned or twisted columns, or may be related to simple spool-turned pillars and half-balusters found on country and even Victorian factory-made furniture of the mid- to late 19th century. Most cupboards of this type are painted in one or two colours; here the painter has pulled out all the stops, with a four-colour treatment in ochre, red, blue and light green. CMC (CCFCS).

436. WALL CUPBOARD, RENFREW COUNTY: THIRD QUARTER 19TH CENTURY; PINE; 74"H X 44"W X 16"D.

The simplicity of this wall cupboard is offset by the vines and other floral motifs painted on its panelled door and stiles. Stylized floral motifs are the rule rather than the exception in Wilno storage chests, but such folk decoration is virtually unknown on cupboards from the area. The relatively free-form execution of vine motifs here contrasts with the repetitious conventionalization of flowers and baskets on the panels of storage chests. The glazed dish-dresser form was probably produced at the same time as the alternative form of the open dresser, in that details of construction, planing, joinery and materials are virtually the same in the examples in figs. 331 and 332. CMC (CCFCS).

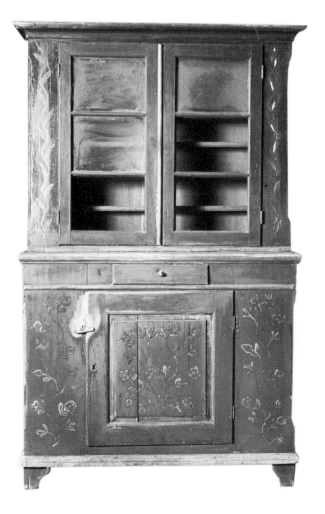

437. Buffet: Third Quarter 19th Century; Pine; 49¼"H X 46½"W X 16½"D.

This pine side board or buffet from the Wilno district perpetuates a form going back to Renaissance prototypes, with an arrangement of drawers above doors, creating storage space for a wide variety of wares, cutlery and linens related to the dining table. Sculptural emphasis is effected by applied moulding strips, and an understated architectural statement is made by means of the V-shaped crosspiece above the drawers, in essence a flattened pseudo-pediment. This device was used widely in late 18th- and early 19th-century neoclassical furniture made throughout Northern and Eastern Europe, and a striking counterpart can be seen in the popularity of this form in furniture made as far away as Dutch settlements in South Africa (see Michael Baraitser and Anton Obholzer, *Cape Country Furniture*, fig. 1021). The scrolled backboard is a country baroque element found in other Wilno examples. There is some restoration to the left drawer face. The dark red painted finish is original.

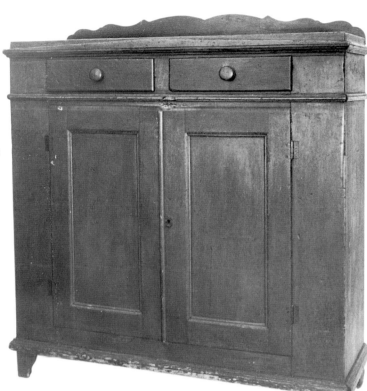

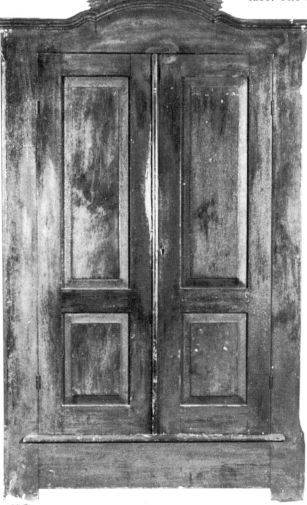

438. Cupboard or Wardrobe: Third Quarter 19th Century; Pine; 78½"H X 46¼"W X 18¼"D.

In the early log homes built by Polish settlers in Renfrew County, the free-standing wardrobe (*szafa*) was a necessary mode of clothes storage before built-in closets of late 19th-century homes. This two-drawer clothes cupboard is similar in form to Ukrainian examples made in Western Canada, but the segmentally scrolled cornice relates it to the Wilno tradition. A distinctive feature is a carved floral and lyre motif at the centre of the pediment.

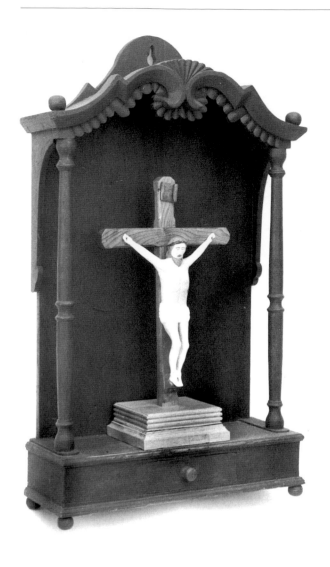
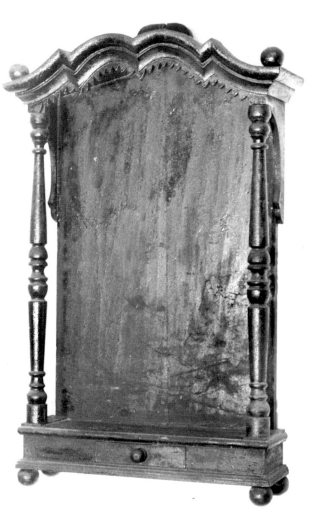

443. Shrines, Renfrew County: third quarter 19th century;
pine; (left) 37½"H X 18½"W X 6½"D; (right) 34"H X 20½"W X 6½"D.

It has been popular to refer to shelves of this sort as reliquaries, but that may be too restrictive since it describes a container to house saintly relics. Many of these shelves have been found in private homes, where the possession of relics is highly unlikely. Instead, such pieces were in most cases the domestic equivalent of niches for the display of holy figures, hence are more accurately placed in the category of shrines. The example on the left is painted dark brown. Like the piece on the left, the shrine on the right is meticulously carved in a country baroque manner, and the segmented curvature of the cornice is like that on several cupboards (figs. 434 and 435) and wardrobes (figs. 438 and 439). The foliate motif at the centre of pediment has here been simplified to a fan. The lower edge of the cornice is cut out in saw-tooth fashion, a flattened alternative to the more sculptural carved teeth on the other shrine. Small drawers on these two examples could serve as storage for candles, or for printed meditations or other devotional materials associated with the saint whose statue was displayed. The shrine on the right, painted apple green, was acquired from the Lapenski family in Wilno, and both may be the work of furniture maker John Kozlowski.

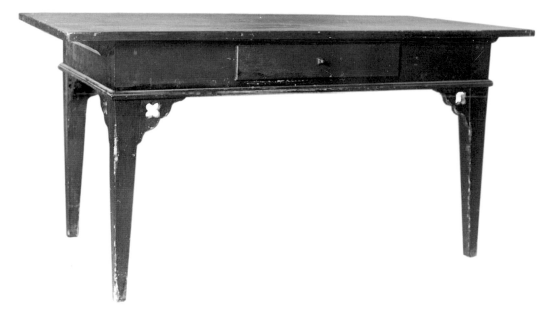

444. TABLE: THIRD QUARTER 19TH CENTURY; PINE; 31"H X 62"W X 32½"D.

Tables found in the Wilno district are normally 5 to 6 feet in length, and 3 feet or less wide, serving variously as work and dining tables. Many, like this example, have cleated tops, decorative mouldings, and scrolled corner-brackets with simple quatrefoil or other designs cut through in fretwork manner. Tables of similar design with simplified corner-brackets were widely made by Mennonites in Western Canada (see figs. 475 and 476), drawing upon a Germanic idiom they had used earlier during periods of domicile in Poland, Ukraine and Russia. This table (*Stol*) with a side drawer is painted in brown, plum-red and green colours.

445. TABLE: LATE 19TH CENTURY; PINE.

The sawbuck table was made throughout the German-speaking regions, Poland and the Scandinavian countries, where it was a practical, stable form. Its survival in Canada has been rather limited; this piece is perhaps the only known specimen found in Renfrew County. It is a late example, but an interesting one because of the elaboration of scrollwork in the shaping of its understructure. The crossed supports, secured by cleats at top and bottom and joined by a medial stretcher, are of massive proportion, in the manner of much earlier tables. CMC (CCFCS).

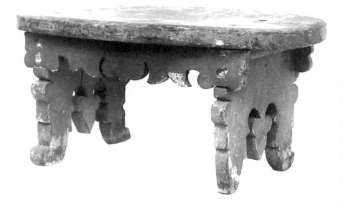

446. FOOTSTOOL: THIRD QUARTER 19TH CENTURY; PINE; 7¾"H X 16¾"W X 10"D.

Although of seeming stylistic insignificance, given their small size and lowly status, footstools frequently bear design similarities to more imposing furniture forms, here manifested in complex scrolled detail characteristic of the Wilno region.

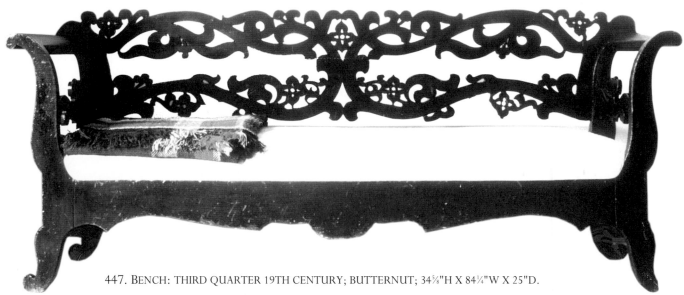

447. BENCH: THIRD QUARTER 19TH CENTURY; BUTTERNUT; 34⅝"H X 84¼"W X 25"D.

The extreme possibilities of country rococo flourish have been reached in the design of this bench, a form which otherwise might be called a country couch. The complexity of carved detail is reminiscent of certain American rococo-revival furniture, notably that of John Henry Belter (1804–63), whose German cabinetmaking background was evident in the elaborate chairs and sofas he made in New York City. Nothing else in the Wilno furniture vocabulary quite matches the frenetic interplay of ever-changing lines, almost as if this were intended to be a demonstration of a local furniture maker's virtuosity. This flamboyance is enclosed within a Biedermeier parenthesis with typical curved arms and feet as in fig. 336. The reddish-brown varnish stain is original.

448. BENCH: LATE 19TH CENTURY; OAK; 34"H X 43½"W X 15½"D.

A bench of primitive construction, this example reveals something of the eclectic influences at work in the making of country furniture in Canada in the later decades of the 19th century. The back seems to be an add-on to a conventional bench form, although there is no reason to doubt that the piece was made as a whole at the time. The curvature of the end posts is vaguely reminiscent of the Biedermeier serpentine profile, but may be more directly indebted to the late 19th-century Victorian curve profile seen on the backs ("harps") of mass-produced washstands. As such, it serves to show the creative integration by country artisans of elements traditional to their homelands and the newly popular styles of factory-manufactured furniture advertised in catalogues which were in wide circulation at the end of the 19th century and beginning of the 20th century. A green overpaint covers the original red finish.

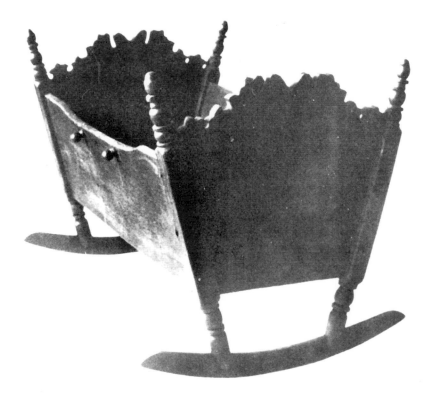

449. CRADLE: THIRD QUARTER 19TH CENTURY; ASH; 26"H X 36½"L X 20"W.

Cradles from the Wilno area are generally of post-and-frame construction, as were those made in French Canada throughout much of the 19th century. The upper sections of the corner posts are given to unusually elaborate series of turnings, and call to mind those on spinning wheels. The intricate scrollwork of the ends, with many variations of detail within a double curve joined at the centre, produces an almost zoomorphic profile, not unlike that on a Western Mennonite corner cupboard found at LaCrete, Alberta (fig. 27).

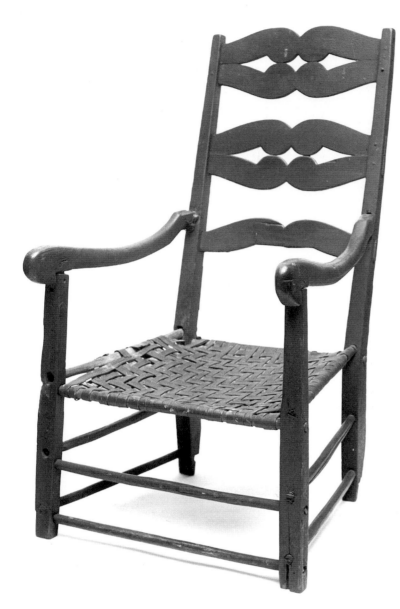

450. CHAIR, SOUTHWESTERN ONTARIO:
LATE 18TH OR EARLY 19TH CENTURY;
VARIED HARDWOODS; 32"H X 22"W X 16"D.

The French tradition in Ontario furniture is seen occasionally, but usually as a late interpretation in which earlier styles have been largely diluted by Empire and Victorian influences. A striking exception is this early chair found at Niagara-on-the-Lake and possibly a survival from earliest French settlements along the Great Lakes. It is a primitive armchair *à la capucine*, using juxtaposed "salamander" slats to produce a refreshing chair-back design. Niagara Historical Museum.

451. CHAIR: SOUTHWESTERN ONTARIO:
19TH CENTURY; VARIED HARD- AND SOFTWOODS.

This remarkable chair of Mohawk provenance, purportedly of ceremonial purpose, was found on the Six Nations Reserve near Brantford. Holes on the top of the chair back suggest the placement of finials, posts or ribbons. Resting upon a framework of square tapered legs and sides which are butted and pegged together is a combined seat-and-back scooped out of a single block of wood. Dowelled into the top is a scrolled comb taken from the same source. Incised vines enhance the sides, and the chair is painted a deep red colour.

WESTERN PROVINCES

452. DISH CUPBOARD, SASKATCHEWAN, EARLY 20TH CENTURY; PINE.

An interesting aspect of Mennonite case furniture made in Western Canada is the feature of separable bases and cornices which resembled each other so closely as to be almost interchangeable. This kitchen piece was made to store regularly used culinary items — cutlery, dishes, goblets and cups. The central crown on the cornice, with scrolled horizontal cornice, is faintly neoclassical in inspiration. The simple returned corner finials may in fact be allusions to Renaissance architectural details.

453. DISH CUPBOARD, MANITOBA: LATE 19TH CENTURY; PINE; 88"H X 50½"W X 19½"D.

Unusual in its gracefulness, this tall cupboard is of considerable sophistication in its design elements. The pleasing vertical line of this piece is effectively accentuated by several devices, notably the arrangement of narrow, upright, raised panels in side-by-side position and the reeded stiles of both sections to emphasize a straight-line upward continuity. The principle is weakened somewhat by the simple horizontal panes in the upper doors. An especially pleasing refinement is the use of cockbead moulding to more sharply articulate the scrollwork of the base of the cupboard. The cupboard was varnished and was never painted; the case rests on a separate plinth; signed on the lower shelf *Abram Martens*. Martens was a village woodworker and cabinetmaker in the Hiebert District (now deserted), located between Roland and Lowe Farm, Manitoba. The cupboard was owned by three generations of Hieberts (the last family owner was Helen Hiebert of Plum Coulee, Manitoba).

454. DISH CUPBOARD, SASKATCHEWAN:
FIRST QUARTER 20TH CENTURY; PINE;
85"H X 39¼"W X 18¼"D.

This scaled-down cupboard is of somewhat later
construction than other examples illustrated here. It
retains the traditional functions of storage below and
display above by its arrangement of blind and glazed
doors, and is given dramatic visual impact by its
bold yellow and green painted colouration.

455. STORAGE CUPBOARD, MANITOBA:
LATE 19TH CENTURY; PINE.

This cupboard has a food-locker base
section, and a three-door arrangement
in the upper section similar to that in
the previous example. Openings in the
bottom doors allow free circulation of
air, thereby making possible the storage
of food. The painted treatment of this
cupboard, with stylized birds on cream-
coloured flat panels set in contrast
to the red colouration of the case, is
unusual in Mennonite examples.

456. Dish Cupboard, Saskatchewan or Manitoba: Late 19th or Early 20th Century; Pine; 81¼"H X 40½"W X 17¾"D.

This cupboard, which retains the bright yellow colour typical of many Mennonite pieces from Western Canada, especially those made in Manitoba, is constructed in the usual format — upper doors, lower doors, and drawers between. The format served well the needs of storage (functional wares, utensils, cutlery and table linens) in the lower section and display (good china) in the glazed upper section. As with other examples, the bracket base is of the five-leg type and is removable.

457. Bookcase, Saskatchewan or Manitoba: Late 19th or Early 20th Century; Pine; 80¾"H X 52½"W X 17¾"D.

This piece was probably intended for the storage of books, as is suggested by the slotted supports and adjustable shelves. The dark stain may reveal the intention to create a parlour piece, or, alternatively, a minister's cupboard to house Scriptures and various religious volumes. The carved shaping of the support exhibits similarities to Renaissance designs, probably filtered through late Victorian revival furniture.

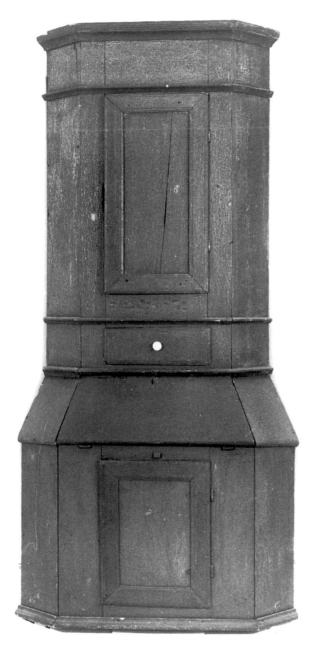

458. CORNER CUPBOARD, MANITOBA:
LATE 19TH CENTURY; PINE; 78"H X 36"W X 20¼"D.

Free-standing corner cupboards were made only occasionally in Western Canadian Mennonite communities, since their function was largely served by smaller versions set higher up on the dado or a specially constructed corner shelf. The known examples have solid, rather than glazed doors. This cupboard, in its original dark-red painted finish, is made in one piece, but the canted waist beneath lower and upper doors gives the impression of two separate sections. The step-back design with inclined mid-section is distantly related to baroque cupboards from southern Germany and Bavaria, an elaborate version of which was known as a *Tabernakelsekretär* or *Tabernakelkommode*.

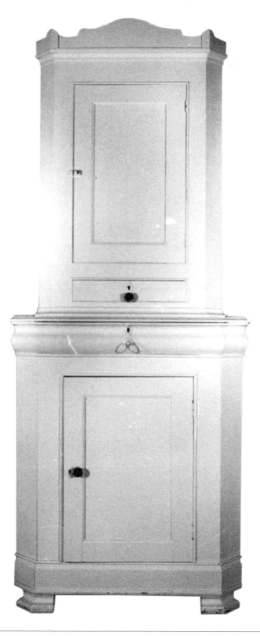

459. CORNER CUPBOARD, SASKATCHEWAN:
EARLY 20TH CENTURY; PINE; 92"H X 37½"W X 22"D.

This pine cupboard from Saskatchewan is remarkable in terms of its strongly Biedermeier design features. The ogee-curved drawer and apron between the lower and upper segments is a neoclassical feature rarely found on furniture in Western Canada, and reflects the Germanic interpretation of that style as brought along by immigrant artisans. The upper unit of this two-piece cupboard, taken by itself, closely resembles many of the small hanging cupboards or dado cupboards shown in the following illustrations. Beneath a modern overpaint is the original red finish.

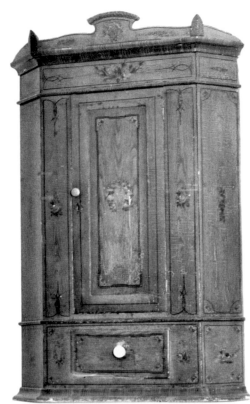

460. Hanging Corner-Cupboard, Manitoba, late 19th century; pine.

While popularly called hanging cupboards, these pieces in fact rested on supports projecting from the walls. The function of the small cupboard hung in the corner has varied greatly, depending upon culture, historical period and, of course, the room in which it is found. In early south German homes, a corner cupboard, situated in the *Herr Gottswinkel* (God's corner), frequently housed a religious artifact (perhaps a carving of a saint, if the family were Roman Catholic, or a Bible or devotional book, if the family were Protestant). In later times, such cupboards continued to be used for items of special monetary or personal value, since tall cupboards were used for storage and display of a more general array of household possessions. In the Mennonite communities of Western Canada, these small cupboards, almost always made with doors and drawers, were designed to hang on nails, to rest on the dado strip over the wainscotting, or both. This piece is grained to impart an impression of formality (as if it were made of oak rather than ordinary pine). The neoclassical profile of the cornice is occasionally also found on wall cupboards.

461. Hanging Corner-Cupboard, Western Canada: late 19th or early 20th century; pine; 57"H X 34"W X 23"D.

This piece is a good example of the typical Western Mennonite corner cupboard, with its panelled door, drawer, cornice and bracket base. The scrolling of the top is in the neoclassical or, more specifically, Empire idiom, and curves and returns give unusual lightness to the base.

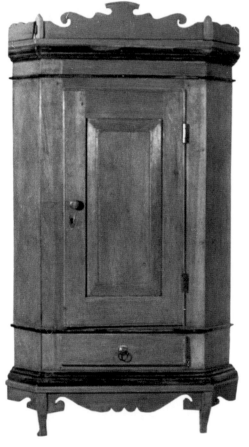

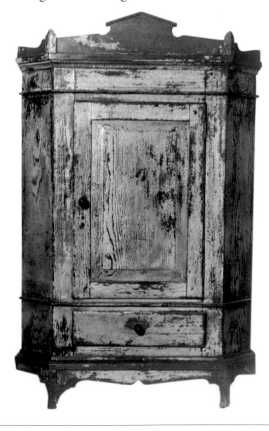

462. Hanging Corner-Cupboard, Western Canada: late 19th century; pine; 49"H X 31"W X 18"D.

A comparatively early piece, this cupboard is finely constructed, with extensive mouldings to define horizontal divisions, juxtaposed against an angular pedimented crest and a slightly curved skirt. The greatly weathered finish retains traces of the original black and yellow colouration.

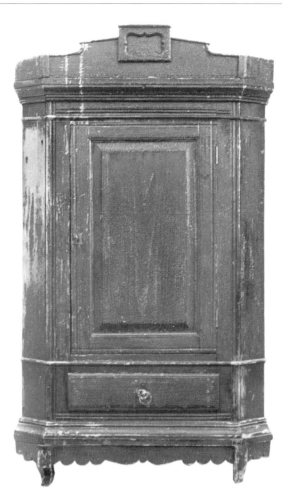

463. HANGING CORNER-CUPBOARD, WESTERN CANADA: LATE 19TH OR EARLY 20TH CENTURY; PINE; 51"H X 33"W X 23"D.

This cupboard is, apart from its tightly scrolled skirt, neatly conceived on the rectangular principle. The geometry of the door and drawer is amplified by mouldings and incised lines which frame these elements. A flattened neoclassical pediment culminates in an interesting structural feature, a cartouche with inner scrolling reminiscent of a popular Chippendale framing device used around panels and panes. The original dark red painted and varnished finish is worn and greatly crackled with age.

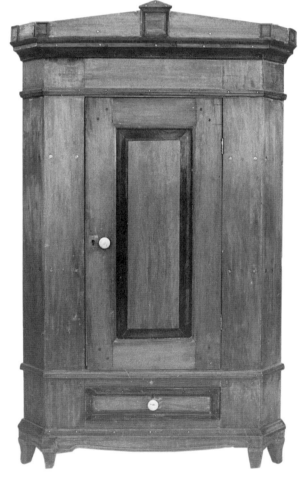

464. HANGING CORNER-CUPBOARD, WESTERN CANADA: LATE 19TH OR EARLY 20TH CENTURY; PINE; 56"H X 31"W X 19"D.

A typical Prairie Mennonite example, this corner cupboard is among the few found along with the original corner shelf on which it rests. The curvature of the crest, along with a central pediment and flanking capped posts, is an architectural device likely adapted from Renaissance-style facades of the Dutch or Polish background of Mennonite settlers.

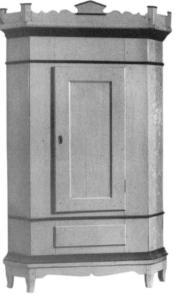

465. HANGING CORNER-CUPBOARD, WESTERN CANADA: LATE 19TH OR EARLY 20TH CENTURY; PINE; 51"H X 33"W X 23"D.

A Manitoba cupboard of simple lines, given sculptural emphasis through fielded panels, applied moulding, and cock-beaded highlighting of the curvature of the skirt. The low triangular pediment contains at its centre a small gabled cartouche, conveying an architectural suggestion of a keystone. Originally painted or stained, it is now in a refinished state.

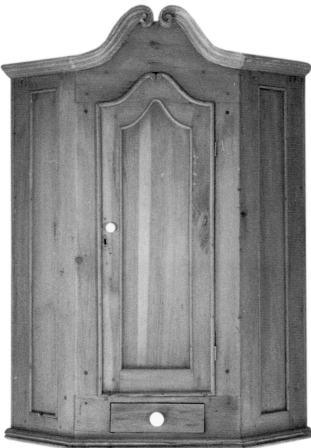

466. HANGING CORNER-CUPBOARD, MANITOBA:
LATE 19TH CENTURY; PINE.

Like the preceding examples, this cupboard was
hung in a corner and may have been supported from
beneath by a railing or shelf. The maker of this piece
shows sensitivity to form, and seems to have worked
from outer profile to inner detail. Considerable
delicacy of design is reflected in the moulded
pediment carved in the shape of a double scrolled
arch. A somewhat surprising and highly successful
innovation is the repeating of the cornice-line in the
shaping of the door and panel, and the finishing of
the thin moulding in the form of back-scrolled ends,
a miniaturization of the pediment above.

467. HANGING CORNER-CUPBOARD, MANITOBA:
LATE 19TH CENTURY; PINE;
57"H X 27½"W X 27½"D.

By the same maker as the example in fig. 466,
this pine corner cupboard shares with the former
the scrolled-arch pediment, a motif associated in
England with Thomas Chippendale, but given
architectural and furniture interpretation
throughout Northern Europe, the Scandinavian
countries, and Russia. An interesting analogy
was suggested by an owner of one of these pieces
who referred to it as a "musk-ox" cupboard. Of
further interest in this example is the neoclassical
treatment in the form of columns on each side.

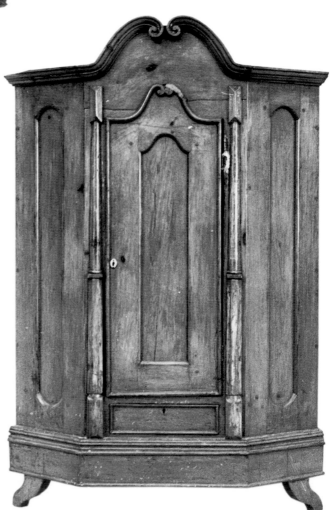

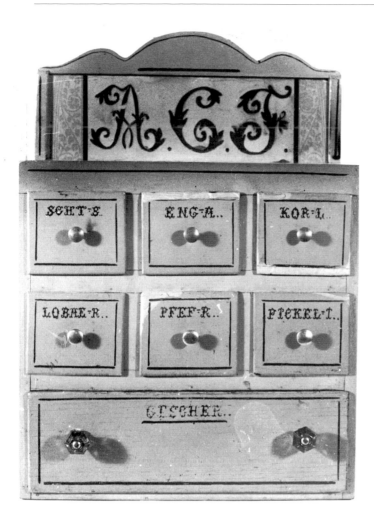

468. HANGING SPICE CABINET, SASKATCHEWAN: EARLY 20TH CENTURY; PINE; 18"H X 12¼"W X 6¼"D.

Hand-painted titles indicate the various spices kept in this small cabinet found in Eastern Saskatchewan, where it was sold in a lot of Mennonite furnishings offered at auction. Labelled spice cupboards are a rarity in Canada.

469. SHELF, MANITOBA: LATE 19TH CENTURY; PINE; 72"H X 60¼"W X 10"D.

A tall shelf, probably for storage of kitchen utensils, crockery or other items. Dowels in the back of the end boards indicate that the unit was secured to the wall to provide stability. The upper and middle shelves are permanent, while the remaining two shelves and supports nailed into the sides to accommodate them were made and added later. The red colour on the later shelves is somewhat lighter than the original red painted finish. The half-circle cutouts on the bottoms are a standard levelling device, while the scrolled cutouts at the top are an interesting country baroque embellishment. JSH (CHC).

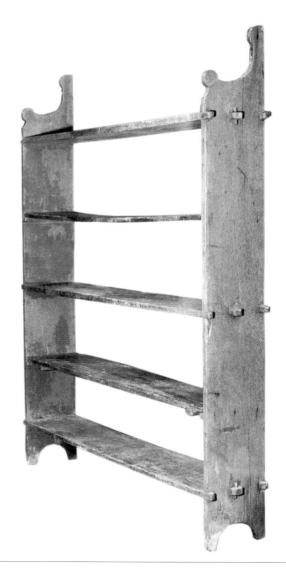

474. CHEST OF DRAWERS, SASKATCHEWAN:
LATE 19TH CENTURY; PINE;
58"H X 47¼"W X 21½"D
(WITH BACKBOARD 66½" H).

Similar in design to the example in fig. 492, this large chest differs internally by a reconfiguring of the drawer arrangement, replacing the upper three in that example by four in this case. The backboard is somewhat lower and more crisply designed here, while some simplifications include the abandonment of the cockbead moulding along the profile of the bracket base. Both pieces are fitted with end-of-the-century pressed-metal hardware.

475. TABLE, MANITOBA, LATE 19TH CENTURY; PINE AND OTHER WOODS.

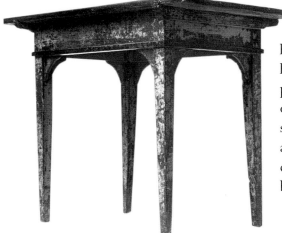

Simple tapered-leg pine tables with applied horizontal moulding strips were common kitchen pieces in Mennonite homes in Russia, where they are seen in photographs of household interiors of the later 19th century. Such tables are practical because they have removable tops which can be taken off for cleaning. The use of corner brackets gives a certain stylishness to an otherwise simple form, as does the feature of applied moulding and delineation of detail by means of contrasting colours, in this case, green trim against a yellow background. JSH (CHC).

476. TABLE, MANITOBA, LATE 19TH CENTURY;
PINE AND OTHER WOODS ; 29¼"H X 36¼"W X 23½"D.

This table shares with the previous example the common features of tapered legs, corner brackets, applied horizontal mouldings and an overhanging top. It retains the original three-colour scheme of red, blue and black. Splines set into channels secure the top against warpage.

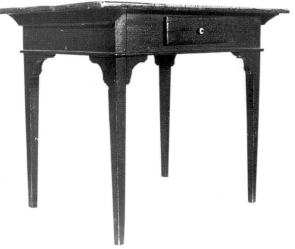

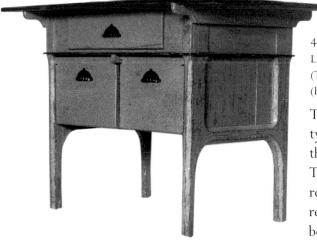

477. BAKE TABLES, MANITOBA:
LATE 19TH CENTURY; PINE AND OTHER WOODS;
(TOP) 30"H X 42"W X 28"D;
(BOTTOM) 35½"H X 72"W X 32¼"D.

Two bake tables are closely related to mass-produced types and are fitted with curved flour-bins similar to those found on the base of "Hoosier" cupboards. Tapered legs and the applied horizontal mouldings reflect the design of Mennonite tables of the time, retaining inset splines beneath to secure the top boards.

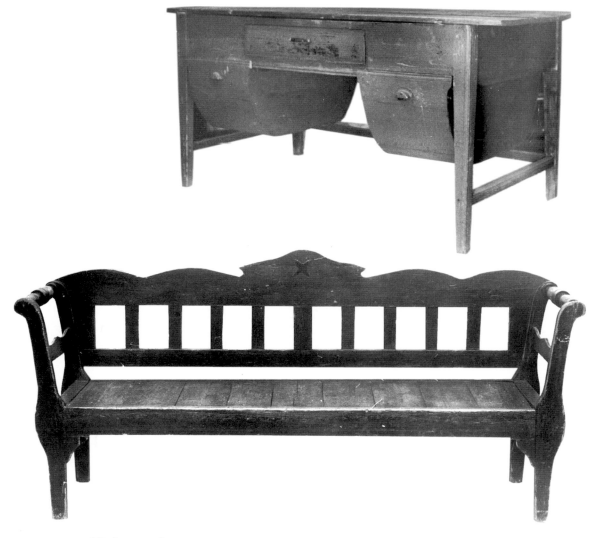

478. BENCH, SASKATCHEWAN: EARLY 20TH CENTURY; PINE AND OTHER WOODS;
34¼"H X 74¾"W X 22½"D.

A bench of neoclassical design influence, notably expressed in the rolled arms, scrolled back and central pediment. The curvature of the arms is rather stiffly articulated. An inner frame and short planks provide the foundation for a tick or other soft covering.

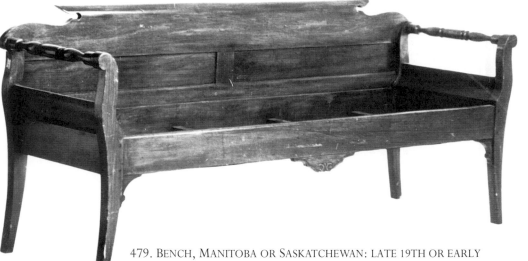

479. BENCH, MANITOBA OR SASKATCHEWAN: LATE 19TH OR EARLY
20TH CENTURY; PINE AND OTHER WOODS.

With its panelled back, curved posts and turned arms, this bench is designed
along the same lines as many of the more numerous bench-beds in following
illustrations. Such benches functioned as country couches, made comfortable
by blankets or other coverings laid over their board seats.

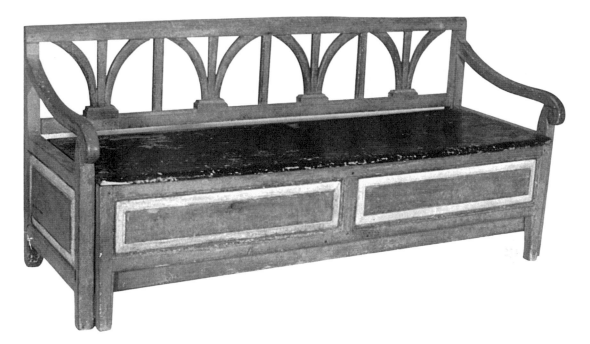

480. BENCH-BED, MANITOBA, LATE 19TH CENTURY; PINE AND OTHER WOODS; 32"H X 69"W X 26"D.

Economy of space and function was achieved when a bench could be combined with a bed,
resulting in the *Schlafbank* form popular in Germanic settlements of Western Canada. Such
multiple-use forms have their counterparts in other cultures, notably in the bench-beds
found in regions as diverse as Poland and Ireland. In Mennonite examples made in Western
Canada, the front slides forward, resting on feet which are separate from the bench section.
This Germanic piece has been given strong visual impact by its painted scheme of red,
black and cream. The division of the back into four sections, each with a tri-pronged splat
arrangement, is a stylized counterpart to the more floral treatment found in benches from
the Polish settlements of Eastern Ontario (see fig. 337).

481. BENCH-BED, MANITOBA: EARLY 20TH CENTURY;
PINE AND OTHER WOODS; 38¼"H X 81"W X 25¼"D.

Ingenuity and poverty were common partners in the experience of
many immigrants who left their homelands under duress. Political,
religious and economic persecution meant that meagre resources
had to be used carefully, as, for example, in the
multifunctional use of furnishings. The
bench-bed combination served well the
need for efficient use of space, providing
seating by day and sleeping
by night in the same room.
As in other examples, the
bed can be extended by
pulling forward the box
beneath the removable seat.

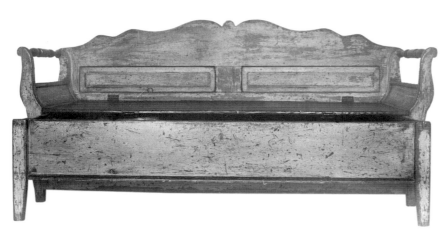

482. BENCH-BED, WESTERN CANADA: LATE 19TH OR EARLY 20TH CENTURY;
PINE AND OTHER WOODS; 34½"H X 76¼"W X 23"D.

The scrolled arms and scalloped back are common features of Biedermeier design, adapted
from high-style hardwood furniture and given an ever-popular country interpretation in
Mennonite sleep-benches made throughout the plains of North America. The square feet
with tapered inside edges are stated independently of the arms, in contrast to their parallel
alignment in other examples. This piece retains its original worn cream colouration.

483. BENCH-BED, WESTERN CANADA: LATE 19TH OR EARLY 20TH CENTURY; PINE AND OTHER WOODS; 32¼"H X 71"W X 22¼"D.

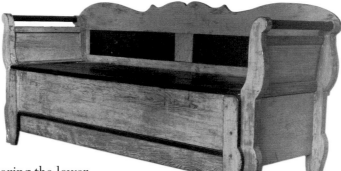

Similar in form to the example in fig. 482, this bench-bed from Manitoba exhibits the effective harmonization of Biedermeier lines in its closed position, with the curvature of the legs on the retractable box section mirroring the lower components of those on the base. The arms are chamfered to produce octagonal posts which are dowelled into the front and back posts.

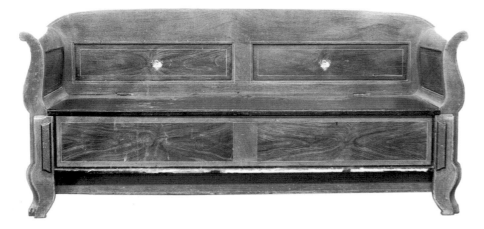

484. BENCH-BED, MANITOBA, LATE 19TH OR EARLY 20TH CENTURY; PINE AND OTHER WOODS.

Stylistically this piece, with its scrolled feet and arms, is a throwback to Biedermeier, English Regency or (especially) American Empire forms, echoing the sleigh-bed form which had become popular in the early and middle decades of the 19th century. Its decoration consists of both grain-painting and stencilling to outline actual panels on the back and create the illusion of panels on the lower front. Beneath the hinged seat is a box which can be pulled forward to function as a bed. It is one of several closely related examples found in the East Mennonite Reserve of Manitoba and somewhat later variations found in the Mennonite settlement near Rosthern in Saskatchewan. Rosthern Community College Museum.

485. BENCH-BED, SASKATCHEWAN: EARLY 20TH CENTURY; PINE AND OTHER WOODS.

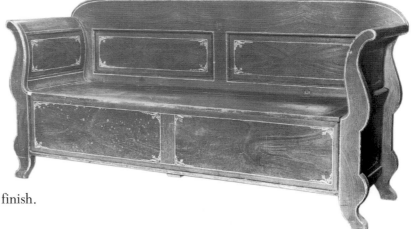

Similar to the preceding example, this Saskatchewan bench-bed is of stout proportions, less of Biedermeier design and more characteristic of the heavy American Empire style which was no less popular in Canada than in the United States. It retains its original paint-grained finish.

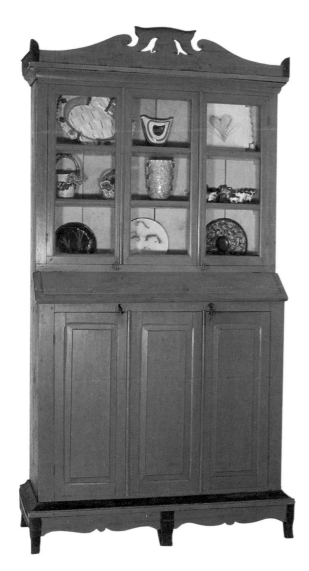

486. Dish Cupboard, Manitoba: Late 19th Century; Pine; 97¾"H X 52"W X 19¼"D.

This large cupboard is painted in the characteristic yellow colour found frequently on Manitoba-Mennonite furniture, and shares other common features, notably the five-legged bracket base on which the case is raised. Most unusual in this example, however, is the carved ornamentation of the cornice, where cutout birds provide a highly decorative embellishment. Such treatments are comparatively rare in Mennonite furniture, unlike the more exuberant decoration of Ukrainian and Doukhobor examples.

487. Hanging Corner-Cupboard, Manitoba: Late 19th Century; Pine.

The transfer of cultural influences from one setting to another was a continuing practice for Mennonites who left their German-speaking European homelands to settle in Russia, then found themselves repeating the experience when they migrated to Canada, bringing with them the even broader influences of both German and Russian life. Visual manifestation of these varied influences can be seen in the decorative detail of this grain-painted cupboard, with shaping of feet, base and cornice in a manner reminiscent of a German country baroque idiom, and, as an ornamental centrepiece, the inclusion of a carved representation of the eagle motif of Czarist Russia. CMC (CCFCS).

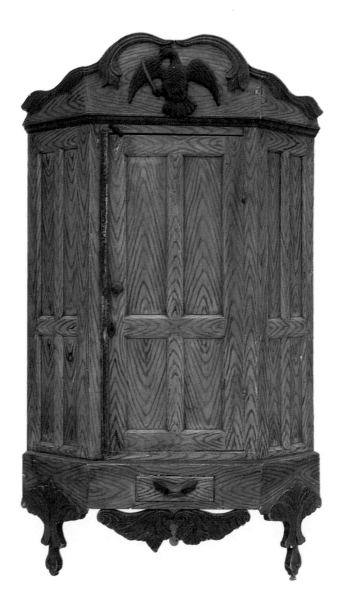

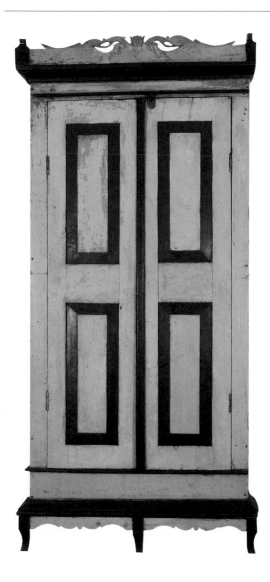

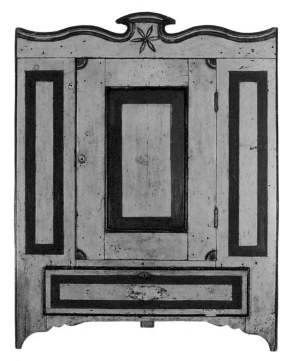

488. STORAGE CUPBOARD, MANITOBA: LATE 19TH CENTURY; PINE; 88½"H X 41½"W X 19¼"D.

Narrow free-standing cupboards frequently served as storage closets for clothing that could be hung, or bedding that could be folded and laid flat on shelving that was often removable. The detachable base with flared feet and a scalloped edge is a simplification of baroque-revival design elements popular in the 19th century. Once again, an unusual ornamental feature here is found in the cornice with its painted tulip and paired-bird motif cut out and highlighted by painted outlining in green and red against the yellow background colour.

489. HANGING CORNER-CUPBOARD, MANITOBA: LATE 18TH CENTURY; PINE; 39"H X 31½"W X 13¾"D.

An extremely unusual Mennonite example, this cupboard was found on Manitoba's East Reserve near Steinbach. While most cupboards of this type have canted sides angling back toward the walls, this piece is conceived as a single facade, with raised panelling of stiles, door and drawer. Serpentine scrolling of the top and base, very much in the Germanic baroque idiom, is derived from formal counterparts, while the six-point compass star indicates the appeal of geometric motifs from the folk tradition. The red and yellow painted finish is original.

490. STORAGE TRUNK, MANITOBA, LATE 19TH CENTURY; PINE; 15½"H X 27¾"W X 13¾"D.

This unusually small storage chest is well supported on a bracket base with tapered legs. A very old red paint has cracked and congealed, and where it has pulled apart, reveals a vibrant yellow original colouring beneath.

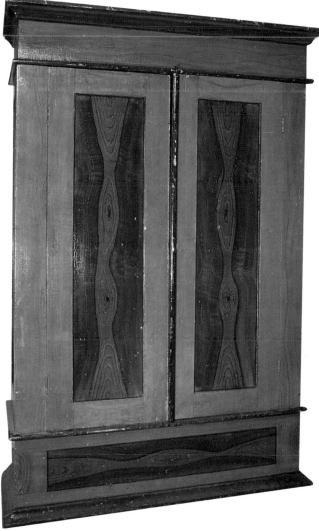

491. Wardrobe, Saskatchewan: Early 20th Century; Pine; 79½"H X 52"W X 21½"D.

The transformative process having been completed, this wardrobe stands completely on its own as a design entity, and all vestiges of the storage trunk have disappeared. This piece is notable for its exuberant painted decoration, which hovers somewhere between simulated graining and pure abstraction.

492. Chest of Drawers, Manitoba: Late 19th Century; Pine; 55¾"H X 48¾"W X 21¼"D (With Backboard: 67"H).

Several versions of the chest of drawers are known in Western Mennonite settlements, most of them with five ranks of drawers, and commonly the upper row is divided into two side-by-side drawers. Most have backboards, reflecting the late period during which such pieces were made in the Prairie Provinces. This example, like most Mennonite case furniture, rests on a removable five-leg bracket base. The drawers are lapped, and considerable design articulation is rendered through the cock-beaded moulding running along the scrolled base. This chest of drawers retains its original yellow painted colouration.

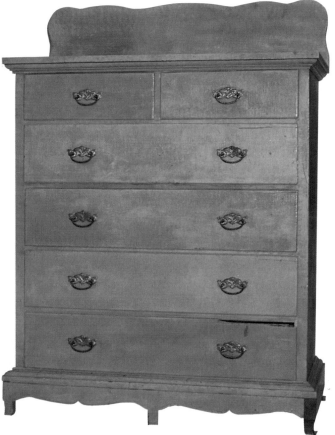

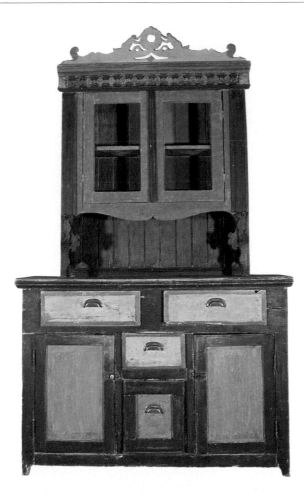

This large piece from Wasel, Alberta, is an intriguing amalgamation of contemporary and traditional elements. While the upper section is structurally akin to other Ukrainian cupboards, the bottom is more closely linked with commercially manufactured cupboards of the "hoosier" type, with large doors and drawers and flour bins. Its folk interest lies in the carved cornice, with mythological figures supporting a central sun motif, and the supports surrounding the work area rendered in the form of male figures (atlantes). These details are the subject of an earlier discussion in an exhibition catalogue by John Fleming and Michael Rowan, *Ukrainian Pioneer Furniture* (Toronto: Ukrainian Museum of Canada, Ontario Branch, 1992). It is related to the cupboard in the following example.

501. Cupboard, Alberta: circa 1920; pine; 87"H X 50"W X 16½"D (top: 38"W X 10½"D).

Closely related to the previous example, and undoubtedly made by the same artisan, this cupboard found at Vilna is painted in the same blue and green colours and shares the compositional arrangement of smaller top set back on larger base section. Birds facing each other around a central circular motif also relate the carved cornice of this piece to the preceding cupboard.

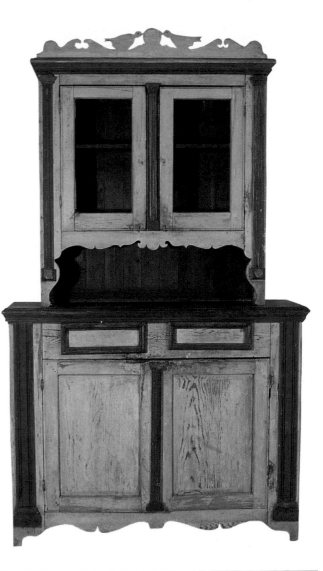

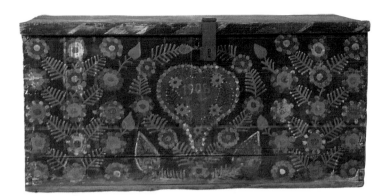

502. TRUNK, 1908; PINE.

A small number of trunks of virtually identical painted decoration have been found in Western Canada. Even ones dated as late as this example are probably the work of Ukrainian carpenters and painters in the homeland, since such traditional modes of folk decoration have been sustained well into the 20th century.

503. WARDROBE, LATE 19TH CENTURY; PINE; 76"H X 60"W X 16"D.

This rather rustic piece from Buchanon, Saskatchewan, reveals indebtedness to high-style sources, seen partially in the baroque scrolling of the door frame and broken triangular pediment with a central carved finial. CMC (CCFCS).

504. WARDROBE, SASKATCHEWAN: EARLY 20TH CENTURY; PINE; 73½"H X 38"W X 17"D.

In this piece the bottom drawer has been abandoned in favour of paired full-length doors. Extensive use of applied mouldings and pre-cut strips provides layers of patterned design on this tall wardrobe found near Canora. Cutout patterns and raised lozenge-blocks are superimposed over the flat door panels, in a manner reminiscent of the wardrobe in fig. 503. Further visual impact is achieved by the incised and painted compass stars set against a polychrome of intense green, sizzling orange and incandescent yellow colours.

518. FRAME: 1907; VARIOUS HARDWOODS; 26"H X 15¼"W.

Like the example in fig. 702, this frame by Zubenkoff uses the two-headed eagle motif. The fact of its association with the Czarist regime, under whom Doukhobors fared badly, may have been of little interest to this resourceful artisan who integrated many ideas for their design value. As in the case of several other Doukhobor frames, inlaid chevron-detail accentuates the inner edges. The combination of relief-carving, beading, and recessed detail (actually the application of a panel behind a cutout section) establishes unusual sculptural depth. Subtle refinements are many: ink-drawn lines define veining of the leaf motifs, meticulous chisel- and knife-work provides feathering of the necks of the eagles, and punchwork decoration gives contrast to background areas. There is an almost Turkish quality to certain details, notably in the cartouches enclosing lozenges inlaid on each side.

519. WARDROBE, SASKATCHEWAN: EARLY 20TH CENTURY; SPRUCE; 77"H X 64"W X 21½"D.

This piece from Polish Parish is believed to have been a minister's cupboard. The curved framing around the panels, with reversing ogee-curves, is a convention dating back to the Renaissance and later rococo styles, popularized in English-speaking countries in Chippendale furniture, and otherwise disseminated widely throughout Europe during the 18th and 19th centuries. Flanking the doors are applied pilasters which are fluted, and surmounted by complex capitals with scrolls and lyre-motifs. It is interesting that while this pine cupboard is finished in a dark red-brown colour, it was given gold accents painted on the capitals. This treatment provides a distant country interpretation of more formal furniture made of mahogany or other expensive woods and fitted with ormolu mounts in the manner of the French Empire style. The love of things French in the sumptuous courts of Eastern Europe may well have been among the indirect influences which give simpler country furniture its frequent high-style allusions.

502. TRUNK, 1908; PINE.

A small number of trunks of virtually identical painted decoration have been found in Western Canada. Even ones dated as late as this example are probably the work of Ukrainian carpenters and painters in the homeland, since such traditional modes of folk decoration have been sustained well into the 20th century.

503. WARDROBE, LATE 19TH CENTURY; PINE; 76"H X 60"W X 16"D.

This rather rustic piece from Buchanon, Saskatchewan, reveals indebtedness to high-style sources, seen partially in the baroque scrolling of the door frame and broken triangular pediment with a central carved finial. CMC (CCFCS).

504. WARDROBE, SASKATCHEWAN: EARLY 20TH CENTURY; PINE; 73½"H X 38"W X 17"D.

In this piece the bottom drawer has been abandoned in favour of paired full-length doors. Extensive use of applied mouldings and pre-cut strips provides layers of patterned design on this tall wardrobe found near Canora. Cutout patterns and raised lozenge-blocks are superimposed over the flat door panels, in a manner reminiscent of the wardrobe in fig. 503. Further visual impact is achieved by the incised and painted compass stars set against a polychrome of intense green, sizzling orange and incandescent yellow colours.

505. TABLE, SASKATCHEWAN: EARLY 20TH CENTURY;
PINE AND OTHER WOODS; 30"H X 92½"W X 35"D.

More in keeping with several Doukhobor examples, this Ukrainian table is long on style. It has two drawers for storage beneath the tabletop, a feature found frequently in Pennsylvania-German tables made throughout the 19th century in Southwestern Ontario. The applied star and lozenges are reminiscent of the treatment of the wardrobes in figs. 503 and 504, and these motifs and the drawers are painted red against a vibrant yellow base colour.

506. SLEEP-BENCH: SASKATCHEWAN: EARLY 20TH CENTURY;
PINE AND OTHER WOODS; 40½"H X 75½"W X 24½"D.

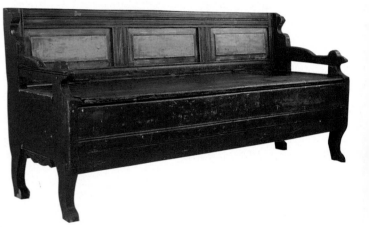

Closely related to the preceding example (and of identical width and length), this bench has plain horizontal lines instead of the scalloped base and elaborately scrolled crest of its counterpart. The carved end profile has an almost Egyptian look with anthropomorphic shaping of arms and posts to resemble legs and feet of some mythological animal.

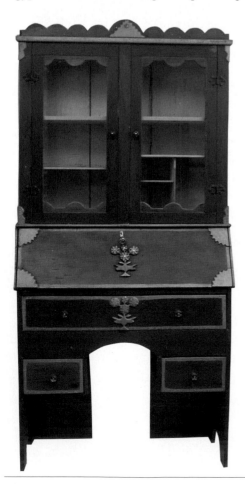

This sphinx-like device may be derived from classical- or Egyptian-revival motifs which figured prominently in the architecture and furniture of the French court in the 17th century, and were later taken to Russia in the reign of Catherine the Great, where high styles in wealthy Ukrainian and Russian estates and homes became a design source and indirect influence upon country cabinetmakers.

507. SECRETARY-DESK: SASKATCHEWAN: EARLY 20TH CENTURY;
PINE; 75"H X 36¾"W X 17½"D.

The desk with bookcase above was an important piece of furniture in both the office and at home, where a corner of the parlour commonly served domestic and business purposes. This tall secretary is of simple slab-construction, with corner braces to secure wide boards nailed at right angles. Its decorative features are built up by means of pre-cut sections applied to corners and flat surfaces. The stylized tree motifs are similar to designs on samplers and other embroidery work, and are likely derived from such sources. The colourful finish is achieved by varied paints and varnish brushed onto the highly grained wood surface.

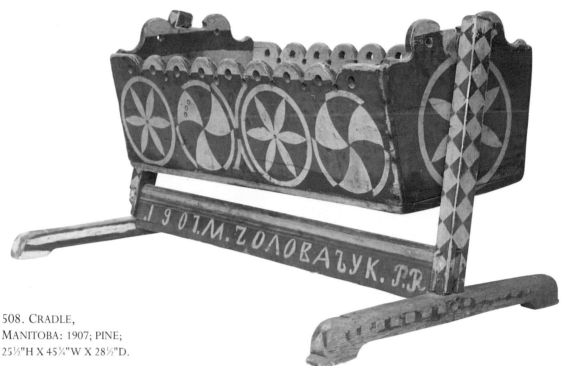

508. CRADLE,
MANITOBA: 1907; PINE;
25½"H X 45¾"W X 28½"D.

Placing a cradle on a frame meant that it could be
readily transported, and be easily rocked when set in place. This highly decorated example comes
from the Ukrainian settlement at Pine River, Manitoba (signified by the initials *PR* painted on the
frame). The elaborate ornamentation includes twelve compass stars, trees, a house and geometric
designs painted in yellow against a red background. The infant who received and used this
remarkable cradle was Metro Zoblotniuk, whose name and birth-date are painted on the base.

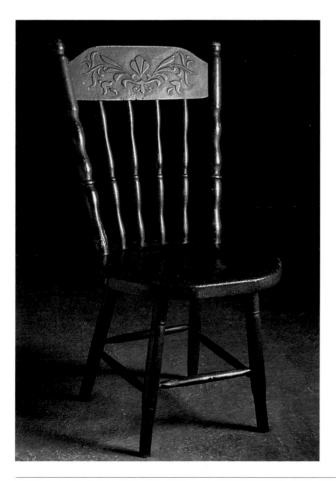

509. CHAIR: EARLY 20TH CENTURY;
BIRCH AND OTHER HARDWOODS; 35¼"H X 18"W X 18"D.

Again clearly inspired by the mass-produced press-
back form, this chair deviates from the prototype
immediately in terms of its unusual proportions (the
back is overly large in relationship to the base) and
in the style of the plank seat, which is heavier and
more sculptural than the catalogue chair. While the
commercial form was generally varnished or stained,
this Doukhobor chair retains its original red paint.
The relief-carved decoration is completely in the
Doukhobor idiom, with symmetrical composition of
fan-and-leaf design-work flanked by hanging tulips.

510. TABLE: EARLY 20TH CENTURY;
PINE AND BIRCH.

A one-drawer table from Grand Forks,
this piece is unusual in its lightness of
execution. The carved lobes are set
unusually far from the skirt. Painted
floral decoration on the drawer front is
also a rarely encountered treatment on
tables, and may be an adaptation from its
more common occurrence on trunks.

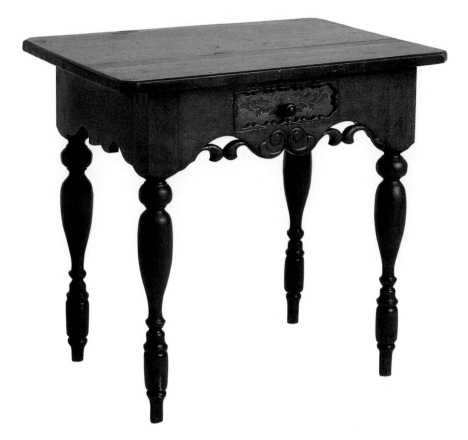

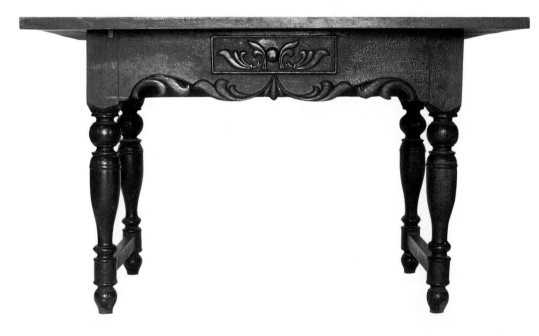

511. TABLE: EARLY 20TH CENTURY; PINE AND BIRCH; 31¼"H X 50¾"W X 29¼"D.

This one-drawer table is one of the strongest statements of carving and painting found on pieces of this type.
The crackled red-brown paint and black trim are completely original, highlighting a vigorously carved skirt
with an elaborately developed floral motif at the centre. The carving is unusually sculptural, and runs close to
the skirt edge, with only a small fretwork element at mid-point on the flanking curves. Carving is also executed
with similar complexity on the drawer front, which is an unusual variation. This piece was stored in Peter V.
Verigin's barn and escaped the fire which destroyed his residence in 1923.

512. TABLE: EARLY 20TH CENTURY; PINE;
30½"H X 44"W X 28"D.

The artist-cabinetmaker Wasyl Zubenkoff produced a considerable range of work from his young adulthood in Russia until within a few years of his death at Verigin, Saskatchewan. One of the most impressive manifestations of his artistry is this painted table, made around 1910–20, with sophisticated renderings of abstract floral designs on the top and stretchers. The floral figures are painted in a white, with shading used at the edges, against a red background in a treatment similar to the one on the cupboard in fig. 603.

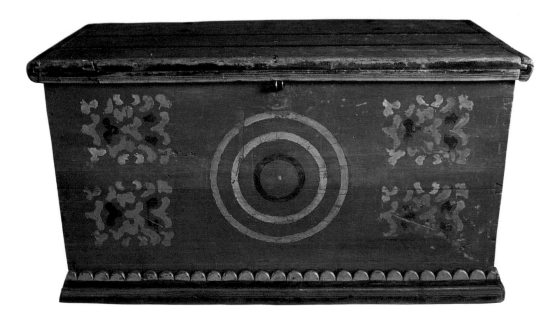

513. TRUNK: EARLY 20TH CENTURY; PINE; 23½"H X 45"W X 28"D.

Found in Saskatchewan, this is a most unusual box. Intricately painted floral designs flank a centre arrangement of concentric circles. The heavily moulded top and base are typical of Doukhobor boxes. While the scalloped lower moulding is unusual, it does have its painted equivalent in demi-lunes found on the boxes in figs. 514 and 679. The ends are canted slightly outward from the base. The extraordinary decoration of yellow, white, black and orange is completely original.

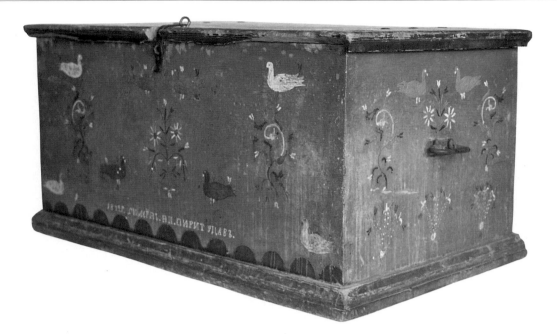

514. TRUNK: 1899; PINE; 22"H X 35½"W X 22½"D.

Related to the preceding examples, and most likely the work of the same painter, this trunk is dated and is exuberantly decorated with a bold profusion of floral motifs, and fourteen birds, and a base row of semicircles drawn and painted in contrast to an orange background. The trunk was found in Saskatoon.

515. TRUNK: LATE 19TH OR EARLY 20TH CENTURY; PINE; 30½"H X 44¼"W X 26½"D.

The manner of painting on this trunk creates an effect substantially different from the preceding examples. Rather than multicoloured motifs in great profusion, here the emphasis is upon a smaller number of motifs set large in a single blue colour against an orange base. The undulating plant supporting the bird is reminiscent of the long vine-motif on the tall cupboard from near Blaine Lake illustrated in fig. 601. The trunk is reported to have been made by John Alec Savinkoff, who came to Canada at a young age from Tiflis Province, in present-day Georgia, near the Turkish border.

516. TRUNK: LATE 19TH OR EARLY 20TH CENTURY; PINE; 26½"H X 49⅛"W X 28½"D.

One of the largest Doukhobor trunks that has been found, this example is over 4 feet long and is nearly the height of a typical table. The painted treatment is interesting in that it brings together the controlled compass-drawn decoration on the top with the freehand rendering of stylized trees on the front. Paint-simulated cut-corner panels serve as framing devices for the pictorial content on this magnificently decorated trunk.

517. COAT RACK: 1905; PINE; 7"H X 39¼"W X 5½"D (WITH PEGS).

One of the most remarkable specimens of carved and painted Doukhobor furniture is at the same time one of the most functional — a rack and pegs for hanging coats upon entering the home. The piece was taken from a home near Verigin, and its date of 1905 (inscribed at the lower left) makes it an exceptionally early Doukhobor piece, made within six years after the arrival of the first group in Canada. The bold turnings on the legs call to mind those on the legs of Doukhobor tables. The decorative embellishment includes a central rosette, with vines extending symmetrically in each direction, terminating in smaller rosettes. The top and bottom edges of the backboard are carved in a way also suggestive of floral design, with the three-lobed motifs which appear frequently in the Canadian Doukhobor decorative vocabulary.
JSH (CHC).

518. FRAME: 1907; VARIOUS HARDWOODS; 26"H X 15¼"W.

Like the example in fig. 702, this frame by Zubenkoff uses the two-headed eagle motif. The fact of its association with the Czarist regime, under whom Doukhobors fared badly, may have been of little interest to this resourceful artisan who integrated many ideas for their design value. As in the case of several other Doukhobor frames, inlaid chevron-detail accentuates the inner edges. The combination of relief-carving, beading, and recessed detail (actually the application of a panel behind a cutout section) establishes unusual sculptural depth. Subtle refinements are many: ink-drawn lines define veining of the leaf motifs, meticulous chisel- and knife-work provides feathering of the necks of the eagles, and punchwork decoration gives contrast to background areas. There is an almost Turkish quality to certain details, notably in the cartouches enclosing lozenges inlaid on each side.

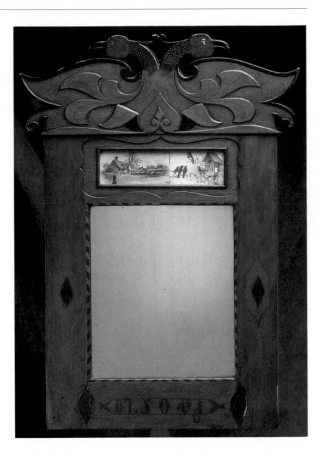

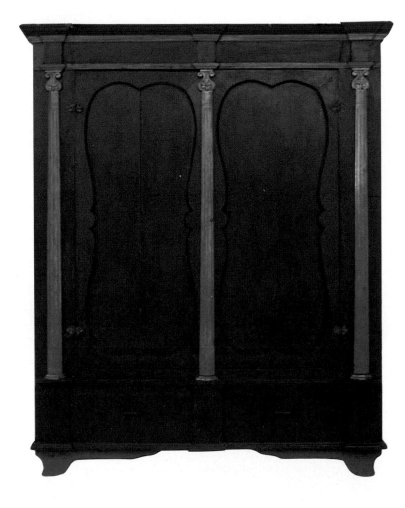

519. WARDROBE, SASKATCHEWAN:
EARLY 20TH CENTURY; SPRUCE; 77"H X 64"W X 21½"D.

This piece from Polish Parish is believed to have been a minister's cupboard. The curved framing around the panels, with reversing ogee-curves, is a convention dating back to the Renaissance and later rococo styles, popularized in English-speaking countries in Chippendale furniture, and otherwise disseminated widely throughout Europe during the 18th and 19th centuries. Flanking the doors are applied pilasters which are fluted, and surmounted by complex capitals with scrolls and lyre-motifs. It is interesting that while this pine cupboard is finished in a dark red-brown colour, it was given gold accents painted on the capitals. This treatment provides a distant country interpretation of more formal furniture made of mahogany or other expensive woods and fitted with ormolu mounts in the manner of the French Empire style. The love of things French in the sumptuous courts of Eastern Europe may well have been among the indirect influences which give simpler country furniture its frequent high-style allusions.

520. CHILD'S BED;
PINE AND OTHER WOODS;
34¼"H X 69"W X 27"D
(OPENS TO 44").

Children's beds from
Western Mennonite
communities were
generally constructed
so that the side could be
pulled out, thereby doubling the size of
the bed. The head- and footboards are scrolled
on the bottom and are given architectural
interpretation by the feature of central pediments.
This piece is finished in an old red colour.

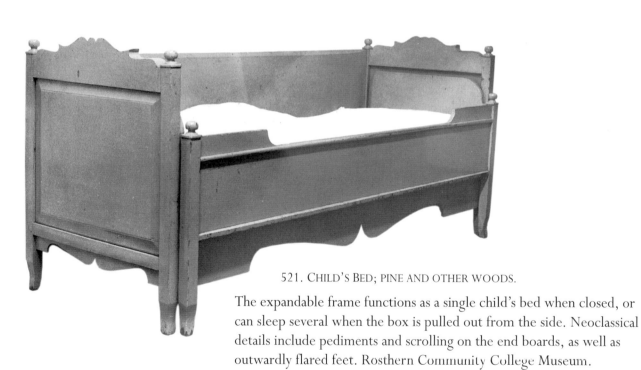

521. CHILD'S BED; PINE AND OTHER WOODS.

The expandable frame functions as a single child's bed when closed, or
can sleep several when the box is pulled out from the side. Neoclassical
details include pediments and scrolling on the end boards, as well as
outwardly flared feet. Rosthern Community College Museum.

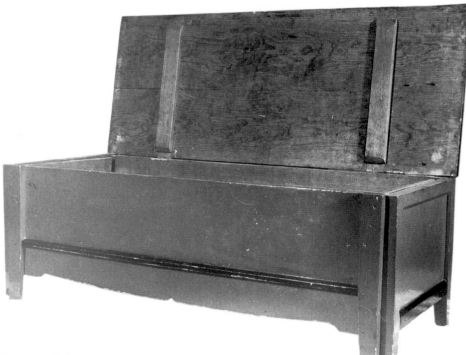

522. Child's Box-bed; pine; 18"H X 55½"W X 21½"D.

A form found in many Mennonite homes in the Canadian prairies was the small lift-top box-bed for children. When not used as a bed, it can serve as a seat or storage box.

523. Cradle, Saskatchewan, early 20th century; pine.

Cradles were usually made with wooden rockers, or with rockers made of a combination of wood and metal, as in this example. Many feature scalloped ends and some are further embellished by means of hearts and other motifs cut through the framework. The hooded cradle is virtually unknown, since the preference was for the open version. Rosthern Community College Museum.

524. CHAIR, MANITOBA: LATE 19TH CENTURY; PINE AND HARDWOODS; 33½"H X 20½"W X 15"D.

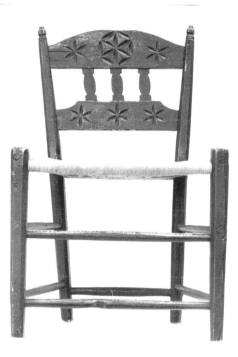

While chairs were of the greatest necessity and hence abundance in the immigrant Mennonite household in Canada, occasional examples reflect an earlier tradition of making chairs specifically as dowry furniture. The form of this chair (one of a pair) from Altona is identical to chairs illustrated in a photograph of the interior of a Mennonite home in south Russia, and similar to a 1766 chair brought from Poland's Vistula Delta by Epp family members to Canada in 1923 and later donated to the Kauffman Museum at North Newton, Kansas. Its decorative treatment of carved six-point compass stars suggests that it was made specially in anticipation or at the time of marriage as a wedding gift.

525. CALENDAR SHELF OR COMB SHELF; SASKATCHEWAN: SECOND QUARTER, 20TH CENTURY; PINE; (LEFT: GLENBOW COLLECTION, CALGARY); (RIGHT) 23¼"H X 12¼"W X 5⅛"D.

Several closely related pieces have been found, suggesting the work of one maker or a group of local carvers imitating one another. Reminiscent of the "last-look" mirrors made at about the same time on the South Shore of Nova Scotia, these Western Canadian shelf-boxes are highly decorative in character. The example on the left, found near Warman, is distinguished by incised, scooped-out or chip-carving, featuring stylized plants, six-point compass stars and other geometric motifs. A shelf holds various articles, a rack is provided for a towel or cloth, and a frame could house either a mirror or calendar. Glenbow Collection. The shelf at right was found in British Columbia, but its strong

similarities to Mennonite examples from Saskatchewan suggest that it was brought to British Columbia from Saskatchewan. Profuse carved geometric devices achieve a strong visual decorative impact. Its red painted finish is old or original.

526. WALL CUPBOARD, WESTERN CANADA:
EARLY 20TH CENTURY; PINE;
84"H X 28"W X 16"D.

Hutterite cupboards, typically of solid-
or panelled-door construction rather
than glazed, served more the functions
of storage than overt display, reflecting
the Hutterite eschewal of the concept
of personal ownership of material goods.
This narrow kitchen cupboard is fitted
with shelves for storage of kitchen
supplies and utensils.

527. WALL CUPBOARD, NORTH CENTRAL
UNITED STATES: LATE 19TH CENTURY; PINE;
80½"H X 51¾"W X 20¼"D.

An unusually early example, this slab-door
cupboard was found in a Western Canadian
Hutterite colony, but was most likely
brought there from the northern American
plains states. It is of early construction,
with square nails throughout, and retains
the original green painted colouration.

528. HANGING CUPBOARD AND CHEST OF DRAWERS,
ALBERTA: 1949; (CUPBOARD) PINE, 38"H X 25"W X 12"D;
(CHEST) PINE, OAK AND OTHER WOODS, 42"H X 33¼"W X 17¼"D.

This cupboard and the chest of drawers were made at the
Beiseker Hutterite Colony by Paul Stahl for his son Paul Jr.
as a bedroom set. The late date of manufacture is evident in
the inconsistency of lapped drawer and flush doors and the
placement of cast metal hinges on the outside surface of frames
and stiles. The cornice is a removable framework, similar to
bases and crowns used on Mennonite pieces made in Western
Canada. The construction of the chest and base are consistent
with the Mennonite chest-on-frame format. That this piece
was once brightly painted is suggested by the survival of
paint fragments on the back and interior. Glenbow
Collection, Calgary.

529. HANGING CUPBOARD, WESTERN CANADA:
FIRST HALF 20TH CENTURY; PINE; 43"H X 25"W X 9¼"D.

The stepping-back of this hanging cupboard is an
unusual variation. The feature of stencilled initials
found variously on spinning wheels or small
boxes, is less common on a larger cupboard. The
stars and central ornamental roundel are applied
to the cornice, and the use of darker and lighter
stains give this cupboard an unusual decorative
impact. This cupboard from Rosedale Colony in
South Dakota was made for the marriage of
Katie Redikuptf and Jacob Wipf. Katie was a
Mennonite who converted to the Hutterite religion,
entering a Schmiedleute community. The couple later moved to the Rosedale, Alberta,
colony, and eventually to the Parkland Alberta Colony, south of Nanton.

530. Hanging Cupboard, Alberta: 1918; pine; 32"H X 30"W X 12¼"D.

While some Hutterite furnishings were painted, others were given brilliant varnish finishes. Round-arched flat panels are occasionally used in the design of cupboards, providing design interest to otherwise plain pieces. This piece was made for Paul Hofer at the Springvale Colony near Rockyford, Alberta, in the year the Hutterites first arrived in Canada. The cupboard is the work of carpenter William Gross, made shortly after he moved to Springvale from Jamesville Colony near Utica, South Dakota. Its purpose was to house various books, particularly the Scriptures. Presently stripped, this cupboard may once have had a stained or painted finish. Glenbow Collection, Calgary. (This example was included in the *All Things Common* exhibition of Hutterite and Mennonite furnishings in London, England, held in spring-summer, 1992.)

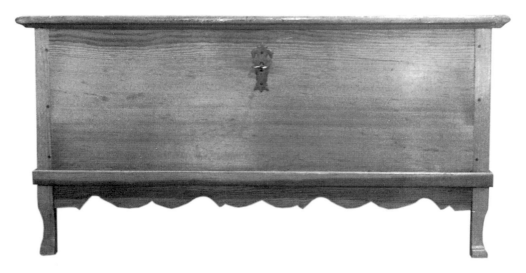

531. STORAGE CHEST ON BRACKET BASE: MID-20TH CENTURY; PINE; 28"H X 52"W X 27"D.

Storage chests in Hutterite communities are stylistically similar to Mennonite examples, and may reflect a common Germanic heritage or some later practices of borrowing from their neighbours on the North American prairies. Such large trunks have long been used for the storage of dowry items. They are well-travelled items, since at the time of marriage they are carried from the wife's colony to that of the husband.

532. STORAGE CHEST ON BASE: EARLY 20TH CENTURY; PINE; 20"H X 32"W X 18¾"D.

This smaller trunk shares structural and design characteristics with Mennonite pieces. Like Mennonite chests, it is well-made, with dove-tailed construction, and is mounted on a removable bracket base. This example is of interest, with simple carved fan motifs as a decorative focus at the centre of each double curve of the skirt.

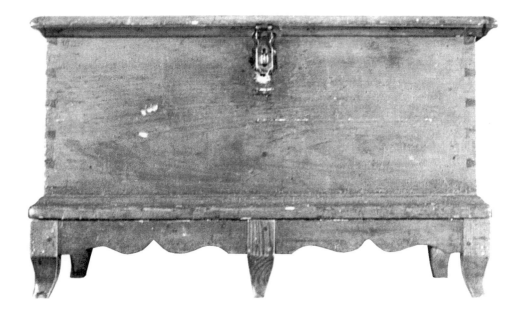

533. Chair, Alberta: early 20th century; various hardwoods, with pine seat; 30¼"H X 18"W X 17⅝"D.

While Hutterite colonies of the 20th century have made common use of simple chairs, including those of the mass-produced "press-back" variety, this example exhibits an awareness of the an earlier neoclassical style. The curvature of the legs is a stylistic throwback to Biedermeier or classical-revival tastes which affected European peasant furniture throughout the 19th century. While the front legs are a restrained interpretation of the Greek *klismos*, the side profile of the back posts is closely related to the scrolled arms on the bench in fig. 29. The seat appears to be a later replacement of an original. This interesting chair was found at the Ewelme Colony near Fort Macleod. Glenbow Collection, Calgary.

534. Comb Box, Alberta: 1937; pine.

While the tendency toward plainness governs the design of larger and more public forms of furniture, smaller and more discreet pieces offer greater possibilities for decorative treatment. This small box, placed near the washbasin, has geometric embellishments similar to those found on Mennonite pieces. As in other Hutterite examples, the decoration is done by means of ink-drawn lines which are filled in with solid colours, using water-soluble paints or inks. The floral motifs are highly Victorian in character and are probably influenced by embroidery patterns. These decorative designs are accompanied by an inscribed date and the initials *R S T*. The shelf was made at the Rockyford Colony, east of Calgary, by the father of Rachel Stahl, who recalled that it was used to hold combs there. Glenbow Collection, Calgary.

535. SAWBUCK TABLE: FIRST HALF 20TH CENTURY; PINE; 29¼"H X 70¾"W X 26"D.

For communal meals, the long sawbuck table was a common feature in the Hutterite colonies. This example retains its original finish, and is constructed of three long boards fastened to a sturdy base of crossed pine members.

536. TABLE, ALBERTA: SECOND QUARTER 20TH CENTURY; PINE, WITH HARDWOOD CLEATS; 30¼"H X 41¼"W X 27"D.

Hutterite and Western Mennonite furniture is in some cases strikingly similar, as can be seen when comparing this table with the Mennonite examples in figs. 475 and 476. Apart from the simplification of omitting the corner brackets normally found on the Mennonite examples (and, for that matter, on the Polish-Ontario tables from Wilno, as illustrated in fig. 444), the proportions, manner of construction, and design of this Hutterite piece are almost indistinguishable from the Mennonite counterparts. Cleats are inserted into grooves to secure the three-board top against warpage, while applied mouldings and a beveled lapped drawer provide sculptural interest in this well-made piece. Whether this table, found at the Cayley Hutterite Colony, once had a painted finish is unclear. Glenbow Collection, Calgary.

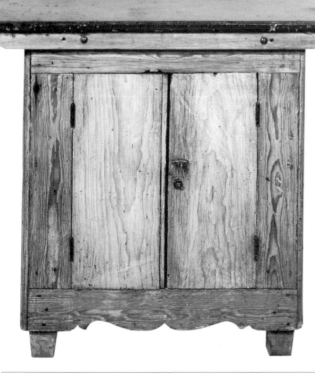

537. TABLE-CABINET, ALBERTA: EARLY 20TH CENTURY; PINE.

The amalgamation of two furniture forms, this piece is both a table and a cabinet. It is a practical piece because flour and other supplies are kept immediately below the tabletop and are readily accessible for food preparation. It has been suggested that a table with cabinet was used to provide meals for invalids or those who were temporarily ill in the home. This piece was so used in the home of Peter Hofer and later came to be used by his daughter-in-law, Margaret G. Stahl of Valleyview Colony, near Torrington. The use of splines set into channels to prevent warpage of the top is similar to the construction of tables made in the Western Mennonite communities as well as in the Germanic settlements of Southwestern Ontario. Glenbow Collection, Calgary.

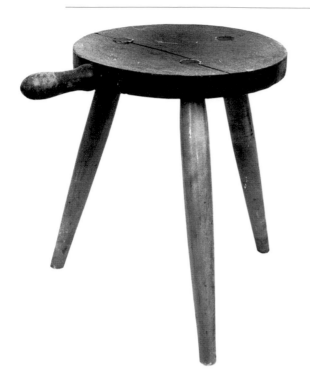

542. STOOL: FIRST HALF 20TH CENTURY; PINE AND HARDWOODS; 14" HIGH X 11½" DIAMETER.

Small stools for use in barns or working elsewhere were of both the three- and four-legged variety. This round example is a common form found through Hutterite colonies in the United States and Canada, and it is painted in bold yellow and green colours, over which is applied a heavy varnish.

543. STOOL: FIRST HALF 20TH CENTURY; PINE AND HARDWOODS; 14"H X 9½"W X 14½"D.

A square stool on four legs, this piece retains its old dark red and green paint. As with most such stools, there is a narrow projection to make it easy to pick up and move from place to place.

544. TRAINING CHAIR: MID-20TH CENTURY; PINE; 17"H X 18"W X 12"D.

Children are raised communally in special buildings in the colonies, where specialized furniture meets particular needs. Among the furnishings for Hutterite children, the most common item is the toilet-training chair with a hinged front rail.

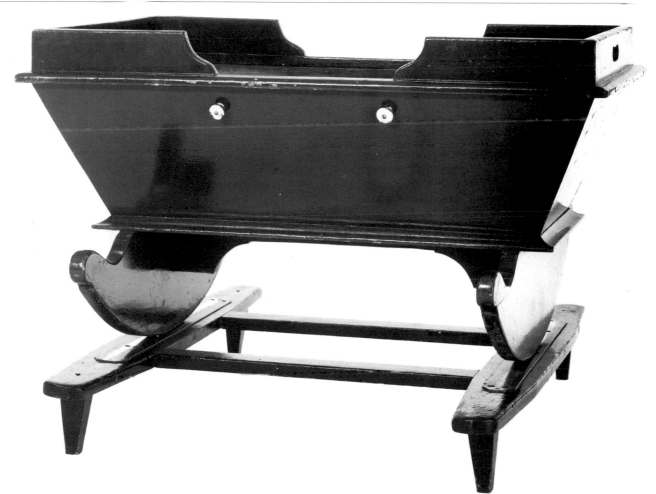

545. CRADLE ON BASE, ALBERTA: EARLY 20TH CENTURY; PINE; 25¼"H X 37½"L X 33"W.

Hutterite cradles differ from Mennonite counterparts with regard to their structural foundations. While Mennonite examples are in essence boxes on rockers to be placed directly on the floor, Hutterite cradles are set into a sturdy box-framework, which reduces both mobility and instability. A tapered wooden peg rising from the ends of the base fits into a slot on the underside of the rockers to prevent the cradle from sliding off the lower framework. This example, with a red painted cradle and black base, and initialled *I K H*, was used by three generations of Hofer family members and was brought from Spring Hill Colony, South Dakota, to Standoff Colony near Macleod. Glenbow Museum Collection, Calgary.

546. STORAGE BOX, SASKATCHEWAN: MID-20TH CENTURY; PINE; 5½"H X 11¼"W X 5¾"D.

The maker of this small storage box, made perhaps to hold sewing articles, has gone to considerable effort to enhance its appearance. Apparent dovetails are in fact a *trompe l'oeil* illusion, consisting of coloured-ink drawn equivalents. Ink and paint are used also in the decoration of the top and sides with basket and floral devices reminiscent of sampler motifs, and the hand-lettered initials of Susanna Tschetter of the Riverview Colony in Saskatchewan. JSH (CHC).

547. CUPBOARD: EARLY 20TH CENTURY; PINE; 77"H X 39½"W X 19¼"D.

The form of this one-piece cupboard resembles a secretary-desk, but the absence of a sliding or fold-out writing surface seems to preclude this function. Decorative interest is achieved primarily by varied use of applied details. A single decorative moulding frames the top and sides of the case, as well as the drawers and upper doors. Scalloped strips are applied over the lower doors, echoing loosely the scrolled base of the cupboard. The designs on the lower doors, perhaps a free adaptation of ecclesiastical motifs (the centre design resembles a chalice), are also cut out and applied to create a *bas-relief* effect.

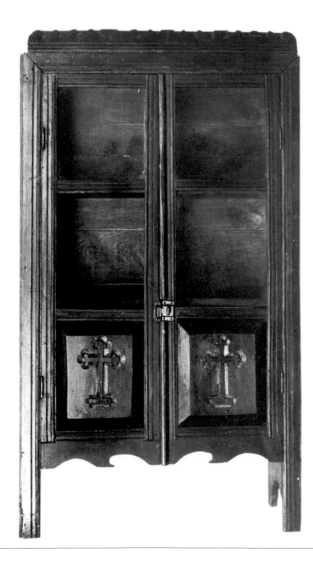

548. CUPBOARD, SASKATCHEWAN: EARLY 20TH CENTURY; PINE; 48½"H X 27"W X 12¼"D.

Because ecclesiastical furniture in the Ukrainian churches of the Canadian prairies was made locally, rather than brought in from European or North American urban centres, it is related technically and stylistically to domestic pieces. This two-door "minister's cupboard" from north of Pelly, Saskatchewan, was constructed to house the library and daily votive books of the parish clergy. Incised crosses on the lower panels serve to distinguish it from more general-purpose storage cupboards of similar construction.

549. CUPBOARD, ALBERTA: EARLY 20TH CENTURY; PINE; 77"H X 49½"W X 20"D.

Found at the hamlet of Shandro (near the village of Andrew) and attributed to William Shandro, this two-piece cupboard is a functional church or domestic piece, hence the openwork area and countertop. The two rows of drawers, one in each section, are a variation of the more typical arrangement. Painted Maltese crosses on the lower doors suggest that this may have been a minister's cupboard or other ecclesiastical piece, although there remains the possibility that it was a domestic cupboard whose decoration was inspired by motifs on furniture seen in the church sacristy or chancel. A late overpaint was removed to show the original treatment of red, dark green, light green, blue and other colours. An interesting detail is the foliate carving on the returns of the corner bracket feet.

550. CUPBOARD, SASKATCHEWAN, EARLY 20TH CENTURY; PINE; 84½"H X 36"W X 16¾"D.

In contrast to Prairie Mennonite cupboards, with their rectangular panelling and framing of doors, Ukrainian cupboards are in many cases constructed in ways which diminish the linear in favour of the curvilinear. In this instance, cutout curves applied to the interior of the door frames and across the pie shelf give considerable flair to what would otherwise be a static form. The cutout of the crown is strongly reminiscent of those on several Ukrainian benches, notably those shown in figs. 579 and 581.

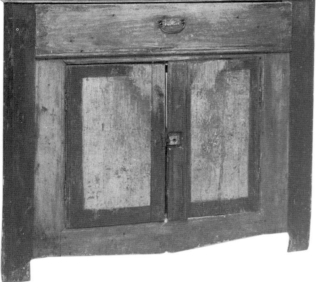

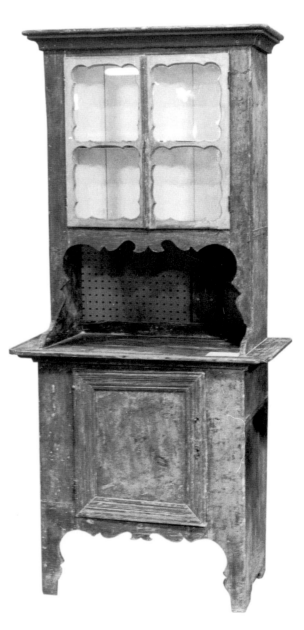

551. CUPBOARD, MANITOBA: EARLY 20TH CENTURY; PINE; 79"H X 44½"W X 27"D.

Found at Spirit Lake, this glazed cupboard has a single drawer, relating it to other Ukrainian examples. It resembles others also in the arrangement of three horizontal panes in the upper doors. The polychrome finish is striking, and the painted treatment of the cornice is similar to *faux*-marble treatments on German country furniture. Such painted technique is virtually unknown elsewhere in Western Canadian furnishings.

552. CUPBOARD, SASKATCHEWAN: EARLY 20TH CENTURY; PINE.

An extraordinarily light appearance is conveyed by the exaggerated height of the feet of the base and the pie shelf of the upper section of this cupboard. Its unusual height and narrowness, along with a thin, overhanging counter, give this cupboard an almost weightless character. The elaborate scalloping relates this cupboard to the examples in figs. 553 and 554.

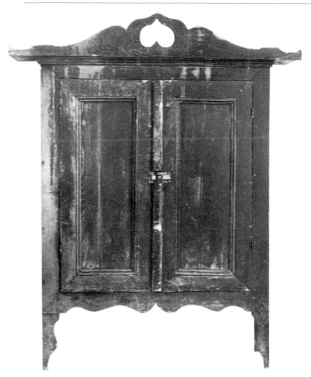

553. Cupboard (Upper Section), Saskatchewan: early 20th century; pine; 40"H X 29"W X 11"D.

Only the top of this interesting cupboard has survived, but the exuberantly scrolled cornice, and high supports around the pie shelf, and the inverted heart cut through the pediment make it an important expression of Ukrainian furniture design in Western Canada.

554. Cupboard, Saskatchewan. early 20th century; pine; 67"H X 29½"W X 19½"D.

The neat lines of this graceful cupboard are carried through from the narrow vertical lower doors through the attenuated supports enclosing the work area and the glazed upper doors. Its lightness of design make it a pleasingly refined expression of country furniture.

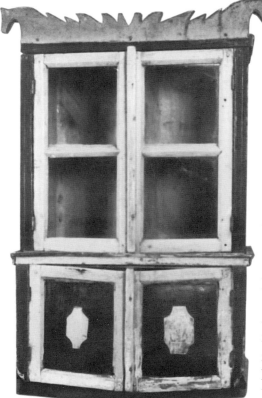

555. Cupboard, Saskatchewan: early 20th century; pine; 44"H X 29½"W X 13⅛"D.

A small cupboard made in the Ukrainian community, this is an interesting example with horse-head motifs extending from the cornice. The use of zoomorphic details has a long history in folk architecture as a protective device against evil spirits dwelling in animals. In Ukraine and Russia, the horse has had a long association with the sun god from pre-Christian times, and hence can be seen as a symbol of life, fertility and happiness. The image, especially in its two-headed form, found its way into the decoration of textiles, jewellery, ceramics and household utensils. The appearance of the horse-head motif on Western Canadian country furniture is a rarity, occurring also in Doukhobor settlements as decorative motifs on a cupboard and spool-holder (see figs. 617 and 682).

556. Low Cupboard, Saskatchewan: Early 20th Century; Pine; 67"H X 37¼"W X 20"D.

Probably intended as a kitchen storage cupboard, this Yorkton-area piece with its slab doors would work to keep cooking utensils and certain materials used in daily food preparation. The central "stile" is really a moulding piece attached to one of the doors which moves when it is opened and closed. The incised and painted roundels, consisting of concentric circles, are unusual, and have few parallels except in the case of several French-Canadian armoires which use this design.

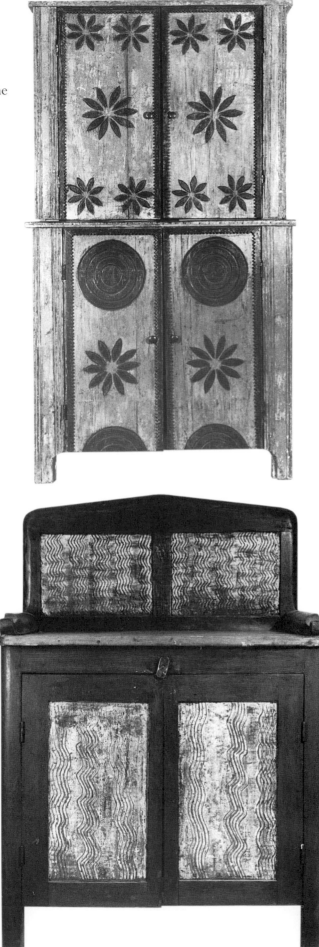

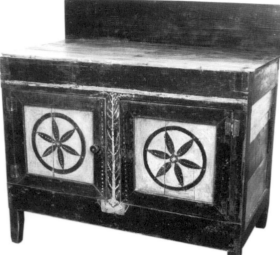

557. Dry Sink, Saskatchewan: Early 20th Century; Pine.

This two-doored cabinet resembles the earlier dry sink form popular in Ontario-German communities in the 19th century. A hinged lid over the well permits use either as a sink or a worktable. The shape resembles that of elm or other hardwood furniture advertised in catalogues and may well have been a homemade equivalent to such mass-produced pieces. The painted six-point compass stars on the doors provide a decorative flourish on an otherwise plain piece.

558. Commode, Saskatchewan: Early 20th Century; Pine; 36½"H X 25"W X 17½"D.

Washstands with high galleries, some with ceramic tiles, were popular in the British Isles and had their mass-produced wooden counterparts in Canada at the turn of the century. This piece of Ukrainian provenance is closely modelled on such forms, but given distinctive expression through the vigorous green and yellow comb-grained treatment.

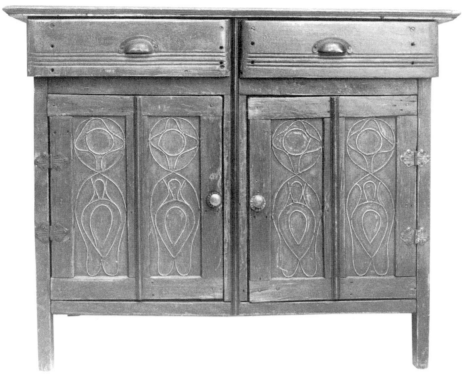

559. COMMODE, SASKATCHEWAN: EARLY 20TH CENTURY; PINE; 31¼"H X 40¼"W X 23"D.

A near copy of mass-produced wooden buffets advertised in turn-of-the-century catalogues, this low cupboard features the simple, light structure of these economical pieces. In contrast to the austere geometry of panels and stiles is an almost organic decorative patterning fashioned from twigs bent and applied to the surface. Much of the red colour has been restored.

560. SHRINE, MANITOBA: EARLY 20TH CENTURY; PINE; 22¼"H X 15¼"W X 5"D.

An ingeniously designed shrine or case for a religious figure, this piece mimics a church sanctuary and in fact expresses the idea of the sacred place within the home, placed as it likely was in a bedroom or other domestic setting. The base for the figure is a miniature altar, emphasizing the Ukrainian sense of continuity between the holiness of the church and the sanctity of the home. The shrine could be closed or opened by means of a hinged door (now missing). This finely constructed piece is believed to be the work of the carpenter who made the cupboard in figs. 498 and 499.

**561. HANGING CUPBOARD,
SASKATCHEWAN: EARLY 20TH CENTURY;
PINE; 20¼"H X 20¼"W X 7"D.**

The rising-sun motif is a device found
frequently in vernacular Russian and
Ukrainian architecture, where it is often
carved into the lintels of windows. Its
appearance on a hanging cupboard is an
expression of the common practice of
using architectural devices in making
furniture. The same motif has been
found on Doukhobor architecture in
Western Canada (see figs. 595 and 597).

562. HANGING CUPBOARD, SASKATCHEWAN: 1914; PINE; 20½"H X 24¼"W X 8¼"D.

While found in Western Canada, the exact cultural context of this piece is somewhat
uncertain. Its free play of decorative motifs, applied mouldings, and exuberantly scrolled
pediment relate it most closely to Ukrainian furnishings. The whimsical scalloped corners of
the opening produce an almost stage-like effect (with stars waiting in the recesses). Its function
was probably less theatrical, serving as a cabinet for toiletries and a bar for towels.

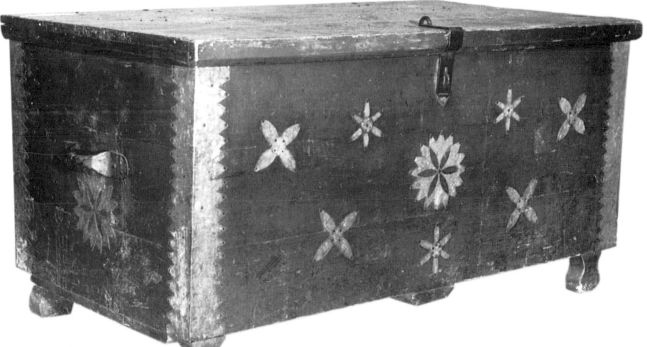

563. TRUNK, LATE 19TH OR EARLY 20TH CENTURY.

This trunk may have been made in the Ukraine or Canada, but its large size and serviceability for transporting family possessions suggests that it may have been brought across the ocean. Cutout tin rosettes applied to the front and ends provide decorative interest.

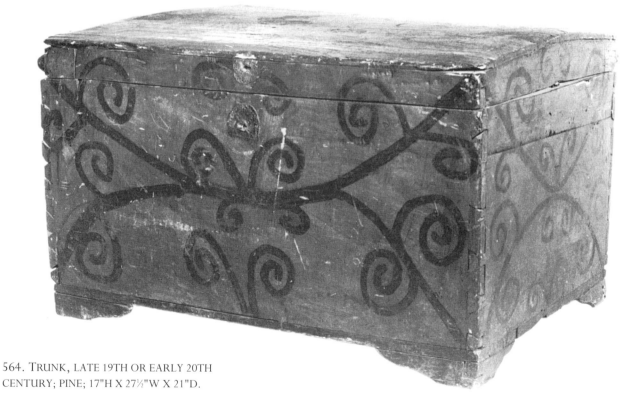

564. TRUNK, LATE 19TH OR EARLY 20TH CENTURY; PINE; 17"H X 27½"W X 21"D.

This dome-top box is in all probability a Canadian product, with 20th-century nails and metal fittings. A dramatic ornamental treatment is achieved by an undulating vine-like pattern painted in black against a red base.

565. WARDROBE: EARLY 20TH CENTURY; PINE; 78½"H X 41¼"W X 20"D.

Most Ukrainian wardrobes are simply constructed with two long doors fitted into a box-like case or with a long single drawer in the base. This arrangement differs somewhat from the placement of two side-by-side drawers typical of Germanic wardrobes made in Canada, notably those forms popular among Mennonites in both Ontario and the Prairie Provinces. The drawer can be seen as a vestigial form of the storage trunk with drawers. The simple lines of this Saskatchewan wardrobe are integrated with a low-key neoclassical statement in the broken triangular pediment.

566. WARDROBE, SASKATCHEWAN: EARLY 20TH CENTURY; PINE; 82"H X 42½"W X 18½"D.

Found in the Yorkton area, this wardrobe retains the doors-and-drawer format of the preceding example, and is capped by a pleasingly scrolled pediment. The shaping of the panel framing by means of series of reversing C-curves is a device used commonly in the late 18th century, notably by Thomas Chippendale in England, and was to become an oft-repeated design in country furniture made over the next century and a half in Europe and North America. Traditional folk decoration includes vines and compass stars carved into the pediment and stiles.

567. WARDROBE, MANITOBA, EARLY 20TH CENTURY; PINE; 74"H X 47½"W X 16½"D.

The country baroque device of reversing C-curves, given wider berth and less intricacy than those on the wardrobe in fig. 566, here provides a framing device for panels given to effectively controlled decoration in the form of painted rosettes. Matching the understated curvature of these frames is the gradual curvature of the cornice itself, reminiscent of the Ontario-German corner cupboard in fig. 391. The case rests on four carved feet set at a diagonal to the framework. The interior is divided down the centre, with shelves on one side and a clothes peg on the other. The appearance of a centre stile is created by a moulded strip attached to the left door. The alligatored painted finish is a contrast of caramel and ochre colouration.

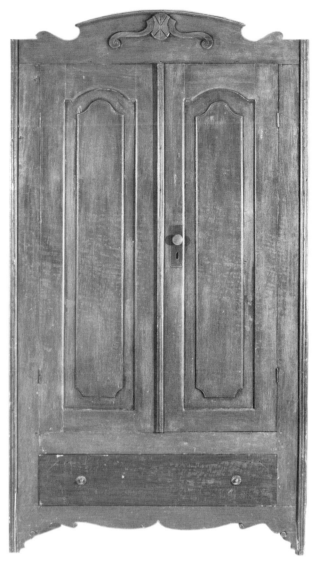

568. WARDROBE, SASKATCHEWAN:
LATE 19TH OR EARLY 20TH CENTURY; PINE.

Like the Ontario-Germanic *Kleiderschrank*, this Ukrainian case piece served as a clothes closet, even though by the end of the century, English-speaking households generally had built-in closets. Details of the doors incorporate several design influences, with Chippendale allusions in the cutout corners at bottom and a suggestion of Queen Anne or Louis XVI design in the centred curvature of the upper ends of the raised panels. The complexity of the scrolled base and the applied armorial device on the cornice reflect elements of baroque design brought to the Canadian Prairies by furniture makers who worked earlier in Ukraine, Russia and elsewhere in Eastern Europe.

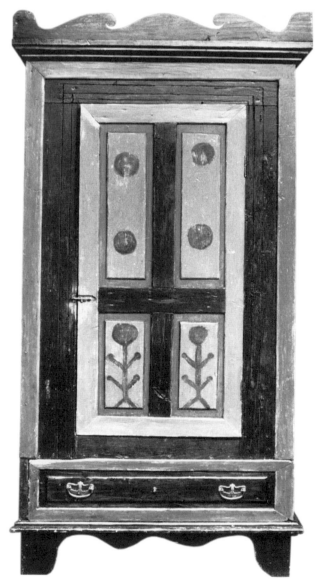

569. WARDROBE, SASKATCHEWAN: EARLY 20TH CENTURY; PINE; 77¾"H X 40½" X 21¾".

This single-doored clothes cupboard is unusually substantial in its construction, with heavy fielded panels and well-developed cornice mouldings beneath a scrolled cornice. Roundels and stylized flowers are painted in freehand manner, providing strong decorative accents on this striking polychromatic cupboard.

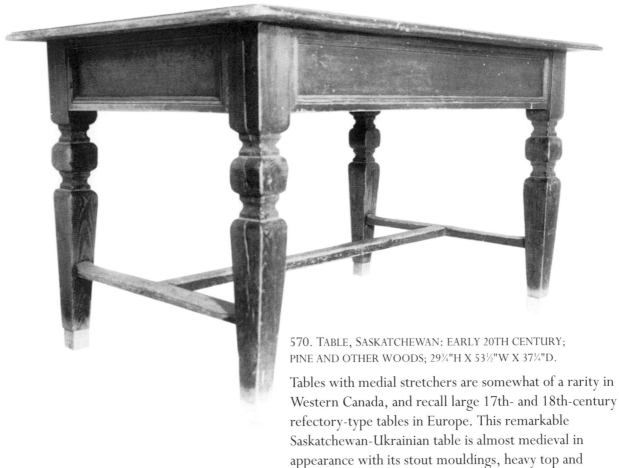

570. TABLE, SASKATCHEWAN: EARLY 20TH CENTURY;
PINE AND OTHER WOODS; 29¾"H X 53½"W X 37¾"D.

Tables with medial stretchers are somewhat of a rarity in
Western Canada, and recall large 17th- and 18th-century
refectory-type tables in Europe. This remarkable
Saskatchewan-Ukrainian table is almost medieval in
appearance with its stout mouldings, heavy top and
massive square legs with carving and tapering.

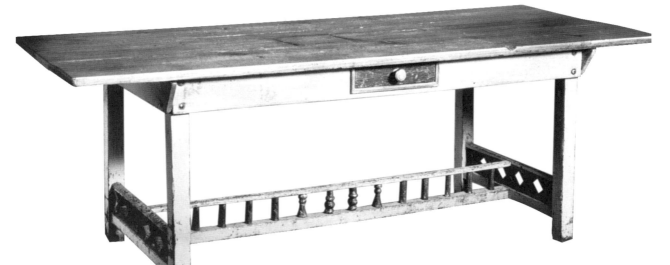

571. TABLE: EARLY 20TH CENTURY; PINE AND OTHER WOODS; 34⅝"H X 81"W X 35"D.

The structure of this table takes it a step up from the example in fig. 570:
here, the medial and end stretchers are surmounted by secondary parallel
rails, between which are set spindles and intersecting diagonal posts. The
result is a trellis-like arcading, a treatment similar in spirit to the smaller
table in fig. 574. The top has been replaced, but the cleats are original, as is
the old green and white painted finish.

572. TABLE, SASKATCHEWAN: EARLY 20TH CENTURY;
PINE AND OTHER WOODS; 29" HIGH X 24" DIAMETER.

Pedestal tables made among both Ukrainians and
Doukhobors in Canada show an awareness of a range of
styles outside local tradition. The upper brackets are a
somewhat ungainly attempt to provide support for the top.
The raising of the pedestal upon a four-legged frame is an
interesting variation from the more typical tripod format.

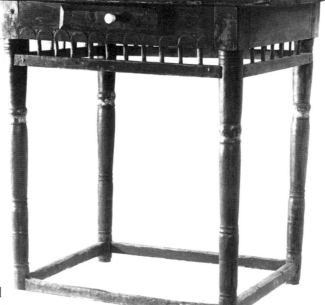

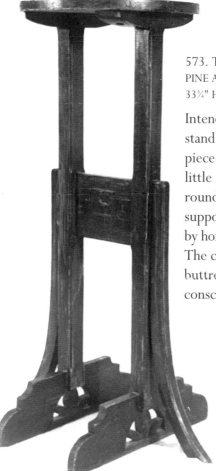

573. TABLE: EARLY 20TH CENTURY;
PINE AND OTHER WOODS;
33¼" HIGH X 13½" DIAMETER.

Intended probably as a candle
stand, this unusual Saskatchewan
piece seems to be all effect and
little substance, the minuscule
round top dwarfed by vertical
supports, themselves stabilized
by horizontal and angled brackets.
The central crosspiece and curved
buttress-like supports suggest
consciousness of *art nouveau* designs popular at the time.

574. TABLE, SASKATCHEWAN:
EARLY 20TH CENTURY; PINE AND OTHER WOODS;
32"H X 35¼"W X 26"D.

The articulation of the skirt as a series of
spindles calls to mind the formal gilt tables
of the French Empire and Directoire periods.
These styles reached the Ukraine and Russia
after the importation of French architects and
ébénistes by the courts and wealthy patrons in these regions.
More primitive or rustic furniture made for the kitchen or servants' rooms of grand country homes
undoubtedly drew inspiration from the high-style furnishings seen elsewhere. A country table of
kindred interpretation is shown in Elizabeth Gaynor and Kari Haavisto, *Russian Houses* (New York:
Stewart, Tabori and Chang, 1991, p. 12). For a related treatment in Doukhobor furniture, see the
chair illustrated in fig. 642.

575. BENCH: SASKATCHEWAN: EARLY 20TH CENTURY; PINE AND OTHER WOODS; 36½"H X 75¾"W X 28"D.

While the horizontal carved channelling of the tapered square legs is similar in spirit to the carving on the Ukrainian table in fig. 570, the work on the upper spindles is a creative imitation of lathe-turning, here

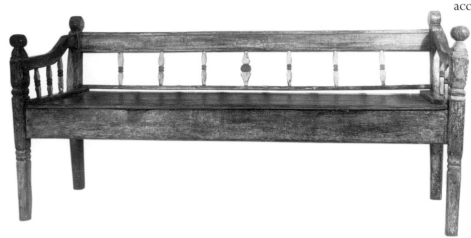

accomplished by saw and knife. The ball-finials on the corner posts are rarely found on Western Canadian benches. Abruptly terminating the downward sweep of the curved arms, they serve the purposes of architectural effect more than comfort. This impressive and richly sculptured piece is painted blue and cream, a decorative finish original to the bench.

576. BENCH: SASKATCHEWAN: EARLY 20TH CENTURY; PINE AND OTHER WOODS; 27"H X 43¼"W X 16½"D.

Shorter than most Ukrainian benches, this piece may have been inspired by the hall seat or short settee

popular throughout Canada in the later 19th century. Every horizontal member is decorated by means of reeding, and the cutouts at each end and on the lower back rail are of distinctive design but distantly related to the treatment of chair backs where the cutout designs serve to lighten the appearance of splats or panels. The seat is constructed of boards laid from front to back on the framework. The worn red-brown painted finish is original.

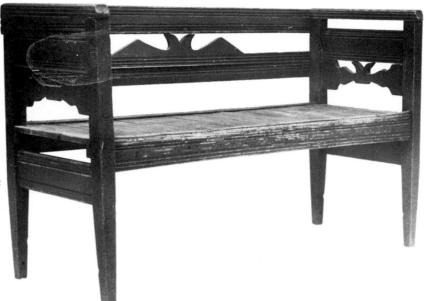

577. BENCH: EARLY 20TH CENTURY; PINE AND OTHER WOODS; 35⁵⁄₁₆"H X 78¾"W X 15¼"D.

This bench is constructed according to a simple principle: four posts and four boards as essential framework, to which are added a seat and back. A gentle canting of the back provides both comfort and aesthetic enhancement. The arms are curved and scrolled on ends extending beyond the posts. Particularly striking is the rhythm of figure-and-ground contrasts running the length of the back, the result of side-by-side placement of flat splats with double-curve side-profiles that resemble turned columns in a balustrade. The heavily alligatored green and ochre paint is original.

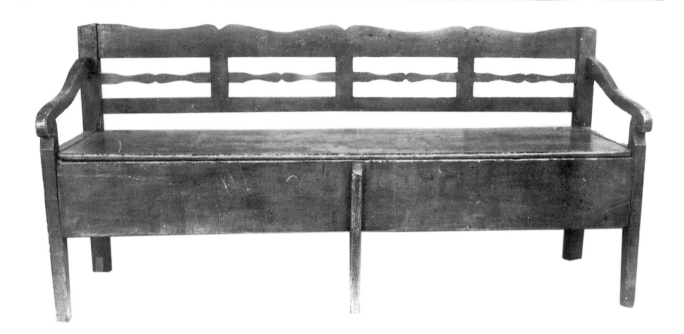

578. SLEEP-BENCH, SASKATCHEWAN: EARLY 20TH CENTURY;
PINE AND OTHER WOODS; 31 ½"H X 75"W X 25"D.

The sleep-bench is found in the Ukrainian as well as other communities of Western Canada.
It differs from the Mennonite bench-bed of Western Canada in that although it is also
constructed so that the front slides forward to enlarge the sleeping area, there are no feet to
support the extended section, as in Mennonite counterparts. Here, the forward-projecting
box functions in the manner of a drawer, somewhat tentatively secured within the channel in
which it slides, and balanced by the counterweight of the bench section. This grain-painted
example is somewhat unusual, because it uses effectively a technique found commonly in
Mennonite but rarely in Ukrainian settlements, and there restricted only entirely to larger case
furniture.

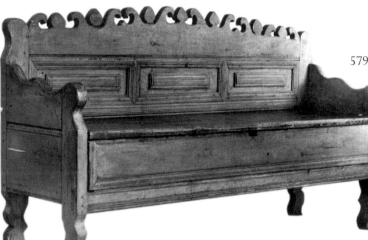

579. SLEEP-BENCH, SASKATCHEWAN:
EARLY 20TH CENTURY;
PINE AND OTHER WOODS;
42"H X 72½"W X 21½"D.

As a statement in fancifulness,
this large bench from Yorkton
may well claim first place.
Its lively expressiveness comes
in large part from a dynamic
established between the
linear and the curvilinear. Extensive reeding and applied mouldings are used to
reinforce the rectangular impact of the boxlike framework and fielded panels,
while a seemingly endless proliferation of scrollwork elements on legs, arms and
crest lend a capricious character to what is in reality a massive and murderously heavy piece.
This remarkable bench is, almost of necessity, of monochrome character, painted in a dark
yellow colour.

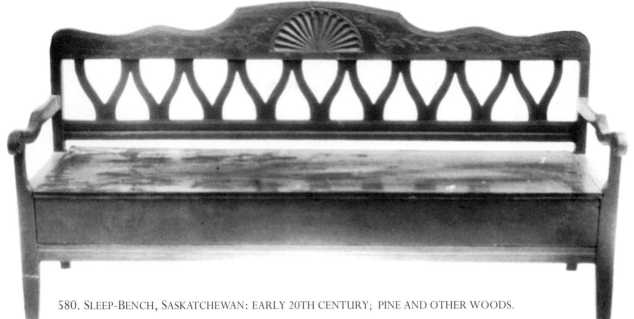

580. SLEEP-BENCH, SASKATCHEWAN: EARLY 20TH CENTURY; PINE AND OTHER WOODS.

Ukrainian benches with splats retain a sufficiently high crest rail to permit carved decorative treatment. The carved fan or rising-sun motif has long been popular, appearing with special enthusiasm during the Louis XIV period in France, and as a common architectural motif carved into gable ends, shutters and window lintels in country homes of the Ukraine and Russia. The motif appears also on a clock case and tilt-mirror shown in figs. 591 and 592. CMC (CCFCS).

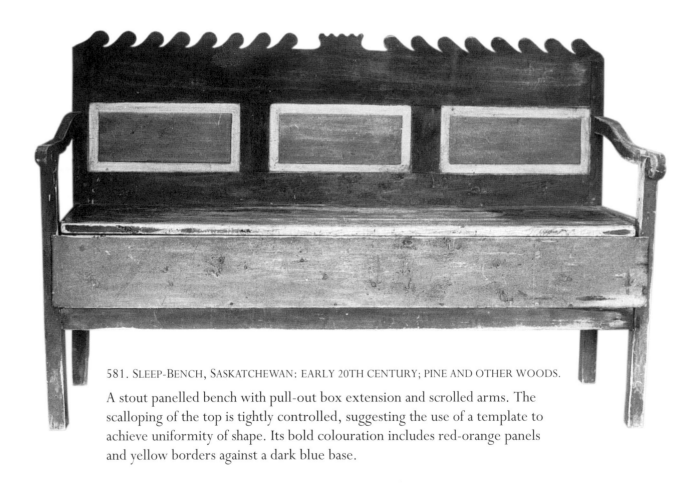

581. SLEEP-BENCH, SASKATCHEWAN: EARLY 20TH CENTURY; PINE AND OTHER WOODS.

A stout panelled bench with pull-out box extension and scrolled arms. The scalloping of the top is tightly controlled, suggesting the use of a template to achieve uniformity of shape. Its bold colouration includes red-orange panels and yellow borders against a dark blue base.

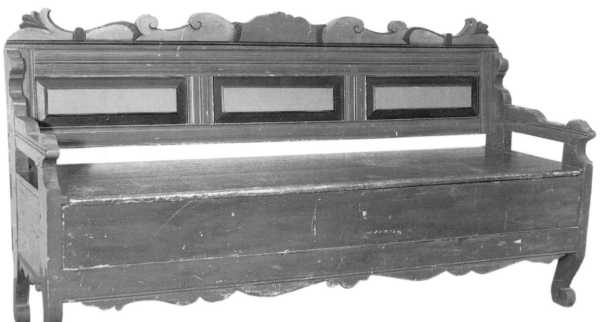

582. SLEEP-BENCH, SASKATCHEWAN: EARLY 20TH CENTURY; PINE AND OTHER WOODS; 35¾"H X 75½"W X 24½"D.

Two benches (figs. 506 and 582) found more than ten years apart in Northern Saskatchewan are of outstanding form, colour and construction. Whether they are of Ukrainian or Doukhobor pieces is somewhat unclear. The comparative complexity and sophistication of construction has led some to consider them Doukhobor, but the general scarcity of benches in the repertory of Doukhobor furnishings calls this attribution into question. Another theory is that these two pieces were the work of a Doukhobor furniture maker, working upon request for Ukrainian neighbours.

583. BED, SASKATCHEWAN. EARLY 20TH CENTURY; PINE AND OTHER WOODS; 41½"H X 78½"W X 51½"D.

The splat-and-rail bench may have been the general inspiration for this pine bed, but its particular arrangement resembles even more closely the mass-produced wooden beds illustrated in Eaton's and other commercial catalogues widely circulated at the turn of the century. Primitively painted geometric and floral devices in orange against a dark green background are freehand decorative enhancements of a severe form.

584. CHAIR, SASKATCHEWAN: EARLY 20TH CENTURY; PINE AND OTHER WOODS; 38½"H X 18¼"W X 16¼"D.

The three-splatted chair, with vertical members tapering outwards from the bottom centre, reflects a design principle used more formally in the late 18th century by English furniture designers, notably Thomas Sheraton, and disseminated widely throughout Europe in the following decades. It is interesting to observe the similarity of design between this early 20th-century Ukrainian chair and another piece made a full century earlier in Newfoundland (fig. 75). Made without benefit of a lathe, this chair has no turned members, and the stretchers are merely rotated a quarter of a turn off the vertical to create the illusion of rounding.

585. CHAIR, SASKATCHEWAN: EARLY 20TH CENTURY; PINE AND OTHER WOODS; 34½"H X 17"W X 15½"D.

Although of Saskatchewan-Ukrainian provenance, this chair is interesting because it suggests that its maker had seen an English or Scottish Sheraton-style chair, either in person or by way of illustration. The simple arrangement of slats and rails, wooden plank seat and square tapered legs is a common peasant-form which transcends national boundaries. The thinning of the back posts, however, is a rather stylish feature, used a manner removed from its original function. Sheraton-style chairs (see figs. 81 and 82) often had this feature for aesthetic purposes, to impart delicacy to the chair back (in which case the narrowing was done sideways, not from front to back), and, in the case of front supports for armchairs, were narrowed for the practical purpose of providing greater space for the wide skirts of the period. Here the device is used for no apparent reason, and may be simply a borrowing without concern for original intentions.

586. CHAIR, SASKATCHEWAN: EARLY 20TH CENTURY; PINE AND OTHER WOODS; 30¼"H X 19¼"W X 19¼"D.

In terms of frequency of survival, the corner chair could be said to be a trace element in Western Canadian country furniture. This rare example was found with Ukrainian furnishings in Northern Saskatchewan, and its rudimentary splat-and-rail construction is in keeping with other Ukrainian seating pieces made there. The corner chair enabled its occupant to change positions and directions with ease.

587. CHAIRS, WESTERN CANADA: EARLY 20TH CENTURY; PINE AND OTHER WOODS; 35½"H X 17¼"W X 16½"D.

This pair of chairs found in Manitoba or Saskatchewan are of the splat-and-rail variety, with board seats and carved detail on the posts. The whittled channelling of the posts and simply carved finials relate these pieces closely to the rocking chair in the following illustration.

588. CHAIR, WESTERN CANADA: EARLY 20TH CENTURY, PINE AND OTHER WOODS; 38¼"H X 23¾"W X 18"D

A close similarity can be seen between this rocking chair and the two side chairs in the previous illustration, particularly in the carved finials and extensively channelled front and rear posts. It is also intriguing to consider the possibility that this chair might be the work of the individual who made the glazed cupboard from Sarto, Manitoba, shown in fig. 499. While the chair is of simpler construction than the cupboard, there is a haunting resemblance between the scrolled pattern (doubly articulated in the front stretcher and crest rail) and scrollwork pediment of the cupboard (also given double articulation by its repetition in the fretwork design).

589. CHAIR, SASKATCHEWAN: EARLY 20TH CENTURY; PINE AND OTHER WOODS.

A rustic armchair with three slats (one missing) between two slightly curved rails. The board seat is laid upon the upper stretchers and wedged at the corners by the square posts. Sloping arms, not quite curved, give an imposing quality to this simple piece, and a degree of refinement is at work in the way the ends of rails and stretchers are disguised by inserting them only partially through holes cut or drilled into the posts.

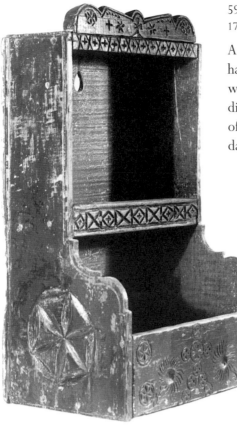

590. HANGING WALL-BOX, SASKATCHEWAN: EARLY 20TH CENTURY; PINE; 17"H X 9¾"W X 6¾"D.

A small hole cut through the back allows this two-tiered box-shelf to hang from a peg in the wall. In form it resembles a small dish-dresser with shelves and a projecting lower section. Tiny crosses, intersecting diagonal lines, and six-point compass stars are carved over the surfaces of the pediment, shelf fronts and end boards. It is finished in an original dark green paint.

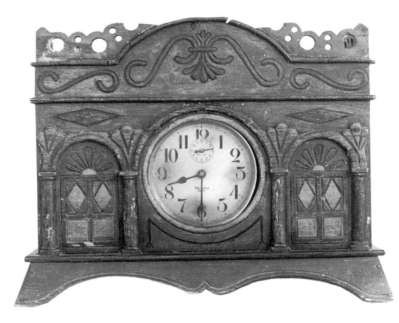

591. CLOCK CASE, MANITOBA: EARLY 20TH CENTURY; PINE; 12"H X 16"W X 6½"D.

One of the most remarkable furnishings found in Western Canada is this all-pine clock case located in the Ukrainian settlement near Sarto, Manitoba. In form, it is a liberal interpretation of the mantel clock, which had become a common part of the parlour furnishings of the late 19th-century Canadian home. Beyond the mimicry of mass-produced furniture is the highly decorative treatment of simulated arches, doors, columns with palmette capitals and a wheat-sheaf-like arabesque carved into the surface and highlighted by painted treatment in many colours. The opening accommodates the common and inexpensive wind-up alarm clock of the day, which, when inserted into handmade case, results in a more stylish timepiece.

592. TILT-MIRROR, SASKATCHEWAN: EARLY 20TH CENTURY; PINE; 17½"H X 11½"W X 5"D.

Pegged to the sides of its scrolled case, this small mirror is easily adjustable, not only for the height of the person reflected there but also for varying heights of commodes or dressers upon which it is placed. The dramatically carved ear-like scrolls and rising-sun or fan motif relate its design to both Ukrainian and Doukhobor furnishings (see figs. 580 and 597).

593. FRAME, SASKATCHEWAN: EARLY 20TH CENTURY; PINE; 17¾"H X 11¼"W X 2¼"D.

Possibly a church piece, but with domestic counterparts as well, this profusely scrolled frame contains three niches which in all probability were used to display religious pictures. If it is a domestic rather than ecclesiastical piece, it would be in keeping with frames traditionally placed in the "beautiful corner" of the room, a votive area containing Scriptures, icons, and related items of religious significance for daily prayers and other spiritual actions.

594. SHRINE, SASKATCHEWAN: EARLY 20TH CENTURY; PINE; 17½"H X 12"W X 5"D.

The story of John Hazelbauer shows that many of the simple furnishings of Ukrainian churches in Western Canada were made locally by members of the congregation. A Ukrainian of earlier German ancestry, Hazelbauer made numerous frames and shrines for use in various churches in and around the town of Krydor. Other pieces by Hazelbauer were more likely used in homes, serving the traditional function of the religious shelf for such items as candles or icons. This example, with symbolic floral and leaf motifs, is painted silver, likely in imitation of the metal or gilded icon-frames used both in ecclesiastical and domestic contexts.

DOUKHOBOR

595. DOUKHOBOR HOUSE: EARLY 20TH CENTURY.

In Russia and the Ukraine, wooden country houses (*izba*) were often highly decorated by means of carved gable boards, shutters or lintels. The long-popular rising-sun motif, an especially auspicious symbol in a northern climate, was an important design element transferred from the homeland to the new land, as in seen in this early photograph (from Koozma Tarasoff, *Plakum Trava: The Doukhobors*, p. 74).

596. TIN ARCADES ON COMMUNITY HOME IN VERIGIN: 1918.

Besides wood-carved decoration, metalwork ornamentation was also executed with considerable competence in Western Canadian Doukhobor communities in both Saskatchewan and British Columbia. One of the most fully articulated expressions of this craft is seen in the work of Ivan Ivanovich Mahonin, whose forty cut-tinwork arcades embellish the verandahs of the community home (the centre for spiritual, intellectual and cultural life) at Verigin. In Russia, the traditional country house was surrounded by a *gulbishche*, or traceried balcony, often highly decorative in its arrangement of elaborately carved balusters or fretwork slats.

597. WINDOW LINTEL, SASKATCHEWAN: CIRCA 1905; SPRUCE; 7½"H X 41"W.

Little remains of the log house at Petrovka, an extinct Doukhobor village south of Blaine Lake, but two lintels above the windows flanking the door are of interest because of the deeply carved sunrise motifs found on each. The decoration of window lintels in Canadian Doukhobor dwellings recalls similar ornamental treatment of architectural details of the Russian *izba*, or peasant's house, particularly in the highly carved and painted *nalichniki*, or window frames.

598. BRICK WITH TULIP MOTIF: EARLY 20TH CENTURY.

The tulip motif seen on carved and painted furniture, and used as an ornamental device in the tinwork panels in fig. 596, was also employed in the brick structure of Doukhobor homes. This yellow-clay brick was made in the second decade of this century at one of the brickworks near Grand Forks, British Columbia.

599. CUPBOARD: EARLY 20TH CENTURY;
PINE; 65"H X 41"W X 17½"D.

General-purpose storage cupboards of
panel door construction were common
items in the Doukhobor domestic
inventory, although larger ones such as
this example were the exception rather
than the rule. Applied to the middle stile
are scalloped boards reminiscent of
carved gable-boards made occasionally
for prayer homes, whose architectural
refinements were generally more
conspicuous than those on ordinary
homes in the community.

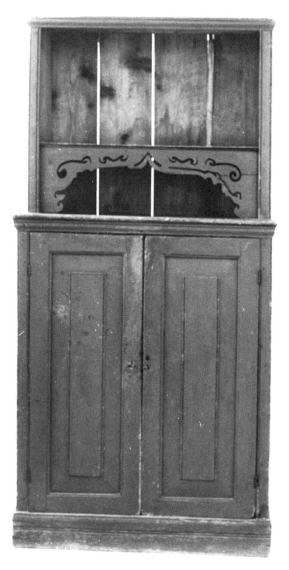

600. CUPBOARD: EARLY 20TH CENTURY;
PINE; 75"H X 36¾"W X 20"D.

Unlike Germanic examples, Doukhobor
cupboards rarely had a pie shelf or similar
open work-area between lower and upper
sections, as is seen in this piece. The raised-
panel and pegged-frame construction of the
doors is typical of Doukhobor furniture-
making competence. The fretwork
decoration, seen more commonly on
tables than on case furniture, echoes an
architectural treatment such as that
illustrated in fig. 596.

601. CUPBOARD: EARLY 20TH CENTURY; PINE.

Found in a poplar-pole house near Blaine Lake, this cupboard is of simple construction, with diagonal decorative bracework. Case pieces are rarely painted in such a dramatic manner, and the undulating vine and floral design is similar to painted decoration on trunks. Of particular interest is the heraldic-inspired device of paired lions, shown in the *couchant regardant* position (reclining and glancing backward).

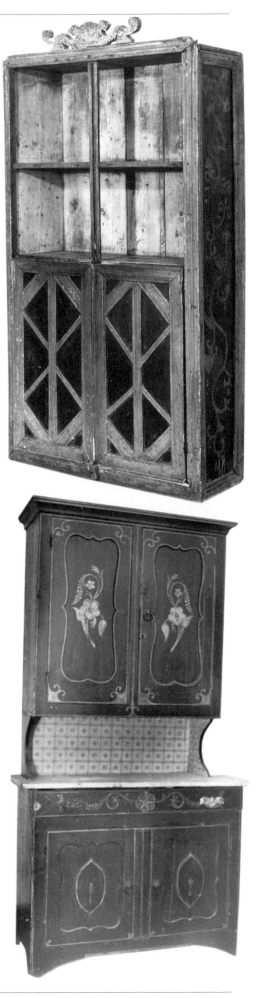

602. CUPBOARD: EARLY 20TH CENTURY; PINE; 86"H X 39½"W X 24½"D.

This unusual Doukhobor cupboard has an upper projecting section with two drawers set side-by-side. The arrangement of panelled doors and two drawers in the base section is typical of traditional kitchen storage cupboards, and the overhanging upper section calls to mind the cornice of the open dresser. The piece is constructed in almost architectural terms, with elaborately scrolled brackets supporting the upper section as exterior wall brackets are used beneath the overhanging roof of a house or other building.

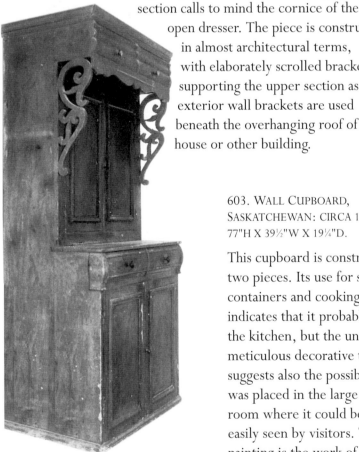

603. WALL CUPBOARD, SASKATCHEWAN: CIRCA 1920; PINE; 77"H X 39½"W X 19¼"D.

This cupboard is constructed in two pieces. Its use for storage of containers and cooking items indicates that it probably stood in the kitchen, but the unusually meticulous decorative treatment suggests also the possibility that it was placed in the large sitting-room where it could be more easily seen by visitors. The floral painting is the work of Wasyl Zubenkoff (d. 1933), a noted Doukhobor craftsman residing at Verigin. The painted flowers and wheat designs are identical to those on the table in fig. 512.

604. LOW CUPBOARD: EARLY 20TH CENTURY; PINE.

While it is frequently suggested that such small cupboards rested on the earthen ledge found in early Doukhobor mud-wall homes, first-hand evidence for the claim is lacking. The red and green colouring of this piece is a frequently found combination. Many Doukhobor furniture pieces are distinguished by small refinements of construction, among them the cock-beaded framework enclosing lower and upper doors.

605. LOW CUPBOARD: EARLY 20TH CENTURY; PINE; 30½"H X 23"W X 12"D.

This cupboard is of primitive construction, with exterior hinges on the upper doors. However, the refinements of this cupboard are evident as well, including moulded-bead treatment of the doors and drawer, and the painted double-tulip motif at the bottom.

606. LOW CUPBOARD: EARLY 20TH CENTURY; PINE; 70"H X 33¼"W X 22"D.

Small cupboards may have rested on a raised platform, but were also frequently hung from nails or pegs in the wall. This free-standing example reveals the predilection among Doukhobor artisans for the cut-corner panel, used again and again in making small cupboards. Such cupboards were useful both for storage and display of articles, and were frequently constructed with solid-panelled doors in combination with glazed doors.

607. CUPBOARD: EARLY 20TH CENTURY; PINE; 57½"H X 36"W X 16½"D.

A case piece in the traditional wardrobe form, this example is finely constructed: panels are framed with decorative mouldings, the corners of the stiles are chamfered (with "lamb's-tongue" endings), the flat "capitals" are given triangular dentil elements, and the scalloped cutouts of the drawer facades are a local cabinetmaking trademark of Doukhobor craftsmen working in the Kootenay region of British Columbia.

608. LOW CUPBOARD: EARLY 20TH CENTURY; PINE; 40¼"H X 23"W X 13½"D.

This exceptionally small cupboard is of interest because of the ideas borrowed from the world of large-scale industrially produced furniture. A strong element of mail-order catalogue influence is likely. The reverse-curved supports flanking the upper section were a common feature of late-Victorian or Edwardian mass-produced furniture advertised by Sears Roebuck in the United States and the T. Eaton Company in Canada. Several closely related prototypes for this cupboard, which blends elements of the parlour cabinet, sideboard and the music stand, can be seen in illustrations 275 and 370 in the 1901 Eaton Catalogue. JSH (CHC).

609. ADVERTISEMENT, T. EATON CATALOGUE, 1901.

The scrolled supports for the upper section of this mass-produced bureau are a recurring element in factory furniture which may have inspired the maker of the small Doukhobor cupboard in fig. 608.

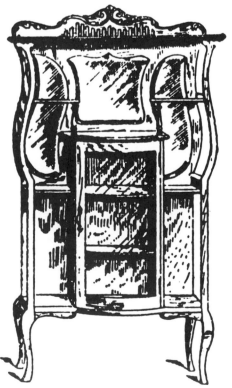

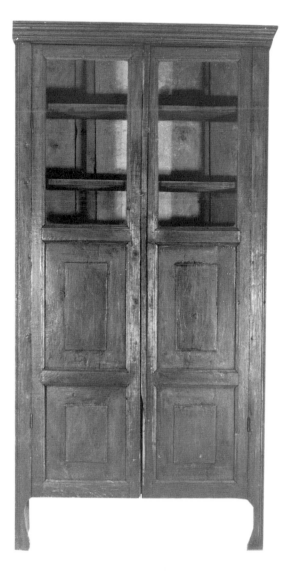

610. CUPBOARD: EARLY 20TH CENTURY; PINE;
76"H X 38¾"W X 13¼"D.

This unusually tall cupboard is graceful in
its narrow proportions, emphasized by the
delicacy of tall feet with a curved inner profile
but external lines that continue the vertical
movement of the beaded-mould detailing
at the corners. Like other cupboards, it
integrates the elements of hiding and showing
by virtue of tall doors which frame both solid
panels and clear panes.

611. BUFFET: EARLY 20TH CENTURY;
PINE; 49½"H X 32½"W X 13¾"D.

Small blind cupboards of this nature
were typically kitchen pieces, used for
keeping storage jars and utilitarian
items. Placement in a "lesser"
room did not necessarily preclude
ornamentation, however. The over-
sized six-point compass stars on the
door panels are skilfully carved, the
arcs accentuated by bevelled edges.
The present grey and cream paint is
a conjectural replacement, since the
piece was found stripped of its original
finish. JSH (CHC).

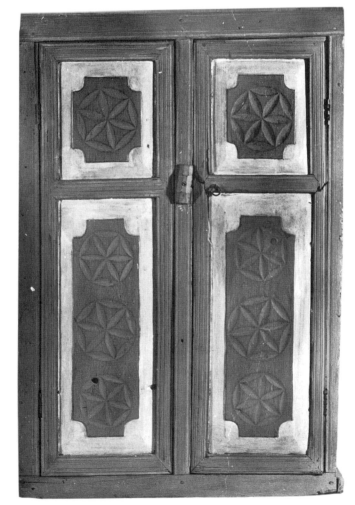

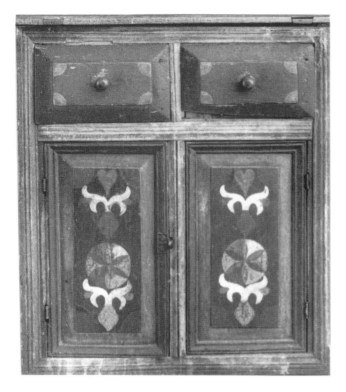

612. LOW CUPBOARD: EARLY 20TH CENTURY; PINE.

This cupboard with drawers above the doors fits into the category of a buffet or sideboard, a piece kept sometimes in the kitchen but also in the eating room of the immigrant settler's house. The painted ornamentation of this small cupboard includes hearts, compass stars, and floral motifs, making it one of the most exuberant specimens of Doukhobor painted furniture. Shortly after this extraordinary piece was photographed in Castlegar, it was destroyed in a fire at the museum. Kootenay Doukhobor Museum.

613. HANGING CORNER-CUPBOARD:
EARLY 20TH CENTURY; PINE.

While the form is extremely simple to the point of austerity, a neoclassical allusion is given in the triangular pediment on this cupboard from British Columbia. The painted floral design at its centre is stylistically related to pierced motifs on metalwork and on table bases. Kootenay Doukhobor Museum.

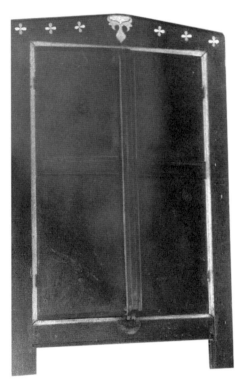

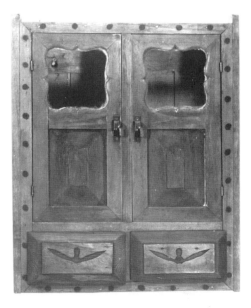

614. HANGING CUPBOARD; PINE;
22¼"H X 18¼"W X 9¼"D.

This tiny hanging cupboard is a distinctive piece, with scrolled panes and raised panels on two slender doors, and the unusual feature of side-by-side drawers with fielded panels and carved decoration. An ornamental band of painted dots makes a decorative framing device similar to that on the cupboard in fig. 617.

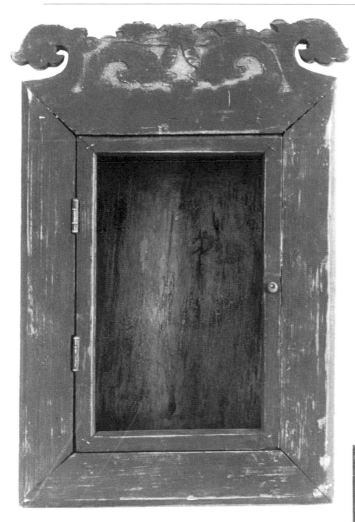

615. HANGING CUPBOARD: EARLY 20TH CENTURY; PINE; 75"H X 36¼"W X 20"D.

Unlike most Doukhobor examples which have glazed doors, or combination glazed and panelled ones, this small cupboard with its original red painted finish is fitted with a solid door. It may have functioned as a medicine cabinet similar to the French-Canadian *pharmacie*. The tulip-like lobed petal found frequently as a decorative treatment of Doukhobor furnishings is here carved in low relief as the crest profile.

616. HANGING CUPBOARD: EARLY 20TH CENTURY; PINE.

The carved tulips and geometric detail on this cupboard are related to the decoration of chair backs and frames, and this piece looks like the work of a frame craftsman. Indeed, the cupboard is essentially a box with a frame attached to its front edge. It retains a worn polychrome finish. CMC (CCFCS).

622. COMMODE: FIRST HALF 20TH CENTURY;
PINE; 30½"H X 34¼"W X 24½"D.

The three-drawer commode (two above,
one below) was an especially popular
form made in the Kootenays, and the
carved decorative scrollwork motifs are
further evidence of Kootenay provenance.
This example, painted in two colours,
is finely constructed with fielded panels,
beaded mouldings, and feet turned from
the stiles.

623. COMMODE: SECOND QUARTER 20TH CENTURY; PINE;
32"H X 31¼"W X 24¾"D.

The form is closely linked with that of other Kootenay pieces, but
the applied decorative treatment is an unusual embellishment.

624. COMMODE: SECOND QUARTER 20TH CENTURY; PINE.

Very similar to the example in fig. 618, and likely by the same maker, this commode is unusual in having five drawers set over two doors. The scalloped cartouche recessed into each of the drawer fronts again defines this as a Kootenay piece, while the high backboard is a distinctive treatment
The finish is a dark red-brown, conveying the appearance of a costly hardwood.

625. VANITY: SECOND QUARTER 20TH CENTURY; PINE AND BIRCH ; 61½"H X 23¾"W X 19½"D.

The chest of drawers with a mirror mounted above was introduced in late-Victorian furniture design, but made its most prominent entry in Canadian bedrooms with its widespread promotion in mail-order catalogues, where it could be purchased separately or as part of a suite of furnishings. Immigrant furniture makers seemed not the least hesitant to use such furniture (or the catalogue illustrations) in order to fashion counterparts for contemporary use, while still providing details which served as a small homage to Doukhobor traditional design. The carved floral elements on the upper rail are also found in the Doukhobor carved washstand in the following illustration, and are themselves a borrowing from English furniture design of an earlier period. The appearance here, on a late-Victorian design, of a traditional form of ornamentation seems incongruous, and is a clear sign of cross-culture influences at work in the early decades of the 20th century.

626. WASHSTAND: EARLY 20TH CENTURY; PINE; 46½"H X 21½"W X 17"D.

This piece has been described variously as a desk, lectern and washstand — an unfortunate consequence of its having been removed from its original setting without any information as to its context and use. It is a most unusual form, possibly unique among Doukhobor furnishings. The sophistication of construction includes fine dovetailing, lathe-turning, mouldings, and a sliding panel which is so well fitted as to be invisible when closed. The relief-carved floral motifs are particularly competent in execution, and are related to similar work on the preceding chest of drawers and that on several tables and shelves. JSH (CHC).

627. BED: EARLY 20TH CENTURY; PINE AND BIRCH.

Said to have belonged to the Peter V. (the Lordly) Verigin himself, this pine bed (top rail shown) exhibits similarities to the commercially produced spool-beds of the late 19th century. The lightly carved decorative treatment of the top rail features simple fans and compass stars.

628. BED: EARLY 20TH CENTURY; PINES; 42"H X 45"W.

Only the headboard has survived from this bed found in Saskatchewan. The posts are curved and they terminate in floral motifs, while the horizontal panel has been warped through a steaming process so that it can be fitted into a curving slot on the inside of the supporting posts. The bottom edge is scalloped and features repetition of three-lobed floral motifs and cutout work akin to that found on the skirt of Doukhobor tables. Remnants of the original brown stain survive on this much-weathered piece. JSH (CHC).

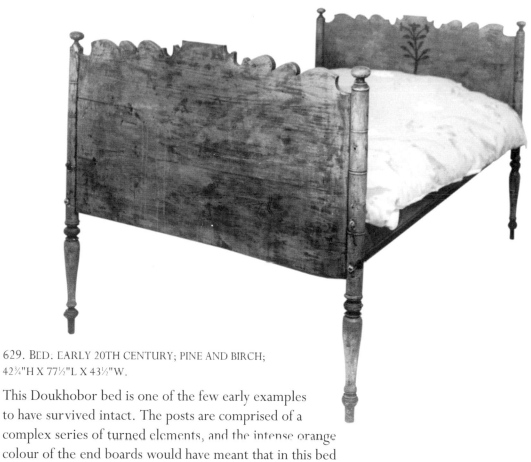

629. BED. EARLY 20TH CENTURY; PINE AND BIRCH;
42¾"H X 77½"L X 43½"W.

This Doukhobor bed is one of the few early examples
to have survived intact. The posts are comprised of a
complex series of turned elements, and the intense orange
colour of the end boards would have meant that in this bed
one never slept entirely in the dark.

630. HANGING CRADLE: EARLY 20TH CENTURY; PINE.

Early photographs show the use of hanging cradles both indoors and outdoors on
Doukhobor pioneer homesteads. Most have hooks at the four corners so that the
cradle can be suspended from two or four points, and rocked from side to side. The
tulip motif is painted in a repeating pattern on each end. CMC (CCFCS).

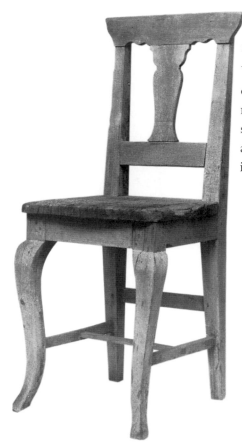

631. CHAIR: EARLY 20TH CENTURY; BIRCH AND OTHER HARDWOODS; 38¼"H X 15¼"W X 16¼"D.

While this interesting chair was found in the Doukhobor community of the Kootenays, it is a rather atypical Doukhobor example. The medial stretcher is not commonly found in the region, although the shaped back-splat is not unlike the profile of porch balusters and other architectural elements. The cabriole leg is complexly shaped, curving in more than one plane simultaneously.

632. CHAIR: EARLY 20TH CENTURY; PINE AND BIRCH; 35¾"H X 15½"W X 15¾"D.

Doukhobor chairs take several forms, some of them recollecting neoclassical or Biedermeier types popular in mid- and late 19th-century Russia. Such earlier stylistic influences are discernible here in the flared legs (a feature found in both front and back legs, with strong contrasting movement of the curved sections above the stretchers) and the dramatically curved stiles of the back. JSH (CHC).

633. CHAIR: EARLY 20TH CENTURY; BIRCH AND OTHER HARDWOODS.

Hybridization of forms is a common feature in Western Canadian country chairs. In this instance, the front legs are turned and the back square. The crest rail is given a vaguely foliate profile, while the posts bend at the top and terminate in floral motifs. The curve of the back, sweeping backward from the straight leg and curving again slightly toward the front again, is a distinctive feature of several Doukhobor chairs.

634. CHAIR: EARLY 20TH CENTURY; PINE AND BIRCH.

An armchair found in Saskatchewan, this may be of either Doukhobor or Ukrainian provenance. The box-stretcher arrangement is in keeping with Doukhobor examples, and the back posts are curved in exactly the same way as in the chairs in the preceding and following illustrations.

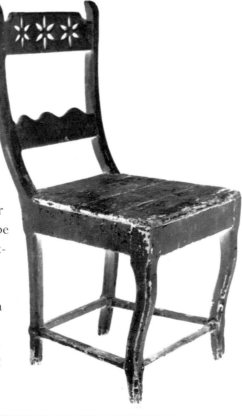

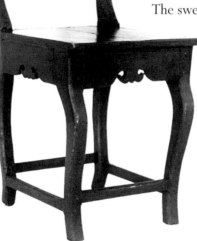

635. CHAIR: EARLY 20TH CENTURY; BIRCH AND OTHER HARDWOODS; 37¼"H X 14½"W X 16½"D.

The swept-back profile of the upper section of this chair makes this a particularly dramatic form. Of note is the carved three-lobe motif repeated on the underside of the back rails and front skirt. There has been some restoration to the front legs.

636. CHAIR: EARLY 20TH CENTURY; PINE AND BIRCH.

The side profile of this chair is quite similar to that of the preceding pieces, and could be from the same workshop. The device of six-point compass star decoration cut through the upper rail suggests that this chair may have had a special setting or was made for a significant life event such as a marriage. A later white paint covers what appears to be the original stained or painted finish. CMC (CCFCS).

637. CHAIR: EARLY 20TH CENTURY; BIRCH AND OTHER HARDWOODS; 37"H X 19¾"W X 16¼"D.

The influence of the mail-order house is particularly evident in many of the chairs made in Doukhobor communities throughout the first third of the 20th century. This chair is in many ways almost indistinguishable from press-back chairs made in vast quantities through Canada and the United States. However, in contrast to the machine-carved embossing of commercial chairs, the carving is here done by hand and employs characteristic Doukhobor decorative details, particularly the split-leaf or lobes and tulip motifs.

638. CHAIR: EARLY 20TH CENTURY; BIRCH AND OTHER HARDWOODS; 38"H X 18"W X 17"D.

The shape of the crest rail is less obviously dependent on the press-back prototype here, and the primitively carved tulip design has a casual character in contrast to the more formal appearance of carved chair backs in figs. 637 and 640. This example was made by Nick Popoff of Pass Creek, British Columbia.

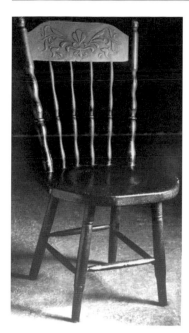

639. CHAIR: EARLY 20TH CENTURY; BIRCH AND OTHER HARDWOODS; 35¾"H X 18"W X 18"D.

Again clearly inspired by the mass-produced press-back form, this chair deviates from the prototype immediately in terms of its unusual proportions (the back is overly large in relationship to the base) and in the style of the plank seat, which is heavier and more sculptural than the catalogue chair. While the commercial form was generally varnished or stained, this Doukhobor chair retains its original red paint. The relief-carved decoration is completely in the Doukhobor idiom, and bears no relation to the decoration found on press-backs, with symmetrical composition of fan-and-leaf design-work flanked by hanging tulips.

640. CHAIR: EARLY 20TH CENTURY; BIRCH AND OTHER HARDWOODS; 37½"H X 16"W X 16"D.

The form here is the press-back chair with turned spindles. This chair has much variety in its carved embellishment — rosettes on the bottom rail, cross-hatching on the edge of the seat, and tulips on the crest rail. The floral design at the centre of the crest, in the form of plants encircled by a ring, is found in variant forms also on the tables in figs. 511 and 664, the inlaid box in fig. 675, and the frame in fig. 701.

641. ADVERTISEMENT, T. EATON CATALOGUE, 1901.

These pressed-back chairs, machine carved, probably influenced the design of Doukhobor examples.

No. 12. Chair, hardwood, antique finish, strongly made, each35c

No. 6. Chair, hardwood, antique finish, shaped wood seat, strongly made, brace arms, each40c

642. CHAIR: EARLY 20TH CENTURY; BIRCH AND OTHER HARDWOODS.

The form of this chair, which has a gallery of turned spindles and carved corner fans, is based on Russian and Ukrainian prototypes. Its counterpart in table form is illustrated in fig. 574. The carved rosettes in the crest rail are reminiscent of those on the chair in fig. 640, while the minutely carved low-relief floral decoration on the crest and centre rail are similar to that on several carved Doukhobor picture frames. Verigin Museum.

643. BENCH: EARLY 20TH CENTURY;
PINE AND HARDWOODS; 39"H X 48¼"W X 14¼"D.

A variety of bench-forms are known among the Doukhobor communities; among them are benches with backs, and without, and benches with drawers or lift-top compartments for storage. The Doukhobor variation of the press-back or simple stick-Windsor chair seems to be the basis for the design of this bench, comprised of an extended board seat and a back of turned posts and spindles.

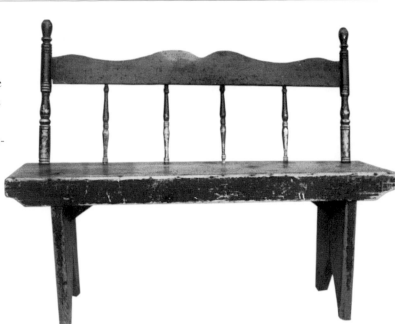

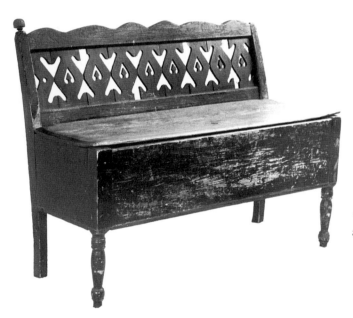

644. BENCH: EARLY 20TH CENTURY;
PINE AND HARDWOODS; 37½"H X 47"W X 22"D.

A boot-bench of considerable style, this example with a hinged lid is raised on finely turned legs. The back is a an elaborately cut out panel slotted into a framework of posts and rails. Found in the Kootenays.

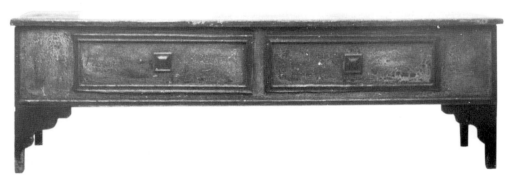

645. BENCH: EARLY 20TH CENTURY; PINE; 19"H X 61¼"W X 14½"D.

An alternative to the hinged lid, in trunks and in benches, is the form with drawers. This bench consists of a box supported on scalloped brackets, with elaborate applied mouldings and pulls on the drawers. The strong, original painted finish is a crackled cream against dark green mouldings and feet.

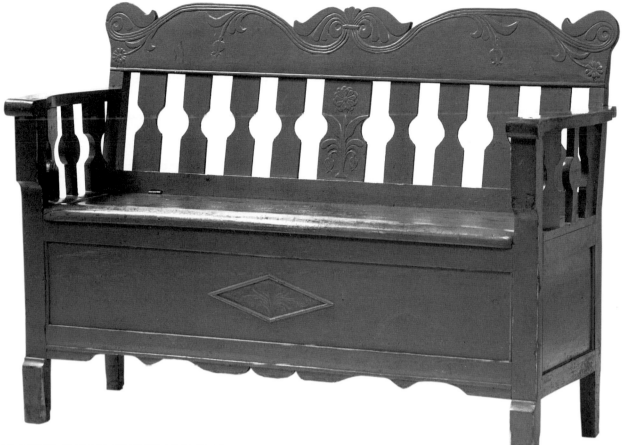

646. BENCH: SECOND QUARTER 20TH CENTURY;
PINE AND CEDAR, WITH BIRCH ARMS; 37½"H X 51¾"W X 16½"D.

This bench was made by Vasya Poznikoff, who lived at Glade (near Castlegar) and, later, Winlaw, British Columbia. It has a hinged seat for storage. The boxlike proportions of the whole and the squared design of posts and arms are probably inspired by mass-produced furniture of the early 20th century, while the back crest-rail is reminiscent of those on press-back chairs. Of unmistakable Doukhobor work is the elaborate carved detail, with characteristic vines, leaves, central lobes and petalled flowers. A yellowish-brown paint covers the original darker brown colour.

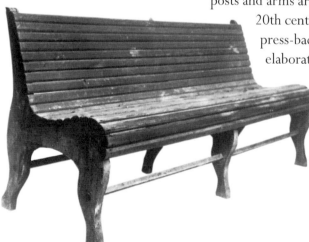

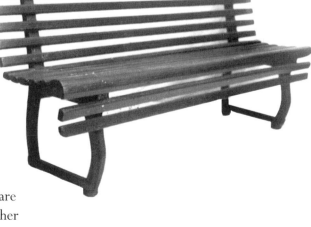

647. BENCHES: SECOND QUARTER 20TH CENTURY,
PINE AND HARDWOODS; (TOP) 31"H X 64¼"W X 17¼"D;
(BOTTOM) 34¼"H X 72¼"W X 23"D.

Popularly referred to as "train-station" benches, the top bench is a form which became popular in Doukhobor communities. Cutout "h" profiles serve as a support, to which are nailed narrow slats to build up the seat and back. Below is another slat-bench from the Kootenays with front and back stretchers.

648. TABLE: EARLY 20TH CENTURY; PINE AND BIRCH;
28" HIGH X 25½" DIAMETER.

Round tables, frequently used as plant stands, were made in
the Doukhobor communities of British Columbia, and possibly in
Saskatchewan as well. The turnings and cabriole legs are typical of early
19th-century English forms made in the Atlantic Provinces and along
the American Atlantic seaboard, suggesting the possibility that the
Doukhobor maker of such tables had seen one of these earlier pieces.
The top rotates on a circular "bird cage" with turned spindles, a feature
associated with high-style New York or Philadelphia furniture.

649. TABLE: EARLY 20TH CENTURY; PINE AND BIRCH; 29" HIGH X 24" DIAMETER.

Another Doukhobor round table, with complex pedestal turnings, delicately
flared cabriole legs, and a square "bird cage" with turned spindles. This and
the previous example retain their original red-brown painted finish. Found
near Yorkton.

650. TABLE: EARLY 20TH CENTURY; PINE AND BIRCH;
33½" HIGH X 28¾" DIAMETER.

This round table incorporates certain design features of the previous
two examples, notably the turned pedestal and cabriole legs,
but abandons the complicated "bird-cage" device for a simple
bracket securing the top to the post. In contrast to the
flowing lines of the preceding tables, this piece exhibits
greater affinity to Doukhobor decorative instincts, notably
in the rich carved profile of the bracket and legs and the
shaping of the feet in the form of the lobed-petal motif
found frequently on other furnishings. The top is not
quite circular, but is rather a polygonal form with
twenty sides.

651. TABLE: 1932; PINE AND BIRCH; 31"H X 47½"W X 34"D.

A five-colour painted treatment makes a bold visual impact on this Saskatchewan Doukhobor table. A later overpaint was removed to reveal an inscribed date and a dazzling array of colours. The maker of this table created considerable verve in the shaping of its legs, but in a one-plane movement from front to back, rather than the more complex sweep of the cabriole leg treatment of the table in fig. 661.

652. TABLE: EARLY 20TH CENTURY; PINE AND BIRCH; 29¼"H X 43¼"W X 28¼"D.

Among Doukhobor furnishings, tables are particularly noteworthy because of the exuberant turnings seen on legs and stretchers. Most have removable cleated tops and one or more drawers. The applied lozenge-motif is relatively uncommon on Doukhobor furniture, and when it does occur, is found most often on the drawers of tables. This piece retains its original red and yellow painted colouring.

653. TABLE: EARLY 20TH CENTURY; PINE; 27½"H X 32½"W X 20½"D.

At times a piece of furniture reveals simultaneous tendencies toward elaboration and simplification, as in the leg-and-frame construction here. The corners of the legs are chamfered, with the transitions at the skirt and stretcher embellished by means of finely carved lamb's-tongue details. At the same time, the skirt is merely nailed directly onto the outside of the legs, rather than being joined into the inner surfaces, a common practice in Doukhobor cabinetmaking. The box stretcher is joined to the interior surfaces by wooden pegs. The outstanding feature of this table is its decorative treatment, with paired hearts cut into the drawer, and inked floral motifs, and *mandorla* devices elsewhere.

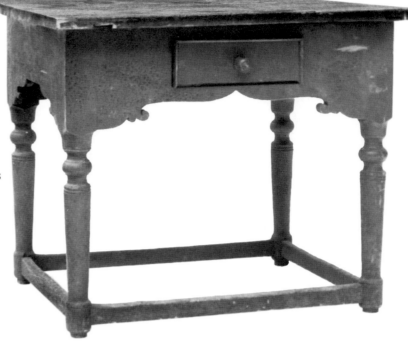

654. TABLE: EARLY 20TH CENTURY; PINE AND BIRCH.

A more robust table than most, this piece from Saskatchewan has a well-worn dark brown painted treatment. Sturdy box-stretchers and heavy turned legs give it strong definition. The scalloped cutouts on the four sides of the base grow out of a European baroque idiom, but are faintly suggestive of the lobed-motif characteristic of Doukhobor decorative detail.

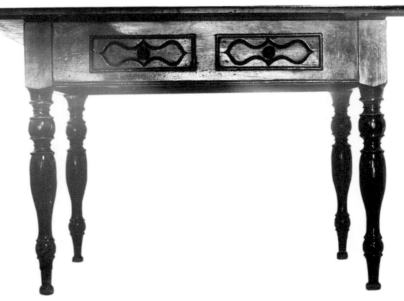

655. TABLES: EARLY 20TH CENTURY; (TOP) PINE AND BIRCH; (BOTTOM) 30¾"H X 50"L X 34¾"D.

Lightness of construction and proportion make the above table somewhat unusual. It is an exceptionally long and high table, and its delicacy is further emphasized in its relative narrowness. It is given a thin black painted finish. The bottom table is from the Kootenays, and has drawers featuring the scrolled inset panels characteristic of furniture made by Doukhobors in that region.

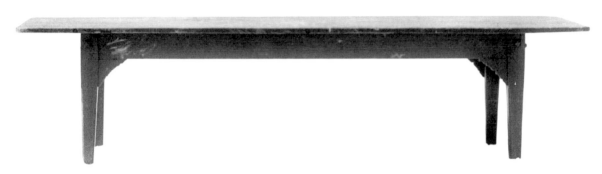

656. TABLE: EARLY 20TH CENTURY; PINE; 30"H X 123½"L X 33"D.

Doukhobor settlements in British Columbia followed a communal form of living, so eating took place at long tables or series of shorter ones arranged end to end. This 10-foot table has tapered square legs and a straight skirt, but the severity of form is modified by decorative carving on the brackets. The worn red paint is original.

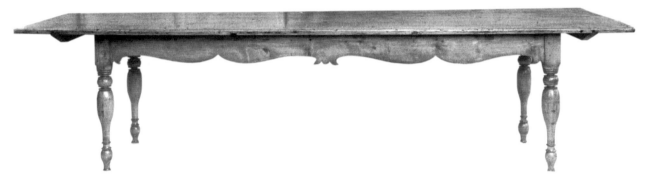

657. TABLE: EARLY 20TH CENTURY; PINE AND BIRCH; 30½"H X 125½"L X 32¾"D.

Another 10-foot example, this pine table features the bulbous turned legs and scalloped skirt characteristic of smaller Doukhobor tables. The top is cleated to prevent warping. A light green finish covers this refinished table from the Kootenay District of British Columbia.

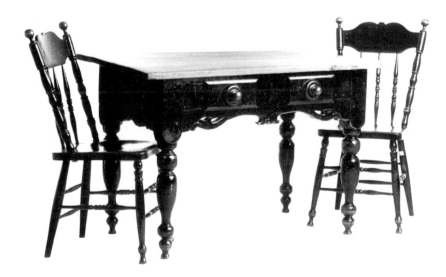

658. TABLE: EARLY 20TH CENTURY; PINE AND BIRCH; 30"H X 47"W X 28"D.

Like other Kootenay pieces, this table is of pine construction but painted in a dark red-brown colour, probably in imitation of a hardwood. The door-pulls of highly exaggerated size are similar to those on the commode in fig. 33. Flanking the table are two Doukhobor chairs found with it in a kitchen in Brilliant, British Columbia.

659. TABLE: EARLY 20TH CENTURY; PINE AND BIRCH; 31⅛"H X 40⅛"W X 27¾"D.

An elaborately executed example, this table is carved on all four sides, with a progression from least complex on the back, to more developed on the sides, and fully expressed on the front. This table had been stripped, and has been repainted to match traces of colour remaining. The bevelled drawers are an interesting variant. How finely constructed these tables are can be seen by the pegged joinery and the use of splines set into grooves to prevent warping of the top.

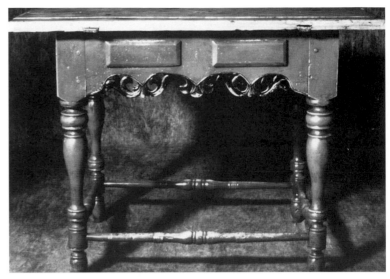

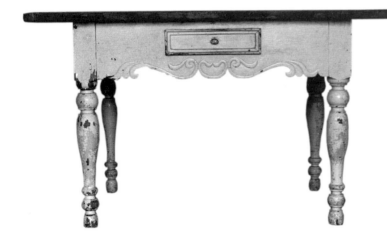

660. TABLE: EARLY 20TH CENTURY; PINE AND BIRCH; 30¼"H X 37"W X 25¼"D.

This one-drawer table is interesting in that the stylized floral embellishment is not carved in fretwork style, but rather in relief along the edge of the skirt, creating in effect an elaborated and considerably widened form of cock-beading. The central decorative cartouche is vaguely reminiscent of the stylized shell-motif or *rocaille*-form in rococo design, distantly echoed in the French-Canadian commode illustrated in fig. 185, or more closely related to the Doukhobor treatment on the table in fig. 664.

661. TABLE: EARLY 20TH CENTURY; PINE AND BIRCH; 32"H X 36"W X 20½"D.

Doukhobors and Ukrainians alike made furniture reflecting the preference for curvilinear elegance brought to Russia by French cabinetmakers in the 18th century. Rare, however, is the Doukhobor table which has both cabriole legs and relief-carved ornament, as in this case. The dark green paint on both top and base is original, and covers the carved decoration, a practice common to most tables, but different from the multicoloured treatment of such motifs on shelves or on the coat rack in fig. 517. There may have been a low shelf originally.

662. TABLE: EARLY 20TH CENTURY; PINE AND BIRCH; 30¾"H X 31¼"W X 24¾"D.

The mail-order catalogue became an important design source for local furniture makers in Western Canada in the early 20th century, much as the late 18th-century catalogues and directories of Chippendale, Hepplewhite, Sheraton and others had influenced taste and provincial design a century earlier. This table with cabriole legs and lower shelf has a close counterpart in the 1901 T. Eaton Company Catalogue (Entry no. 92) at an affordable price of $1.40 (or in golden oak at $1.75) (illustration below). The influence stops short at the more sculptural treatment of the Doukhobor example, with a raised-panel drawer front and the retention of fully proportioned legs rather than the streamlined flat cutout versions in the catalogue table. This piece was found at Castlegar, British Columbia.

663. ADVERTISEMENT, T. EATON CATALOGUE, 1901.

Tables with flattened cabriole legs set at a 45-degree angle to the rectangular top or lower shelf were advertised widely in turn-of-the-century furniture catalogues. The Doukhobor table in fig. 662 is closely modelled on the catalogue example.

No. 92. Bedroom table, hardwood, antique finish, strongly made, 20 x 28-inch top, shaped legs and drawer, $1.40.

Same table, made in solid oak, golden finish, $1.75.

664. TABLE: EARLY 20TH CENTURY; PINE AND BIRCH; 32½"H X 60¼"W X 33"D.

Along with the preceding piece, this specimen is among the very finest of Doukhobor carved tables known (another similar example exists). On this two-drawer table the carved lobes are rendered with unusual boldness and competence. The cock-beaded edge of the skirt is a kind of double-play, in that it also creates the vines which meet at the centre, terminating in the form of a foliate motif, itself enclosed within a ring. A most interesting Renaissance, or, more accurately, rococo, intrusion occurs just below this point in the form of a relief-carved *rocaille* design. This outstanding table has never been overpainted and retains its original, crackled brown painted finish.

665. TABLE: EARLY 20TH CENTURY;
PINE AND BIRCH;
28¼"H X 37½"W 26"D (BASE MEASUREMENTS).

Although the top to this piece is missing, it is important as an extremely well-ornamented example and one given to distinctive techniques of carving. The fretwork carving through the ends and the relief-carved treatment of the drawer fronts are rarely encountered features in Doukhobor furniture. The piercework scrolling of the bottom edge of the skirt is, on the other hand, is a device found on many decorated tables in this tradition.

666. TABLE: EARLY 20TH CENTURY; PINE, SPRUCE AND BIRCH; 32½"H X 35¼"W X 27½"D.

One of the most unusual of tables is this piece with a removable cabinet which rests on the box stretcher. The fretwork is among the finest known, with rounded carved detail giving refinement to the floral shapes cut as piercework on the base. Another technique, that of veneered inlay, is used on the centre of the skirt, with green and red stain used to accentuate petals on the floral motif. There has been the suggestion, but no firm corroborating evidence, that this table was used in Doukhobor prayer services (*sobranie*) and the cabinet employed for placement of water, salt and bread, which were elements of this special religious event. JSH (CHC).

667. TRUNK: LATE 19TH CENTURY; PINE; 30½"H X 44¼"W X 26½"D.

This large storage trunk was made in Russia, where the well-developed tradition of village blacksmithing could produce the heavy decorative ironwork strapping used here. The hand-wrought birds and floral motifs used as decorative enhancements parallel painted treatments found on other examples. This example, found at Sifton, Manitoba, carried settlers' effects for the laborious 1898–99 crossing to Canada, where it was brought eventually by train to Manitoba. Known as *sunduki*, Doukhobor trunks were made in considerable numbers in Russia in preparation for the departure to Canada, and more were made after arrival in the new land where they provided safekeeping for the growing inventory of textiles in the Doukhobor pioneer homes.

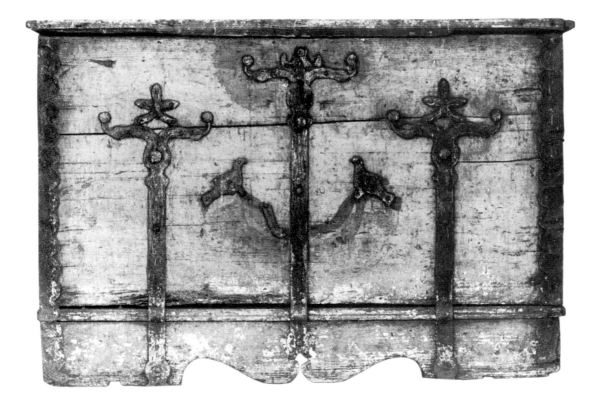

668. TRUNK: LATE 19TH OR EARLY 20TH CENTURY; PINE; 23¾"H X 35⅞"W X 22½"D.

Found in the Yorkton area of Saskatchewan, this flat-topped *sunduk* is competently constructed with dovetailed corners, applied base mouldings, and a hinged upper section, cut just below the lid. The heart and floral- or flame-like device are painted in cream colour against a red base.

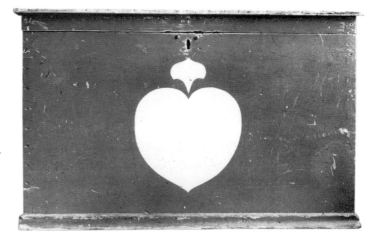

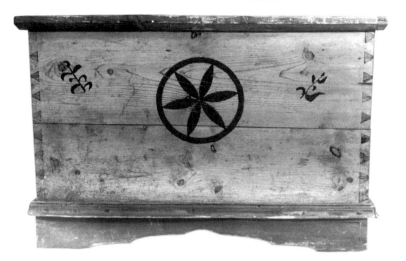

669. TRUNK: LATE 19TH CENTURY; PINE; 28"H X 43"W X 28"D.

A large trunk with a moulded lid and dovetailed construction. This piece, found near Saskatoon, is mounted on a bracket base set apart by an applied moulding strip to keep its contents safe from damp floors. The finish is a worn orange colour, with a compass star and the unusual detail of floral sprigs in dark green.

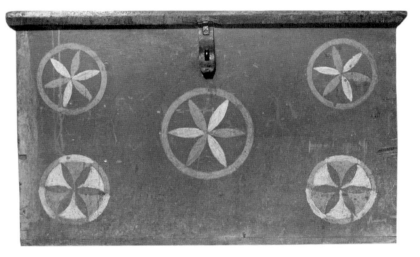

670. TRUNK: LATE 19TH OR EARLY 20TH CENTURY; PINE; 24¼"H X 39½"W X 26¾" D.

Probably of Russian manufacture, but found in Saskatchewan, this large pine trunk has heavy ironwork typical of pieces brought from the homeland. The lid is hinged and is enclosed by moulding strips which overlap the box. The decoration is bold, with multicoloured compass stars and a red-orange painted finish.

671. TRUNK: LATE 19TH CENTURY; PINE.

This trunk is set apart, both figuratively and literally, by the highly unusual feature of turned feet upon which the case and bracket base are lifted from the floor. Alongside the more conventional compass stars and demi-lunes are inverted anchors painted on the front of this finely made example.

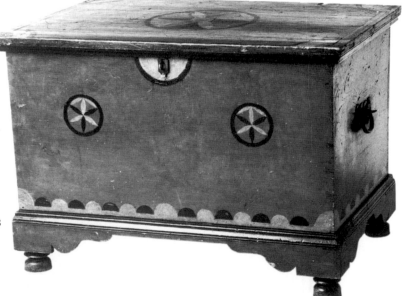

672. TRUNK: LATE 19TH CENTURY; PINE; 23⅝"H X 37¼"W X 24⅝"D.

The decorative vocabulary of Doukhobor carvers and painters was highly eclectic and drew upon a geographically vast range of subjects. The folk arts of Turkey and other southern neighbouring lands, and even occasional themes from the further reaches of Eastern Asia should be considered along with design influences from Western European furniture. Here, the yin/yang symbol is used, perhaps as a counterpart to the more frequently employed compass star, which appears on the top. This early box, with what may be somewhat later painted or repainted decoration, was reputedly brought to Canada from Viandka, in Siberia. Glenbow Collection.

673. TRUNK: LATE 19TH CENTURY; PINE; 22¾"H X 36"W X 21¾"D.

A trunk from north of Verigin, with lobed-petal motifs painted on the front. As in the preceding example, the yin/yang symbol serves as a decorative element, this time positioned on each end of the box. On many Doukhobor trunks and small boxes, the corners are painted either as fans or simply as single-colour quarter-circles, creating the illusion of cut-corner panels.

674. TRUNK: EARLY 20TH CENTURY; PINE.

Several closely related trunks are probably of Western Canadian manufacture, and are filled with mass-produced moulded hardware sold in village general stores. The construction of such examples is frequently of high order, as seen here in the unusually meticulous dovetail joinery and skilfully painted tulip decoration of front, top and ends.

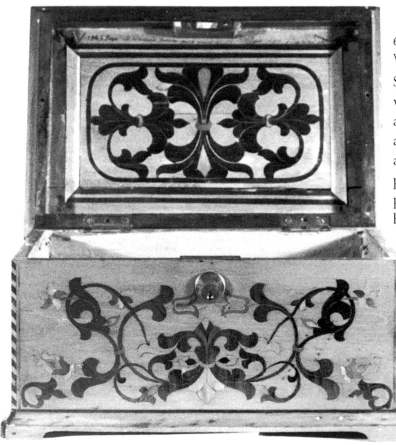

675. TRUNK: SECOND QUARTER 20TH CENTURY; VARIOUS HARDWOODS.

Several furniture makers in British Columbia were highly adept in the art of wood inlay, a technique used on several small boxes and picture frames. Rarely has such work achieved the heights of this example, with a profusion of floral design work comprised of pre-cut dark wood veneers set into a lighter hardwood background. By the use of several hardwoods and the addition of wood stains, considerable gradation of colour has been achieved. The pattern is finely composed, with vertical axial symmetry on the front and both vertical and horizontal axial symmetry on the lid. The diagonal pattern of contrasting inlaid woods at the corners is similar to that on the interior of several picture frames.

676. TRUNK. 1899; PINE.

Several *sunduki* have been located
bearing the date 1899. The year is, of course,
of great significance, for it was in 1899 that the first
Doukhobors arrived in Canada. It is possible that such boxes were made either on the occasion
of departure from Russia, or as the first storage pieces and multipurpose furniture for use in
the quickly erected sod homes on the Saskatchewan prairie. Tinwork corner-mounts on this
chest would provide additional strength during the long journey to Canada. As in many
examples, its painted embellishments include the name of the owner and geometric
decoration in the form of six-point compass stars.

677. TRUNK: 1899; PINE.

Bearing the date and name of an early owner,
this *sunduk* has simple iron handles which could have been made in the newly established
settlements in Western Canada. The floral decoration is primitive, rendered in several
colours against the vibrant orange background used widely in painting Doukhobor trunks.

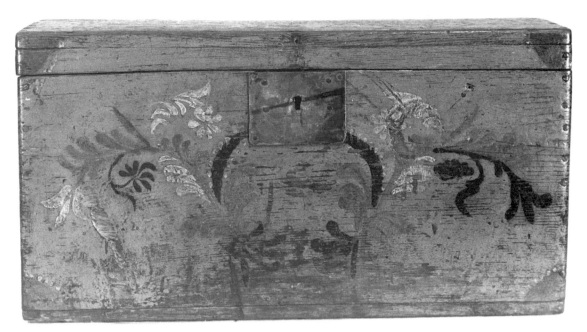

678. TRUNK: LATE 19TH CENTURY; PINE; 11½"H X 21"W X 14"W.

As in several other examples, the top of this modestly sized storage box is cut from the dovetailed framework itself and made without a moulded cornice extending beyond the lid. A small iron lock may be a later addition. The use of white colouration in the floral motifs is found also in the decoration of boxes in figs. 514, 677 and 679. This well-made box was found at Grand Forks, British Columbia, but is probably a Russian-made piece which was brought by settlers to Canada in 1899 and then carried once again when some Doukhobors moved on to British Columbia in the early 20th century.

679. TRUNK: EARLY 20TH CENTURY; PINE; 22¼"H X 46"W X 27¼"D.

A small group of lavishly painted trunks makes a good display of the richness of decorative treatment accorded these functional pieces. This trunk with overlapping lid and base encased within applied mouldings was found north of Blaine Lake. Paired birds flanking a central flower are painted against an orange field, with green demi-lunes accentuated by series of dots providing a border along the base. It was reputedly painted by a Doukhobor woman who settled at Blaine Lake, and whose artistic abilities were continued by her granddaughter, Agatha Stupnikoff, of that community.

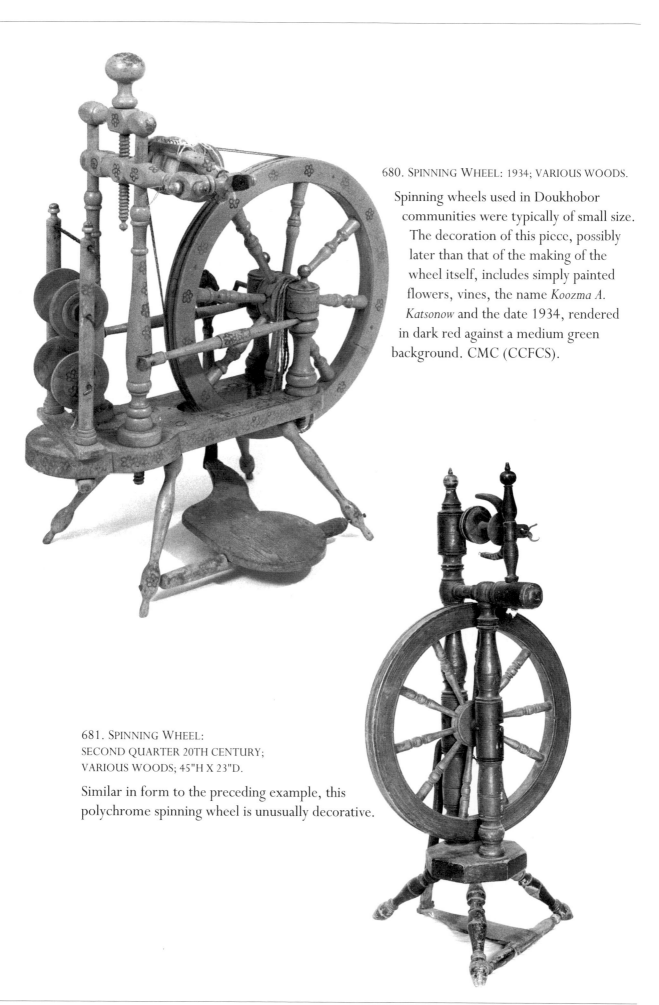

680. SPINNING WHEEL: 1934; VARIOUS WOODS.

Spinning wheels used in Doukhobor communities were typically of small size. The decoration of this piece, possibly later than that of the making of the wheel itself, includes simply painted flowers, vines, the name *Koozma A. Katsonow* and the date 1934, rendered in dark red against a medium green background. CMC (CCFCS).

681. SPINNING WHEEL: SECOND QUARTER 20TH CENTURY; VARIOUS WOODS; 45"H X 23"D.

Similar in form to the preceding example, this polychrome spinning wheel is unusually decorative.

682. SPOOL HOLDER, SASKATCHEWAN:
EARLY 20TH CENTURY; PINE AND OTHER WOODS;
14"H X 13½"W X 5¼"D.

While this sewing utensil, carved by Alexey William Kurenoff (born 1885), was useful to its adult user, it was at the same time a source of creative enjoyment for a Doukhobor girl (Mary Zubenkoff) who claimed that it was the only toy she had in the house. While her mother spun linen, she and other children tied strings around the necks of the horses, which they named Jesca and Bell. The horse head was an important symbolic architectural detail on the roof of Russian peasant houses, later adapted as a decorative device for furniture (see figs. 555 and 617) and, in this case, for making a rack for spools of thread, wool or yarn.

683. FLAX COMBS, BRITISH COLUMBIA:
SECOND QUARTER 20TH CENTURY;
HARDWOOD; (TOP) 23"W X 16"D;
(BOTTOM) 14"H X 15¾"W X 7"D.

Large wooden combs cut from pine or other softwood found on the Canadian prairies were used for narrow-width weaving, used for making bands or scarves. Simple six-point compass stars add decorative interest to these utilitarian items. JSH (CHC) and private collection.

684. MANGLES: SECOND QUARTER 20TH CENTURY, BIRCH; (RIGHT) 26"L X 3"W; (LEFT) VERIGIN MUSEUM.

Mangles were commonly used for smoothing bed sheets and other coverings. Occasional Doukhobor examples are given decorative enhancement in the form of simply inscribed or drawn compass stars. Here the ornamentation is much stronger, with pinwheels painted in white on a dark red background. The second example is unpainted, and the handle-end carved in the shape of a tulip.

685. LADLES: FIRST THIRD 20TH CENTURY; BIRCH.

The tips of ladle handles were frequently carved to simulate the heads of birds or animals, particularly horses. Several variations can be seen in this assortment of Doukhobor utensils.

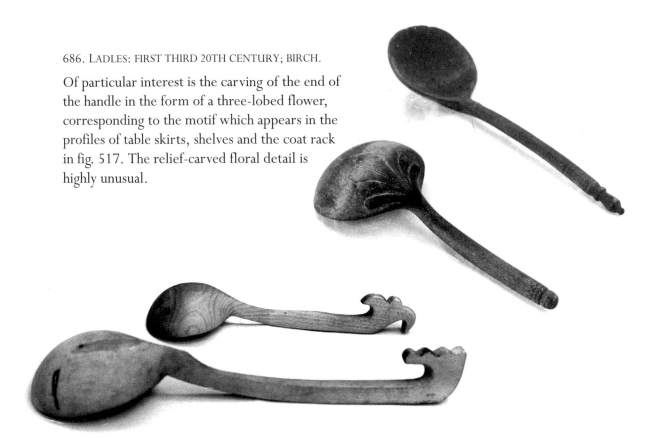

686. LADLES: FIRST THIRD 20TH CENTURY; BIRCH.

Of particular interest is the carving of the end of the handle in the form of a three-lobed flower, corresponding to the motif which appears in the profiles of table skirts, shelves and the coat rack in fig. 517. The relief-carved floral detail is highly unusual.

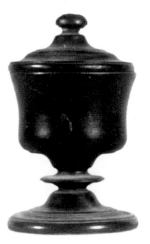

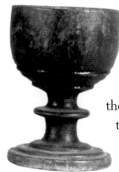

687. SALT BOWLS: EARLY 20TH CENTURY; HARDWOOD; 5¼"H X 3¼"W AND 3½"H X 2½"W.

At the important Doukhobor spiritual rituals (*sobranie*), symbolic elements of bread, salt and water were placed in containers upon a table as an act of offering, thanksgiving and remembrance. These small turned utensils from the Kootenays are salt bowls used on such special occasions, and the exceptional delicacy and frequency of their turnings recalls similar refinement of detail on tables and other furnishings.

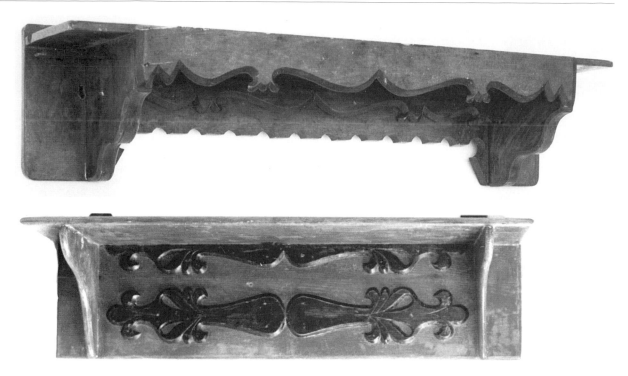

688. SHELVES: PINE; (TOP) EARLY 20TH CENTURY; 6"H X 24½"W X 6"D; JSH (CHC); (BOTTOM) EARLY 20TH CENTURY; 7"H X 26¾"W X 7¼"D.

Found in Saskatchewan, this single-coloured shelf (top) is elaborately scalloped with reverse curves and floral motifs running along the front edge as well as on an applied piece set in relief against the backboard beneath. The technique of built-up decoration is employed frequently in Doukhobor furniture, where cutout designs are superimposed upon other layers of wood. In the bottom shelf, pre-cut patterns, painted black, are set in contrast to the orange backboard and projecting section of this small shelf found at Grand Forks in British Columbia.

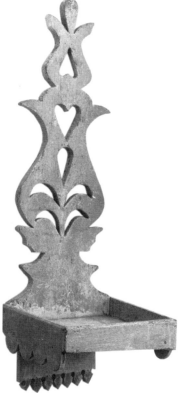

689. SHELF:
EARLY 20TH CENTURY;
PINE; 7"H X 23"W X 7"D.

The carving on this shelf from Saskatchewan is more elaborately developed than that on the preceding example. Here, carving is not only a technique for establishing a profile along the edge of a facade, but a means of embellishing the surface itself. Floral and fan-like motifs are finely carved in low relief and accentuated by a red and black painted finish. JSH (CHC).

690. SCONCE: EARLY 20TH CENTURY; PINE; 22¼"H X 7½"W X 6¾"D.

The absence of wax drippings or stains suggests that this piece did not actually serve as a candleholder, but its design calls to mind such lighting fixtures. It may in fact have been intended as a shelf upon which a candle and its brass or iron holder rested, or simply as a shelf for display of a small item accorded aesthetic importance in the household. JSH (CHC).

691. CLOCK CASE: EARLY 20TH CENTURY; PINE; 13"H X 8"W X 5¼"D.

Reputedly made for the purpose of carrying time to the workplace, this pine case and timepiece served as a field clock for Saskatchewan Doukhobors. A sliding glass (missing) was slotted into the sides. The familiar lobed-petal design spreads outward from a central heart in the crest. The carved treatment is closely related to that found on decorative crests on furniture made in the Kootenays, but this piece was found in Saskatchewan near Verigin.

692. FRAMES, SASKATCHEWAN: (TOP) 1906, VARIOUS WOODS, VERIGIN MUSEUM; (BOTTOM) EARLY 20TH CENTURY, PINE, MOUNTAINVIEW DOUKHOBOR MUSEUM.

The importance of pictures in the pioneer household, even when they are photographs or other printed forms, is indicated by the meticulous carved or inlaid decoration of numerous frames in the Doukhobor community. The top example is comparatively simple, decorated with inlaid tulips and a date of 1906. More elaborate than this piece is the richly carved frame below, containing two photographs, the one on the left a picture of the Doukhobor poet Ivan F. Sysoev (1894–1967), author of more than a thousand hymns and poems and prominent pacifist. The low-relief carved decorative details include rosettes and other stylized floral motifs in symmetrical arrangement.

693. FRAMES: EARLY 20TH CENTURY.
(RIGHT) MOUNTAINVIEW DOUKHOBOR MUSEUM;
(LEFT) GRAND FORKS; PRIVATE COLLECTION.

The frame at right is scrolled on the top and sides, and flat on the bottom, as is typical of many Doukhobor frames. Shown in the photograph is Peter V. (Lordly) Verigin (1859–1924), early spiritual leader among Doukhobors of Western Canada. The frame at left, below, is a simpler version of carved frames shown in subsequent illustrations. The relief-carved compass star is set within an undulating motif reminiscent of winged heads found in heraldry and early tombstones in the British Isles, New England and Atlantic Canada.

694. FRAME: EARLY 20TH CENTURY; PINE; 32"H X 20"W.

Placed in a frame of his own design and construction are two photographs of Wasyl Zubenkoff (1861–1933). The upper picture shows him with an unknown individual posing after his arrival in Saskatchewan, while the larger portrait shows the young Zubenkoff in Cossack uniform, in which capacity he served Lukeria Kalmikova for twelve years prior to his conversion to the Doukhobor principles of nonviolence and spiritual communism.

695. FRAMES, SASKATCHEWAN: EARLY 20TH CENTURY; VARIOUS HARDWOODS; (LEFT) 9"H X 7"W; (RIGHT) 9"H X 7"W.

Made by Wasyl Zubenkoff, the frame on the left is evidence of the variety of skills he brought to his work. As in other frames he and other Doukhobor woodcarvers made, the construction entails the arrangement of four corner-blocks placed over the diagonal join of mitered framing members. An interior border with an inlaid pattern of alternating light and dark diagonal strips sets off the wider outer frame, itself embellished with finely carved floral motifs and an inverted heart at the top. The startling variety of decorative motifs used by Wasyl Zubenkoff is again seen in the frame on the right, made by him at or near the same time as the previous example. The relief-carved detail is more concentrated and elevated from the background here, but the use of a thin interior frame of inlaid diagonal strips here is a recurring element in his work. Many of his frames use corner blocks of a dark wood, contrasted with the lighter frame which is finished in a clear varnish.

696. FRAME, SASKATCHEWAN: 1906; PINE; 15"H X 12½"W.

This comparatively large frame was made for a mirror. Found at Pass Creek, British Columbia, and the work of Doukhobor carpenter Phillip Picton, it has a 1906 date, which indicates that it was made in Saskatchewan before the transfer of many Doukhobors from that province to the Kootenays in and after 1908. While one side is competently carved in relief, its maker seems to have decided upon a shortcut on the remaining three sides, which are more simply incised and painted.

697. FRAME, SASKATCHEWAN: 1903; VARIOUS HARDWOODS; 10½"H X 8½"W.

This exceptional frame is of sufficiently high calibre to be mistaken for the work of Wasyl Zubenkoff. It is, in fact, a product of Zubenkoff's "student," John Kasakoff, who frequently matched the quality of Zubenkoff's carving. Kasakoff, too, uses an interior frame with diagonal inlay, arranged symmetrically. Sharp relief-carved floral motifs and the date 1903 emblazon the corner blocks and frame strips, the top and sides of which have exterior scalloping similar to that used in the frame in fig. 698.

698. FRAME: EARLY 20TH CENTURY; HARDWOOD; 12"H X 15"W.

Like other examples, this frame has a plain strip to denote the bottom side. Most frames are vertical, and were probably intended for portraits, photographic or otherwise. This horizontal format is less common. The corner blocks, made of the same wood and colour as the frame strips, are more closely integrated into the decorative design, in which relief-carved leafage and floral motifs appear in profusion.

699. FRAME, BRITISH COLUMBIA: 1922; HARDWOODS; 9"H X 10"W.

On occasion, small furnishings or utilitarian items were made and decorated as tokens of affection, falling into the category of the arts of courtship. This flamboyantly carved piece was made in 1922 by a Doukhobor young man, Peter P. Konkin, for his true love, Nastasia Sofonoff, who, along with her parents and other family members, was the subject of the photograph contained in his ornate frame. Found in the village of Blueberry, the frame gives dramatic evidence of the long survival of Doukhobor arts to late date.

700. FRAME: EARLY 20TH CENTURY; VARIOUS HARDWOODS; 8¾"H X 9¾"W.

The profile is comparatively simple, comprised of double curves on three sides. The bottom edge is straight, reflecting a general tendency in the design of Doukhobor frames to make the bottom the simplest of the four sides. Here, pencil decoration has been used in place of what would normally be accomplished by carving (floral designs) or inlay (chevron details of inner edge of sides). It is interesting that the intricacy of pencil drawing reveals details not easily apparent in other forms of embellishment, notably in the way in which the artist goes beyond the normal conventionalization of floral devices to depict what actually appears to be a stylized wheat-sheaf.

701. FRAME: EARLY 20TH CENTURY; HARDWOOD; 10½"H X 7¾"D.

The design work on this meticulously carved example is complex and greatly varied. The details of the lower corners (plants in pitchers) are contained within the block, while those at the top (abstract floral motifs) cross over into the frame. The symmetrical foliate device with an enclosing ring is related to the similar device found frequently on tables and on the frame in fig. 702. On both sides are identical arrays of leaf motifs, arabesques and paired tulips. Punch-work stippling of the background establishes contrast for the low-relief carved detail. The finish is an old or original varnish.

702. FRAME, SASKATCHEWAN: 1907; VARIOUS HARDWOODS; 31"H X 18"W.

Perhaps the crowning achievement of Wasyl Zubenkoff's carving artistry is this extraordinarily detailed frame made at Kamsack early in the century. Zubenkoff used a wide variety of decorative techniques in his furniture-making, including carving, inlay and painting. The double-headed eagle is a heraldic motif with ancient roots in the Holy Roman Empire, taken over at later date by the Austro-Hungarian Empire, and brought eventually to Russia, where the emblem was used in the court of Catherine the Great and by subsequent Czarist regimes. Such official public motifs were important sources for simplified designs used by folk artists, and in this case it served well Zubenkoff's desire to create an impressive crest for this finely carved mirror frame. Further embellishments include inlaid floral displays and the date 1907. The picture set into the upper section, depicting women sewing on modern machines, appears to have been taken from one of various catalogues readily available in country homes (catalogues were yet another source for furniture designs).

703. BED, MANITOBA: LATE 19TH CENTURY;
PINE AND OTHER WOODS;
46"H X 79½"L X 43¼"W.

This bed could be of Icelandic background, and is among several pieces found in the Interlake district of Manitoba. Its swelling curves, heaviness of construction, and inset panelling of ends resembles many features of peasant beds found also in regions across Northern Europe, extending eastward into the Ukraine and Russia. A similar example is illustrated in Gaynor and Haavisto, *Russian Houses*, p. 37. It retains its original light green painted finish.

704. CHAIR, SASKATCHEWAN: SECOND QUARTER 20TH CENTURY; HARDWOOD;
36½"H X 18½"W X 18¾"D.

This remarkably carved chair is one of a set of four found in the church at Polish Parish, south of Weyburn. There have been differing reports as to its cultural provenance. Tentative information at this time suggests that these chairs may be the work of O.L. Pearson of Percival, Saskatchewan, who made furniture during the 1920s and 1930s for personal use and also for Polish residents in Polish Parish and other communities in the Weyburn area. The scallop-carving of the splat is exceptional in its refinement, and a V-shaped emblem-like motif with in-turned centre scroll extends from the splat across the join and up the crest rail where it follows the curve backward over the top. The legs are of a modified cabriole type, ending in vestigial animal-foot elements, hence a late allusion to the *pied-de-biche* chair from the French reigns of Louis XIV and Louis XV. The seat is made of fir, while the legs, posts and carved crest rail are poplar.

GLOSSARY

Acanthus
Stylized leaf design in classical architecture, used in decorative mouldings and on Roman and Greek capitals. It appeared in many variations in later antiquity, and in Byzantine, Gothic and Renaissance decorative arts. It came into widespread use in the embellishment of furniture in the Renaissance and especially in the classical-revival forms of the late 18th and early 19th centuries.

Adam Style
Neoclassical development, primarily in architecture, associated with the designer Robert Adam (1728–1792). His sources of inspiration seem to be a combination of French neoclassicism of the mid-18th century, ideas brought back from his visits to Italy, and his own creative ingenuity. His designs for wall furniture were published in *The Works in Architecture* (1773).

Anthemion
"Formalized honeysuckle," a form of decoration used especially during the neoclassical period, hearkening back to palmette forms used in Greek architectural ornament. The motif gained considerable vogue in the Adam and Regency periods.

Apron
Horizontal rail spanning the distance between legs on tables and chairs, and bracket feet on chests. Sometimes the aprons of such pieces of furniture were given decorative interest by means of carved profiles or ornamented surfaces.

Arabesque
Pattern of interlacing foliage and tendrils, or stylized curvature, derived ultimately from Greek sources. Its adoption and repeated use in Islamic art led to its later description as arabesque. In architecture and furniture from the Renaissance period on, it included a range of possibilities, from grotesques to exuberant forms designed by Charles Lebrun to the undulating curve produced by linked C- and S-scrolls.

Arbalète
Crossbow, crossbow-shaped, particularly in reference to the shaping of facades of buffets and commodes of Louis XV styling. It is a description found frequently in reference to French-Canadian furniture of the late 18th century.

Arcading
Decoration formed from a continuous pattern of arches or arcades, used widely in architecture, and from there, applied to the design of furniture. Arcading may be literal (open), or suggested (closed), as when carved or built up in relief against a facade.

Armoire
Large cupboard or wardrobe, serving purposes of storage for clothing or other articles. Its linguistic origins are uncertain; it is possible that the name derives from *aumbry*, an alms-cupboard or cupboard for sacred vessels found in churches.

Astragal
Small semicircular moulding, loosely descriptive of glazing bars of the late Georgian period. In architecture it is a thin semicircular horizontal moulding placed on a column.

Armoire-à-deux-corps
Piece of furniture consisting of an upper and a lower cupboard. A Renaissance form of large proportions, it was in its simplified version a commonly used piece in French-Canadian homes known as a *buffet deux-corps*, it was typically placed in the common room, and was the keeping-place of linens and eating-wares.

Bahut
A wooden coffer which could be transported, hence functionally a kind of medieval luggage. The original bahut was normally fitted with a hinged flat lid, but by the end of the 16th century was increasingly given an arched or vaulted lid.

Baluster
A short upright column or post, found on balconies, or between horizontal rails on benches or chair backs. Balusters were frequently slender at the top and bulging below, shaped to resemble classical vase forms.

Banding
Decorative border or edging of wood veneer, with the grain running either across the band (cross-banding) or diagonally to it (herringbone or feather banding). Banding was used extensively in late 18th-century English furniture, and the practice was continued in the making of hardwood furniture in areas of English settlement in Eastern Canada and also by Germanic cabinetmakers in Southwestern Ontario.

Baroque
A later version of Renaissance decoration, occurring historically between Mannerism and rococo. The style is characterized by elaborate curvature and ornamentation, and is perpetuated in Canada less in sculpture and more in scrolled profiles on country furniture, made variously in areas of French, German, Polish, Ukrainian and Doukhobor settlement.

Bas-relief
With reference to carved ornamentation in architecture and furniture, the term means shallowness of execution, rather than in-carved sculptural treatment. Low-relief decorative carving was popular among such diverse groupings as French-Canadian furniture makers in Eastern Canada and Doukhobor artisans in Western Canada.

Beading
Narrow moulding, generally semicircular in profile, used in architecture and furniture to break the expanse of a large surface or highlight the edge of a section, panel, door or drawer.

Bergère
Upholstered armchair with a wide seat and rounded back; first developed in 18th-century France and much copied in other countries. The form was most fully elaborated as a commodious armchair of the Louis XIV–Louis XV period, with upholstered armrests, sides, back and wings.

Biedermeier Style

A 19th-century German style, essentially a heavy, solid varia-
tion of French Empire. It is an eponymous term, derived from
the fictional Gottlieb Biedermeier, a character in the journal
Fliegende Blätter who symbolized middle-class vulgarity, hence
suggesting the commonplace. The style aspired to a kind of
tasteful form for every man, but its expensive veneers restricted
such furniture to a somewhat moneyed Everyman. The neo
classical forms, particularly those defining posts and arms of
seating furniture, were widely used in Germanic and Polish
furniture made in rural settlements of Ontario and Western
Canada.

Blind Door

Solid door, usually panelled, but sometimes of slab construc-
tion, used on a cupboard or a dresser. The name is related to
the function of hiding, in contrast to glazed doors used for the
purpose of display of good china and other signs of affluence.

Blown and Fielded Panels

These are panels which stand in low relief against surround-
ing flat or bevelled bands, the whole set within a joined frame.

Bombé

Literally, bulging; a *bombé* commode is one with convex swelling
in the front and sides of the case. The form required consid-
erable sophistication on the part of cabinetmakers, and rarely
reached Canada, but is occasionally found on some French-
Canadian two-tiered buffets and commodes.

Bonnet Scrolls

An American term for a curved and scrolled pediment on high-
boys, bookcases and other furniture. The shape is that of a pair
of reversing curved members, broken at the centre to per-
mit placement of a finial or other ornament.

Bracket Foot

In contrast to an independent, turned support, a bracket foot
is normally cut from either the case of a chest or other furni-
ture case, or, alternatively, made from pieces fitted together
at the corners. Bracket feet may be flat, or moulded, in which
case the front and side surfaces are shaped by means of mould-
ing planes.

Brettstuhl

A traditional Continental-German chair, it is in essence a heavy
plank seat with a flat-shaped back mortised into the top and
straight flared legs socketed into the bottom. A few chairs of
this form were made in the Germanic settlement at Renfrew
County in Eastern Ontario.

Buffet

A French term to describe a side or serving table. Historically,
the buffet was a showpiece, placed in the banqueting or din-
ing room, in contrast to the dresser, which was located in
the kitchen.

Buffet Bas

A low cupboard, resembling the bottom section of a two-tiered
buffet, used for storage of food and dishes, as well as func-
tioning as a serving table.

Bun Foot

A flattened ball-foot introduced in the late 17th century, placed
beneath heavier pieces of furniture such as wardrobes or other
large cupboards. The form had largely gone out of style by the
end of William and Mary period, but appears occasionally
on early New England or French-Canadian furniture.

Bureau

A piece of furniture with the writing surface or flap hinged so
that it rests at an angle of 45 degrees when closed. The space
behind the flap has pigeonholes with small drawers below them.
Often such pieces include a bookcase with glazed or blind doors
above.

Burl

An abnormal protrusion on a tree caused by its attempt to cure
a disease or cover a broken limb, producing grain characteris-
tics.

Butted or Butt-joined

Formed by two boards simply joined with squared edges.

Cabling, Cables

Continuous ornamentation of architecture or furniture, exe-
cuted to resemble twisted rope. The design appears frequently
in Romanesque architecture in the carving of mouldings, and
came into furniture design in the 18th century.

Cabriole

The double curve on a furniture leg, the upper part swelling
out, the lower swinging in toward the foot. It was popular in
18th-century table and chair designs, in which the curvature
of natural forms was applied to furniture members. The term
is derived through French from the Italian *capriola* and refers
to the bent position of the knee in dancing. In French design
the cabriole leg is called the *pied de biche* (foot of a female deer).
Such dancing furniture became popular with the emphasis upon
graceful curvilinearity in the Louis XV and Queen Anne peri-
ods in France and England, and make their primary Canadian
appearance in 18th-century Quebec tables and chairs.

Captain's Chair

A low-backed Windsor characterized by turned legs, spindles
and stretchers, and a continuous U-shaped arm often sur-
mounted by a crest rail on short spindles.

Cartel

A small ornamental medallion or cartouche decorated in the
rocaille style and often executed in openwork. Such decora-
tion is generally associated with grander styles of cabinet-
making, and is found in a few rare instances in French-Canadian
commodes.

Cartouche

A framed medallion often surrounded by an ornamentation in the form of a foliated scroll. Simpler cartouches are found occasionally on drawer fronts and in the pediments of cupboards.

Carver Chair

A rush-seated chair with turned legs that rise vertically above the seat to support spindle arms and to frame complex arrangements of spindles forming the back. This type of chair is reputedly associated with the name of John Carver, founder of Plymouth Colony, south of present-day Boston.

Catalogue Style

A term used for some time in Western Canada to describe furniture made according to the design of mass-produced pieces advertised in publications such as the T. Eaton Catalogue. The practice was not altogether new, in that publications of Chippendale, Hepplewhite and Sheraton had served as similar inspiration to furniture makers a century or more earlier.

Cavetto

Concave moulding, comprising a quarter circle when viewed in profile. In architecture and furniture alike, it is usually a component of a more elaborate cornice, providing a transition from the vertical to the horizontal of the uppermost element.

Chaise

French term for chair, meaning most types other than those with arms, which are known by the word *fauteuil*.

Chamfer

Term for smoothed-off edge or bevelled angle. It is a decorative effect achieved by carving away the corner of a square member at a 45-degree angle.

Chevron

Ornamentation achieved by arrangement of reeding, fluting or inlay at acute angles to form V-shaped motifs along a band or border.

Chip-carving

Shallow carved ornament, usually of geometrical patterns, drawn with mathematical instruments and chipped out.

Chippendale Style

Furniture style connected with the drawings and publications of Thomas Chippendale the Elder (1718–1779), English cabinetmaker and designer. Particularly influential was his pattern book, *The Gentleman and Cabinet-Maker's Directory*, published in 1754. His designs fall into several categories, notably rococo, Chinese and Gothic. He also produced neoclassical work in the style of Robert Adam. Among Chippendale elements incorporated in the works of country furniture makers in Canada were the cut-corner panel, the scrolled broken-arch pediment, the square- or chamfered-leg table and the splat-back chair.

Cleat

A wooden member, either pinned, nailed or dovetailed at right angles to strengthen or secure butt-joined or tongue-and-groove board surfaces as in tabletops, desk lids and the like.

Cock-beading

Small, half-rounded projecting moulding applied to the edges of drawers, doors, or along the profile of case furniture. In earlier furniture, the raised edge is not applied but rather produced by carving away the adjacent surface, leaving a decorative moulding.

Colonette

A miniature column, circular or quadrangular, which may reproduce on a small scale the characteristics of one of the classical orders of large architectural columns.

Console Table

A side table fixed to the wall and supported by brackets usually carved in scroll form, or by legs only at the front. The console table, frequently gilded or otherwise formally enriched, is generally counted in the elevated category of aristocratic or ecclesiastical furnishings, serving only as a distant inspiration for the occasional simplified country counterpart.

Corner Cupboard

A free-standing, built-in or hanging cupboard made to fit the corner of the room. In the British Isles, corner cupboards in parlours were generally slender and of tall proportion, finely constructed to serve as display cabinets. The form in Canada often functioned also as a kitchen piece, for both storage and display of utilitarian wares. The hanging cupboard, found in many cultures, was especially popular in Mennonite homes of Western Canada, where it typically rested on a shelf placed on dado wall-mouldings.

Cornice

The uppermost member of entablature, the cornice is the moulded projection surmounting the frieze of an architectural or furniture facade.

Cove Moulding

A large concave moulding placed beneath the cornice of a cupboard or other piece of case furniture, normally at the juncture of the projection and the frieze.

Crest Rail

The upper horizontal rail of a chair or bench, connected at each end to the back posts. The crest rail is sometimes decorated by carved or painted embellishment of its front surface and sometimes by variations in shape or profile.

Cresting

Decorated top-rail of the back of a chair or sofa, but more characteristically the decorated top-piece of a cabinet, usually carved or pierced.

Cricket Table

A small, plain three-legged table, suitable for many purposes, and easily placed on uneven floors by virtue of its stable arrangement of supports. Such tables, common in the British Isles, are found occasionally in Anglo-American settlements in Ontario and the Atlantic Provinces.

Crockets

Hook-shaped leaf ornaments on the angles of pinnacles and canopies in Gothic architecture and furniture.

Crosier

A foliated scroll terminating in the form of a crosier; alternatively, an armrest ending in a spiral. The device is sometimes used in the decoration of arms on Quebec chairs and *banc-lits*.

Crotch-grained

Grain accomplished by cutting with the intersection (or crotch) of a tree's major limbs. The use of crotch-grained solid woods or veneers was reserved for high-style furniture in which such selected materials were commensurate with the substantial expense of a particular piece.

Cupboard

Originally a "board for cups;" later a generic term for all receptacles fitted with doors, whose functions became increasingly diverse. The term can refer to any storage unit for dishware, utensils, books, clothing or valued possessions.

Cyma

A curve which reverses itself, hence a double-curved detail, usually as the profile of a moulding. In furniture the cyma curve was particularly emphasized in classical-revival designs, found variously in the shape of legs, mouldings, scrolled pilasters or drawer fronts. On mouldings, it is defined as either *cyma recta* (when the concave section is at the top) or *cyma reversa* (when the convex section is above).

Deal

A general term for soft wood, usually pine or fir, sawed into board form.

Dentil

Moulding of small rectangular blocks arranged horizontally in series on architectural cornices. This decorative device, comprised of "teeth" with spaces between, is used also beneath the projections of furniture.

Dish Dresser

A type of cabinet with open shelves above for the display of dishes and with cupboards or drawers below. Versions were made in many countries, perpetuated in French Canada as the *vaisselier*, and in areas settled by immigrants from the British Isles as open dish-dressers. Unlike the buffet, the dresser was a kitchen piece.

Dovetail

Wedge-shaped tenon which fits into a corresponding mortise to join two pieces of wood at right angles. Dovetail joinery is the work of capable furniture makers, as opposed to at-home carpenters who ordinarily made simpler furniture with pieces butted together.

Dowel

A wooden peg used to join two pieces of wood; often used in place of mortise and tenon in machine-made furniture. Dowels were frequently used to peg legs and aprons, or stiles used to frame door panels.

Dower Chest, Dowry Chest

A chest made to commemorate or anticipate a wedding, usually incorporating names and dates in its decoration. The form derived from the custom of the bride bringing her belongings (dowry) to the wedding in a chest.

Draw Table

An extending table with the top divided into three leaves, those at each end sliding under the centre leaf when the table is closed; when open, the centre leaf occupies the space left by drawing out the leaves.

Dry Sink

A recessed tray, usually above a closed cupboard, to contain pans for dishwashing. In Canada the dry sink is particularly associated with Germanic settlements in Ontario.

Eastlake Style

Named after Charles Locke Eastlake (1836–1906), furniture designer, who advocated a return to simple, joined construction. His book *Hints on Household Taste in Furniture, Upholstery and Other Details* (1868) was intended as a manual by which medieval English and Jacobean forms could be translated for middle-class homes of the Industrial Age.

Ebéniste

Originally referring to sophisticated artisans who made luxury furniture, *ébénistes* were 17th- and 18th-century specialists in the art of veneering with ebony, a heavy, black, African wood. While this rank of guild worker was not found among the makers of simpler, country furniture, there were furniture makers who simulated inlaid ebony veneers through the use of black paint.

Ebonized

Stained black to imitate ebony, an economical substitution for the earlier French practice of costly veneering with ebony wood. In Canada, ebonizing of furniture details was especially popular among German Ontario cabinetmakers.

Empire

The style created by furniture makers and decorators during the first French Empire (1804–1814). Its English equivalent was the Regency style. Designs from this period incorporated Greek and Roman motifs, as well as Egyptian themes following Napoleon's military expedition to Egypt in 1798. Canadian furniture after 1825 drew from the ponderous American Empire style, reflected in such details as neoclassical inlay design, massive columns and ogee curves on drawer fronts, feet and pilasters.

Entablature

The horizontal upper part of an order of architecture supported by columns and consisting of an architrave, frieze and cornice. The architectural orders are traditionally comprised of column and entablature arrangements forming the basis of the five classical styles of architecture.

Entrelacs

A continuous ornament formed of interlacing curved motifs or interlocking circles. The term *entrelacs* is used primarily in the context of French furniture, and is similar in form to the *guilloche*.

Escutcheon

The fitting over a keyhole or back of a handle, made of various materials, the most popular being metal, bone or ivory. Escutcheons are decorative as well as functional, varying in degrees of complexity with the costliness of the furniture.

Fauteuil

French term for a chair with arms.

Fauteuil à la bonne femme

Literally, a grandmother's armchair, this Continental French chair was made in several styles. When fitted with double-curved horizontal slats between the back posts, it was known as the *fauteuil à la capucine*, and is related to the Canadian chair of the same name, but without the profusion of chamfered cubes on the front legs and back posts.

Fancy Chair

A family of chairs made in America influenced by the delicate painted chairs of the Sheraton period. Usually of neoclassical style, painted and decorated with striping and stencils. The form was made especially popular when such chairs were manufactured on a large scale by firms such as the Hitchcock Chair Factory in New England.

Feather Painting

A technique of furniture decoration involving the use of a feather to create linear patterns, often imitating wood grain over a contrasting undercoat.

Federal Period

The classical style in the United States which coincided with the rise of Federal government (1789 to circa 1820). Prominent elements include the elliptical fanlight and free-standing classical portico in domestic architecture, while in furniture design it combined English and French classical-revival themes in a renewed emphasis on inlaid or carved neoclassical motifs and also on the robust rectilinear profile.

Festoon

Identical and regularly repeated motifs (sometimes called swags), most common examples being garlands of fruit or flowers suspended so as to produce a pattern of end-to-end shallow curves.

Fiche

The term refers to a type of hinge used on armoires and some other case pieces. The *fiche* hinge is comprised of a centre pin, at either end of which is placed a forged or wrought tenon, one attached to the door, the other to the stile of the carcase. This arrangement, in some variations, permits the removal of the door by lifting it off the part of the hinge mounted on the case.

Finial

Decorative knob ornament of various shaping, used architecturally as a focal point between halves of a scrolled pediment on a canopy or gable. In furniture it could perform a similarly prominent role as a part of the crown of a tall clock or cabinet, or service more modestly as the upper end of chair posts or as the juncture of table stretchers.

Flemish Scroll

Double scroll, as in the carving of front legs and stretchers in late 17th-century English chairs. It is a form of the ogee or cyma curve.

Fluting

Concave grooves used particularly on friezes and columns. In furniture, fluting was part of the neoclassical embellishment of late 18th-century domestic design, gradually giving way to a preference for reeding as a means of furniture ornamentation in the early 19th century.

Foliated Scroll

Decoration of flowers and foliage which interlace and run into one another, a form of Romanesque architectural ornament transferred to the enhancement of stately furniture in the Renaissance and following stylistic periods.

French Foot

Curved foot similar in basic shape to the cabriole leg. The French effect is achieved by the graceful flaring of the bracket foot outwards from the piece which it supports.

Fret

Decorative pattern, either perforated or in solid, or a continuous ornament formed of broken lines. In its neoclassical manifestation, fretwork was typically based on the key pattern or meander from Greek architecture. In later times it came to mean virtually any kind of decorative work cut through the framework or crown of a cupboard or other piece of furniture.

Frieze

In architecture, the frieze is the middle section of an entablature, situated horizontally between the cornice above and architrave below. In furniture, it normally refers to the outward-facing horizontal section below tabletops and cornices of cabinets.

Glazing Bars

The narrow wooden members in windows or the doors of a cupboard which frame the glass panes. Glazing may use flat bars or stepped-up counterparts shaped by means of moulding planes.

Gothic

A revival of taste for medieval architecture begun in the middle years of the 18th century. In furniture, the Gothic taste may be expressed simply by means of pointed arches, or more elaborately by inclusion of Gothic geometric decoration (trefoils, quatrefoils and the like), linen-fold panels, crockets and other carved details.

Greek Key

Classical frieze ornament of repeated patterns of lines at right angles to one another, otherwise known as a meander.

Guéridon

A small portable stand for lamp or candlestick, also known as *torchère*. Early versions had human or animal figures as a central standard, while later forms were simpler and lighter, coming more to resemble tripods from antiquity.

Guilloche

Ornamentation consisting of bands of interlaced circles or ovals. The pattern is a repeating one, with lines passing over and under one another alternately. A design used widely in ancient Celtic decorative arts, the style was used in architecture and furniture design after the Renaissance. In Canada the *guilloche* was used in varied forms on some French-Canadian furniture, on chairs made in Anglo-American communities, and on clothes cupboards in Alsatian settlements of Southern Ontario.

Gulbishche

A traceried balcony found on a Russian home, its balusters elaborately shaped to produce a decorative effect of repeating motifs. Simpler counterparts were made in Doukhobor communities of Western Canada.

Hepplewhite Style

Furniture style associated with the publications of George Hepplewhite (d. 1786), English cabinetmaker and designer. His *The Cabinet-Maker and Upholsterer's Guide* (1788) can be seen as a popularization of the more ponderous neoclassical designs of Robert Adam. The tapered square leg, the block (Marlboro') foot, and the shield-back chair are recognizable trademarks of the Hepplewhite style.

Inlay

Decorative pattern composed of contrasting woods set into the solid wood of a piece of furniture, as distinct from marquetry, which is veneered decoration.

Izba

Traditional Russian country house or cottage. The Russian peasant's *izba* was often given to extensive decoration, particularly in traceried balconies or carved barge-boards and window casings.

Japanning

European or American varnished decoration in imitation of Oriental lacquer, on wood, metal or papier-mâché. In Canada the technique was only faintly hinted at by painted decoration.

Kiste

German word for chest (an alternative word is *Truhe*), meaning a storage trunk with a hinged lid, and sometimes fitted also with drawers. Such trunks served general storage purposes, but were also frequently used for the keeping of the dowry, the possessions the bride would take into marriage.

Kleiderschrank

In German, a clothes cupboard, with an upper section with pegs for hanging items, and a lower section with drawers for flat storage of bedding and other articles. The term is frequently shortened in common parlance to *Schrank*, which is a non-specific term for a cupboard of any kind.

Klismos

Type of chair with inward-curving sabre-shaped legs, first developed in ancient Greece and revived in the late 18th century. A design invented by Greek designers about the 6th century B.C., it has concave legs which splay outward with uprights crossed by a shallow concave backrest. Made in various forms within the English Regency and French Directoire styles, it was taken up in the American Empire style of the early 19th century. Canadian manifestations are probably of both English and French derivation, in the form made in the Atlantic Provinces, Quebec and Ontario, and even late interpretations in early 20th-century Western Canadian chairs made in Mennonite, Hutterite, Ukrainian and Doukhobor communities.

Kommode

German word for chest of drawers; related words are *Kommod* (Russian) and *commode* (French).

Kredens

Polish dish-dresser, either of the open or glazed-door type. Both forms were made in the Wilno district of Eastern Ontario, typically with traditional baroque-style cornices; many are believed to be the work of furniture maker John Kozloski.

Lamb's Tongue

A simple stop detail for a chamfered corner which follows a cyma curve from the full width of the chamfer to the point of the right angle, resembling a tongue shape.

Lapped, Lipped

Doors and drawers which overlap the frame, usually with a moulded edge.

Loudon, J.C.

Known initially for his ideas on gardening, and the advocacy of the picturesque landscape ideal through his various publications, John Claudius Loudon (1783–1843) broadened his interests in later years to include architecture and furnishings. In his *Encyclopedia of Cottage, Farm and Village Architecture and Furniture* (1842), he promoted designs which would suit Victorian middle-class taste and affordability.

Louis Styles

From the early 17th to the late 18th century there was a series of styles in architecture and furniture associated more or less with the ranks of Louis XIII, Louis XIV, Louis XV and Louis XVI. The Louis XIII style was a sober one, emphasizing the rectilinear, while it was followed by the grandly and grandiosely sumptuous tastes of the nobility of the Louis XIV period; with the Louis XV style came an atmosphere more lyrical in sensibility, and a movement away from the rectilinear toward curving, flowing lines (seen especially in the cabriole leg, popular in this period); yet another shift in taste occurred with the return to the more rectilinear and classical (though less pompous than the XIV style), inspired greatly by archaeological excavations at Pompeii and Herculaneum. These styles were largely determinative of French-Canadian furniture types made from the late 17th through the late 18th centuries.

Lozenge

Diamond-shaped panel decoration. In French-Canadian furniture, a distinction is made between diamond-point panelling and lozenge panelling. In the former, the panel is pointed and executed in high relief, with facets resembling those of a diamond; in the latter, the lozenge does not project, but rather is the shape produced by a groove cut in the panel. In other Canadian country furniture, the term lozenge is used simply to suggest a diamond shape, whether carved, incised, applied or painted on a facade.

Marbling, Marbleizing

Descriptive term for the painting of wood to imitate the colour and characteristics of various marbles. Possibly of Persian origins, the technique found its way into Europe in the late 16th century, where it was used widely in the decoration of both domestic and church interiors, and eventually in the painting of furniture and even in the embellishment of endpapers of books. Canadian examples include painted cupboard-panels and tabletops as well as wainscotting and fireplace mantels.

Marquetry

The decoration of veneered furniture with pictorial, floral or geometric designs cut from sheets of contrasting wood veneers and sometimes incorporating slivers of ivory, mother-of-pearl or other materials; a process by which designs are cut into a veneer and various woods and materials are then inlaid, so that veneer and inlaid ornamental pattern form one thin sheet.

Menusier

In France and French Canada, *menusiers* were highly competent woodworkers who were capable of all manner of furniture assembly, notably the making and joining of pieces by mortise-and-tenon method, as well as possessing skills in dovetailing, turning and carving. They did not, as a rule, undertake the more formal means of cabinetmaking used by *ébénistes*, that is, ebonizing, veneering, parquetry and metal-working.

Mortise

Slot in a post or other member which accepts the tenon of the piece to be joined to it. The mortise is the socket into which is fitted the tenon.

Mullion

see Glazing Bars

Nalichniki

Window frames on Russian country houses, frequently of high ornamental character. Elaborate versions resemble portals with their scrolled pediments, frequently given to a profusion of carved and painted detail. Simpler frames and lintels were embellished with carved sun-motifs, a detail sometimes found in Doukhobor houses in Western Canada.

Neoclassical

The design style dominating architecture, painting and furniture in Europe and America from the second half of the 18th century. The reappropriation of Greek and Roman decorative motifs was encouraged by literary studies as well as archaeological excavations at Herculaneum, Paestum and Pompeii between 1738 and 1756 and the publication of various pictorial studies. Neoclassicism was expressed variously in France as Louis XVI, Régence, Directoire and Empire, while in England it was known as Regency. It came to America and Canada through various means — through French Empire styles in Quebec, and through followers of the traditions of Adam, Hepplewhite and Sheraton in English regions. Some neoclassical themes are found even in late 19th- and early 20th-century East European settlements in Western Canada, where such English and French styles had travelled East on earlier occasion, only to be brought West by immigrants after 1874.

Ovolo

Concave moulding which, seen in profile, forms a quarter circle. It is placed in architecture and furniture between the projecting cornice and upright entablature. Known also in furniture terminology as a "quarter round," it imparts sculptural fullness at the meeting place of vertical and horizontal elements, in contrast to the receding nature of *cavetto* moulding.

Ormolu

Meaning gold leaf, it is the name of the process by which furniture was given greater visual luxuriance by means of mounts fashioned from the more expensive metal, or, in imitation, made of cast bronze. Achieving its highest expression in costly furniture of the French court, ormolu was made more affordable by the substitution of cheaper metals elsewhere. Some Western Canadian Ukrainian furniture is ornamented with gold paint, suggesting the attempt to emulate by means of products from the hardware store that which originally came from the goldsmith.

Palmette

Fan-shaped decoration based upon the Egyptian lotus-motif, with a large central leaf and smaller flanking ones. The palmette was one of the many elements from antiquity which was given new popularity in the classical revival of the later 18th and early 19th centuries.

Parquetry

The inlaying of veneers in geometric patterns as distinct from the floral and figurative designs of marquetry with which it is sometimes used.

Paterae

A composition (the singular is *patera*) of circular or oval ornamental disks or rosettes, sometimes in association with floral and leaf ornament, a neoclassical motif brought to North America from English and French sources. The design appears in furniture decoration as a device which is sometimes inlaid, applied or painted.

Pediment

Derived from an architectural source, consisting of a gable placed over a portico, the pediment is used in classically inspired furniture as a crown on cupboards and other large case pieces. Pediments may be closed or open — closed when the diagonal or scrolled members meet at the apex; open when they stop short, leaving a central opening in which is frequently placed a finial or other focal ornament.

Peg-top Table

A table on which the top is secured to the base by removable pegs through the supporting cleats. A popular and highly sensible feature which prevents warpage while securing the table during use, and permits the top to be taken away for cleaning.

Pilaster

A flat pier applied to an architectural or furniture facade, providing in profile the suggestion of a column with base (plinth), shaft, capital and entablature.

Plinth

Base of a column, pier or pilaster. Its upper edges are sometimes chamfered, rounded or tapered at front and sides.

Press

A word of medieval origin, generally applied to tall cupboards with doors and shelves for storing linen, clothes and kitchen utensils. The term, an old word for cupboard, continues in use in rural areas of Ireland. In Canada the word retains only restricted usage, referring principally to clothes storage cupboards with drawers below and doors above.

Prince of Wales Feathers

A decorative motif based on the three ostrich plumes that form the crest of the Prince of Wales. The motif was widely employed by Hepplewhite as a design for chair backs, and found its way to North America at the end of the 18th century. Its survival in English Canada reflects sustained cultural connections between Canada (British North America) and England.

Quarter Column

Plain or elaborated column, cut from the round so that seen in profile it comprises a quarter of a circle. On furniture, quarter columns are frequently set into the vertical corners of case pieces to disguise joinery and provide a more graceful meeting of front and sides. At other times, quarter columns may be placed horizontally beneath the projecting cornice on the entablature of cupboards, functioning as ovolo mouldings.

Queen Anne Style

A term used to describe the architecture and furniture made during the first two decades of the 18th century, which included the reign of Queen Anne (1702–1714). Emphasis was less upon sumptuous of decorative detail and more upon gracefulness of line, notably in the detail of the cabriole leg and preference for the gently curvilinear profile.

Rail

The horizontal members in panelled construction of doors or sections of case furniture. The term refers also to the horizontal members of a chair back or table frame.

Ramka

Russian word for frame, used variously for pictures or mirrors (the German equivalent is *Rahmen*). In Western Canada, elaborately carved frames are among the most highly decorated of furnishings made in Doukhobor communities.

Rat-tail Hinge

Two-part structure in which the support element is forged as a curved bracket with a pointed end and is applied to the face of a cupboard. The other element, attached to the door, rests upon the former, allowing the door to be removed by lifting it upwards from the support.

Rebate, Rabbet

Rectangular recess cut to receive a corresponding section in the frame of a piece of furniture. A rebate (or rabbet) is frequently a groove into which is inserted a tongue or an edge of a corresponding piece.

Reeding

Decorative feature, applied usually to pilasters in architecture or furniture, or stiles flanking cupboard doors, consisting of a band of parallel convex mouldings. Reeding is a reversal of the phenomenon of fluting, which is comprised of parallel concave channels.

Régence

Stylistically, the term Régence is usually extended to cover the final years of Louis XIV and the early years of Louis XV— approximately 1700–35. (The literal period of regency, in which Phillipe, Duke of Orleans, presided during the childhood of Louis XV, is defined by the dates 1715–23.) During this time, the massive sumptuousness of the Baroque was yielding gradually to the lighter elegance of the rococo.

Regency Style

Description used for furniture fashionable in England when George, Prince of Wales, was Regent for his father, George III, from 1811 to 1820. Partially derived from Greek revival, classical and Egyptian ornament, the style spread from England to America. In its fully developed form, the Regency style represents an increasingly opulent expression of classicism. In furniture style, this development was seen in the use of animal forms as supports and forms of elaboration.

Reliquary

A receptacle for religious relics. Because relics of saints and martyrs were generally the possession of churches and not individuals, reliquaries are more properly restricted to the category of ecclesiastical furnishings. The term has frequently been used to describe domestic cupboards and shelves used in the home, a misinterpretation of their function, which was not to house relics but rather to store or display holy pictures, religious sculptures or other accessories used for home devotions.

Renaissance

The revival of interest in the learning, art and architecture of Greco-Roman civilization that began in 15th-century Italy, reaching England in the 16th century, with a marked effect on architectural design, and, in corollary fashion, furniture and applied arts.

Rococo

As an alternative to the severity of classicism, the rococo style represented greater informality and freedom of composition. Sinuous lines came to dominate architecture and furniture design, reflected in the popular use of series of C- and S-scrolls. A variably abstract motif vaguely suggestive of a shell and known as *rocaille* was a familiar device in rococo ornament. In furniture, the S-shaped curve was seen in the outline of commodes and the shape of legs, frequently rendered in cabriole form.

Roundel

A decorative device which is circular in shape. The term is generally applied to carved ornament that occupies a circular space, and includes *paterae*, plaques and medallions with traditional geometric motifs.

Sabre Leg

A concave chair-leg of rectangular section that resembles the curve of a cavalry sabre, and based on the ancient *klismos* chair used in Greece from the 6th century B.C. The form was widely used in chairs of neoclassical design made in Europe and countries receiving European immigrants in the late 18th and early 19th centuries.

Sawbuck Table

A traditional design in which the table top is supported on X-shaped trestles at both ends.

Serpentine Front

Curved shape, convex at the centre and concave at the sides, used for chest and table furniture in the 18th century.

Settle Bed

A bench with back and arms, and a hinged boxlike seat which can be folded forward to make a bed. The settle bed is a good example of space-saving furniture, usable by day for sitting and by night for sleeping. In French Canada, the settle bed is known as a *banc-lit*.

Sheraton Style

Furniture style associated with Thomas Sheraton (1751–1806), English cabinetmaker and designer. His several publications advertised tasteful furniture made either of fine woods (mahogany, satinwood) or given decorative interest by means of painting. His *The Cabinet-Maker and Upholsterer's Drawing Book* (issued in four parts, from 1791 to 1794) was highly influential, and widely used by furniture makers in Britain and America. His later designs showed the increasingly heavy influences of the French Directoire and Empire styles, and lead toward the neoclassical Regency taste in England and Canada.

Shoe Foot

A shaped horizontal element used to raise chests or cupboards from the floor. Catherine Parr Traill, in her advice to settlers in Canada, describes their function as keeping furniture dry by lifting it off the damp ground, a significant consideration in the case of first-generation dwellings, which had earthen floors.

Skamya

A long bench with an open back and frame or cut from the solid, made throughout many regions of Russia and Ukraine, and a popular seating-form among Doukhobors and Ukrainians in Western Canada.

Skat

Storage cupboard in Russian homes, often taking the form of a wardrobe. It was made in Ukrainian and Doukhobor settlements in Canada's Western provinces. It came to replace the trunk for the storage of bedding and other articles.

Skirt

A horizontal strip of wood below the lowest member of the framework of a chest, cabinet or table. Skirts were usually plain, but sometimes given decorative interest by means of scrolled or scalloped profiles.

Skryzynia

A storage chest made in Poland and, later, in the Polish-speaking community in Renfrew County in Ontario. The traditional Polish chest with hinged lid, frequently enhanced by means of painted floral decoration, was made in considerable quantity in the Wilno area.

Smoke-graining

A decorative technique achieved by passing a lighted candle over partially dry varnish applied to an undercoat of light paint.

Splat

Central vertical member of a chair back, often a vehicle for decoration, either in profile or in fretwork carving.

Spline

A flat key or strip of wood fitting into lengthwise grooves to join boards, as in a tabletop. Splines slotted against the grain serve as braces to prevent warping of boards.

Stile

The stile is the vertical member of a frame enclosing a door panel, or of a case piece, joined by horizontal rails.

Stol

Polish term for table. The typical Ontario-Polish form had a cleated top pegged to an elongated frame, usually fitted with a side drawer.

Stretcher

Horizontal reinforcing member or underbrace at the base of a chair or table. Intersecting, centrally connecting or set at right angles to legs, they are known as X-stretchers, medial stretchers or box stretchers, respectively.

Stringing

Thin line of wood or metal used as a decorative border in furniture.

Súgán

The Irish word *súgán* refers to twisted straw or hay rope, and is applied as a furniture term to chairs with woven rope seats. In Ireland, the use of rope instead of wood was necessitated by the severe shortage of timber. Such chairs have been found in Irish settlements of Canada's Atlantic Provinces as well as in the Acadian communities of New Brunswick and Cape Breton in Nova Scotia.

Sunduk

Russian word for storage trunk, generally with handles at both ends and fitted with hinged lid. Such trunks, or *sunduki*, served as a means of carrying possessions during Doukhobor immigration to Canada, and for storing a wide range of items in the households of the first generations of settlers in Saskatchewan and British Columbia.

Szafa

A free-standing wardrobe or clothes cupboard made in Poland, and a form continued in the Polish community in Eastern Ontario.

Tambour Front, Tambour Door

Strips of wood glued to a canvas backing and used for desk tops or shutters, permitting a flexible door or pair of doors to be opened along a track and turned in along the inside of the compartment.

Tenon

Tongue-piece in a joint, which fits into a mortise or an opening in a post or other member.

Tongue-and-groove

A joint of two boards made by slotting the edge of one and narrowing the edge of the other to fit into it. While the technique was known in medieval furniture and architecture, it was again made popular by mass production of finished board-timber in the late 19th century, at which time it was widely used in furniture construction, flooring and wainscotting.

Torchère

Small portable stand for lamp or candlestick, also known as a *guéridon*.

Trestle

Connecting and stabilizing supports for tables.

Trompe l'oeil

An effect of optical illusion, in painting or inlaid decoration, meaning, literally, deceive the eye. Such techniques in painting were highly developed in late antiquity, notably at Pompeii, where the painted image takes on the impression of three-dimensional reality. In furniture *trompe l'oeil* devices are seen as the simulation of columns and pilasters or imitation of marble by means of painting technique.

Turnings

Lathe-finished members such as legs, posts, stretchers, balusters and spindles, often to give decorative treatment (for example spiral-, ball-, or bobbin-turning).

Truhe

see *Kiste*

Uzorochye

An ancient Russian word denoting anything which is decorated by means of rich patterning.

Vitruvian Scrolls

Wavelike patterns of convoluted scrolls on borders and friezes, used in architecture and on formal furniture of neoclassical design.

Wainscot

A word of Dutch origin (*wagenschot*) meaning wagon wood, that is, oak. It was eventually used to describe oak furniture of solid, panelled construction, as in wainscot bed or wainscot chair, as well as for the lower panelling of rooms.

Windsor Chair

A generic name for chairs and seats of stick construction with turned spindles socketed into solid wooden seats to form backs, legs and arms. Such chairs are sometimes known by the designations stick-back or spindle-back. Variations of Windsor chairs include high-back and low-back, hoop-back (curved top) and comb-back (straight top in the shape of a comb). In England the centre of the Windsor-chair industry was Buckinghamshire, but many regional variations were made concurrently. Early American Windsor chairs were produced in Philadelphia and in the New England states, from where they found their way into Eastern Canada at the end of the 18th century.

Zlaban

Polish word for settle bed, meaning literally sleep-bench. The form consisted of a bench which could be enlarged for sleeping. The front is constructed in such a way as to permit it to be pulled forward, making a double bed, usable for children or visitors.

Zydel

Polish term for chair, of which some distinctive examples have survived in the Wilno area of Ontario and in Polish settlements in Eastern Saskatchewan.

ACKNOWLEDGMENTS

How many months and miles ago was it that an innocent suggestion became an obsession? The thought of writing a book on Canadian country furniture has a certain outlandish dimension, given a geographical span of more than 4,000 miles and the existence of many cultural and linguistic variations. One of the most extraordinary images remembered from this experience is that of having looked at Canadian kitchen cupboards in homes overlooking both the Atlantic and Pacific oceans. True, I could have (and did) choose to allocate three-month time-blocks for this region or that, and make repeated visits to follow through on enquiries frequently begun but not completed on the first occasion, but solo enterprise could hardly meet the daunting challenges posed. Instead, what accomplishment can be claimed must be credited to the hundreds of people visited, whose generosity of intellectual and physical assistance earns them the well-deserved title of invisible co-authors.

There is a group of individuals whose scholarly help is most deeply appreciated. In Canada, I am very grateful to several established writers on the subject of furniture who have so generously provided the benefit of their intelligent insights, the use of photographs, further direction to places and persons, and generous endorsement of my efforts. Notable among these are Barbara and Henry Dobson, whose exhibitions and handsome publications have opened our eyes to the extraordinary beauty of early furniture in Eastern Canada. Howard Pain, who produced the definitive volume on Ontario furniture, has kindly provided the foreword to this book, while Donald B. Webster, Director of the Royal Ontario Museum's Canadiana Department and editor of Canada's "big book" of furnishings and antiques, has been very kind through assistance given in our discussions and putting me in touch with important private collections. In Europe I had the particular good fortune to be assisted by Georges Klein, Director of the Alsatian Museum in Strasbourg. I am also grateful to have been a repeated guest in the home of Dr. Siegfried de Rachewiltz, Director of the Landesmuseum Schloss Tirol at Brunnenberg. On numerous visits to Great Britain,

Dr. James Ayres has long been marvellously kind to me, in having me as guest in his home, as well as being an intellectual friend in the discussion of many aspects of the materials and contexts of artistic process. Claudia Kinmonth, who attended one of my lectures in England and enriched my understanding of aspects of country furniture shared by several cultures, has since published her magnificent study of Irish vernacular furniture and has been so kind as to write the introduction to this book.

Finally, I would like to thank Noel Hudson and John Denison at Boston Mills Press; Kathleen Fraser, editor; Andrew Smith, designer; and the staff at Boston Mills for their enthusiastic and unflagging help in getting the dog-eared pages into book form.

INDIVIDUALS

Many, many are those who have helped by means of sharing their collections and well-developed insights, or just the right comment, which sometimes opened new investigative possibilities or undermined casual assumptions. Among these are Alan Abraham, Zalman Amit and Ann Sutherland, Lindsay and Lenore Anderson, Peter and Lindsay Baker, Fred Baur, Peter and Maggie Bell, Danielle and Jean-Marc Belzile, Clay and Carole Benson, Douglas and Bonnie Bentham, James Bisback, Peter and Janice Bisback, Jan and Maureen Bos, Rick Bowerman and Joanne Bennett, John and Diane Brisley, Rod and Aggie Brook, Larry and Ruby Buechler, Susan Burke, Valerie and Scott Burkett, Bill and Caroline Byfield, Ron and Wendy Cascaden, Alan Clairman, Pauline and Jowe Creighton, Holly and John Curtiss, Richard and Wendy Davis, Peter deJong, Pascal and Angela Dinaut, Barbara and Henry Dobson, Bill Dobson and Linda Hind, Ken and Ginny Douglas, Chris Edgar, Gerald and Marlene Fagan, Jeff Ferguson, David and MaryJo Field, John and Vikki Forbes, Sean and Terry Fuller, Richard Fulton, Cecile Gallant, Jean and Gervais Goodman, Hugh Gough, Greg and Cathy Griffith, Peter Gritchin, Gary and Dale Guyette, Isabelle Hambleton, John and Heather Harbinson, Chuck and Robin Hayes, Gary Hughes, Norma and Jim Hiscock, Linda Howard and William Troy, Chris Huntington and Charlotte McGill, Ed Iwanchuk, Isabelle Jones, Johnny Kalisch, David and Marie Kaufman, Peter Kertesz, Paul Killawee and Judy Aymar, Brian Knapp, Dino Kritikos, Robert

Kursky, Jean-Louis Laloy, Peter and Gail Land, Leslie Langille, William and Barbara Leask, Paul Legris, Marianne Letasi, Wayne Lintack, Geraldine Lowe, Mr. and Mrs. Jim MacLeod, Paul Madaule, Janet Marsh, Gerald and Sharon Mason, David and Sue McKee, Chris and Gordon McNish, Ron and Sandi Mielitz, Jim and Marlene Miller, Reg and Pat Moore, Dwayne and Nina Morberg, Bev Morrison, Jo Mott, Alain and Loreen Nowack, Shane and Marie O'Day, Ron and Rose O'Hara, Robert and June O'Neill, Howard and Marlene Pain, Walter and Sally Peddle, Jim and Pat Pesandro, Sue Pasquale, Tim and Gerta Potter, Ralph and Patricia Price, Matt and Ray Probick, Andy Rathbone, James and Margaret Reimer, Judy and Earl Rhodenizer, Frances Roback, Wayne and Gloria Ross, Lloyd and Brenda Ryder, Peter and Margaret Seitl, Nettie Sharpe, Mr. and Mrs. Stan Sherstibitoff, John Silver, Jim and Louise Shockey, Paul and Cheryl Smith, Warren Snider, Jim and Susan Snowden, Mike and Dorothy Speer, Jamie Stalker, Ruth Stalker, Mr. and Mrs. Peter Stanley, Robert and Brenda Starr, Murray Stewart and June Miller, Doug Stocks, Jean-Claude Sussini, Gail Syvverson, Koozma Tarasoff, Dennis Teakle, Fred Timishenko, Martha Todd, Margery Toner, Lynne Van Schyndal and Gabriel LaChapelle, Peter and Helen Vernon, Jerry and Deborah Vidito, Terrance and Lois Walker, Sandra Morton Weiss, Susan Whitney, Greg Williams, Ted and Peggy Williams, John and ElizabethWilman, John Wine, Joyce Wright, William Yeager and others who wish to retain their anonymity. I would like to express my tremendous gratitude to Ron Mielitz, who so magnanimously acted as chauffeur in Quebec and the Western Provinces, continually making on-site repairs to his vintage Honda Prelude in order to get us to the next destination. If the current book were to produce a novelistic sequel, it would probably take the form of an adventure-thriller with the title *Travels With Ron*.

AND TO SUSAN

In expressing my gratitude to my overwhelmingly supportive wife, Susan Hyde, I wish to make a clear break with those credits which refer to spouses as "patient" or "understanding." There is something a little too lifeless in that kind of praise, and hardly descriptive of the present situation: far from the image of the patient endurer has been Susan's far more intelligent role as one who continually engages me in vigorous discussion of themes, premises, motivations and aesthetic issues. It has been a continual source of happiness to have Susan there, trekking to places far and wide (is there a valley in Nova Scotia we did not visit together?), and for her active role in interviewing, measuring, documenting and analysing items in museums, private collections and in their original domestic settings. For your role as morale-booster, energizer, intellectual inspirer and kindred spirit, I thank you, Susan. It is a pleasure to know that this book has been possible because of the boundless support of a constant friend.

MUSEUMS AND OTHER INSTITUTIONS

Art Gallery of Nova Scotia, Halifax, Nova Scotia
Black Creek Pioneer Village, Toronto, Ontario
Canada House, London, England
Canadian Museum of Civilization, Hull, Quebec
DesBrisay Museum, Nova Scotia
Detroit Institute of Arts, Detroit, Michigan
Doon Heritage Crossroads, Kitchener, Ontario
Glenbow Museum, Calgary, Alberta
Jordan Museum of The Twenty, Jordan, Ontario
Joseph Scheider Haus Museum, Kitchener, Ontario
Kings Landing Historical Settlement, Kings Clear, New Brunswick
Kootenay Doukhobor Museum, Castlegar, British Columbia
Markham District Historical Museum, Markham, Ontario
Montreal Museum of Fine Arts, Montreal, Quebec
Mountainview Doukhobor Museum, Grand Forks, British Columbia
New Brunswick Museum, St. John, New Brunswick
Newfoundland Museum, St. John's, Newfoundland
Niagara Historical Society Museum, Niagara-on-the-Lake, Ontario
Nova Scotia Museum, Halifax, Nova Scotia
Randall House, Wolfville, Nova Scotia
Quebec Museum, Quebec
Royal Ontario Museum (Canadiana Department), Toronto, Ontario
Steinbach Mennonite Village, Steinbach, Manitoba
Upper Canada Village, Morrisburg, Ontario
Verigen Museum, Verigen, Saskatchewan

BIBLIOGRAPHY

History

Brown, Craig, ed. *The Illustrated History of Canada*. Toronto: Lester and Orpen Denys, Ltd., 1987.

Bumstead, J.M., ed. *Canadian History Before Confederation: Essays and Interpretations*. Georgetown, Ont.: Irwin-Dorsey Limited, 1979.

Campbell, G.G. *A History of Nova Scotia*. Toronto: The Ryerson Press, 1948.

Clark, Andrew Hill. *Three Centuries and the Island: A Historical Geography of Settlement and Agriculture in Prince Edward Island, Canada*. Toronto: University of Toronto Press, 1959.

Cochrane, J.A. *The Story of Newfoundland*. Boston: Ginn and Company, 1938.

Cornell, Paul, Jean Hamelin, Fernand Ouellet, Marcel Trudel, and William Kilbourn. *Canada in Unity and Diversity*. Toronto: Holt, Rinehart and Winston, 1967.

Finlay, J.L. *Pre-Confederation Canada: The Structure of Canadian History to 1867*. Toronto: Prentice-Hall Canada, Inc., 1990.

Harvey, D.C. *The French Regime in Prince Edward Island*. New Haven: Yale University Press, 1926.

MacNutt, W.S. *The Atlantic Provinces: The Emergence of Colonial Society 1712–1857*. Toronto: McClelland and Stewart, 1965.

————. *New Brunswick: A History 1784–1867*. Toronto: Macmillan of Canada, 1963.

Makowski, William Boleslaus. *History and Integration of Poles in Canada*. Niagara Peninsula: The Canadian Polish Congress, 1967.

Marunchak, Michael H. *The Ukrainian Canadians: A History*. Winnipeg: Ukrainian Free Academy of Sciences, 1970.

Mika, Nik, and Helma Mika. *United Empire Loyalists: Pioneers of Upper Canada*. Belleville, Ont.: Mika Publishing Company, 1976.

Multiculturalism Directorate. *The Canadian Family Tree*. Don Mills, Ont.: Corpus, 1979.

O'Driscoll, Robert, and Lorna Reynolds, eds. *The Untold Story: The Irish in Canada*. 2 vols. Toronto: Celtic Arts of Canada, 1988.

Radecki, Henry, and Heydenkorn, Benedykt. *A Member of a Distinguished Family: The Polish Group in Canada*. Toronto: McClelland and Stewart, 1976.

Reid, W. Stanford, ed. *The Scottish Tradition in Canada*. Toronto: McClelland and Stewart, 1976.

Tarasoff, Koozma J. *A Pictorial History of the Doukhobors*. Saskatoon: The Western Producer, 1969.

————. *Plakun Trava: The Doukhobors*. Grand Forks, B.C.: Mir Publication Society, 1982.

Wade, Mason. *The French Canadians: 1780–1967*. 2 vols. Toronto: Macmillan of Canada, 1968.

Woodcock, George. *The Doukhobors of Canada*. Toronto: McClelland and Stewart, 1977.

Furniture

Baneat, Paul. *Le mobilier breton (ensembles et details)*. Paris: Ch. Massin et Cie, 1935.

Baraitser, Michael, and Obholzer, Anton. *Cape Country Furniture*. Cape Town, South Africa: M. Struik Publishers, 1982 (1978).

Bayard, Emile. *Les meubles rustiques regionaux de la France*. Paris: Garnier frères, 1925.

Bird, Michael. *All Things Common: Mennonite and Hutterite Traditional Arts*. London, England: Canada House, Ministry of Foreign Affairs, 1992.

————. *Beyond Survival: Ontario-German Decorative Arts in the Queen's Bush*. Bruce County Museum and Ontario Heritage Foundation, 1980.

————. "Doukhobor Folk and Decorative Arts," *Canadian Folklore* 4 (1984), pp. 43–65.

————. "Friedrich Ploethner (1826–1883): Cabinetmaker and Weaver." *Canadian Collector* (May/June 1980), pp. 28–32.

————. "The Painted Furniture of John and Christian Gerber," *Waterloo Historical Society* (1981), pp. 26–31.

————. "Perpetuation and Adaptation: The Furniture and Craftmanship of John Gemeinhardt (1826–1912). *Canadian Antiques and Art Review* (March 1981), pp. 19–34.

————. "The Traditional Folk Arts of Lunenburg County." In *The Spirit of Nova Scotia*, Richard Field, ed.

————. "When Furniture Becomes Folk Art: Neustadt Cabinetmaker John P. Klempp (1857–1914). *Canadian Collector* (Sept./Oct. 1982), pp. 46–50

Bird, Michael, and Kobayashi, Terry. *A Splendid Harvest: Germanic Folk and Decorative Arts in Canada*. Toronto: Van Nostrand Reinhold, 1981.

Bishop, Robert. *Centuries and Styles of the American Chair, 1640–1970*. New York: E.P. Dutton and Co., 1972.

Blachkowski, Aleksander. *Dawne Meble Ludowe Polnocnej Polski*. Torun: Muzeum Etnograficzne w Toruniu, 1976.

Brett, Gerard. *English Furniture and Its Setting: From the Later Sixteenth to the Early Nineteenth Century*. Toronto: University of Toronto Press, 1965.

Burke, Susan M., and Hill, Matthew H., eds. *From Pennsylvania to Waterloo: Pennsylvania-German Folk Culture in Transition*. Kitchener, Ont.: Friends of the Joseph Schneider Haus, 1991.

Canada House: *All Things Common: Mennonite and Hutterite Home Furnishings* (Catalogue Text: Michael Bird, Nancy-Lou Patterson). London, England: 1992.

Canadian Museum of Civilization. *Art and Ethnicity: The Ukrainian Tradition in Canada.* Hull: Canadian Museum of Civilization, 1991.

Carved and Painted Woodwork by Russian Craftsmen. Smolensk: Sovetskaya Russia Publishers, 1985.

Comstock, Helen. *American Furniture: Seventeenth, Eighteenth and Nineteenth Century Styles.* New York: The Viking Press, 1962.

Cotton, Bernard D. *The English Regional Chair.* Woodbridge, Suffolk: Antique Collectors Club, 1990.

————. "Irish Vernacular Furniture." In *Regional Furniture: The Journal of the Regional Furniture Society*, vol. 3. 1989, pp. 1–26.

Craig, Clifford, Kevin Fahy, and E. Graeme Robertson. *Early Colonial Furniture in New South Wales and Van Diemen's Land.* Melbourne: Georgian House, 1972.

Deneke, Bernward. *Bauernmöbel: Ein Handbuch für Sämmler und Liebhaber.* München: Keysersche Verlagsbuchhandlung, 1969.

Desjacques, G. *Le mobilier breton (rustique).* Hennebont: imp. J. Mehat, n.d.

Dobson, Henry, and Barbara Dobson. *The Early Furniture of Ontario and the Atlantic Provinces.* Toronto: M.F. Feheley Publishers, 1974.

————. *A Provincial Elegance: Arts of the Early French and English Settlements in Canada.* Kitchener: Kitchener-Waterloo Art Gallery, 1982.

Dolz, Renate. *Bauernmöbel.* München: Wilhelm Heyne Verlag, 1972.

Eastlake, Charles. *Hints on Household Taste in Furniture, Upholstery and Other Details.* New York: Dover Publications, 1969.

Fales, Dean A. *American Painted Furniture, 1660–1880.* New York: E.P. Dutton, 1972.

————. *The Furniture of Historic Deerfield.* Deerfield, Mass.: Historic Deerfield, 1976.

Filbee, Marjorie. *Dictionary of Country Furniture.* London: The Connoisseur, 1977.

Flandrin, Jean-Louis. *Families in Former Times: Kinship, Household and Sexuality.* Cambridge: Cambridge University Press, 1979.

Foss, Charles H. *Cabinetmakers of the Eastern Seaboard.* Toronto: M.F. Feheley Publishers Limited, 1977.

Frankel, Candie. *Encyclopedia of Country Furniture.* New York: Michael Friedman Publishing Group, 1993.

Gauthier, Joseph Stany. *Le mobilier bas-breton* (ensembles et details). Paris: Ch. Massin et Cie, 1927.

————. *Le mobilier des vielles provinces de France.* Paris: Ch. Massin et Cie, n.d.

Gaynor, Elizabeth, and Kari Haavisto. *Russian Houses.* New York: Stewart, Tabori and Chang, 1991.

Gilbert, Christopher. *English Vernacular Furniture, 1750–1900.* New Haven and London: Yale University Press, 1991.

Gloag, John. *Guide to Furniture Styles: English and French 1450–1850.* London: Adam and Charles Black, 1972.

Groer, Leon. *Decorative Arts in Europe 1790–1850.* New York: Rizzoli, 1985.

Hayward, Charles H. *English Country Furniture.* London: Evans Brothers Limited, 1959.

Hepplewhite, George. *Cabinet-Maker and Upholsterer's Guide.* London, 1788.

Hinckley, F. Lewis. *A Directory of Antique Furniture.* New York: Bonanza Books, 1953.

Holme, Charles, ed. *Peasant Art in Russia.* London: The Studio, Ltd., 1912.

Hooper, Toby, and Juliana Hooper. *Australian Country Furniture.* Victoria, Australia: Viking O'Neil, 1988.

Hope, Thomas. *Household Furniture and Interior Decoration,* 1807. London: John Tiranti Limited, 1946.

Janneau, Guillaume. *Le meuble populaire francais.* Paris, 1977.

Janzen, Reinhild Kauenhoven, and Janzen, John M. *Mennonite Furniture.* Intercourse, Pa.: Good Books, 1991.

Johannesen, Stanley. "The Unknown Furniture Master of Waterloo County." *Canadian Collector* (July/Aug. 1977), pp. 18–23.

Johannesen, Stanley, and Bird, Michael, *Furniture and Fraktur: An Exhibition of Artifacts from Waterloo County and Germanic Ontario* (Sept. 18–Oct. 16, 1977), Waterloo: University of Waterloo Art Gallery, 1977.

Kinmonth, Claudia. *Irish Country Furniture 1700–1950.* New Haven and London: Yale University Press, 1993.

Kirk, John T. *Early American Furniture.* New York: Alfred A. Knopf, 1970.

Knell, David. *English Country Furniture: The National and Regional Vernacular 1500–1900.* London: Berrie and Jenkins, 1992.

Loudon, J.C. *Encyclopedia of Cottage, Farm and Villa Architecture and Furniture.* London, 1833.

MacLaren, George. *Antique Furniture by Nova Scotian Craftsmen.* Toronto: McGraw-Hill Ryerson, 1961.

————. *Nova Scotia Furniture.* Halifax, N.S.: Petheric Press, 1969.

McIntyre, John. "John and Ebenezer Doan: Builders and Master Craftsmen." *Canadian Collector* (July/Aug. 1979), pp. 27–32.

————. "Niagara Furniture Makers–I," *Canadian Collector* (May/June 1977), pp. 50–3.

———. "Niagara Furniture Makers–II," *Canadian Collector* (Sept./Oct. 1977), pp. 50–3.

———. "Niagara Furniture Makers–III," *Canadian Collector* (March/April 1978), pp. 24–8.

———. "Niagara Furniture Makers–IV," *Canadian Collector* (July/Aug. 1978), pp. 37–40.

McMurray, Allan Lynn. "Wilno Furniture," *Canadian Collector* (Nov./Dec. 1975), pp. 10–16.

Minhinnick, Jeanne W. *At Home in Upper Canada.* Toronto: Clarke, Irwin, 1970.

———. *Early Furniture in Upper Canada Village, 1800–1837.* Toronto: Ryerson Press, 1964.

Montgomery, Charles. *American Furniture: The Federal Period, 1785–1825.* New York: The Viking Press, 1966.

Morgan, Robert J. "A Brief History of Cape Breton Island." Sydney, N.S.: The Beaton Institute, 1971.

Nutting, Wallace. *Furniture of the Pilgrim Century.* Framingham, Mass.: Old American Co., 1921–24.

———. *Furniture Treasury.* 2 vols. New York: Macmillan Company, 1928.

Nykor, Lynda M., and Patricia D. Musson. *Mennonite Furniture: The Ontario Tradition in York County.* Toronto: Lorimer, 1977.

Oliver, Lucile. *Mobilier Alsacien.* Paris: Editions Massin, 1965.

Opolovnikov, Alexander, and Yelena Opolovnikov. *The Wooden Architecture of Russia.* New York: Harry N. Abrams, 1989.

Ormsbee, Thomas H. *Field Guide to Early American Furniture.* Boston: Little, Brown and Co., 1952.

Pain, Howard. *The Heritage of Upper Canadian Furniture.* Toronto: Van Nostrand Reinhold, 1978.

Palardy, Jean. *The Early Furniture of French Canada.* Toronto: Macmillan of Canada, 1963.

Peddle, Walter L. *The Forgotten Craftsmen.* St. John's, Nfld.: Harry Cuff Publications Limited, 1986.

———. *The Traditional Furniture of Outport Newfoundland.* St. John's, Nfld.: Harry Cuff Publications Limited, 1983.

Peesch, Reinhard. *The Ornament in European Folk Art.* New York: Alpine Fine Arts Collection, Ltd., 1982.

Praz, Mario. *An Illustrated History of Furnishing from the Renaissance to the 20th Century.* New York: George Braziller, 1964.

Pronin, Alexander, and Barbara Pronin. *Russian Folk Arts.* London: Thomas Yoseloff Ltd., 1975.

Quimby, Ian M.G., and Scott T. Swank. *Perspectives on American Folk Art.* New York: Dover Publications, 1980.

Riley, Noel. *World Furniture.* Secaucus, New York: Chartwell Books, 1980.

Ritz, Gislind M. *Alte bemalte Bauernmöbel Europa.* München: Verlag Callwey, 1980.

Rowan, Michael, "Doukhobor Tables," *The Upper Canadian* (May/June 1982), p. 47.

Rowan, Michael, and John Fleming. *Ukrainian Pioneer Furniture.* Toronto: Ukrainian Museum of Canada (Ukrainian Women's Association of Canada: Ontario Branch), 1992.

Rybakov, B.A. *Russian Applied Art of Tenth–Thirteenth Centuries.* Leningrad (St. Petersburg): Aurora Art Publishers, 1971.

Ryder, Huia G. *Antique Furniture by New Brunswick Craftsmen.* Toronto: Ryerson Press, 1965.

Santore, Charles. *The Windsor Style in America: 1730–1830.* Philadelphia: The Running Brook Press, 1981.

Schmitz, Hermann. *The Encyclopedia of Furniture.* Ernest Benn Limited, 1926.

Shackleton, Philip. *The Furniture of Old Ontario.* Toronto: Macmillan of Canada, 1978.

Sheraton, Thomas. *Cabinet-Maker and Upholsterer's Drawing Book.* London: 1791–94.

Shockey, Jim. "The Best of the West: Western Canada's Homemade Treasures Come of Age." *Canadian Century Home* (April–May 1987), pp. 14–17.

———. "Doukhobor Sunduki," *The Upper Canadian* (Jan./Feb. 1989), pp. 18–19.

———. "Doukhobor Frames," *The Upper Canadian* (Nov./Dec. 1990), pp. 66–7.

Smith, Anne, ed. *The Victorian House Catalogue.* Republication of *Young and Marten's Catalogue*, from 1895 on. London: Sidgwick and Jackson, 1990, New York: Sterling Publishing Company, 1992.

Smith, George. *The Cabinet-Maker and Upholsterer's Guide: Being a Complete Drawing Book.* London: Jones and Co., 1826.

———. *A Collection of Designs for Household Furniture.* London: 1808.

Smolensk Museum of Art. *Carved and Painted Wordwork by Russian Craftsmen.* Smolensk: Sovetskaya Russia Publishers, 1985.

Stevens, Gerald. *In a Canadian Attic.* Toronto: Ryerson Press, 1963.

Stewart, Don R. *Pre-Confederation Furniture of English Canada.* Toronto: Longmans, 1967.

Symons, Scott. *Heritage: A Romantic Look at Early Canadian Furniture.* Toronto: McClelland and Stewart, 1971.

Tardieu, Suzanne. *Meubles regionaux dates.* Paris: Editions Vincent, Freal et Cie, 1950.

The 1901 Editions of T. Eaton Co. Limited. Toronto: The Musson Book Company, 1970. Introduction by Jack Stoddart.

Toller, Jane. *English Country Furniture*. Cranbury, New Jersey: A.S. Barnes & Co., 1973.

Viel, Lyndon C. *Antique Ethnic Furniture*. Des Moines, Iowa: Wallace Homestead, 1983.

Voronov, Vasilii Sergeevich. *Peasant Art*. Moscow, 1972. (NK975.V62 1972)

Ward, Gerald W.R., ed. *Perspectives on American Furniture*. New York: W.W. Norton and Company, 1983.

Webster, Donald B., ed. *The Book of Canadian Antiques*. Toronto: McGraw-Hill Ryerson, 1974.

Webster, Donald B. *English-Canadian Furniture of the Georgian Period*. Toronto: McGraw-Hill Ryerson, 1979.

Whitehead, Ruth Holmes. *Eliteky: Micmac Material Culture from 1600 A.D. to the Present*. Halifax: Nova Scotia Museum, 1980.

Wilkie, Angus. *Biedermeier*. New York: Abbeville Press Publishers, 1987.

Yeager, William. *The Cabinet Makers of Norfolk County*. Simcoe, Ont.: The Norfolk Historical Society, 1975.

Related Works

Adamson, Anthony, and John Willard. *The Gaiety of Gables: Ontario's Architectural Folk Art*. Toronto: McClelland and Stewart, 1974.

Ackroyd, Peter. *Chatterton*. London: Penguin, 1987.

Bachelard, Gaston. *Poetics of Space*. New York: The Orion Press, 1964.

Canadian Museum of Civilization. *From the Heart: Folk Art in Canada*. Toronto: McClelland and Stewart, 1983.

Catermole, William. *Emigration: The Advantages of Emigration to Canada*. London: Simplin and Marshall, 1831. Coles Reprint, 1970.

Flandrin, Jean Louis. *Families in Former Times: Kinship, Household and Sexuality*, 1976. Cambridge: Cambridge University Press, 1979

Hansen, H.J. *European Folk Art*. New York: McGraw-Hill Book Company, 1968.

————. *Painting in Canada: A History*, 1966. Toronto: University of Toronto Press, 1977.

Harper, J. Russell. *A People's Art: Naive, Primitive, Provincial and Folk Art in*

Canada. Toronto: University of Toronto Press, 1974.

Howison, John. *Sketches of Upper Canada*. Edinburgh: Oliver and Boyd, London: G. and W.B. Whittaker, 1821. Coles Reprint, 1970.

Traill, Catharine Parr. *The Canadian Settler's Guide*, 1855. Toronto: McClelland and Stewart, New Canadian Library, 1969.

————. *The Backwoods of Canada*, 1836. Toronto: McClelland and Stewart, 1929.

INDEX

Italics refer to figure numbers.

Roentgen, David, 93
Russian Mennonite, 84
Ryder, Huia, 30

S

St. Andrew's Cross, *201, 202*
Salamander chairs, *221, 222, 223, 226*
Savinkoff, John Alec, *515*
Schwager, Alois, *425, 427*
Schlafbank (see bench bed)
Scottish furniture, *40, 43, 96*
Scottish immigrants, 26, 66–67
seigneurial system, 41–42
settle, 39, *71*
settle bed (see bench-bed)
Shackleton, Philip, *361*
Sheraton style, 16, 17, 20, 40, 56, 63, 67, 68, 69,
 70, 71, 75, 76, 81, 82, 88, *103, 247, 374, 494,*
 584, 585
Sheraton, Thomas, 16, 17, *213, 227, 292, 293*
shoe foot, 28
Shuh, Jacob, *386*
Sibley chairs, *83–85, 117*
Sifton, Clifford, 90
skamya, 100
sleep-bed (see bench-bed)
Snider, Samuel, *321*
sobranie, 101, *666, 687*
Stahl, Paul, *528*
Stokes, Thomas, 25
stol, 81
Strum, Alexander, *8*
Stuart, James, 48
súgán chair, 38, 39, *161*
sunduk, sunduki, 100, *513–516, 667–679*
Sysoev, Ivan F., *692*
szafa, 80, *438, 439*

T

Talbot Settlement, 67
Talon, Jean, *196*
Tarasoff, Koozma, 337
Thomarat, Jeanne, 17
Tolstoi, Leo, 97
Traill, Catharine Parr, 14, 18, 28, *269*
transitional chest, 35, *99, 139, 309*
tridarn, 70
trompe l'oeil, *470, 546*
trundle (truckle) bed, 40, *343*
Tulles, Pallister and McDonald, 25
Tutenkhamen, King, 24
Twiss clocks, *216, 248*
Tyson, John U., *323*

U

Ukrainian furniture, 92–95
Ukrainians in Canada, 90–92
uzorochye, 99

V

Verigin, Peter V. (Lordly), 96, *511, 627, 693*
Victorian style, *46, 103, 448, 457*
Vinecove chairs, *80, 109*

W

Waddell, James, 27
Weber, Samuel, *353*
Webster, Donald B., 13–14, 19–20, 27
Welsh cupboard, 70
Wettlaufer, Eckhardt, *433*
Wilkin, John M., *147*
William and Mary style, *74, 87*
Windsor-style chair, 38, 59, 63, 71, 77, *2, 7, 72, 79,*
 80, 90, 101, 108–110, 294–296, 346, 383, 384
Woodard, Emiline, *305*
Woodall, W.H., *384*
writing-arm Windsor, *101, 115*

Y

Yorkshire immigrants, 26

Z

zlaban, 81
zoomorphic motifs, 58, 93, 94, 98, 99, *27, 49, 499,*
 501, 555, 601, 617, 685
Zubenkoff, Wasyl, 99, *512, 518, 603, 694, 695, 702*
zydel, 81